ANCIENT JEWISH ART

EAST AND WEST

ANCIENT JEWISH ART

EAST AND WEST

GABRIELLE SED-RAJNA

INTRODUCTION BY BEZALEL NARKISS

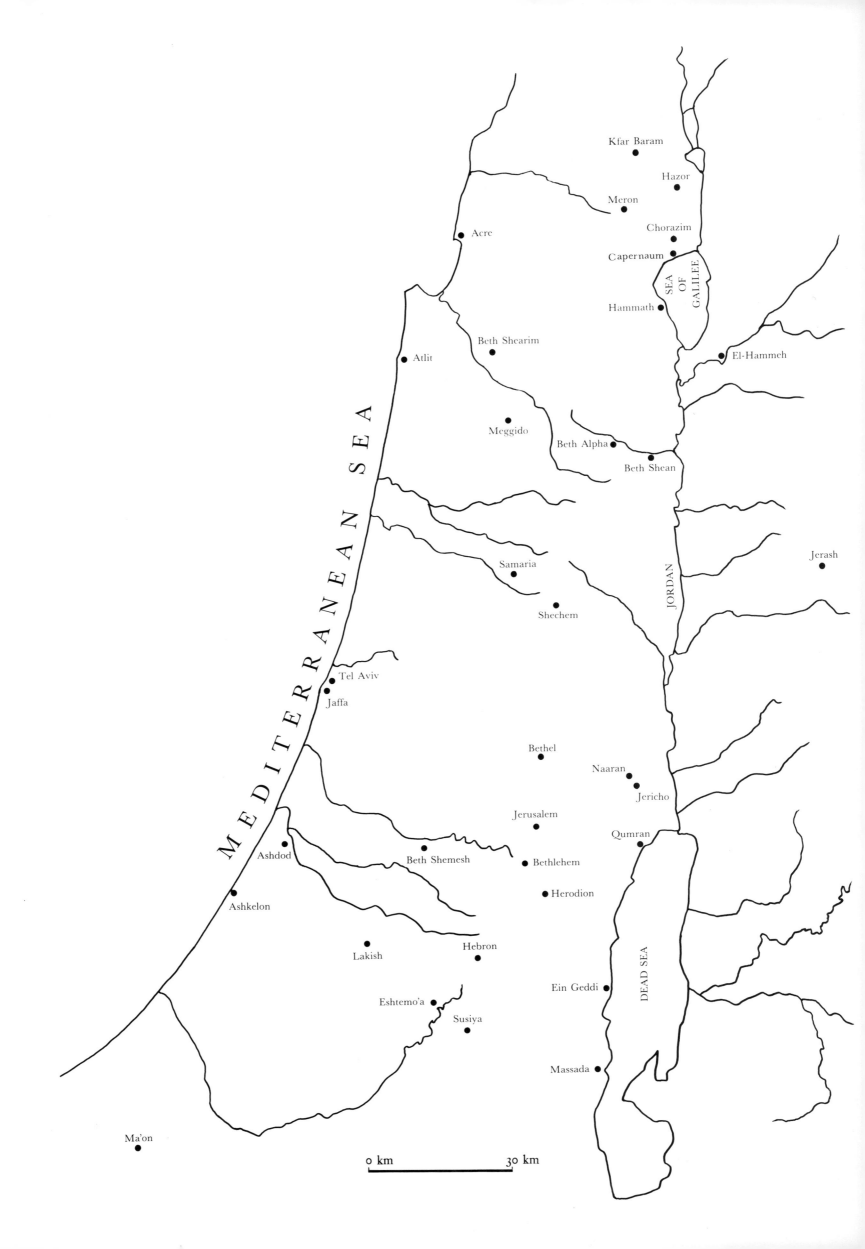

MEDITERRANEAN SEA

Kfar Baram

Hazor

Meron

Chorazim

Acre

Capernaum

SEA OF GALILEE

Hammath

Beth Shearim

Atlit

El-Hammeh

Meggido

Beth Alpha

Beth Shean

Samaria

Jerash

Shechem

JORDAN

Tel Aviv

Jaffa

Bethel

Naaran

Jericho

Jerusalem

Qumran

Ashdod

Beth Shemesh

Bethlehem

Herodion

Ashkelon

DEAD SEA

Lakish

Hebron

Ein Geddi

Eshtemo'a

Susiya

Massada

Ma'on

0 km 30 km

INTRODUCTION
BEZALEL NARKISS

THE ORIENT

THE GENESIS OF SYMBOLS

NARRATIVE SYMBOLS

THE IMAGE OF THE WORLD

THE WEST

STYLES OF THE DIASPORA

CEREMONIAL ART

THE RENAISSANCE OF NARRATIVE ART

This book is dedicated to my mother
Irène Rajna
G.S.-R.

FOREWORD

Forty years of discoveries, of objective and uninhibited scholarly research, have led to the renewal of the image of Jewish art, an image tarnished by misunderstandings and prejudices of nineteenth century historians. The moment was opportune to reconsider the subject and to present in a continuous picture the themes and forms which ensure the specificity of this art in the changing historical environments of the East and West.

This is the objective of the book. The undertaking, ambitious in its scope, demanded comprehensive and generous collaboration. It was unfailingly forthcoming so that it is now my pleasant task to name all those who have had a part in the realization of this work.

My first thought is devoted to the memory of my beloved teacher, the late Professor Georges Vajda, whose wisdom and constant care were with me at each step of my way. My deepest gratitude is addressed to Professor Bezalel Narkiss for his disinterested and continuous help throughout the preparation of this book. My warmest thanks also go to Professor André Caquot for his interest and valuable advice. Bibliophiles and those who admire fine illustration will join me in appreciating the competence and meticulous care brought by Yves Rivière to the realization of this book.

I wish also to thank the Israeli scholars who placed at my disposal documents relating to their recent discoveries and their work in progress. I refer especially to Drs. Moshe Dotan, Dan Barag and Dan Bahat.

In accordance with the plan of this series and thanks to the technical assistance of the publisher, the greater part of the documentation, especially of the archeological sites and the manuscripts and objects preserved in Israel, as well as of the Budapest manuscripts and some of the objects at present in Paris, are original photographs. My cordial thanks to the curators of the Israel Museum, the Department of Antiquities of the Israel Ministry of Education and Culture, the Museum of the Chief Rabbinate, Hechal Shlomo, the Italian Synagogue and the Jewish National and University Library, all in Jerusalem; the Haaretz Museum, Tel Aviv; the Academy of Sciences, Budapest; the Musée Cluny, Paris; and M. Victor Klagsbald of Paris, who generously permitted access to their treasures.

The documentation was completed with the cooperation of many scientific institutions: Bibliothèque nationale, Paris; British Library, London; Bodleian Library (Oxford), Vatican Library, Biblioteca Ambrosiana, Milan; the university libraries of Hamburg, Darmstadt, Leipzig and Stuttgart; Bibliothèque municipale of Marseilles; Musée du Louvre; Musée Juif, Paris; Jewish Museum, London; and the Badisches Landesmuseum, Karlsruhe. I trust that their curators and staff will accept this expression of my thanks.

I cannot close this foreword without saying what I owe to the Institut de Recherche et d'Histoire des Textes and its director Jean Glénisson. His encouragement and friendly atmosphere and the scientific services lavishly provided by the Institute were of incalculable help and support throughout this undertaking. Finally, I would like to express my grateful acknowledgement to Michel Garel for his intelligent and devoted assistance.

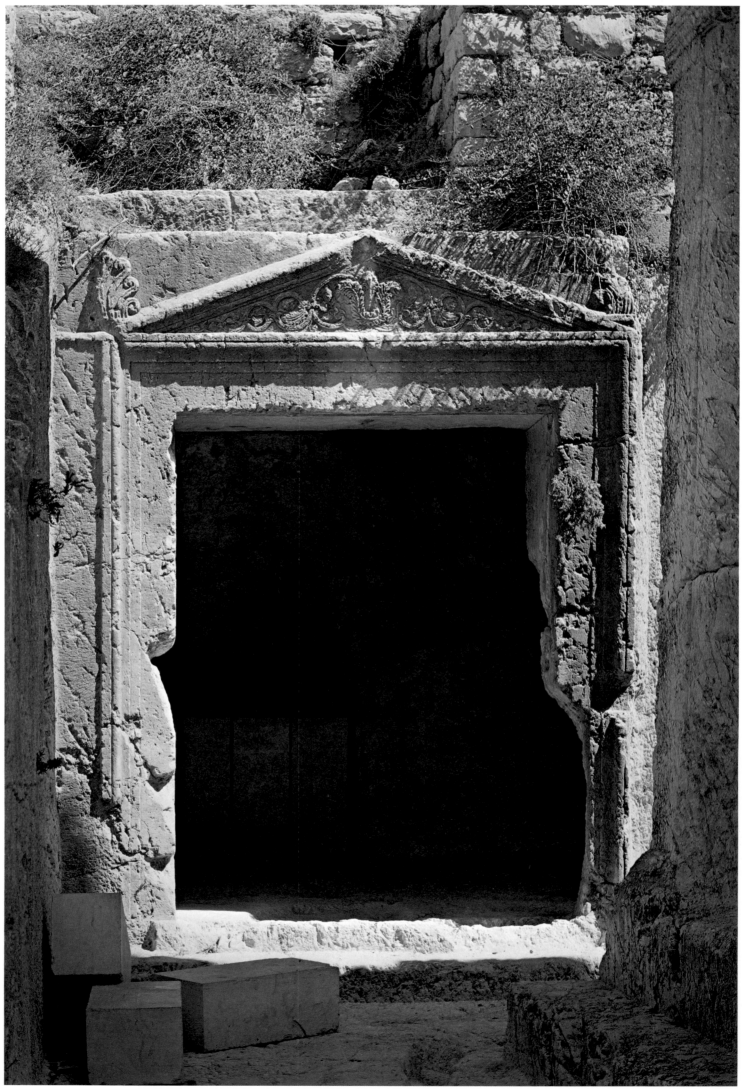

Sculptured tympanon from the catacombs known as "Josaphat Tombs." Kidron Valley, Jerusalem, II–I B.C.E.

INTRODUCTION

To identify the characteristics of Jewish art throughout its history, one must first agree on the meaning of the term "Jewish." We must define the criteria which determine that certain groups of people from France, Yemen, Russia and other countries are called "Jews." It is only after this concept has been clarified that we may define the elements typical of the visual expression of these people and their attitude towards the plastic arts; only then will it be possible to define specific objects intended for iconographic or ritual purposes, and approach a study of stylistic problems.

The fundamental criterion of the Jew in every place and in every time has been essentially his religion. However, Judaism is not limited to an intellectual adherence to monotheism. It includes the acceptance of a code of laws that regulate both individual and communal life in accordance with the Mishna and Talmud. Mishnaic laws, derived from the Bible, were adapted to the realities of the Hellenistic period and were above all concerned with community life in the Holy Land. The organization of this communal life resembled that of the Greek cities, each community being free to form its own traditions and set up laws according to its own needs. The laws that governed the nation as a whole, however, had to do with Temple services and ceremonials. But in spite of their comprehensive nature, these laws did not prescribe strict liturgical uniformity. At the beginning of the Mishnaic era (3 B.C.E.), the prayers had not been definitively fixed. Ceremonies were not uniform nor was public reading of certain passages on the Sabbath mandatory. Clearly, the laws of the Mishna did not define belief as much as they proposed an ethic—a way of life. The 613 precepts of the Mishna—the number symbolically corresponds to all the parts of the body—do not constitute dogma but rather define behavioral and practical principles. This ethic, which also includes rules concerning rituals, is the factor which according to one vision of Judaism defines Jewish identity.

Only a small number of pious people are conscious of the nature of their faith in a unique God, or of their adherence to the messianic hope, but every man is able to judge whether or not he is living in acordance with the precepts and traditions of Judaism. It is this ethic which, extending beyond religion, forms the Jewish nation. And it is from this point of view that we must also consider the cultural manifestations of this people, its literary works and its visual arts. Since this ethic regulates all aspects of the life of both the individual and the community, there can be no Jewish art except within the context framed by rabbinical rules and communal ritual traditions.

The Jewish attitude toward the plastic arts must be defined from the same point of view; here we are concerned with the attitude of the Jewish people after the Hellenistic period, since this differs considerably from that of the Israelites of the Bible.

For the man of the Ancient East, sacred images represented a living reality. Confusion between the symbol and reality was in the eyes of the early Hebrews characteristic of idolatry. The fashioning of sacred images was incompatible with the belief in the existence of one God—an idea expressed by the Second Commandment (*Exodus* XX,4): "Thou shalt not make unto thee any graven image," but with this further clarification (XX, 5): "Thou shalt not bow down to them, and thou shalt not serve them." But it is certain that this injunction was never interpreted as an absolute prohibition against every figurative representation. Some chapters later on (*Exodus* XXV) relate the making, on divine command, of the Tabernacle, whose principal component was the Ark of the Covenant adorned at the top with two cherubim facing each other, wings touching. These cherubim,

whose appearance apart from the wings is not precisely described in the text, were represented by lifelike creatures which medieval iconography later endowed with human faces. God appeared to Moses between the two cherubim (*Numbers* VII, 89) and later the Bible calls God, "he who dwells within the cherubim."

The construction of the Tabernacle was clearly directed by aesthetic considerations. Bezalel, the artist entrusted with the execution, is said to have been "filled … with the spirit of God" (*Exodus* XXXI, 1-3 and XXXV, 30-31). Further, King Solomon did not hesitate to include the imposing bronze basin of ablutions, the "sea" resting upon twelve bronze oxen within the Temple (I *Kings* VII, 25). It was only when Jeroboam cast calves, like Aaron's Golden Calf (I *Kings* XII, 28), thus manifesting an idolatrous intention, that the anger of God was aroused.

Fear of idolatry, still alive during the Hellenistic period and certainly under the reign of the Seleucids, was, however, of a different nature. Greek culture and Greek religion exercised a real fascination on the wealthy and cultured classes. The Hellenization of the Jews, had it been allowed to pursue its course to the end, would have led to the disappearance of the Jewish communities. Alarmed by this real danger and by the spectacle of the priests making ever greater concessions to the Seleucids, the Hasmoneans—or Maccabees—a pious priestly family, instigated the outbreak of a revolt that had been brewing. The episode of Hannah and her seven sons, who were executed for refusing to violate religious law,[1] is an illustration of the isolated acts of rebellion that preceded the great insurrection of the Hasmoneans.

This period was transitory. Once the Temple had been purified of images of the alien religion, and the Hasmoneans firmly established in the government, the fear of idolatry diminished and the rigor of the law lost its justification. During the Mishnaic period, especially after the destruction of the Temple, fear of graven images gradually gave way to tolerance. Several accounts in the Talmud offer proof that certain renowned rabbis freely admitted works of art, explicitly distinguishing their aesthetic function from the religious significance that was attached to them in other circles.[2] There were certainly exceptions. Such was the case of Rabbi Nahum bar Simai, a celebrated ascetic, considered a saint because he refused to look at even a coin struck with an image in relief. When he died, to spare him the offense he had tried to avoid all his life, statues which punctuated the route of the funeral procession were covered as his coffin passed.[3] This story, apart from its ideological interest, is also valuable for its testimony to the existence of statues in the streets, even in towns inhabited by Jews.

According to other opinions, the Second Commandment, interpreted literally, concerned only images in high relief or sculptured in the round, and not incised relief or two-dimensional art. This may explain the attitude of Rabbi Yochanan, a learned scholar of the third century, who did not forbid painted decoration in the synagogue,[4] or that of Rabbi Abun in the fourth century who was not opposed to using mosaics to decorate floors.[5] These testimonies render homage to the tolerant spirit of the religious authorities of these centuries, and provide explicit proof of the existence of such paintings and mosaics in the Galilee itself.

This permissive attitude, already quite accepted during Roman times, is certainly at the origin of the similar position adopted by the leaders of the medieval European communities. Whenever they were asked whether images (then commonly occurring in the synagogues on stained glass and in manuscripts) were lawful or not, their objections were inspired rather by fear that the faithful would be distracted, than by concern for the literal observance of the Second Commandment.[6] Opposition on the grounds of religious principle prevailed during certain periods, particularly when society itself was in accord. Such was the case with Jews living in Byzantium during the iconoclastic period or of Jews in Islamic-ruled regions who were subject to the religious doctrines of Islam. Similarly, in southern Germany during the twelfth and thirteenth centuries the Ashkenazi *Hassidim*, represent-

atives of an ascetic trend, opposed all aesthetic manifestations, privately, publicly, or in the synagogue. For example, manuscripts could not be decorated. For over a hundred years the *Hassidim* influenced manuscript decoration.

However, figurative representation was not entirely banned. The human face was simply replaced by the heads of a bird or some other animal—a motif that became so familiar that painters continued to use it even when they no longer understood its significance. Also, in certain later manuscripts women were still shown with animal-like heads.[7]

The intransigence of the *Hassidim* was not widely diffused. In the majority of communities artistic production was tolerated and even encouraged when a didactic purpose was involved or when a beautiful setting was imparted to the precepts (*hiddur mitzvah*), the two goals often going together. In general, there was no general restriction concerning the use of art objects in private life. Nineteenth century historians have exaggerated the effects of the Second Commandment on the evolution of art and on the role of art in Jewish culture. Their conception of the genius of Judaism, which they considered deprived of all inclination towards the visual arts, is belied by the objects and monuments that give evidence that aesthetic inclinations and an admiration of beauty existed among the Jews of Antiquity and the Middle Ages, as it did among other peoples.

To decorate a synagogue, an object, a book or oneself in order to accomplish a precept with elegance became one of the most important customs of Jewish life. A community sufficiently wealthy to build itself a house of assembly also decorated it in the taste of the period. If the same community could indulge in a liturgical book reserved for the use of the officiating rabbi, it was customarily illuminated in the contemporary style. A private individual who could for his personal use commission a manuscript, a Bible, a prayerbook or a philosophical treatise generally made a financial effort to ensure that the execution would be perfect and the ornamentation luxurious.

Several objects intended for ceremonial use owe their existence to the desire to give beauty to the rituals or the laws. An example is the spice box which marks the ceremony ending the Sabbath. Until the thirteenth century a simple myrtle branch was generally used for this purpose. Rabbi Ephraim of Ratisbonne (d. 1175) remarked that he placed these branches inside small glass cases. This was probably the beginning of a development culminating in the spice boxes shaped like little Gothic towers of which numerous sixteenth century examples exist. The almost uniform style of these objects in the West suggests that the first boxes of the type were most probably designed during the Gothic period, perhaps in imitation of Christian censers which originated in oriental models.[8] Once adopted, the forms of ritual objects were habitually considered to be authentically Jewish, and respectfully reproduced throughout the centuries. Certain objects might belong to only one school. For example, the Torah sheath used in Eastern countries was replaced by a "mantle" and "crown" in the West. Certain forms created for utilitarian reasons survive while the function they formerly expressed has become obsolete. An example is the vertical stand for the Hanukkah lights. It was added at a certain period to the horizontal burners so that they could be suspended and is now scrupulously preserved in countries where the *Hanukkiya* is displayed vertically. This respectful preservation of the familiar and traditional, of the symbolical form of objects intended for rituals, acquired doctrinal authority through the ages and is one of the principal features of Jewish art.

There are also specific shapes as well as certain motifs and iconographic elements that are considered Jewish, and from a chronological view, these constitute the first characteristics of Jewish art. Among the iconographic types, certain symbols remained particular to Judaism: the seven-branched candelabrum or *menorah*, the *lulav*, *etrog*, and a synagogue wall with a door or an ark instead of a divine image. Narrative iconography, composed

principally of Biblical and Midrashic episodes, originated in Antiquity, probably from a desire to illustrate manuscripts containing paraphrases of the Bible. These iconographic themes, later adapted for the decoration of Jewish synagogues, were also taken up in Christian churches and manuscripts. But even though this iconography was adopted by Christians and thus ceased to be exclusively Jewish, Jews continued to use it during the Middle Ages and Renaissance until the Emancipation. In the Middle Ages a special iconography, consisting of ritual or didactic scenes, evolved for the illustration of liturgical books, especially for the Passover *Haggadah*.

In addition to the iconographical elements proper to Jewish art, certain types borrowed from Christian and pagan sources were added. These were reinterpreted and invested with a Jewish significance, and were absorbed in their original form into the repertoire of Jewish themes. A famous example is Orpheus playing the harp and charming the beasts. In Hellenistic art he represents the victory of the soul over the forces of the universe and over death. Jewish art borrows this image to represent David, the psalmist-king who prefigures his promised Messianic descendant.[9] Another example of a borrowed motif is the animal-headed personage already mentioned, later adopted by the German schools of the thirteenth century. Its source may perhaps be found in Christian or Islamic art, where it indicated the holiness of the Evangelists and the celestial deacons.[10] At first this connotation was also present in Jewish art, for instance in the eschatological composition in a thirteenth century Biblical manuscript (see p. 166). Later, the motif was used freely for decoration without any particular connotation.

The style of a national art is generally considered the most important criterion of its character. Egyptian, Greek and Chinese art are easily identifiable by their style in spite of regional or chronological variations. It is even possible to discern at what moment and in what manner certain aspects of these styles were modified by external influences. Roman art was influenced by the Greek art through later Hellenistic expression. Thirteenth century art in England, Spain and Germany was shaped by French styles. All these however preserved their national character, at least for a certain period of time.

Jewish art, even at the beginning, was never characterized by a specifically national style. In every place and in every era its manifestations display traces of borrowings from the local schools. The style of the paintings of the Dura-Europos synagogue is Eastern Hellenistic, exactly like that of other monuments of the region. The structures of Galilean synagogues resemble those of Syrian temples and Paleo-Christian churches. European and Oriental illuminated manuscripts from the tenth to the sixteenth century show close affinities to the pictorial style of the local schools of their respective areas of origin. The elements specific to Jewish art are its unique symbols, certain iconographical types and the form of the ritual objects, but hardly ever the style. In spite of a certain degree of autonomy on the social level, the dependence of the Jewish communities on the material civilizations surrounding them was almost total. In the artistic field this dependence is attested by the style of the works, freely and willingly borrowed from Gentile art.

In considering the characteristics of Jewish art it is also necessary to delineate its important periods. Jewish art must be set apart from that of the ancient Israelites as well as from the Hellenistic forms that flourished under the Romans. The Hellenistic era may be regarded as a transitional time during which Jewish art took form, and then began to flower at the time of Herod the Great, finally developing more fully after the destruction of the Temple. The appearance of Jewish art corresponds in some sense to the survival of a new Judaism that had no political center.

The final stages of Jewish art should be examined with a flexible perspective. The decline began with the Emancipation in the nineteenth century. Until this period Jews who aspired to become free artists in the

Renaissance sense of the term, had to leave their communities or lead a double life. After the Emancipation, Jewish artists, having acquired the techniques, aesthetic perspectives and themes of the Gentiles, could pursue their art without any inhibitions. Some exceptions remained, and religious art, where traditional rules are respected, survives to this day.

Despite essential differences between the art of the Israelites and Jewish art, the Jews of later periods are the direct heirs of the Israelites, of the religious concepts and traditions that are rooted in the Bible and in the Biblical period. Certain monuments of the Israelite era were of fundamental importance, and their memory was perpetuated in Jewish tradition throughout its entire history. The most important of these is without doubt the Temple which made Jerusalem the religious, national and political center of Judaism. By virtue of the same tradition, the predecessor of Solomon's Temple—the Tabernacle of the desert and its accoutrements—also became a sign of the spiritual and political cohesion of the nation.

No material vestige has survived of the Tabernacle, or of the Temple of Solomon and Zerubavel. The few surviving fragments of the Herodian Temple barely allow a reconstruction of the general aspects of the immense ensemble. It is, however, of vital importance to understand these antecedents and attempt to reconstitute the chief components of their structures.

The construction of the Tabernacle is the first artistic realization commemorated in the Bible (*Exodus* XXV-XL). The Biblical account is abundant in details relating to the fashioning of the Ark of the Covenant (*Exodus* XXV, 10-17; XXXVII, 1-6), of the candelabrum (*ibid.*, XXV, 31-39; XXXV, 14; XXXVII, 17-24), of the incense altar (*ibid.*, XXX, 1-5; XXXV, 15; XXXVII, 25-28), of the altar of burnt offerings (*ibid.*, XXVII, 1-8; XXXV, 16; XXXVIII, 1-7), the shewbread table (*ibid.*, XXV, 23-30; XXXV, 13; XXXVII, 10-15) and their ritual implements. The two cherubim with spread wings (*Exodus* XXV, 18-20), described in no greater detail, were probably images of living creatures.

The first expression of the presence of God among his people was superceded by the Temple constructed during Solomon's reign. The site was chosen by David, who had installed the Ark of the Covenant on Mount Zion after the capture of Jerusalem. Desirous of building a sanctuary to shelter the ark, the last years of his life were spent trying to assemble the materials necessary for this enterprise and fixing the site of the Temple where the angel appeared to him (II *Samuel* XXIV; I *Chronicles* XXI). A tradition spanning nearly a thousand years of history affirms that the site chosen by David was the same Mount Moriah (II *Chronicles* III, 1), where God appeared to Abraham as he was about to sacrifice Isaac (*Genesis* XXII, 1-18). David's dream was realized by his son Solomon. Upon acceding to the throne, Solomon unified the kingdom and enlisted the cooperation of his neighbors. The list of materials and manpower mobilized by this king is imposing (II *Chronicles* II). And in addition to the compulsory labor he forced on his own subjects and on the indigenous inhabitants, Solomon called in special artisans from nearby countries. These craftsmen, with their skills and knowledge, contributed their own artistic style that seems to have marked the edifice.

Biblical sources permit us to reconstruct the design and general layout of the Temple.[11] A rectangular space of 60 x 20 cubits (a cubit was equivalent to about 50 cms.) was divided into three sections of equal breadth and of varied length: the hall (*ulam*), the sanctuary (*hechal*), and innermost sanctum called *devir*—an architectural term usually translated as Holy of Holies. The descriptions leave the appearance of the facade uncertain. Although interpretations of these descriptions often differ in detail, scholars see affinities with contemporary Syrian sanctuaries (Lachish, Beth Shean, level VI, Hazor, level 1 b). These affinities are especially visible in the design of

a temple wherein the central chamber was not accessible to the majority of the worshippers, the priest being the only person permitted to enter. This design was also typical of Canaanite places of worship. The vestiges of the Temple of Hazor, its votive steles and sanctuary containing the statue of the divinity that only the officiating priest was permitted to perceive, preserve the memory of this religious perspective.

Reconstruction of the sanctuary at Hazor, level 1b., XIV–XIII century B.C.E. Jerusalem, Israel Museum.

The creation of ornamentation and furniture was given to Hiram of Tyre, an artisan "filled with wisdom and understanding, and capable of creating anything from bronze" (I *Kings* VII, 14). He fashioned bronze columns with *fleur-de-lys* capitals, a wooden altar covered with gold that was placed before the Holy of Holies and an even larger bronze altar of the burnt offerings. There was an enormous basin for the purification rituals — ten

cubits in diameter and five cubits in height—called the "sea," and it was supported by twelve oxen oriented in threes towards the four points of the compass, another reminder of cosmic symbolism. The high priests alone were permitted to see the cherubim with outstretched wings (I *Kings* VI, 23-28) that were above the Ark of the Covenant. The image of these beings, reshaped by interpretations that evolved from one period to the next, became one of the constant motifs of medieval iconography.

The first Temple, destroyed in the capture of Jerusalem by the army of Nebuchadnezzar in 586 B.C.E., was rebuilt with Cyrus' authorization. The work was not finished until the reign of Darius (521-485 B.C.E.), although the consecration took place in 516 B.C.E. This edifice is too briefly described in the Bible (*Nehemiah* III-IV), to allow a precise reconstruction. In any event it seems that the second sanctuary, although of fundamental importance for national revival, was architecturally far more modest than Solomon's Temple.

The real restoration of the Temple is associated with Herod the Great (37-4 B.C.E.).[12] Nothing remains of this monument, whose splendor filled the ambitious monarch with pride, except for some parts of the outer supporting walls and the impressive gates. Its appearance, however, can be reconstructed from literary sources, the most important being the accounts of Flavius Josephus and the treatise *Middot* from the Mishna. Written in the second century, the latter presents a rather idealized image of the Temple. This treatise, as its name "Measures" suggests, provides indications concerning the dimensions of the original sanctuary which Herod's restoration seems to have followed scrupulously. The description contains some discrepancies which result from a confusion of the data relating to the dimensions of the real building and those of the idealized sanctuary described in the vision of Ezekiel (XL-XLIII).[13]

Flavius Josephus gives two descriptions of the Temple which do not duplicate each other. The first,[14] written immediately after the war, presents the Temple as a vital center of resistance and emphasizes the powerful structure of the edifice. The second,[15] composed nearly twenty years later, commemorates the splendor of the restored Temple.

Herod started the work in the fifteenth year of his reign (according to the *Jewish War*, 18, *Jewish Antiquities*), but not without first having to overcome the people's distrust of his ambitious project. The building of the new sanctuary took eighteen months, the work as a whole not less than eight years. Even then the undertaking was only partially completed. By the year 64, eighteen thousand workers were still working on it. Although the descriptions of Josephus seem extremely meticulous, some contradictory details render the plan of the Temple uncertain. However, its general appearance can be reconstructed. It had been a series of enclosures, with porticoes and terraces, rising towards the summit of the hill. Steps led towards the inner sanctuary from an outer courtyard. This second enclosure was divided into two sections by walls. One part was reserved for women and the other for men who had attained a state of purity. In the western part of the men's section was the actual *naos*. The *naos* is thought to have taken the form of a basilica-like nave, flanked on both sides by aisles and preceded by a vestibule with an imposing facade. The door of the facade was gilded and crowned by a tympanum decorated with vines and golden clusters of grapes.

The reconstruction of the Temple facade remains uncertain; Josephus' descriptions suggest an ensemble of a composite style—a succession of enclosures adorned with majestic porticoes reflecting the traditions of Mesopotamian architecture. The decoration consisted of columns with capitals of juxtaposed orders that bore little resemblance to their original models, while vines and acanthus leaves on the pediments seem to be imitations of the Hellenistic style. Today, only fragments of the outer wall of this famous edifice survive, on the eastern and southern sides,

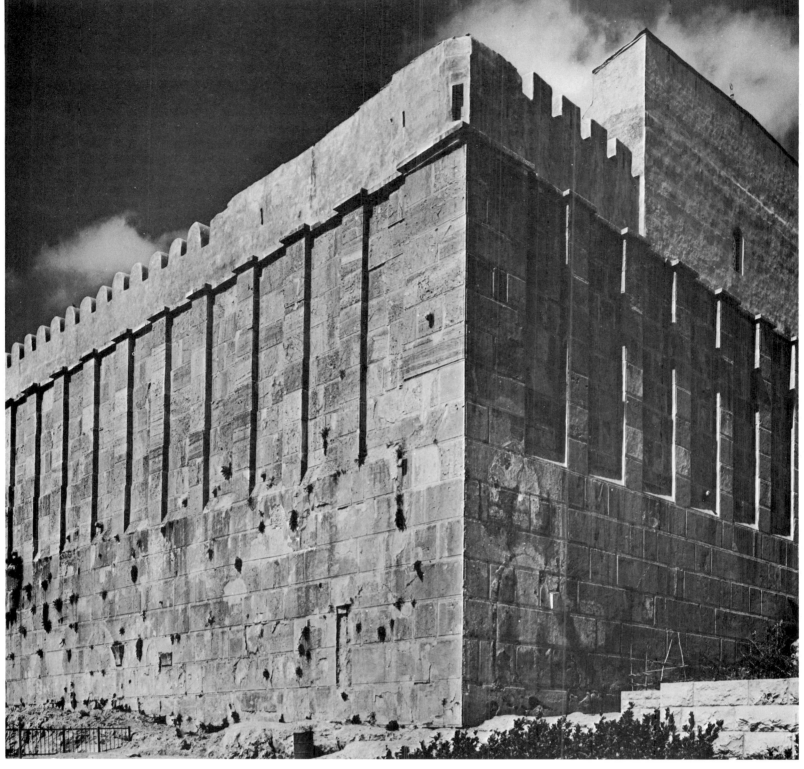

Hebron, Tomb of the Patriarchs, structural wall by Herod the Great (37-4 B.C.E.)

and on the western side — the "Wailing Wall." The double-chiseled stone masonry, its nuances proportionally calculated to catch the light, displays refined workmanship. This masonry is typical of Herodian constructions. It can be seen also at Hebron in the sacred enclosure that Herod built on the principal site of the cult of the Patriarchs (*Jewish Antiquities*, XIII, 91).

Vestiges of civil architecture from the Israelite epoch are rare. The establishment of towns and fortresses probably followed techniques of construction and planning very similar to those of neighboring Assyrian and Phoenician sites. The interior ornamentation was certainly similar. The ivory plaques covering the furniture of the celebrated "house of ivory" of King Ahab (874–853 B.C.E.) were decorated with motifs resembling those on the ivories found at the sites of the Assyrian rulers' palaces at Nimrod and Arslan Tash. The palm-leaf floral motifs were probably

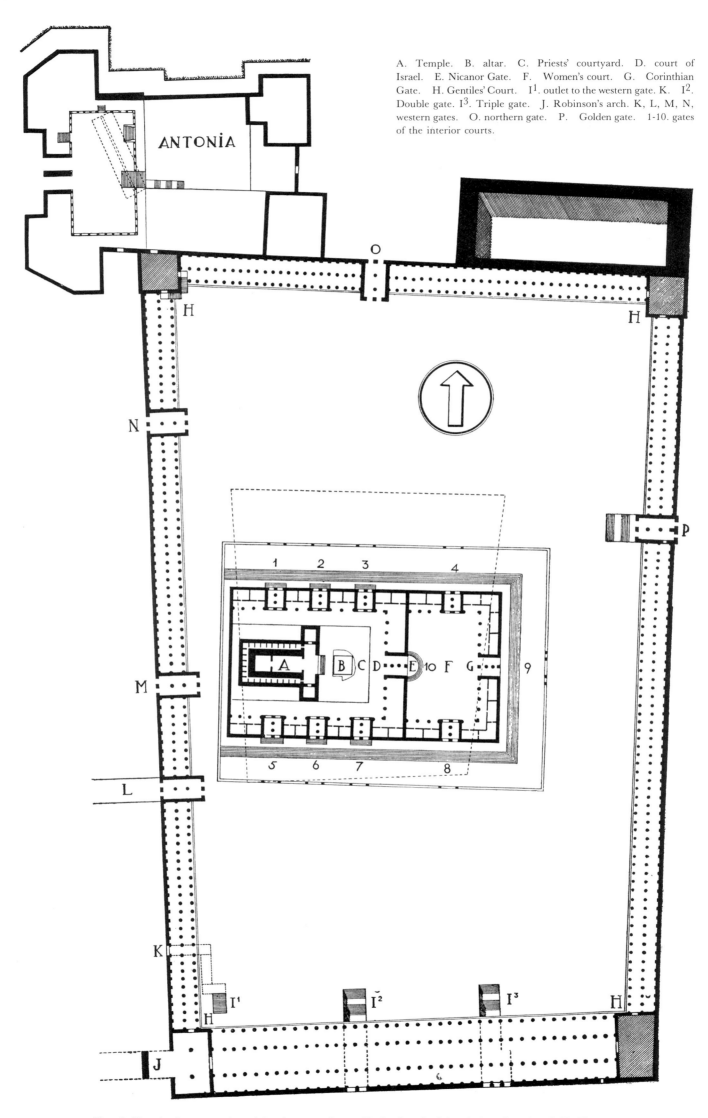

A. Temple. B. altar. C. Priests' courtyard. D. court of Israel. E. Nicanor Gate. F. Women's court. G. Corinthian Gate. H. Gentiles' Court. I¹. outlet to the western gate. K. I². Double gate. I³. Triple gate. J. Robinson's arch. K, L, M, N, western gates. O. northern gate. P. Golden gate. 1-10. gates of the interior courts.

ANTONIA

Herod's Temple. Reconstruction of the plan according to Flavius Josephus' descriptions (based on L.H. Vincent).

like "the palm trees and open flowers" which, alternating with cherubim, encircled the interior of Solomon's Temple (I *Kings* VI, 29 and 35). Other motifs, such as "the woman in the window" or the winged sphinx, are representations of themes from Assyrian mythology.

Very few and insignificant Jewish vestiges survive from the Persian period. The Hellenistic age, on the other hand, left numerous monuments, the great majority belonging to funerary art. The side of Jerusalem facing the Kidron Valley, below the Mount of Olives, is bordered by an important necropolis. Traditionally considered as the route that the Messiah will take to enter the holy city at the end of time, this valley has been the privileged resting place for those awaiting resurrection. Among the thousands of modest tombs on the slopes of the Mount of Olives arose several monuments.[16] The best known is the so-called "Tomb of Absalom," an edifice embedded within the cliff. Its crown, in the form of a cone that perhaps once terminated in a sheaf of palm leaves, is supported by half-columns in the Ionic style, bearing a Doric frieze with triglyphs and metopes. The juxtaposition of elements of different orders is one of the characteristics of this architecture. The only entrance, a narrow bay carved into the rock, has seven steps leading to a square chamber with stone benches. When this mausoleum was cleared of debris, a monumental portal carved into the cliff was exposed behind it. The facade, whose only decoration is a sculptured pediment, conceals a sepulchral ensemble composed of rooms with arcosolia niches and benches.

Known as the Tomb of Josaphat, the monument is similar to the Tomb of Absalom. This has been confirmed by the discovery of another group of the same type—the "Tomb of Zachariah" and the "Tomb of the Bnei Hezir." From the inscriptions carved over the architrave of the latter, it seems that the priestly family of the Bnei Hezir erected it to commemorate the *nefesh* (the "soul" of the deceased). The *nefesh* memorial was usually in the form of a stele or pyramid. This particular one is known as the "Tomb of Zacharias" and resembles in its form the "Tomb of Absalom." Neither tomb permits access to the interior. They are simply funerary symbols connected by an underground corridor to the catacombs of the Bnei Hezir. In any case these are the most ancient of well preserved monuments displaying a predominantly Hellenistic influence, although the precise dates are uncertain. Their architectural style and decorative elements, as well as the epigraphic characteristics of the inscription, situate them between the third and the middle of the first century B.C.E. This type of funerary complex, composed of catacombs with monumental facade and adjoining memorial, still persisted in the Herodian period, as may be seen in the "Tomb of the Kings" in the northwestern part of Jerusalem. The monument is dated. One of the sarcophagi in the chamber bears an inscription with the names of Izate and Helena of Adiabene, Izate's mother, known from the chronicles of Josephus (*Jewish Antiquities*, XX, 95). In speaking of the tomb Josephus mentions three pyramids that were built above the catacombs. While the pyramids no longer exist, the stone debris found near the monument seems to indicate that the description of the Jewish historian was accurate on this point. The monument as it now exists presents a structure analogous to that of the tombs of the Kidron Valley. The facade and the sarcophagi are decorated with motifs that were current in Hellenistic art: acanthus leaves, vines, garlands and rosettes.

This repertoire, occurring constantly on the objects as on the monuments, became enriched towards the end of the first century. Over a stone door of a tomb at Kfar Yassif (second century), among the usual ornaments— rosettes, disks, medallions with multiple rays—appear religious symbols: the facade of the Temple, represented in the form of an arch supported by two columns and mounted by a shell, and the seven-branched candelabrum. These symbols, together with the representation of the Ark of the Covenant and other ritual objects of the

Temple, were frequently depicted, especially after the capture of Jerusalem in 70 C.E., and became the most characteristic motifs of Jewish art.

The reign of Herod the Great was a period of enormous constructions. Several of his ambitious ensembles still survive, notably two fortresses that the king built for his own use. The Herodion, which he used as a refuge in his flight from Jerusalem, is situated to the south of Bethlehem. According to Flavius Josephus (*Jewish War*, I, 673), this fortress contained the king's tomb. The Herodion was built on a hill, and was reached by two hundred marble steps. The circular enclosure has three half-towers to the north, south and west, and a round tower to the east. Several constructions have been revealed in the thickness of the walls: a bath, a colonnade hall and a building with an adjacent ritual bath that perhaps served as a synagogue during the occupation of the fortress by the Zealots. According to Josephus' indications and recent excavations, habitations were to be found at the foot of the fortified hill.

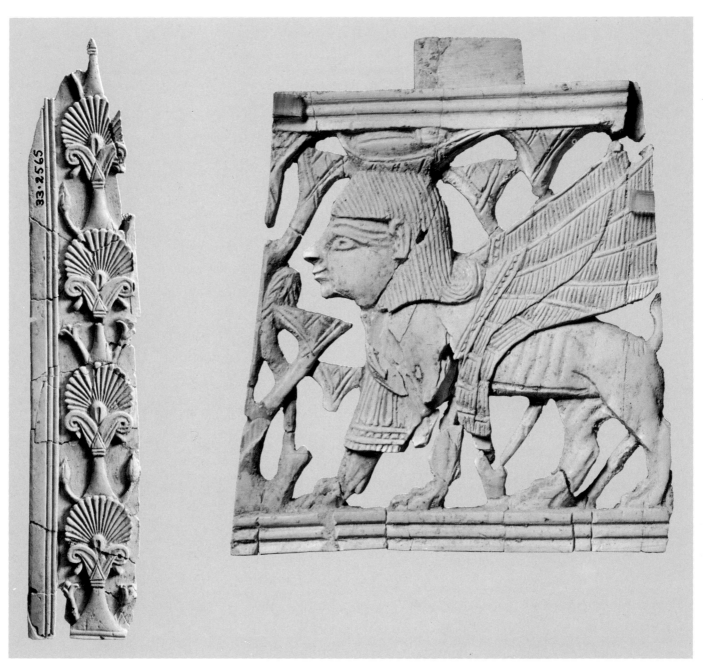

Frieze with palmettes. Samaria, VIII cent. B.C.E. Ivory plaque. Jerusalem, Israel Museum.
Winged Sphinx. Samaria, VIII cent. B.C.E. Ivory plaque. Jerusalem, Israel Museum.

"Woman at the window." Arslan Tash, IX cent. B.C.E. Ivory plaque. Karlsruhe, Badisches Landesmuseum.

The second fortress, Massada, is built on the eastern edge of the Judean desert, on an isolated peak, an advance post of the mountain chain that dominates the southern part of the Dead Sea.[17] Massada controlled the eastern and southern frontiers of the kingdom. According to the account of Flavius Josephus (*Jewish Wars*, VII, 285-303), which has been fully confirmed by the excavations, Herod transformed the arid rock into a fortress of incomparable perfection. The ascent was by three paths. From the Dead Sea side it was called, because of its narrowness and numerous detours, "the snake path." The two other paths were on the western slope, toward the mountain, where the differential in height was only some tens of meters. Each of these paths ended in iden-

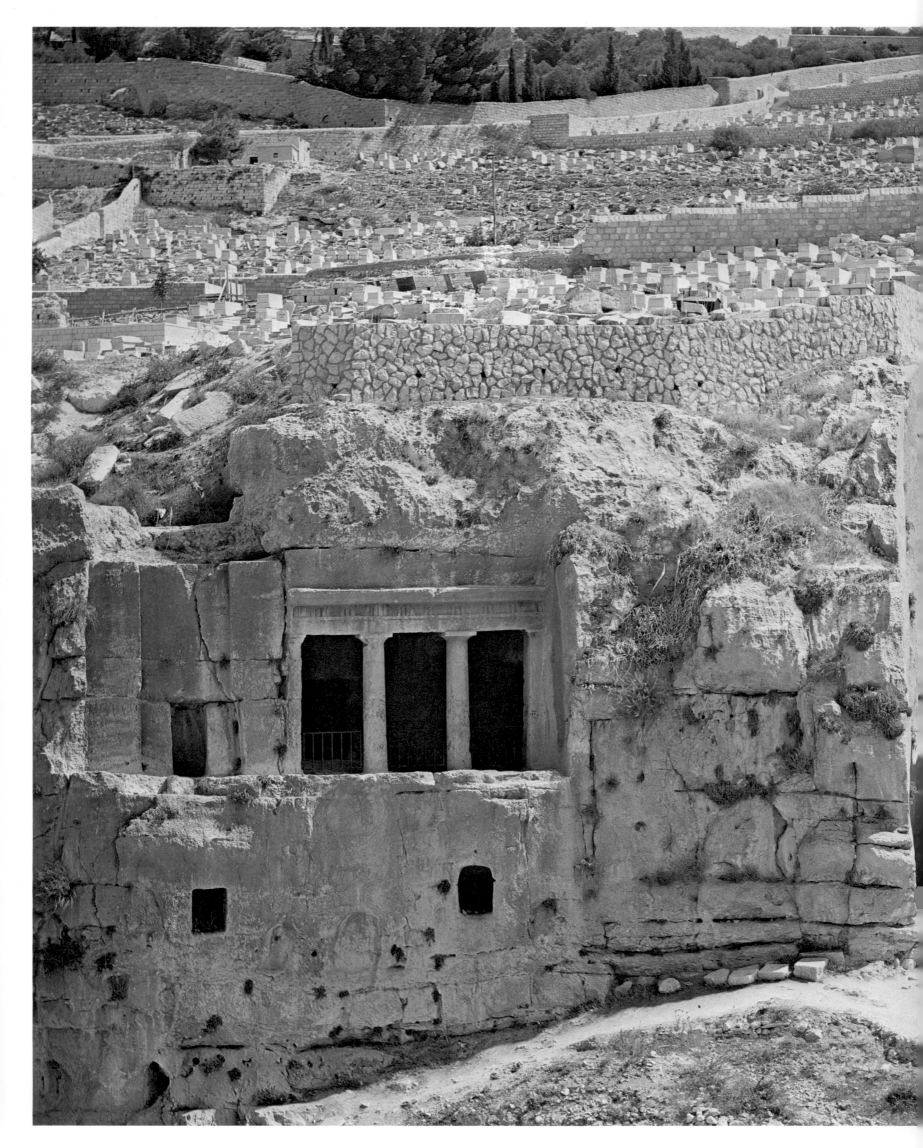

22
22

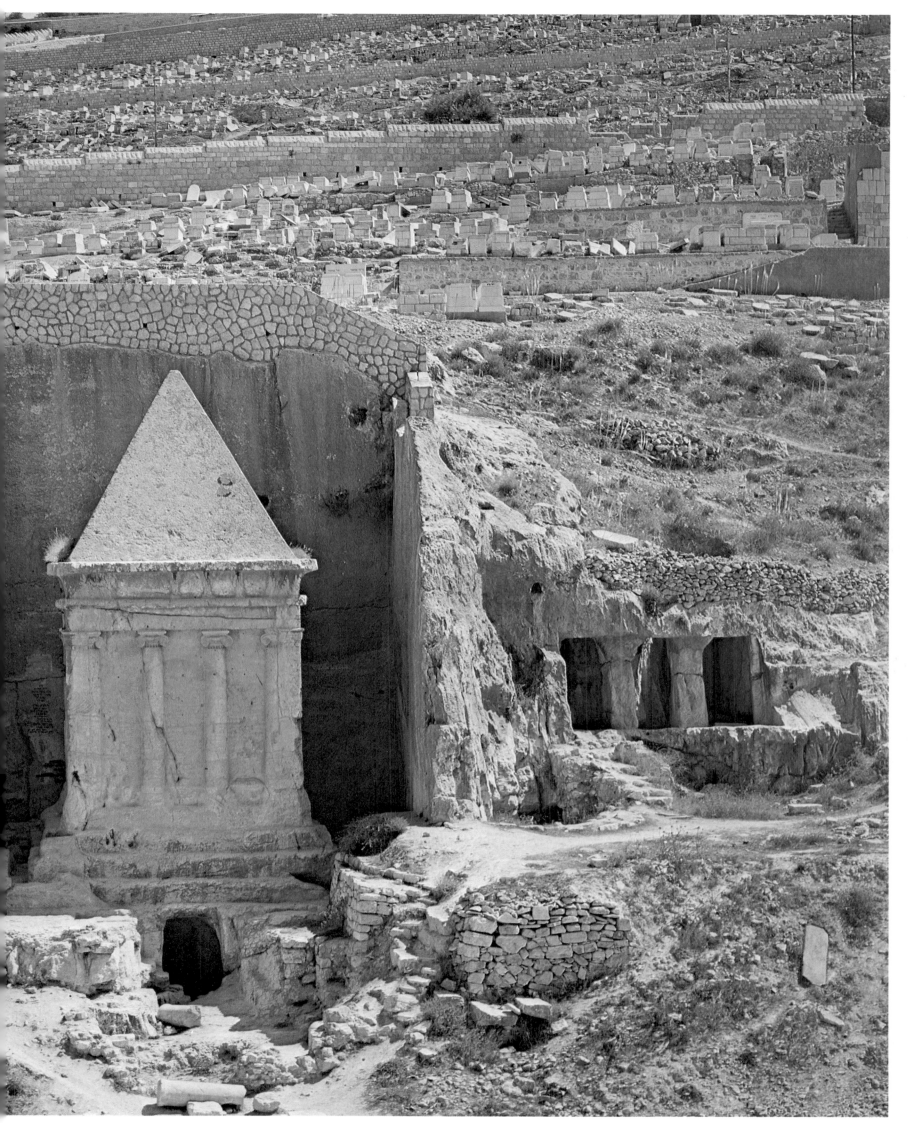

Catacombs of the Bene Hezir with the Tomb of Zachariah. Kidron Valley, Jerusalem. II–I cent. B.C.E.

23

HERODION. General Plan
I Eastern circular tower
II-IV Semicircular towers to the
north, west and south
V Enclosure
VI Staircase leading to palace.
VIII Peristyle, with interior garden
XI and XXXIV Structures to the
north and south of the peristyle
XII, XIII, XXXII Entry gates
XVI-XVIII Four-column hall and
adjoining rooms.
XIX-XXII Courtyard in the form of
a cross
XXIII-XXXI Bath
XXXVIII-XL Storerooms

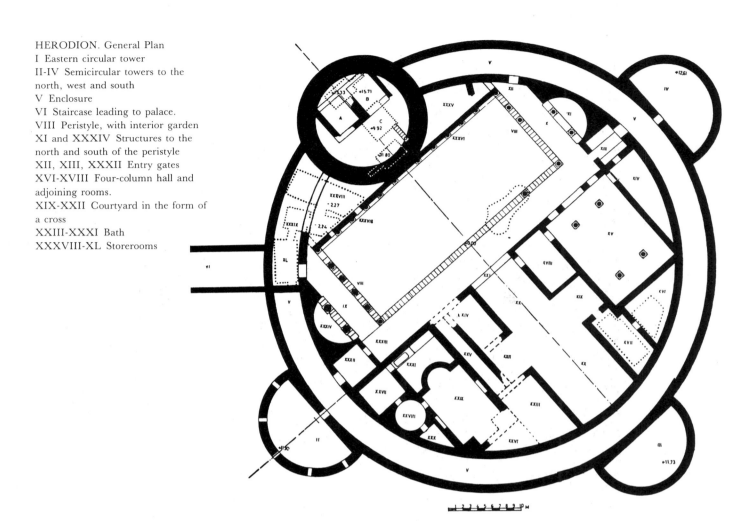

Herodion. Plan of the fortress
constructed by Herod the Great (37–4
B.C.E.)

24

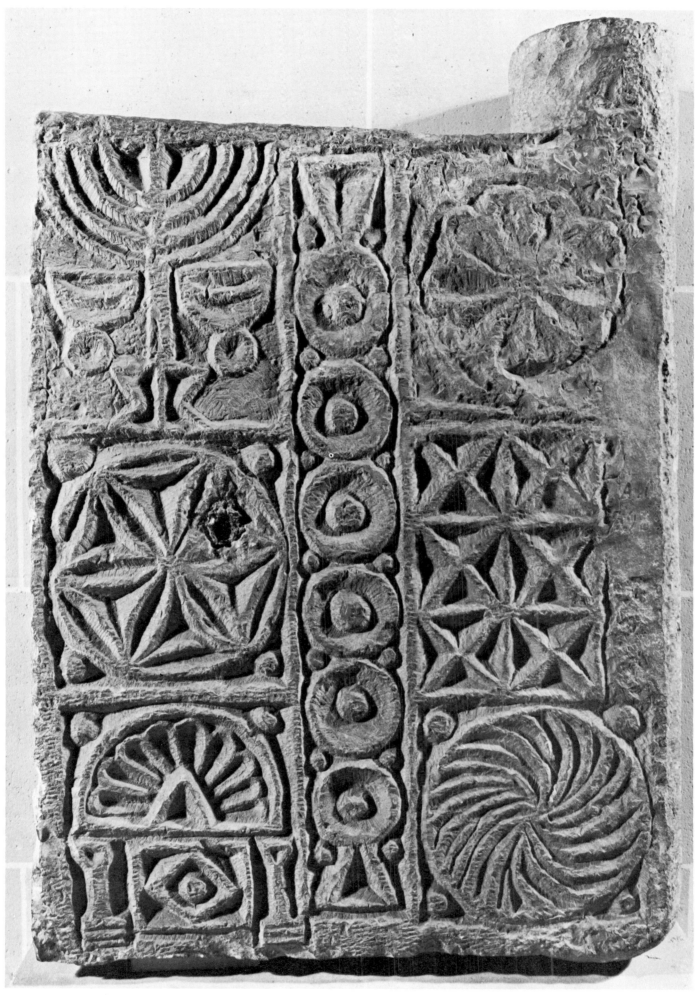

Kfar Yassif. Tomb entrance. II cent. B.C.E. Paris, Louvre Museum.

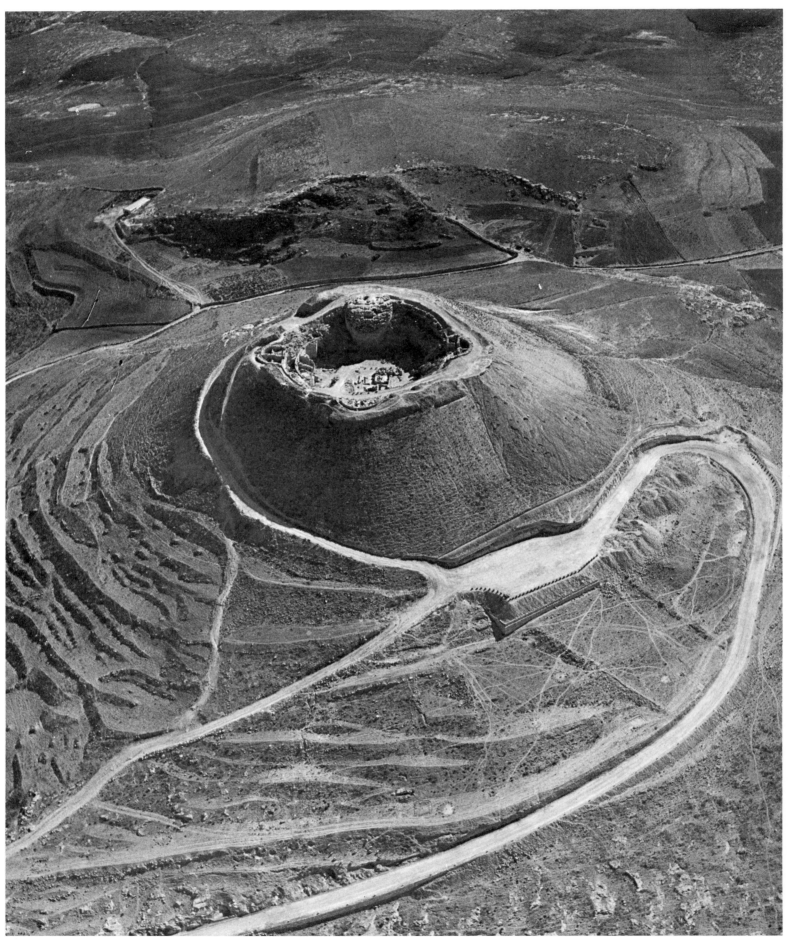

Herodion. Aerial view of the fortress.

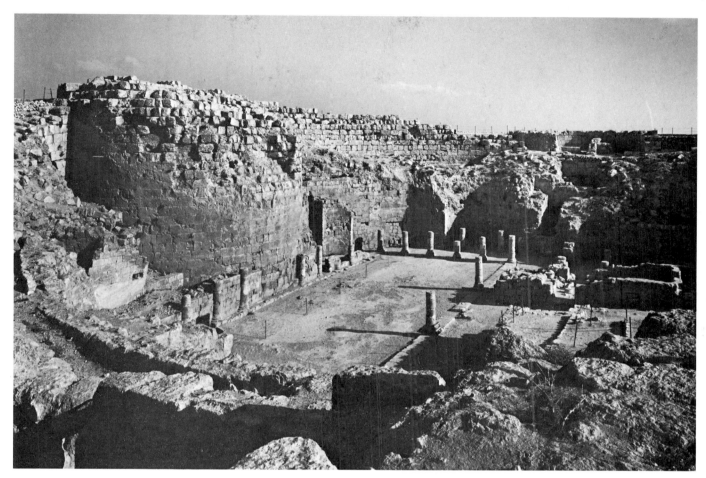

Herodion. View of the peristyle. Epoch of Herod the Great (37–4 B.C.E.).

tical gates giving access to the interior of the enclosure. Guarded by some thirty towers, the interior is shaped by the slope of the mountain. Within the walls, the buildings are functionally distributed, most of them concentrated in the northern part of the summit. The most imposing edifices served as living quarters for the king. The Northern Palace hosted official receptions, while the Western Palace was used for both administrative services and as residences for the court. The King's private apartments were also in the Northern Palace which faced fresh breezes and was sheltered from the midday sun. Three superimposed levels were constructed on the slope of the mountain to form a formidable edifice overlooking an abyss and dominating an immense panorama. No luxury denied, the lower level included a square courtyard encircled by columns with Corinthian capitals and frescoes on the wall that appeared like a marble veneer. The second level, also decorated with frescoes, contained a small pool, a cistern, and a staircase leading to the lodgings at the top level. The living quarters, isolated by an area covered by a black and white mosaic, also had fresco-decorated walls and ceilings. On the highest level, outside the palace, was the bath with its underground heating system that ensured graduated temperatures for the traditional chambers — the *caldarium*, the *tepidarim* and the *frigidarium*.

The Western Palace, designated for ceremonies and receptions, contained a room for the throne, a dining hall, dependencies and a bath whose mosaic pavement is almost entirely preserved. This building is surrounded by the administrative services, lodgings for officers and an imposing network of storehouses for reserves of arms and supplies. A short distance away, a rectangular hall divided in the center by a wall and flanked on three sides by stone benches, served as a synagogue. Although the benches are of a later period — from the Zealot occupation of the fortress — the construction itself is contemporary with the fortress. The synagogues of the Herodion and

Massada are the oldest to have been found in Israel; their design was the prototype perhaps for other Galilean synagogues.

The splendor of Massada did not outlive its builder. In the year 66 C.E., a handful of Jewish soldiers, the Zealots, installed themselves there for their last and heroic resistance. They survived for five years, completely surrounded. In 72 C.E. Governor Sylva finally penetrated the fortress. The nine hundred and sixty Zealots, rather than surrender, set fire to the buildings and committed suicide in the face of the final Roman assault. The fortress was again inhabited by Christian monks in the fifth and sixth century. Some cells and a church, the walls adorned with a mosaic of potsherds pressed into the mortar, and a mosaic pavement still partially extant, are the only witnesses of their probably quite brief presence in the fortress which remained abandoned after them.

The war against the Romans, the destruction of the Temple and the loss of national independence provoked profound cultural transformations in Jewish life. Geographic unity was broken and political autonomy lost for centuries. Ensuring internal homogeneity became a vital necessity. It was the epoch for editing the Mishna, then the Talmud, and for forming a kind of ideological enclosure around Judaism to secure its survival. Aspiration to national restoration underlay every thought. In the visual arts, this aspiration was expressed by a new language. Religious symbols such as the facade of the Temple, the image of the ark, the candelabrum and ritual accessories

Massada. Frescoes from the Northern Palace. Herod the Great

Massada. Bath, mosaic pavement.

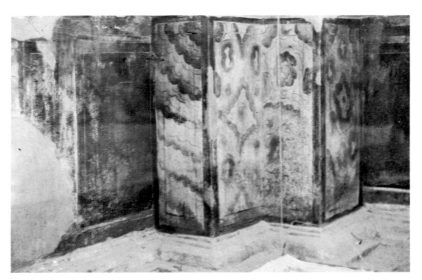

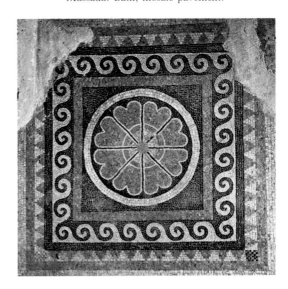

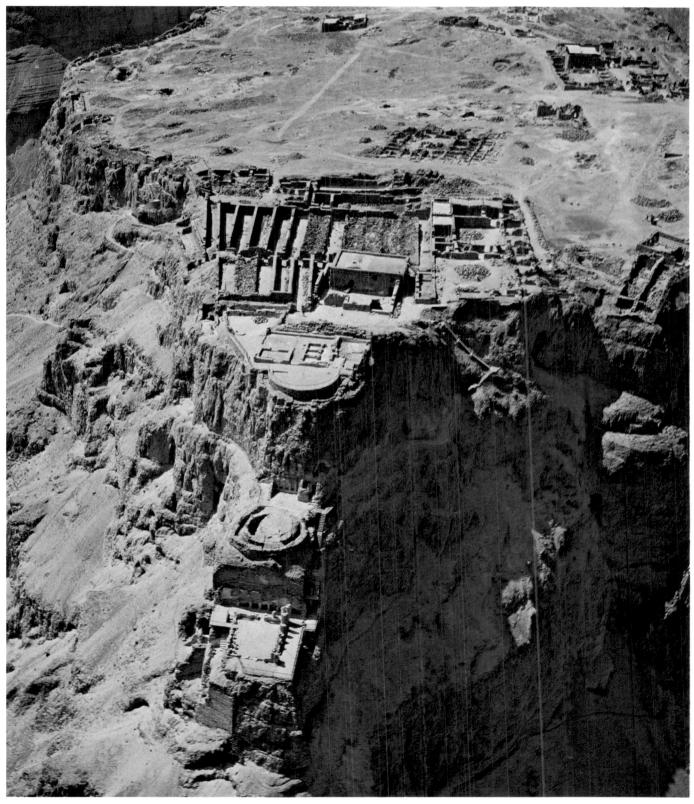

Massada. Aerial view of the Northern Palace.

decorated objects and monuments. Their role was twofold: to evoke the past, the spiritual center of Judaism that no longer existed except on the ideological level, and to prepare for the future, when through fidelity to tradition, this center would again become a living reality. The appearance of these symbols marks the birth of Jewish art.

ORIENT

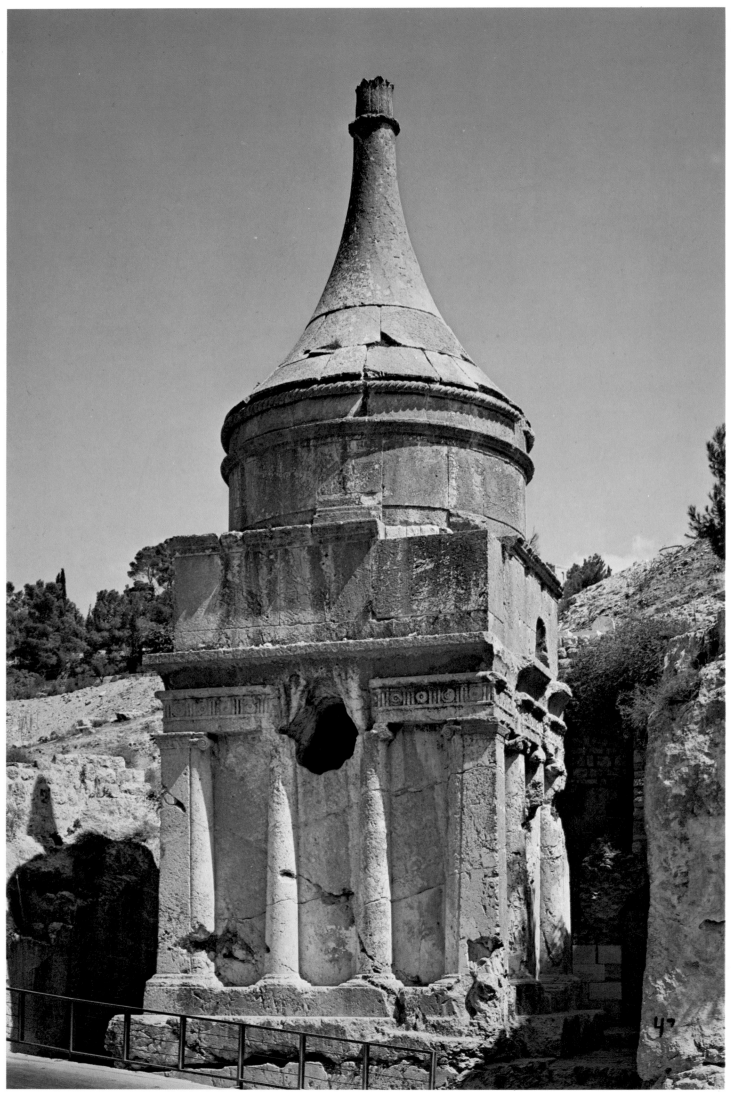

Funerary monument known as "Absalom's Tomb." Kidron Valley, Jerusalem. II–I cent. B.C.E.

32

THE GENESIS OF SYMBOLS

From the Hasmonean period marking the awakening of the national consciousness until the destruction of the Temple in 70 C.E., Jewish official art remained non-figurative. The priestly class ruled the nation and were primarily concerned with the purity of the religion and the cult as a whole. Adherence to doctrine was observed even though the categorical prohibitions against figurative art (*Exodus* XX, 4; *Deuteronomy* V, 8) were replaced by more liberal interpretations on the matter of the idolatry interdiction (*Leviticus* XXVI, 1; *Deuteronomy* XXVII, 15). Ornamentation was permitted in the representation of non-animate objects, geometrical and plant motifs, all of which had their origins in either Hellenistic or local oriental art forms.[18]

The ruling class showed a change of heart after the fall of Jerusalem, the principal center of the religion, and the loss of national independence. Forced to adopt a certain *modus vivendi* with their Roman masters, the Jews modified their ideas and gradually came to accept figurative art as a part of life. At the same time their devotion to the memory of the Temple and unwavering recollection of its implements and ritual objects gave rise to a new repertoire of specifically Jewish religious symbols that made an appearance on minor objects and monuments — a sign that the nation was striving to affirm its identity and recover its independence.

The coins reflect the ideas of the ruling class and quite clearly trace the evolution of these themes.[19] Hasmonean coins still carry the usual symbols of Hellenistic art: the cornucopia (horn of plenty) and leafy wreath under John Hyrcanus I (135–104 B.C.E.), the eight-pointed star with an anchor or *fleur-de-lys* on the reverse side under Alexander Jannaeus (103–76 B.C.E.), a palm branch under John Hyrcanus II (63–40 B.C.E.). Only the coins issued by the last representative of the dynasty, Mattathias Antigonus (40-37 B.C.E.) carry religious emblems. The seven-branched candelabrum may be seen on one of these issues, appearing perhaps for the first time as the supreme symbol with both the national and religious connotation of the Jewish people.

Bronze struck by Mattathias Antigone (40-37 B.C.E.); obverse: seven-branched candelabrum, Greek inscription, "to the king (Antigone)."

The coins issued by Herod the Great (37–4 B.C.E.) revert to the Hellenistic tradition. All of these pieces carry inscriptions in Greek designating Herod as King. One series is also dated.[20] The decoration includes symbols from the preceding period — horn of plenty, wreath — and some new emblems of a military nature — the *pilos* and shield,[21] or naval motifs such as the boat and anchor. It seems that any representation that might have offended the religious sensitivities of Herod's subjects was carefully avoided. Perhaps the only exception is the series depicting an eagle with outspread wings. This might have been seen as a replica of the famous emblem that decorated the pediment of the Temple, an image that aroused the Jews to violent protest. But its destruction was ruthlessly punished by Herod.[22]

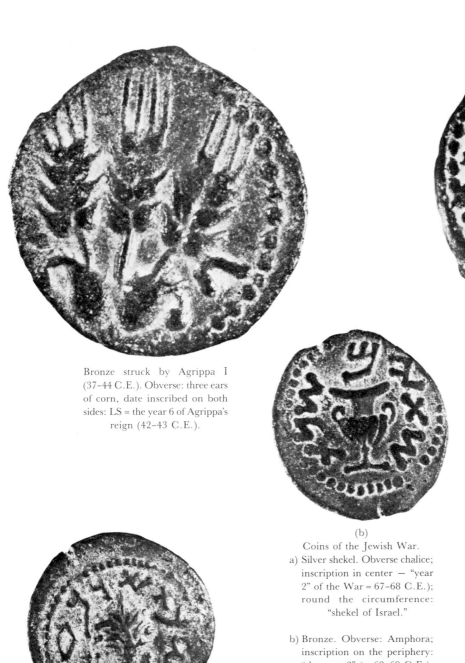

Bronze struck by Agrippa I
(37–44 C.E.). Obverse: three ears
of corn, date inscribed on both
sides: LS = the year 6 of Agrippa's
reign (42–43 C.E.).

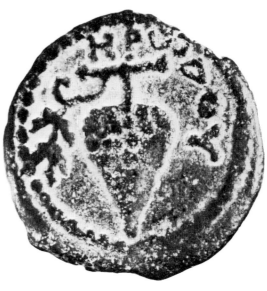

Bronze struck by Herod Arche-
laus (4 B.C.E.–6 C.E.). Obverse:
bunch of grapes with vine leaf,
Greek inscription "Herode."

(b)
Coins of the Jewish War.
a) Silver shekel. Obverse chalice;
inscription in center — "year
2" of the War = 67–68 C.E.);
round the circumference:
"shekel of Israel."

b) Bronze. Obverse: Amphora;
inscription on the periphery:
"the year 3" (= 68–69 C.E.).

c) Bronze. Reverse: vine leaf; in-
scription: "for the liberation of
Zion."

d) Bronze. Obverse: *etrog*; in-
scription: "for the redemption
of Zion" (year 4 = 69–70 C.E.).

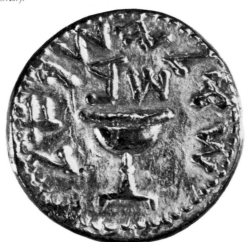

e) Bronze. Reverse: *lulav* between
two *etrogim*; inscription: "year
4" (69–70 C.E.).

Although they did not break with Hellenistic traditions, the coins issued by Herod's three sons were more diversified because of specific conditions prevailing in each of the kingdoms after the division of the realm. Herod Archelaus (4 B.C.E.-6 C.E.), whose coins were always inscribed "Herod" followed by his distinctive title of "Ethnarch," obtained the most important part of the kingdom—Judaea, Samaria and Edom with their chiefly Jewish population. To the emblems already employed—horn of plenty, boat with a high prow and helmet—he added motifs that, without having an explicitly religious significance, were to become part of the characteristic ornamentation of Jewish art: the triple bunch of grapes and the vine. Herod Philip II (4 B.C.E. - 34 C.E.), who reigned over the northern part of his father's kingdom, populated mainly by non-Jews, issued coins showing the royal effigy with the Temple erected in honor of Augustus on the reverse.[23] The coins bearing the name of Herod Antipas (4 B.C.E. - 39 C.E.), third son of the illustrious monarch, are mainly of historical interest: they are all dated and inscribed with the name of Tiberias, founded by Herod Antipas in 19 C.E. Agrippa I (37-44 C.E.), grandson of Herod the Great, recovered almost all his grandfather's territory with Roman support. The coinage he issued reveals a certain degree of concern for the sensibilities of his subjects. While continuing to issue coins with the Roman emperor's effigy, he added a special series for the benefit of the Jews—three ears of corn on one face and an object resembling a parasol on the other.

The first fundamental change in the iconographic vocabulary was brought about by the Jewish War (66-70 C.E.). The political and religious character of this uprising of the national consciousness is faithfully reflected in the coinage. Struck in silver (a prerogative of the Emperor throughout the Roman domains), these pieces proclaimed the Jewish right to autonomy. The Greek inscriptions make way for "Jerusalem the Holy" written in the ancient Hebrew character. The Hellenistic emblems are discarded and symbols evoking the festivals and ceremonies of Jewish religious life appear.

The coins of an early issue bear the image of the ritual vessels used in the Temple. The silver shekel of Year I and Year II (66/67 and 67/68) are adorned with a chalice, the bronze coins of Year II with an amphora. Another series displays the plants that comprise the traditional sheaf carried on the Feast of the Tabernacles (*Sukkot*). This great agricultural festival marking the end of the harvest (*Deuteronomy* XVI, 13-15) was an important event of the religious year in the Temple (I *Kings* VIII, 2). The sheaf consists of the Four Species, produce of the Holy Land, symbolizing the offering of the first fruits in the Temple. The palm branch (*lulav*), and the citrus fruit (*etrog*), are its most distinctive elements and appear repeatedly in compositions representing religious objects of the Temple. They first appeared as independent symbols—a palm branch between two citrus fruits—on the bronze coins during the fourth year of the Jewish War. The pomegranate, one of the seven products that were typical of the country, appears on the silver shekel of Year I and Year II. Pointing to an iconographic renewal, the coins of the Jewish War are also remarkable for their fine craftsmanship, an achievement despite the difficult conditions that prevailed at the time of their issue.

A symbol of Judaea, the palm also becomes a commemoration of a Roman victory on their gold coins of that period. They were all inscribed *Judaea capta* and bear the effigies of Vespasian or Titus on the face and of an allegorical story of defeat on the reverse side. In one story, Judaea is a female figure seated under a palm tree and guarded by a Roman soldier. In another version, the Roman soldier is replaced by the god of victory who is depicted grasping a shield. In a third story, trophies are placed beside a woman clad in mourning garments. And still another version shows captive Judaea represented by a seated woman, head in her hands, near a soldier leaning against a palm tree.

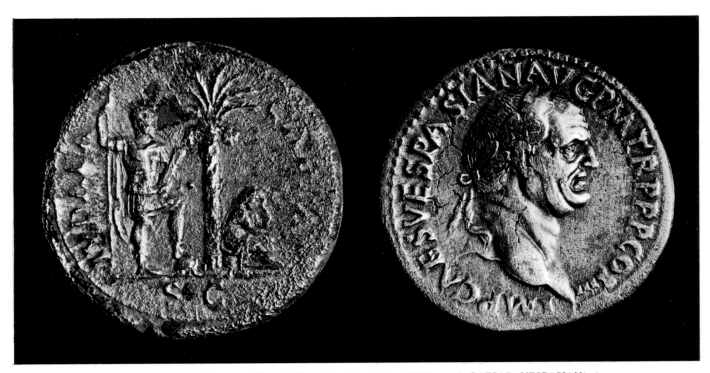

Bronze sesterce. Obverse: effigy of Vespasian; inscription: IMP(erator) CAESAR VESPASIAN(us)
AUG(ustus) P(ontifex) M(aximus) TR(ibunicia) P(otestas) P(atriae) P(ater) CO(n)S(ul) III. Reverse: Judaea
captive, seated under a palm tree; to the left of the tree a solider (Titus?) stands guard. Inscription: JUDAEA
CAPTA; in the center: S(enatus) C(onsulto) (date: 71 C.E.).

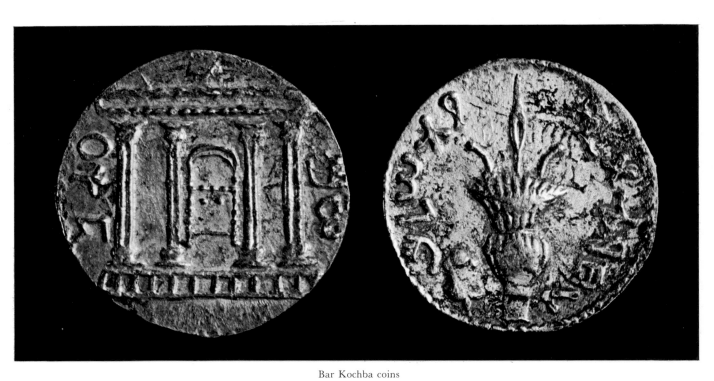

Bar Kochba coins
Silver tetradrachma. Obverse: Temple facade; inscription: Shimon. Reverse: *lulav* with an *etrog* on its left;
inscription: "For the liberation of Jerusalem" (134–135 C.E.).

The tragic outcome of the war did not irrevocably destroy Jewish hopes. Sixty-two years later a second revolt broke out. The spiritual leader of this movement was the sage Rabbi Akiva; the military operation was directed by Simon bar Koziba, better known as Bar Kochba. During the three years of this second war (132–135 C.E.), in the midst of a desperate struggle, Bar Kochba issued coins. Reusing Roman pieces, he preserved their nominal values—drachma, tetradrachma and denier. Each series is dated and each year bears a different inscription. The coins of the first year read in Hebrew "For the redemption of Israel"; of the second "For the liberation of Israel;" of the third, "For the liberation of Jerusalem." We do not know if Bar Kochba actually reached Jerusalem or if he was only expressing a hope.

The repertoire of symbols is entirely religious. During this war, as during the earlier struggle, political demands and spiritual aspirations remained inextricably connected. Some of the monetary emblems of the first conflict were revived. The bronze coins of the first year bear the amphora, the silver tetradrachmae of the first two years the *lulav* and *etrog*. Among the new symbols appear the musical instruments used by the priests during religious ceremonies—the five-stringed lyre decorates the bronze coins of the first year, a narrow, three-stringed lyre those of the second, and two silver trumpets (*Numbers* X, 2) the silver deniers of the second year. The range of plant motifs was increased by the triple pomegranate that appears on the reverse side of most of these coins.

The most important innovation is the appearance of the image of the Temple itself in the form of the sanctuary facade. The facade of a building had always been a symbol of the holy or sacred in imperial Roman art, especially in the East. In the Judaic context this symbol acquired a double significance. It was both a commemoration of the destroyed holy edifice and an image of the spiritual focus that always remained identified with Jerusalem. In slightly varying forms the representation of the Temple became the central element of the symbolical repertoire. It matters very little that none of these variants exactly reproduces the sanctuary as it was rebuilt by Herod; it is an image of the ideal Jerusalem and constitutes one of the paramount symbols of Jewish art.[24]

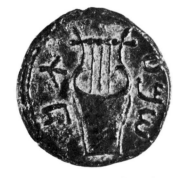

Silver denier: Reverse: five-stringed lyre; inscription: "year 2 of the liberation of Israel" (date 133–134 C.E.).

Silver denier: Obverse: three-stringed lyre; inscription: Shimon (134 C.E.).

On the tetradrachmae of the first and second years of the revolt where this symbol makes its first appearance, the facade of the Temple is composed of four columns supporting a massive cornice. A miniature image of a Temple is placed between the two inner columns. Depicted without doors, standing on raised feet with two disk-like forms, perhaps indicating the staves that served for transportation (*Exodus* XXV, 13), the image suggests the Ark of the Covenant (*Exodus* XXV, 10-15), which was a sacred symbol in itself. Later the image of the ark was replaced by that of the case or shrine, designed to safeguard the Scrolls of the Law, which with reference to its symbolical prototype, was also called "ark." This case is sometimes shown with the doors open, allowing the scrolls within to be perceived. In a parallel series, for the silver pieces of the second year of the uprising the cornice has a star above it. This star has often been taken as an allusion to Bar Kochba, an appellation signifying "Son of the Star" bestowed on Simon bar Koziba as a token of the messianic hopes that his movement awakened. "Son of the Star" was, in fact, one of the titles of the Messiah, according to the messianic interpretation given to Balaam's prophecy (*Numbers* XXIV, 17): "There shall come a star out of Jacob."

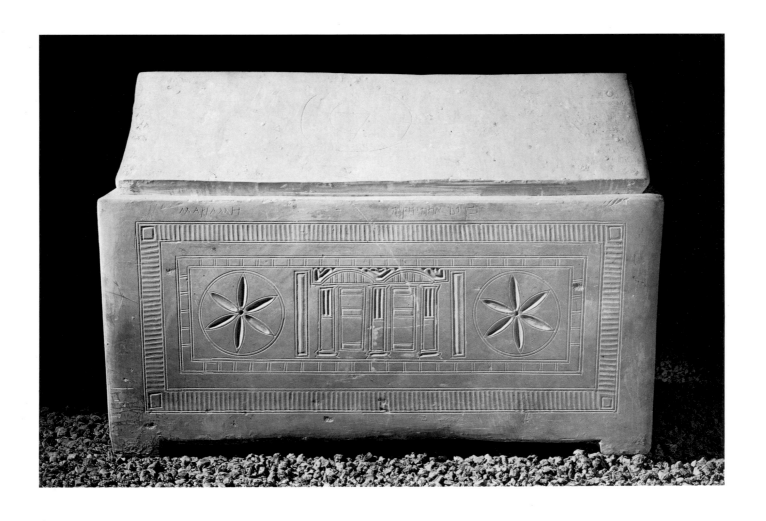

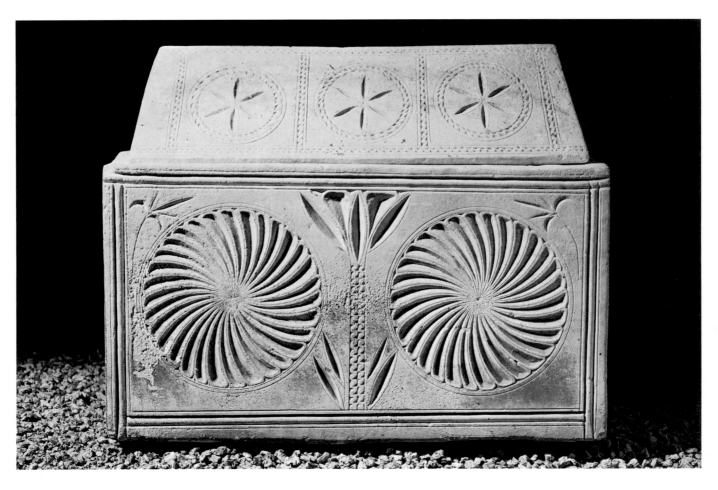

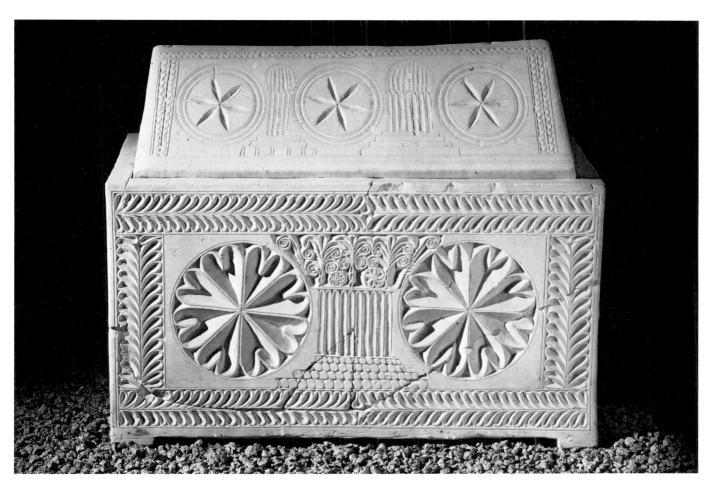

Ossuaries. 50 B.C.E.-70 C.E. Limestone. Jerusalem. Israel Museum.

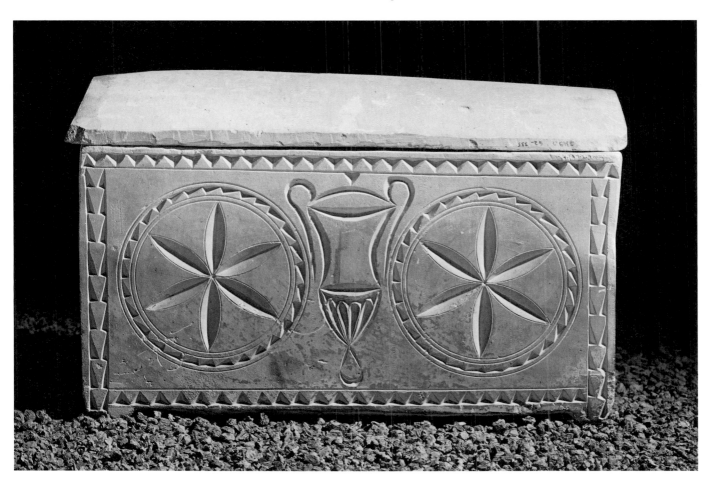

The Bar Kochba coinage presents an almost complete series of sacred symbols: the Temple, the ark, the ritual vessels—chalice and amphora—the priestly musical instruments—lyre and trumpet—and the plant motifs associated with the festivals—*lulav* and *etrog*—or symbolizing the Holy Land—pomegranates, bunches of grapes and vine. In a way these representations mark a preliminary stage in the development of Jewish art, the genesis of a symbolic language and ideology that were to provide the basic elements of every artistic manifestation of Jewish culture and civilization.

The elements of this symbolic language were effected at the same time in the ornamentation of monuments and minor objects. Appearing as isolated figures during the Hasmonean period, the sacred symbols disappeared almost entirely during the reigns of Herod's sons. It was not until after the destruction of the Temple that they constituted the current iconographical repertoire. The evolution of the ornamental vocabulary is, however, more complex in monumental art which was more directly affected by economic and social factors.

The great majority of the surviving monuments and objects from the middle of the second century B.C.E. to the end of the first century C.E. belong to funerary art—tombs carved into the rockface, occasionally with a monumental facade, ossuaries or sarcophagi accompanied by lamps and ritual vessels. The ornamentation oscillates between two extremes. Tombs and sarcophagi, made for the aristocratic classes, reflect their clients' taste for the Hellenistic culture whose artistic language they adopted. The ossuaries, on the other hand, are characterized by references to the traditions of the ancient East. This distinction affects the technical quality of the work as much as the style of the decoration.[25]

Ossuaries are constructed in accordance with the funerary practice called *ossilegium*—the act of gathering up bones.[26] After interring the corpse and leaving it in a vault for about a year—the time necessary for the decomposition of the flesh—the bones were taken out of the sarcophagus and placed in an ossuary. The purpose of this second inhumation was apparently practical, to make space in a vault often belonging to a specific family for other bodies. The custom had long been practiced in Crete and Mycenae, and for four thousand years in Phoenicia. It does not seem to have reached the Asian interior. Among Jews, only those living in the Holy Land seem to have adopted it, and only during the Roman period. Ossuaries found in Palestine are not earlier than 200 B.C.E. or later than 200 C.E.[27]

Ossuaries are shaped like sarcophagi but in reduced size. Their length varies between 50 and 80 cm., and they are most frequently carved out of a single block of soft stone. Trapezoid in shape and wider towards the top, they are sometimes mounted on supports. The lid, also of a single stone, may be flat, semispherical or vaulted. Perishable materials such as wood or potter's clay were probably also used.

A number of ossuaries bear the name of the deceased on one side, the inscription in most cases being restricted to the name. An onomastical survey shows a preponderance of Hebrew and Aramaic names over Greek, an indication that the deceased belonged to the lower classes.

Most of the ossuaries found predate the fall of Jerusalem. Religious symbols appear only very exceptionally in their ornamentation which draws on the common repertoire of the Hellenistic Orient—floral motifs of local character and elements of Greek architecture in a provincial interpretation. The ornamentation is usually along the longer sides. The major motifs are carved into the stone in a technique that involves alternating between deep incisions and flat surfaces without transition, so that a vivid contrast is created between the zones of light and shade. The secondary motifs are carved around the primary and in the larger spaces between them. For the major themes a symmetrical disposition is customary.[28] A characteristic ornament found on ossuaries is the

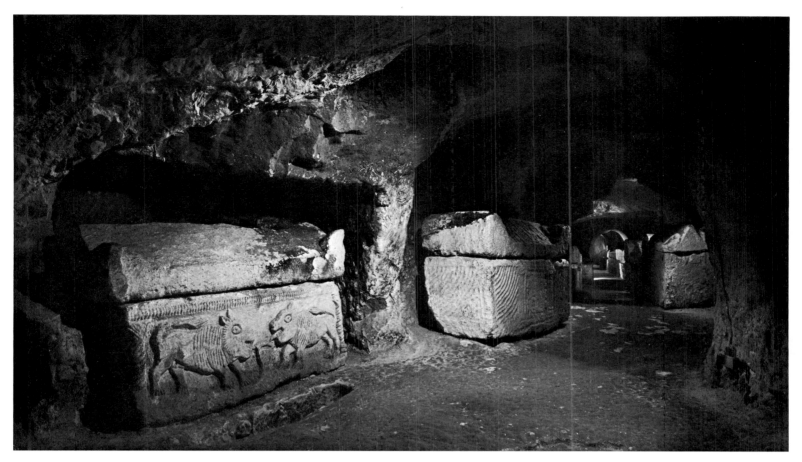

Beth Shearim. Entrance to funeral chamber. Catacomb 20. III cent. B.C.E.

rosette. Carved in deep relief, with sharp edges, these rosettes may have three, six, twelve, sometimes even twenty-four petals, and may be surrounded by wreathes or zigzag patterns, or simple linear circles. They are always symmetrically disposed, two to a side flanking a central motif. The latter only consist of a vertical groove with small motifs arranged in a zigzag pattern, or at times be enhanced by a floral motif such as a stylized vine. But sometimes the central ornament is also carved in relief, as sharply as the major motifs. In some examples various symbolical elements, such as a fluted column, a palm tree, a stylized wreath or a chalice, separate the rosettes. In another series the rosettes are placed under arcades, a reference to the oriental theme of the holy edifice. Another architectural composition, consisting of the image of a structure with closed doors flanked by small columns perhaps represents the Ark of the Covenant. But this identification remains hypothetical. The doors may define the image as the case within the ark. The date that the case first appears as a substitute for the ark is difficult to establish. Therefore the interpretation of representations during the transitional period, the second half of the second century, often has to rely on conjecture.

In contrast to ossuary ornamentation, that of sarcophagi belongs to the aristocratic tradition. The fundamental distinction lies chiefly in the technical quality of the execution. The wealthier classes could engage well trained craftsmen who were familiar with Hellenistic art.[29] Nevertheless, there is no absolute differentiation between the decoration of ossuaries and sarcophagi. Some sarcophagi are decorated in the technique and manner of the ossuaries, and the motifs of local Oriental art are quite frequently found together with Hellenistic ornaments. The latter, however, remain specifically characteristic of an ornamental trend where religious symbols rarely appear.

Some well known sarcophagi were found in the Tomb of the Kings to the north of Jerusalem. A richly ornamented lid carries an elaborate border of acorns, grapes, eight-petalled rosettes and vine leaves. The border is further marked by garlands of olive leaves and interlaced patterns. The end of the lid is adorned with a triple palm and two lilies. The combination of Hellenistic motifs with those of oriental flora confers a typically local character on the decoration.[30]

Another celebrated sarcophagus, of more historical than artistic interest, is that of Queen Saddan, discovered in the same tomb. The lid is in the form of a roof with a sharp edged peak. The front side bears two disks carved in relief, and unfinished rosettes. Between the ornaments a double inscription in Estrangelo Syriac and in Aramaic gives the name of the deceased Queen Saddan, identified as Helena of Adiabene, a person who, according to Flavius Josephus[31] converted to Judaism in 48 C.E. and was buried in Jerusalem by her son Izate. When the sarcophagus was discovered, the body was still intact.

Wooden sarcophagi, less time resistant and certainly much less costly, were also used; numerous fragments testify to their existence. It has been possible to reconstruct some of them, such as a sarcophagus from Ein Gedi, which was decorated with rosettes similar to those found on ossuaries, here carried out in bone inlay.[32]

In the third century, funerary art entered a new phase. The religious symbols that had appeared on the coins of the first and second Jewish wars began to figure on the walls and in the epitaphs. Representations of animate beings also made their first appearance. However, this art basically remained the visual expression of a symbolical language; human and animal figures were themselves understood as symbolical themes.

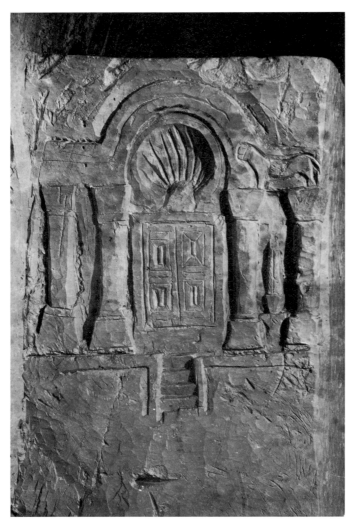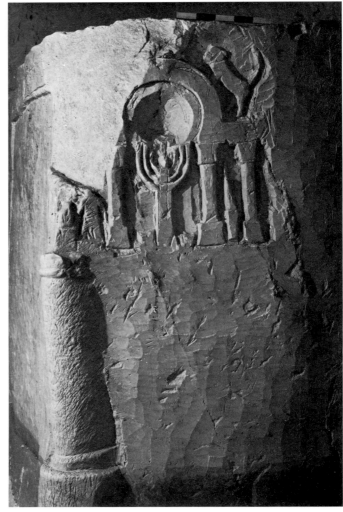

Ark of the Covenant. Beth Shearim. Catacomb 4. Candelabrum flanked by columns and a lion. Catacomb 20.

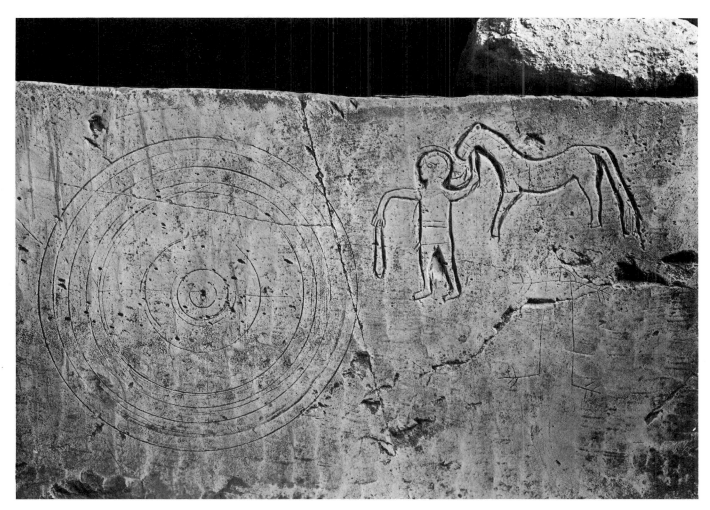

Graffiti: Cosmological diagram and a rider leading his horse. Beth Shearim. Catacomb 1. Jerusalem. Hebrew University, Department of Antiquities.

The most impressive funerary ensemble in the Holy Land is the necropolis of Beth Shearim on the western slopes of Galilee.[33] The town was already known during the era of the second Temple, and is mentioned by Flavius Josephus.[34] At the end of the second century, Judah Hanassi[35] made it his residence and installed the Sanhedrin, the highest religious, juridical and political institution of the Jews of the Holy Land. Beth Shearim thus became the center of Jewish intellectual life.

The site was discovered in the nineteenth century. In the course of systematic excavations, resumed in 1936, the necropolis was identified beyond doubt as that mentioned in the Talmud (Babylonian Talmud, *Rosh Hashanah* 31b; *Ketubot* 103b—104b; Jerusalem Talmud, *Moed Katan* III,5). Beth Shearim was the burial ground of some illustrious Mishnaic doctors, above all, of Judah Hanassi who was interred there in 217. After this date, Jews of the Holy Land, like Jews of the entire Mediterranean area, often demanded that their bodies be transported to Beth Shearim and buried close to this saintly man.

The necropolis, destroyed in 351 during a Roman campaign of repression, consists of about twenty catacombs, with very long passages leading to the burial rooms. Doors separate the rooms some of which are decorated with geometrical motifs in relief. The two largest catacombs, numbered 14 and 20 respectively, were approached by a court with a very large facade. Two mausoleums placed near the tombs have been reconstructed on the basis of surviving remains.

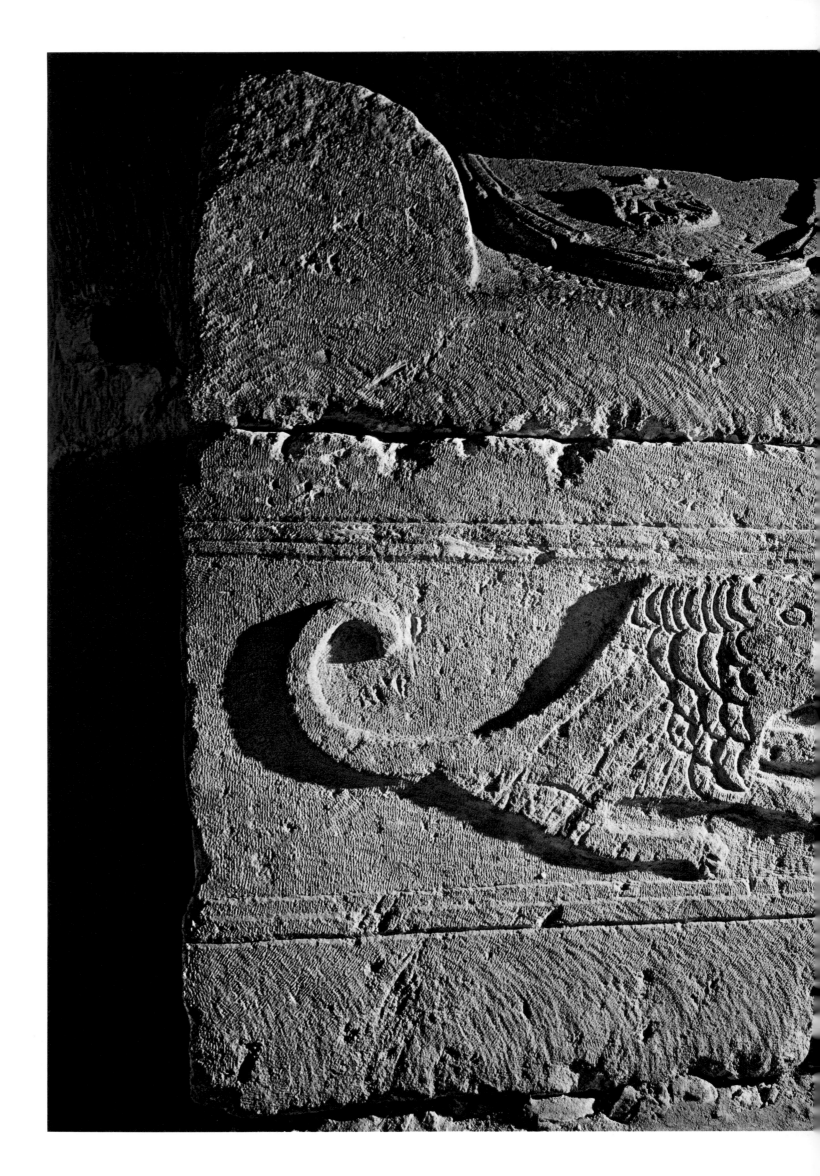

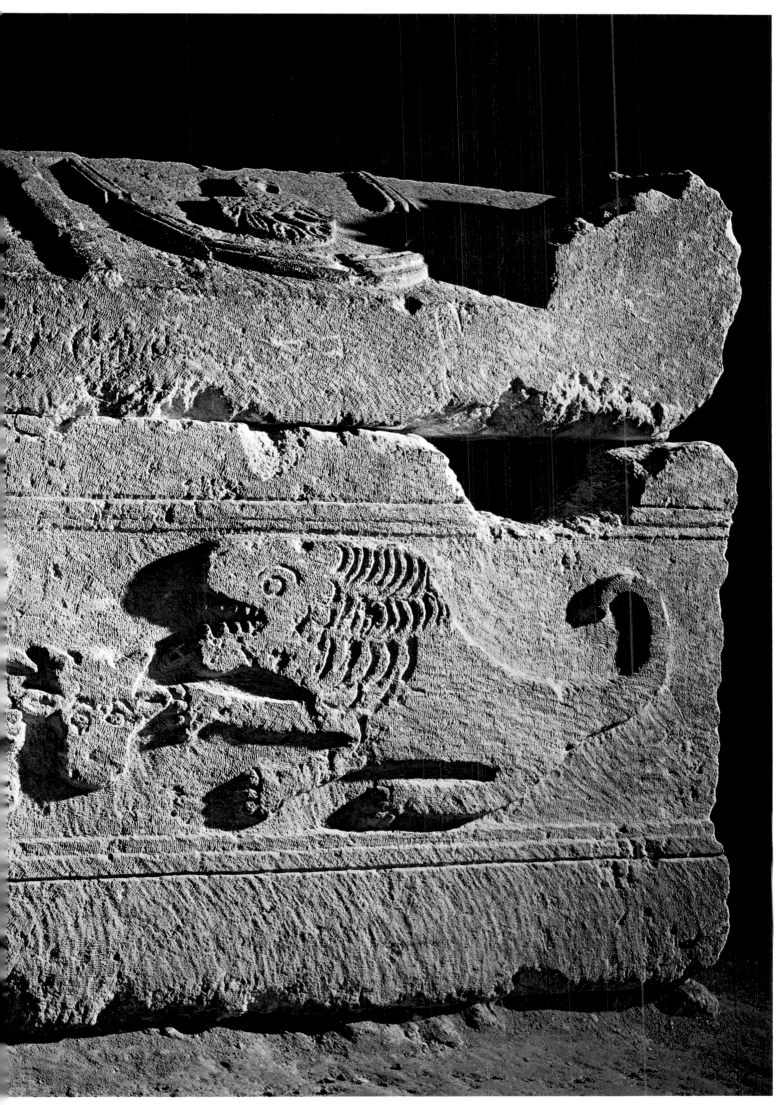

Beth Shearim. Catacomb 20. Sarcophagus of confronting lions.

Beth Shearim provides extremely rich epigraphical material.[36] The majority of the epitaphs are in Greek; the Hebrew inscriptions were found chiefly in Catacomb 14 which contained the tombs of Rabbi Gamaliel, Rabbi Simeon and Rabbi Hanina. The tomb of Judah Hanassi has not yet been identified.

Numerous engravings and grafitti, crudely executed, decorate the walls of the catacombs. These form a contrast with the fine technique of the inscriptions. The discrepancy is most probably due to the differing qualifications of the artisans; the engravings might have been entrusted to local workmen, not necessarily Jewish, while more skilled craftsmen had to be called on for the inscriptions. These engravings, however, present considerable interest as evidence of the thematic evolution. Religious symbols were used as familiar elements of a symbolical language that was known and understood by all members of the community. The themes that were still isolated on the coinage are freely arranged; the forms are varied, while motifs are grouped in a composition. Symbolical art had become a living component of the culture.

The dominating symbol of Jewish funerary art in the Judaistic context is the seven-branched candelabrum. There can be no doubt that to the religious and cosmological[37] interpretations attached to the number of branches, an eschatological symbolism was added causing this image to be preferred to all others in the decoration of epitaphs and walls of catacombs.[38]

Numerous variations of the candelabrum are found in Beth Shearim. Carved in *graffito*, or sculptured in relief, the branches are curved, slanting or bent at an angle. A rather large candelabrum stands on the head of a personage in military attire. This is one of the oldest forms of the iconographical theme of the human figure as the living support of a sacred symbol, a theme that continued in Christian art. The earliest examples of similar Christian warriors take the form of a man in military attire carrying a cross on his head, an apparent substitution for the candelabrum in Beth Shearim.[39]

The Ark of the Covenant, another central religious symbol of the Temple, also appears on the walls of Beth Shearim, not attached to the Temple as on the Bar Kochba coinage, but appears by itself. It appears that here the the figure is that of the case which at this period was displacing the ark itself. The structure with a semi-circular pediment, and closed doors reached by seven steps suggests some resemblance with the Ark of the Covenant painted on the ciborium above the Torah niche in the synagogue of Dura Europos. The analogy is all the more remarkable since the two monuments, more or less contemporary, are situated at a considerable distance from each other. On the wall opposite the ark stands a lion, shown close to a candelabrum, between two small columns. The candelabrum is surrounded by a *lulav*, an *etrog* and an incense shovel. The motif of the lion, guardian of the sanctuary, is part of the traditional repertoire of the Ancient Middle East. It is adopted in Jewish art, most often in association with the ark or the candelabrum, and also appears as guardian of the entrance to synagogues.

Apart from the specifically Jewish symbols, *graffiti* of sometimes problematic interpretation appear on the walls of the catacombs, reflecting non-Jewish influences. Several themes and certain ways of treating living creatures testify to the influence of Near Eastern, even Egyptian art. The figure of a rider carrying a club appears twice, in relief and in engraved *graffito*. In typically oriental style, the horse's walk is rendered by the simultaneous movement of the two legs of the same side. Near the engraved horseman, a *graffito* of nine concentric circles represents perhaps the cosmological diagram of the earth, the seven heavenly planets and the constellations, as depicted in contemporary texts. Boats loaded with cargo recall the funerary ships of Egyptian art.

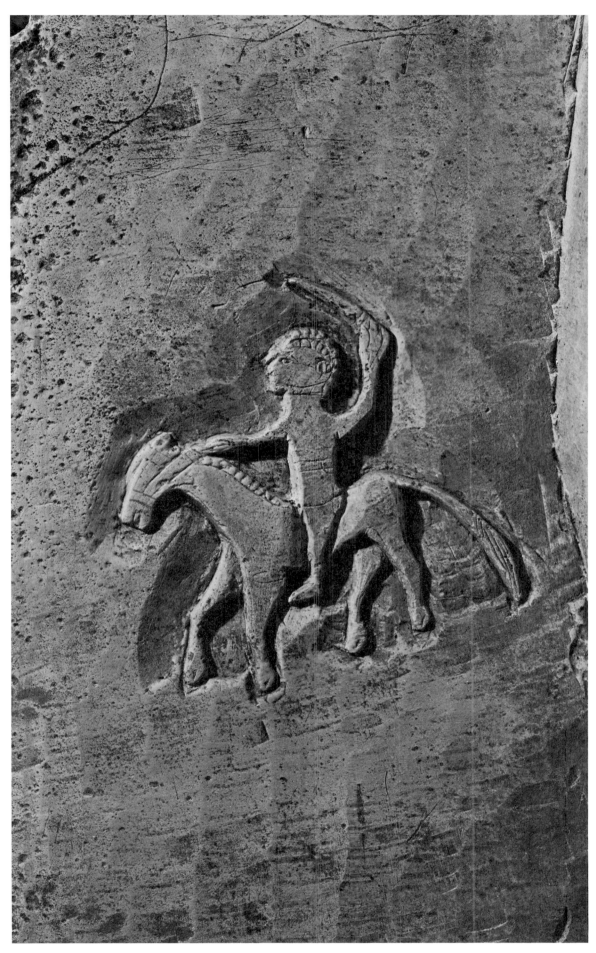

Beth Shearim. Catacomb 1. Armed horseman.

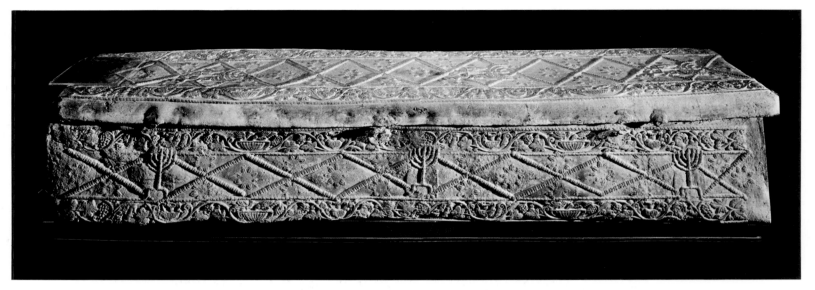

Lead sarcophagus, with floral motif, pecking birds, amphora, and candelabrum in relief.
Beth Shearim. IV C.E. Jerusalem, Israel Museum.

Many sarcophagi and fragments with figurative decoration were found in Catacomb 20. The epitaphs are all in Hebrew. On the longer sides of the sarcophagi are some compositions, such as lions facing each other on either side of a bull's head, as yet not satisfactorily explained. The proportions of animal forms as well as the schematic treatment of volume and movement belong to popular local art.[40] In spite of this recurrence of ancient oriental motifs, the infiltration of Hellenistic themes is clear. A *graffito* shows two gladiators in combat—a motif widely used on contemporary Roman lamps. Hellenistic influence is present even more directly in the fragments of sarcophagi, of which some at least were certainly imported. One fragment, especially well-known because of its pagan character, portrays Leda and the swan.[41]

The art of Beth Shearim does not reflect Oriental and Hellenistic traditions alone. Fragments of a frieze of one of the mausoleums, situated near Catacomb 11 show processions of animals, and wolves intertwined in violent combat. This motif, with no equivalent in Near Eastern or Greco-Roman art, has affinities only with the art of the steppes, Scythian or Sarmatian, and is a parallel still unexplained.[42]

While it may be assumed that the candelabrum became the predominant funerary symbol because of the eschatological interpretation attached to it, it was also sometimes used in a much wider connotation, as a sign distinguishing a Jewish monument or a monument constructed for Jewish purposes. In this connection the lead sarcophagi found at Beth Shearim enter a category very different from that of the *graffiti* and stone sarcophagi; they were made either in Jerusalem, Ashkelon or Phoenician workshops for a not exclusively Jewish clientele. The ornamental technique is fine and precise. Sarcophagi with the same basic decoration of floral or geometrical motifs might have a cross or a candelabrum added, according to demand. Once the lead was cast in the common mould, the sign appropriate to the recipient was added by a seal. On a particularly well preserved sarcophagus this sign, consisting of a candelabrum surrounded by *lulav*, *etrog* and incense shovel, is superimposed at regular intervals on a background decor of Hellenistic motifs—bunches of grapes, amphorae and pecking birds alternating with the foliage of vines.

The diffusion of these symbols in the Jewish communities of the Diaspora must have immediately followed their creation in the East, since the various elements of this new language were used in a similar connotation and in similar forms, almost without a chronological gap whatever the geographical distance.

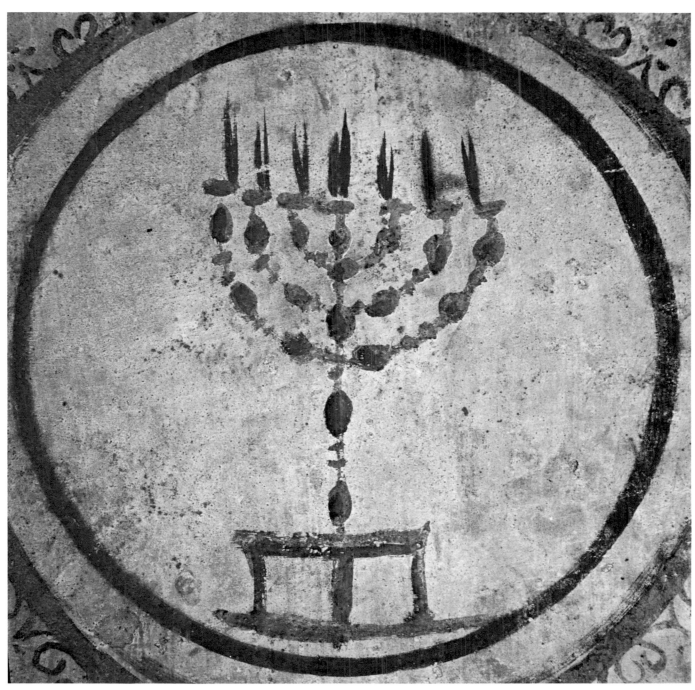

Candelabrum. Vault painting. Rome, Catacombs of the Villa Torlonia. III-IV C.E.

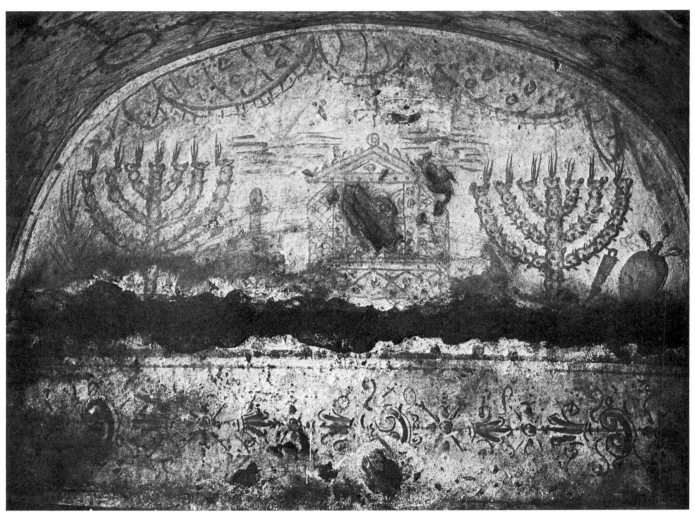

Ark of the Covenant flanked by candelabra. Painting at the back of an arcosolium. Rome. Catacomb of the Villa Torlonia, III-IV century

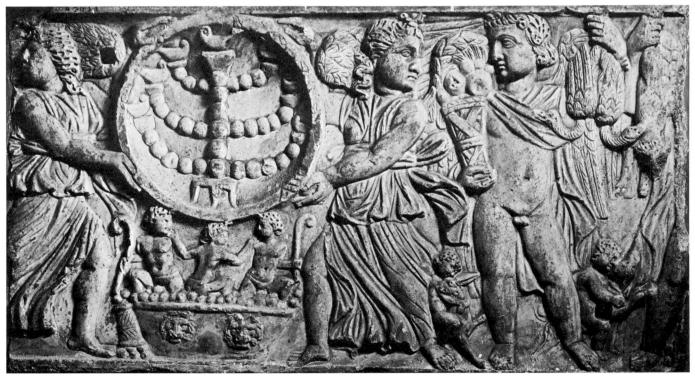

Marble sarcophagus with relief of candelabrum in medallion, winged Victories, Seasons, and *putti* pressing grapes. Rome. Catacomb of the Vigna Randanini, III-IV century. Rome, Thermae Museum.

The funerary art of the European communities, especially in the three great Roman Jewish catacombs, is in its principal elements identical to that of Beth Shearim. The epitaphs and the walls bear the same sacred symbols. Local tradition marks the surrounding ornamentation, whose influence varied from monument to monument. The earliest known western Jewish catacomb is that of Monteverde, cemetery of the Trastevere community of Rome.[43] The sepulchral inscriptions date from the end of the first century to the end of the fourth. Most of the epitaphs are written in Greek, Hebrew is rarely used and only one inscription is in Aramaic. The Monteverde catacomb reflects a perfectly homogeneous ideological world. Most of the epitaphs display the candelabrum, the symbol that, as at Beth Shearim, seems to be the most widely adopted eschatological sign. The type of candelabrum varies. The branches may be curved or bent at an angle, and other symbols such as the *lulav*, the *etrog* or the Temple vessels are often present. The candelabrum also appears beside the ark, shown with a triangular pediment and the outlined representation of the Torah scrolls.

The bare smooth walls, entirely undecorated, correspond to the austere and consistent language of the symbols accompanying the epitaphs. With rare exceptions, such as the sarcophagus with a human figure reclining on the lid whose presence in the catacomb may be accidental, no element foreign to Judaism is encountered in the ornamentation.

Equally consistent and exclusive is the art of the catacomb of the Villa Torlonia, also in Rome.[44] The epitaphs display the same symbols as at Monteverde and appear again in the painted wall decorations. A candelabrum of impressive dimensions is painted in the center of the ceiling, like a reduced image of the heavens. The back wall of an arcosolium is decorated with a painting representing the ark, with a bulging pediment and open doors, flanked by a candelabrum on each side. This composition was to become the typical formula used to indicate a holy place in Jewish art.

While the imagery of the Villa Torlonia, like that of Monteverde, reflects a world confined to its own values, the Roman communities did not always remain entirely closed to the surrounding culture. Some vestiges carry the imprint of local traditions, and certain compositions reveal the attraction of ideas then current in the Hellenistic world, at least in some circles. Such vestiges appear principally in the third great Roman catacomb, the Vigna Randanini.[45]

The two hundred epitaphs of the Vigna Randanini catacomb are also marked by symbolical engravings of *graffiti*. The candelabrum alone, or surrounded by *lulav* and *etrog*, Temple vessels and the *shofar*—the ritual horn blown on certain festivals—are repeated in various forms. But even in these *graffiti*, in addition to the specifically Jewish signs, other figures appear, alien to this vocabulary and often of uncertain significance, such as confronting buffalo heads, a ram's head with an *etrog*, amphorae, or birds pecking on a tree.

The Hellenistic influence is manifested more concretely in the decoration of several sarcophagi. Hebrew inscriptions accompany popular local motifs, and religious symbols are associated with themes typical of Hellenistic art. The most celebrated piece found in this catacomb is particularly composite in character.[46] The relief on the front of the sarcophagus, only partially preserved, represents a medallion carried by two winged victories which encloses a seven-branched candelabrum, also in relief; beneath is a Dionysiac scene, three *putti* pressing grapes in a vat. To the right of the victories with their attributes were figures personifying the four seasons. The figure of autumn is intact; winter is fragmentary, but spring and summer have disappeared. All the elements of this relief reflect beliefs current in the Greco-Roman world. The seasons are an allegory of the recurring rebirth of nature and of the resurrection of the soul; the victories symbolize the immortality of the soul gained in death;

the *putti* pressing grapes evoke the mystic liquor of blessed immortality. Then, the sign of a particular group is added, such as the candelabrum, the Jewish symbol of eschatological hope. The only original element in the composition is the candelabrum; the rest of the motifs are the current adornment of Roman sarcophagi, with the portrait of the deceased in the medallion replacing the candelabrum.

No less unusual are the paintings of the sepulchral chambers. Three out of the four chambers of the Vigna Randanini still display legible paintings. The first two are pagan in motif, offering no indication that the cemetery had a Jewish affiliation. In the center of the ceiling of the first chamber is a victory crowning a naked ephebe. Around this are birds, baskets of fruit and peacocks. In the second room Fortuna and her cornucopia, surrounded by putti and sea-horses, adorn the ceiling.

In contrast to the pagan imagery of these frescoes, the walls of the fourth chamber have no ornamentation other than painted bands separating geometrical figures, the exceptions to these patterns being an *etrog* in a corner of the ceiling and a candelabrum painted above an arcosolium. According to an early hypothesis, these two types of frescoes existed in adjacent chambers of the same monument, since the chambers with pagan frescoes predate the appropriation of the monument for Jewish burial purposes. The fourth chamber, intended from the beginning for this use, may at first have been independent and then annexed to the first two during an expansion of the Jewish cemetery.

However, the general ambiance, especially the decoration of the sarcophagi, suggests a different explanation. The themes of the frescoes and reliefs belong to the contemporary repertoire of funerary art. These eschatological

Glass ground with image of the Temple inscribed: "The House of Peace." Rome. III–IV century.
Vatican, Biblioteca Apostolica.

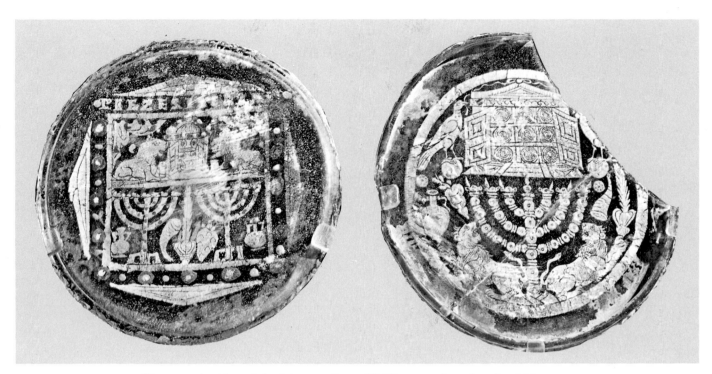

Glass grounds with symbols of the *sacra*. Rome. III–IV century. Jerusalem. Israel Museum.

themes, common to the whole Hellenistic world, were adopted as the usual genre decoration without any religious significance. The Jewish symbols were added to this background decor as a distinctive sign of the community.

The ornamentation on ritual objects or on objects for daily use followed an evolution paralleling monumental art. Among the objects found in the Roman catacombs were glass goblets and cups of which only the ornamental fragments survive. The decoration was executed in gold-leaf, placed on one layer of glass and covered by a second so that the configuration remains visible.[47] To this ingenious technique corresponded an equally delicate workmanship in the composition and drawing of the decorations which are variations on the symbolical themes already specified. The usual pattern is a circle divided into two sections by a horizontal line, each containing a different composition. The image most frequently found in the upper section is the case for the ark, with open doors, the Scrolls of the Law visible within. It is flanked by two birds, or two guardian lions, or two candelabra. In the lower part other symbolical elements appear in various groupings: the *lulav* and *etrog* between two candelabra, or the candelabrum between two lions. In one rare example a table and a fish allude perhaps to the messianic meal promised to the righteous in Jewish legend.[48] A very beautiful piece presents a different scheme. The sacred edifice is placed in the center of the circle, surrounded by a portico with two entrances on the right in the form of little semispherical constructions; the edifice is approached by several steps and two independent columns representing perhaps the columns of Solomon's Temple, called Jachin and Boaz (I *Kings* VII, 21). The pediment displays a candelabrum; an inscription encircles the composition and says "the House of Peace." These glass fragments are not exclusively Jewish in content. Many display Dionysiac and Mithraic themes, as well as scenes from the Old Testament invested with Christian symbolism, or illustrations of New Testament scenes. The pieces executed for the Jewish community may be recognized by their characteristic symbols, and probably originated in the same workshops that produced glassware for the Christians.

The surviving clay lamps were also found to a large extent in tombs. Those of the Second Temple period are without ornamentation, or are decorated with rosettes and disks resembling contemporary ossuary motifs.

Seven burner clay lamp, with David and Goliath in relief. Alexandria. I–III century. Yale University Art Gallery.

From the end of the first century the decoration was enriched with Hellenistic elements to which Jewish symbols were gradually added. The iconographic types remained stable: the candelabrum alone, or with the *lulav* and *etrog*, or with the incense shovel, or the Temple vessels. The form of the objects represented and their disposition on the lamp varies according to the centers of production.[49] Lamps with a single burner made in Palestine have two quite large orifices in the center of the upper surface for pouring in the oil. The candelabrum in high relief is placed above these orifices, most frequently accompanied by the incense shovel and the *shofar*. On Alexandrian lamps these two orifices are smaller, leaving almost the whole surface to the candelabrum, here surrounded by the *lulav* and *etrog*. Lamps originating in Carthage of rather unrefined workmanship have a characteristically oval form, and are decorated with a candelabrum of branches bent at an angle. The products of Cyprus may be recognized by the candelabrum placed horizontally in relation to the axis of the lamp. In another series, maybe of Palestinian provenance, the candelabrum is incised on the base or on the handle. These almost mechanical figurations of the symbols had no other purpose than to indicate the religion of the client, customary in Jewish and Christian circles without any profound symbolic significance. Moreover, the formal criteria characterizing the different centers of production cannot be classified too strictly, as imported pieces often served as models in local work.

Less usual were lamps with several burners, from five to eight in number. Seven-flame lamps were probably variants of the Temple candelabrum, adapted for domestic use. These lamps are often decorated with arcades framing the burners, or repeating their number. Under the central arcade may appear a stone, perhaps a reminiscence of the *nefesh*, a type of commemorative monument widespread in the art of the Ancient East to which the arcade motif also belongs.[50] One of these seven-burner lamps is distinguished by its figurative decoration. Two persons confront one another, one on either side of the central orifice. On the right a man wearing a short

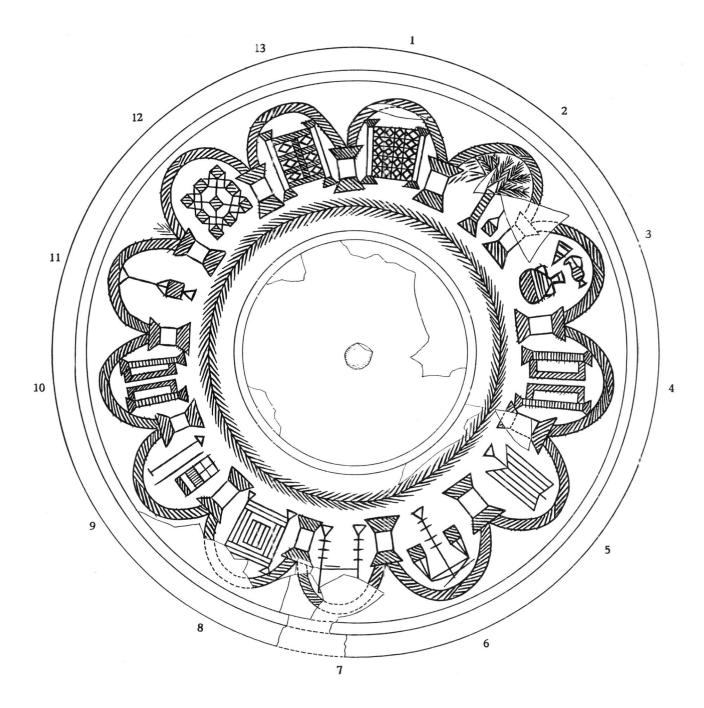

Glass plate from Catacomb 15 at Beth Shearim. IV century. Decor
incised with a crystal point, representing thirteen semi circular arches
supported by column. Various objects appear between the columns:
closed doors (1, 8, 13); a palm tree (2); a bottle and an amphore
(3); open doors (4, 10); a candelabrum? (5); a hanging lamp (11);
a geometrical figure (12); and two unidentified objects (7, 9).

According to Nahman Avigad, Beth Shearim. III. Jerusalem.

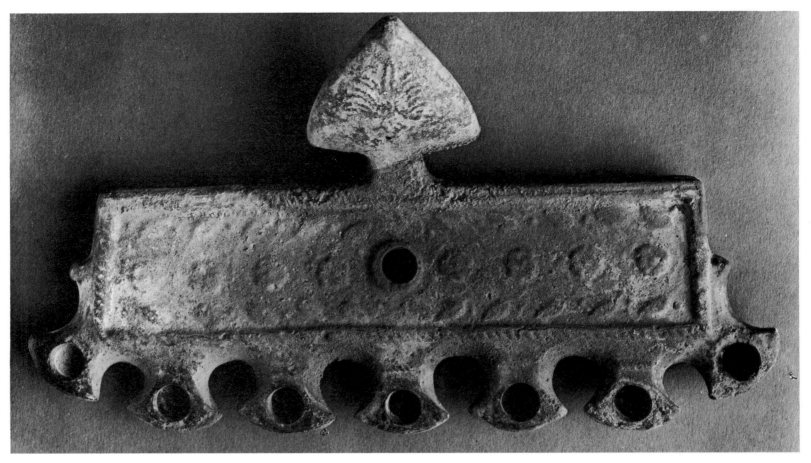

Seven burner clay lamp decorated with rosettes and palmettes (*lulav*). IV–VI century. Paris. Louvre.

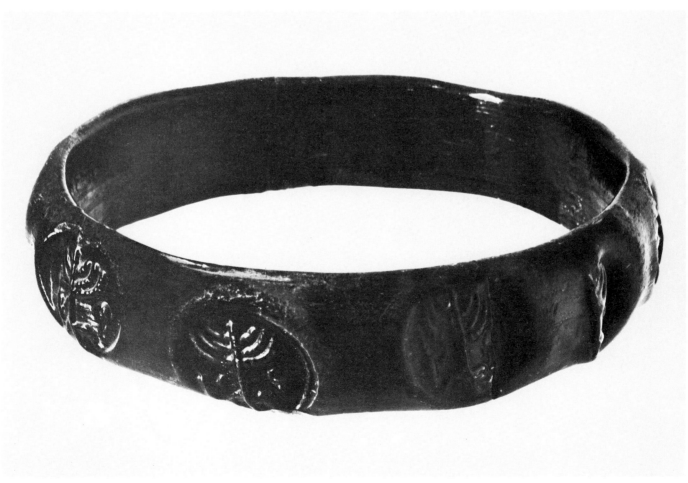

Bracelet decorated with candelabra. Jerusalem. VI century. Molded glass. Tel Aviv, Haaretz Museum.

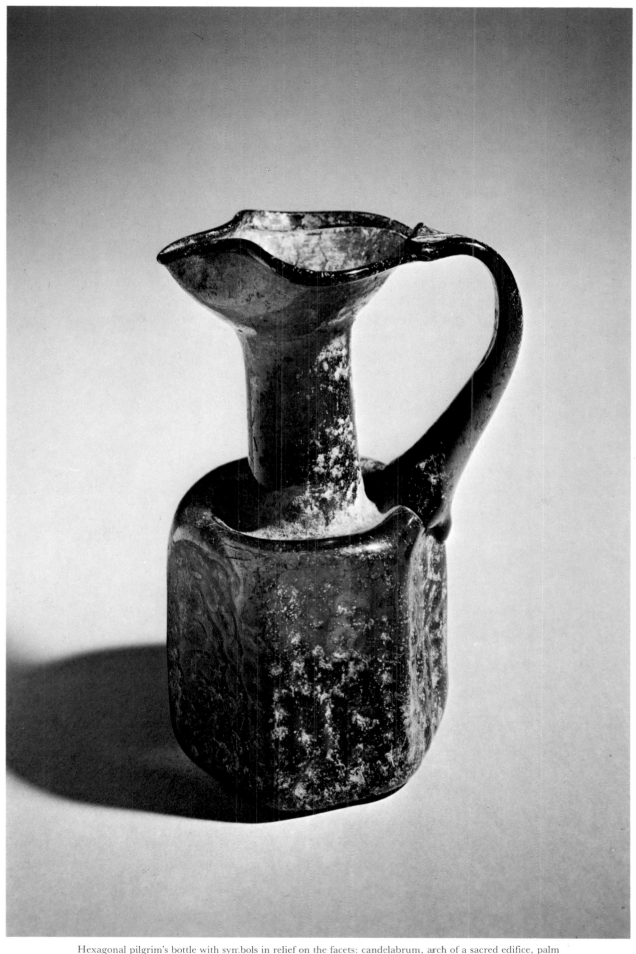

Hexagonal pilgrim's bottle with symbols in relief on the facets: candelabrum, arch of a sacred edifice, palm tree. Jerusalem. VI century. Molded glass. Tel Aviv, Haaretz Museum.

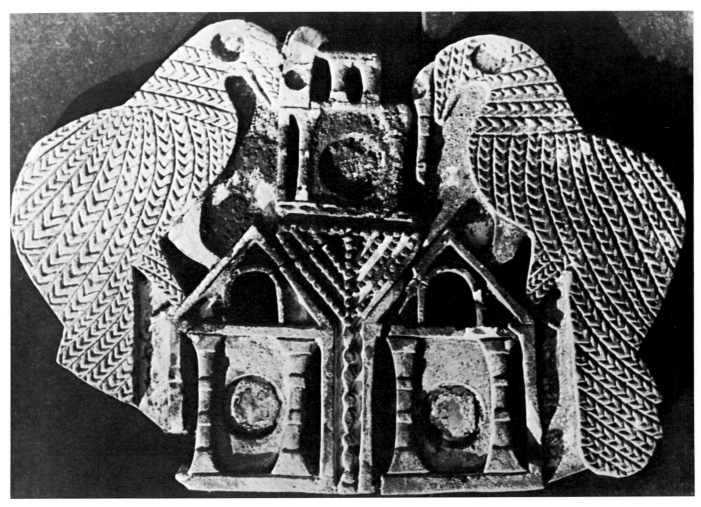

Plaque inlaid with little mirrors. Palestine. V century. Limestone. Present locale unknown. Old photograph.

tunic holds a sling in his raised hand; on the left a taller figure, heavily armed, raises his shield to deflect two stones launched in his direction. Inscriptions identify the two figures as David and Goliath. The epigraphic characteristics show that the lamp probably came from Alexandria, the most important center of production from the first to the third centuries. This rare specimen of Biblical illustration would thus have been contemporary with the Biblical frescoes of Dura-Europos. We cannot be certain for whom the object was intended. The number of burners would have suited Jewish users, but the Coptic church had also adopted the seven-flamed lamp.[51] Bronze lamps are more rarely found. A very fine specimen, originating in Syria, has a handle formed by a candelabrum, surrounded by the *lulav* and *etrog*. Similar models bearing a cross instead of a candelabrum may have come from the same workshop.

Workshops producing goods for both Jews and Christians existed in various crafts. In the fifth and sixth centuries, Palestinian glass workshops, long famous for the quality of their wares,[52] were making bottles specifically for the pilgrim trade. The same types of glass, in different nuances of brown or green, with the same forms—small vases with hexagonal bodies and wide necks or more elongated bottles with a handle—bore either Jewish or Christian insignia, and were cast in metallic moulds.[53] The bottles intended for Jewish use displayed the candelabrum with *lulav* and *etrog*, alternating with arks, and perhaps very schematically showing the Temple facade.

The use of symbolical signs became so widespread that they were reduced to mere ornaments, employed to decorate objects of common use. Thus, a bracelet, also of molded glass, has a candelabrum design on each

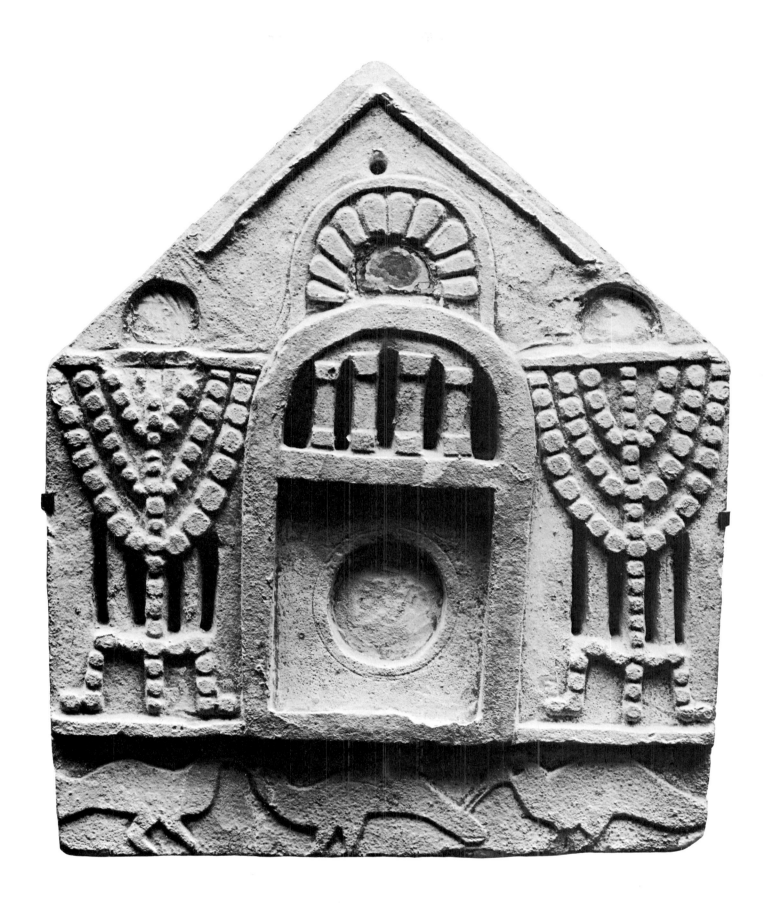

Plaque with mirror, decorated with the Ark of the Covenant and two candelabra. Limestone. Palestine. V century. Jerusalem, Israel Museum.

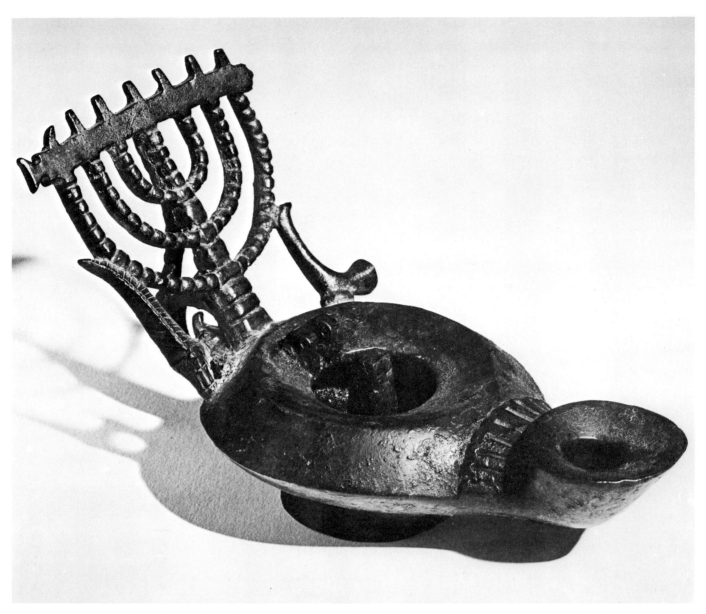

Lamp with handle in the form of a candelabrum, supported by a *shofar* on one side, and a *lulav* and *etrog* on the other.
Alexandria? IV century. Bronze. Jerusalem, Israel Museum (coll. Mrs. M. S. Schloessinger).

of its facets. The candelabrum might have figured on certain objects as an apotropaic image. This was the case, it seems, with a series of stone plaques with little mirrors that were suspended on the wall inside a house to ward off the evil eye.[54] On one such plaque[55] the mirror was fixed in the center of a small construction rather like an ark in form, flanked on both sides by the seven-branched candelabra. On another plaque, the candelabrum, placed in the center, is flanked by two birds, a theme already encountered on glass fragments and reappearing in a sixth century mosaic in Beth Alpha.

The art of symbols, born from the impetus of a movement both spiritual and national, penetrated progressively into all the domains of Jewish existence. This rigid and hieratic art provided a formal language that was particularly adapted to the character of a people with a culture tending by education to intellectual abstraction and traditionally distrustful of the sensibilities of Hellenistic art. The iconographical types formulated during the first centuries of our era have remained the basis of all Judaic artistic creation, whatever its stylistic dress.

Until quite recently this symbolic art was considered the only artistic stream of Jewish culture. Thanks to an accidental discovery, this misconception has been dissipated.

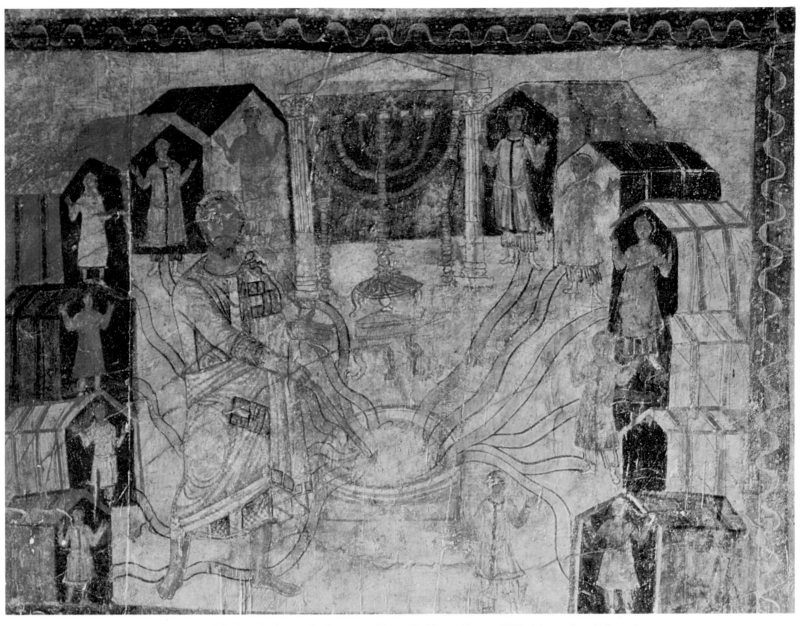

Dura-Europos. The Israelites' camp in the desert. The well of Beer (*Numbers* XXI). West wall, middle register.

NARRATIVE SYMBOLS

It is easy to imagine the astonishment of the five archeologists who in November 1932 saw the painted walls of a third century edifice emerge from the sand[56]. The town of Dura-Europos, site of this discovery of capital importance in the history of Jewish art, was founded on the west bank of the Euphrates by the Seleucids. The Parthians conquered it in about 150 B.C.E. The city, a prosperous international commercial center as long as the West and the Persianized Orient entertained peaceful relations, was occupied by the Roman legions in 163 and absorbed into the Syrian *limes*. In 227, with the advent of the Sassanian rulers, redoubtable enemies of Rome, this advance post of the empire endured several assaults, finally succumbing in 256. During the final siege the inhabitants of Dura, cut off from outside help, sought to strengthen their walls with sand embankments. Roofs of houses rising above the ramparts were levelled off, and the debris was used for the fortifications. But these efforts were in vain. The Persians took the city through passages hollowed out under the walls. Dura disappeared from history. But the labors of its last defenders allowed the preservation of the Roman East's largest known ensemble of mural paintings, buried under the sand for seventeen centuries. In 1921, an English officer fighting a group of Arabs camping on the site, dug a trench among the ruins and discovered the first fragments of painted walls. When the region was joined to territories under French mandate, systematic excavations were undertaken under the direction of Franz Cumont and continued with the collaboration of Yale University. This led to the uncovering of a vast ensemble of structures, including, beside private habitations, temples of various pagan divinities, a Mithraeum, a Christian baptistery and a synagogue.

Little is known about the origins of the Jewish community of Dura-Europos.[57] The building that served its religious requirements in 256 was a residential structure converted into a synagogue, then rebuilt to enlarge the areas assigned for public use, namely the vestibule and assembly hall. The building was embedded in a block of houses adjoining the western rampart and separated from it only by a narrow street. The west wall of the assembly hall, facing the entrance, ran along the street. The hall was oriented from east to west in breadth; a niche in the west wall marked the direction towards Jerusalem, and two doors on the east side gave access to the vestibule. Stone benches lined the four walls. The vestibule, almost square in shape, was surrounded on three sides by columns, forming a sort of ambulatory. The assembly hall and vestibule, intended for public use, were approached on the east side by several rooms that served either as residences or as lodgings for travelers. Since the street was entirely filled in to strengthen the defenses, the west wall, the side most effectively shored up by the fortifications, was preserved to almost its full height. Of the side walls only trapezoidal-shaped fragments survive, with the shortest side towards the east.[58] The coffered ceiling, demolished to serve as filling, has been partially recovered on the ground. One of the ceiling tiles found in the debris of the assembly hall carries an inscription commemorating the reconstruction: "in the year 556, the second of the reign of Philip (Julius) Caesar . . ."[59] The date is given according to the computation of the Seleucid calendar, and corresponds to 244–245 C.E. The first synagogue was apparently built in the early third century.

DURA-EUROPOS. PLAN OF THE FRESCOES

West wall

1. The sacrifice of Isaac (Genesis XXII). 2. The Davidian Messiah (Genesis XLIX, 9–10). 3a. Jacob blessing his sons (Genesis XLIX, 1–28). 3b. Jacob blessing Ephraim and Menassah (Genesis XLVII). 4. The calling of Moses (Exodus III, 2–5). 5. Moses on Mount Sinai (Exodus XIX, 20). 6. Moses (?) reading the Law (Exodus XXIV, 7) or: Joshua (?) reading the Law (Joshua VIII, 34) or: Ezra (?) reading the Law (Nehemiah VIII). 7. Abraham receiving the promise (?) (Genesis XV,5) or: Joshua at Gibeon (Joshua X, 12–13). 8. Solomon: the Judgment (I Kings 111, 16–28) or: receiving the Queen of Sheba (I Kings X, 1–13). 9. The Exodus from Egypt (Exodus XIV). 10. The camp in the desert (Numbers XXI). 11. Consecration of the Tabernacle (Exodus XL, Numbers VII). 12. Solomon's Temple (I Kings VI). 13. The Ark among the Philistines (I Samuel V and VI). 14. Elijah resuscitates the widow's child (I Kings XVII, 17–24). 15. The Triumph of Mordechai (Esther VI; IX, 11–14). 16. The anointing of David (I Samuel XVI). 17. Moses drawn from the Nile (Exodus I–II).

South wall

18. Consecration of the Temple (I Kings VIII, 1–II). 19. Elijah at Zarephath (I Kings XVII, 10–16). 20. The prophets of Baal on Mount Carmel (I Kings XVIII, 25–29). 21. Elijah on Mount Carmel (I Kings XVIII, 30–38).

North wall

22. Jacob's dream (Genesis XXVII, 10–17). 23. The battle of Eben Haezer (I Samuel IV, 1–11). 24. Ezekiel's vision (Ezekiel XXXVII).

East wall

25. David and Saul in the wilderness of Ziph (?) (I Samuel XXVI). 26. Balshazzar's Feast (?) (Daniel V).

In the earlier edifice the prayer hall and the adjoining room — the areas assigned to public use — were decorated with wall paintings. The surviving parts of the wall, the fragments of reused plaster and the ceiling tiles that were found scattered on the ground allow a reconstitution of the earlier decoration. On the walls it was arranged in three superimposed sections. The ornamentation in the lowest section was of marble imitation. The second was decorated with alternating rectangular panels and lozenges, crowned by the white band of the third section. Painted tiles, each with a floral or fruit motif in the center, produced the effect of a panelled ceiling.

When the synagogue was reconstructed it was also redecorated. The prayer hall of the second synagogue was painted with frescoes in five superimposed zones, the lowest decorated in panels of *trompe-l'oeil* marble, alternating with rectangular panels representing leopards or other felines and roundels containing masks. The remnants of the uppermost level and the fragments found in the ruins suggest that it may have been painted to imitate certain architectural elements that were intended as a frame for the median zones. In this area were narrative frescoes in three horizontal sections, illustrating various Biblical scenes. The division into horizontal sections is interrupted in the central zone of the west wall above the Torah niche. The niche, placed in the middle of the wall, or slightly off-center towards the north, is decorated in the interior and in back of the ciborium. It is surmounted by a vertical panel flanked on either side by two superimposed persons. These indicate the end of the narrative frescoes, or act as an introduction to them. The ceiling was panelled, with each section painted before being set in place. The 234 panels recovered, out of the 450 demanded by the putative reconstruction, display allegorical figures — faces surrounded by wreaths and flowers — astrological symbols, animal figures or flower motifs. Some elements belonging to Jewish art can also be seen: the triple bunch of grapes, the pomegranate, the ears of corn, and on three fragments, the *etrog*.

Archeologists and historians agree that this decorative ensemble was carried out in two phases, and that some still visible parts of the painting belong to the first phase. This distinction is based on criteria of style and content. The painting of the Torah niche, the panel above it, the decoration of the ceiling and of the lowest section, which were later incorporated into the ambitious composition of the second phase containing the narrative paintings, originated in the first period. The decor of the lower section and of the ceiling, as well as the paintings of the niche, were left in their original state. The panel above the niche was repainted to bring its content and coloring into harmony with the narrative frescoes. The two phases of painting correspond to a separation in time, and to the contribution of craftsmen of different backgrounds. They represent above all two different artistic conceptions. The earlier stage still belongs to the symbolical trend that made its appearance after the destruction of the Temple, marking the first specifically Jewish artistic manifestation. The symbols are still present in the second phase; the whole ensemble of the composition is organized in terms of a symbolic idea. But the iconographical language is that of a fully developed narrative art that has no antecedents, at least among surviving fragments that would enable its evolution to be traced. The literary sources of this art, the Bible and Biblical commentaries have to a great extent been identified, but the identification of the iconographical sources is still the object of various hypotheses. In the absence of known models and also because of the fragmentary state of some of the panels, the interpretation of many details remains however controversial, even after forty years of impassioned research. As for the underlying plan of the composition as a whole, and the ideological program directing it, the hypotheses proposed to explain it are almost equal in number to the publications devoted to the synagogue.[60]

The only part of the earlier decoration preserved in its original form is the painting of the niche. The upper part is adorned with a conch in white stucco on a dark blue background; the lower part is painted to imitate

marble, resembling in color and technique the still visible ornamentation on the walls of the first synagogue. The interior of the ark is divided by yellow bands, separating bunches of grapes, oranges and pomegranates that have been painted red, black, yellow and green. Outside of the ciborium, an area reserved in other Dura sanctuaries for the image or symbol of the divinity—the painter arranged a panel in three sections. In the center is the facade of the Temple, resembling the representation on the Bar Kochba tetradrachmae. The general structure, four columns supporting a massive architrave, is the same except for the image of the ark which has been placed between the central columns and takes on imposing dimensions. The doors of the ark are closed, and its pediment is decorated with a conch. The painting portrays rather the case of the ark, an image gradually being substituted for its desert prototype. To the left of the facade appears a monumental candelabrum of unusual form. The oblique branches, composed of circles or little disks instead of the "flowers" and "knops" of the Biblical description (*Exodus* XXV, 31-40), the massive foot, squat in comparison with the body, recall representations of the "tree of life" in Ancient Eastern art. An *etrog* and a *lulav*, also disproportionately large in comparison with the Temple facade are placed near the candelabrum. On the right side of the panel there is a figurative scene, the sacrifice of Isaac. This is the first known visual transposition of this Biblical episode. Its appearance near the Temple can be explained by the link that the Bible (II *Chronicles* III, 1) establishes between the Mount Moriah of the sacrifice of Isaac and the mountain chosen by David for the building of a sanctuary. The ancient commentaries[61] considered this mountain the paramount abode of the divine presence.

The treatment of the scene remains faithful to the methods of symbolic art. The episode is evoked by the juxtaposition of the indispensable elements of the narrative. Reading upwards, we first see the ram tied to a tree; then Abraham, from the back, wearing a white tunic and knife in hand; the altar of superimposed blocks of stone; the schematic figure of Isaac laid on the altar and above him the divine hand emerging from the clouds. In the upper right hand corner is an element which has no apparent direct connection with the event: a tent with a personage at the door, viewed from the back like Abraham. The interpretation of the fresco presents no difficulties. Only two details depart from the Biblical text. The presence of a man in front of the tent is not justified by any textual allusion, at least at this stage of the action. Of the various explanations proposed, the simplest suggests that he is one of the servants left waiting (*Genesis* XXII, 5).[62] The second divergence is the substitution of the tree for the "thicket" mentioned in the text probably because the painting was based on the Targum Onkelos which employs the word "tree" instead of the "thicket" of the Hebrew text.[63]

The panel is archaic and provincial from the artistic point of view. However, it is of great interest, albeit timid and discreet, in the history of iconography. This scene is the first attempt in Jewish art to transpose a literary account into visual form. The figures are static and inexpressive. The representation of the human face is avoided. It is nevertheless a significant attempt, marking the transition between symbolical language and narrative art, the first among the countless images of the sacrifice, and basic to Jewish iconography and Christian typology. In Jewish tradition this episode is also the one most frequently evoked in the history of the covenant between God and Israel—which is precisely the central theme of the paintings of the second phase of the Dura-Europos synagogue.

The artist of the first decoration placed a vertical panel representing a tree or a vine stretching the full height of the wall above the niche. The yellow-painted objects on the two sides of the trunk have been conjecturally identified. On the left there seems to be a throne with another object placed on it, perhaps a crown, and on the right a table supported by two rampant lions. The whole scene has been interpreted in messianic terms. The

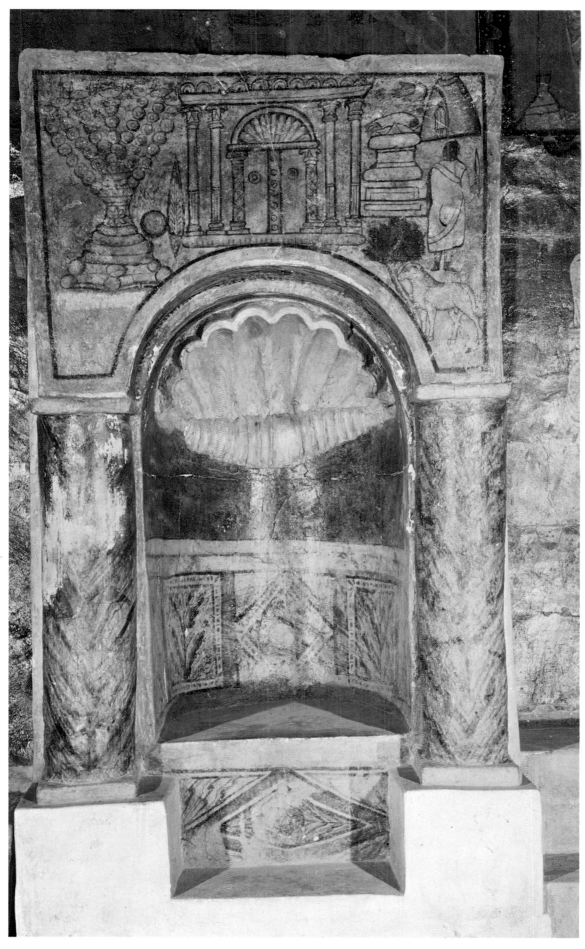

Torah niche. Temple façade. Sacrifice of Isaac (Genesis XXII). West wall.

Orpheus surrounded by animals.
Below (later reworkings): Jacob blessing his sons
(Genesis XLIX). Jacob blessing Ephraim
and Menasseh (Genesis XLVIII). West wall,
central panel.

Reconstitution of the central panel in its first
state. According to Goodenough, Jewish
Symbols in the Greco-Roman period.

Tree of Life, which is its central element, would then be the tree legendarily associated with the feast of the righteous in the messianic age.[64] The panel seems to have undergone two successive over-paintings at brief intervals, probably when the second phase of the decoration was nearing completion. These reworkings were intended to bring the content into conformity with the program of the new decor.

In a first repainting the artist left the tree, the throne and the table undisturbed, but introduced several new elements: a placid-looking lion superimposed on the tree at the level of the foliage, a personage seated on a throne above the leaves with two other figures one on each side. During a second over-painting, the tree, throne and table were covered with a thick layer of red paint, with only the lion and the upper group to be still incorporated into the new composition. On the same level as the lion, on the left, appears the figure of a seated man, in kingly garb, wearing a Phrygian cap and playing a lute. Behind his shoulder an eagle can be discerned, and to his right the uncertain outlines of various beasts, maybe some birds, or perhaps a monkey. The Phrygian cap, the musical instrument and the eagle belong to the usual iconographical formula used for representing Orpheus charming the animals.[65]

The image of Orpheus in a Jewish synagogue among sacred symbols in a composition evoking the messianic hope is certainly an unexpected phenomenon. At the time when the synagogue was built, the Orpheus cult was the most popular of all the syncretist beliefs that had become diffused throughout the Roman empire. Orpheus taming ferocious beasts with his music was the sage mastering the forces of the universe. Returning alive from Hades, he represented victory over death and showed the way to eternal life. The symbols evoking these mysteries were borrowed by other faiths that promised salvation. Sometimes Orpheus was identified with David, the shepherd-king, author of the Psalms; or he prefigured the Messiah—descendant of David—already on earth, or still awaited. In the Dura synagogue the Orphic symbol might however have assumed yet another significance. More than individual salvation, it was perhaps the resurrection of the nation that he was supposed to announce. In Jewish tradition, belief in the resurrection of the individual is indissolubly linked with the rebirth of the entire nation. This hope of collective redemption, with connotations at once political and spiritual, indeed seems to be the principal theme of the Dura-Europos paintings. Thus understood, the figure of Orpheus, introduced in the heart of the new composition, is harmoniously integrated into the whole program.

David depicted with the attributes of Orpheus appears again in a sixth century mosaic discovered a few years ago in Gaza.[66] The iconographic formula is also frequently used in medieval manuscripts where the emphasis is placed on the royal aspect of the personage. The musician-king replaces the shepherd singer.

In the course of this alteration the painter introduced two other scenes in the lower part of the panel: on the left, Jacob blessing his sons (*Genesis* XLIX, 10) and on the right the patriarch giving his benediction to Ephraim and Manasseh, the sons of Joseph (*Genesis* XLVIII, 13-19). Both episodes are connected with the scene in the upper section of the panel. This, in its earlier version, was composed of a person on a throne and two bystanders. In the second version, the central figure, who represents the Messiah-King promised in the prophecy (*Genesis* XLIX), is surrounded by thirteen persons, six on one side and seven on the other. According to the generally accepted interpretation, these are the personification of the twelve tribes—thirteen with the two half-tribes of the sons of Joseph—the "people" spoken of in *Genesis* XLIX, 10—understood as the whole House of Israel united around the Davidian Messiah. The setting was inspired by the great historical compositions of Roman art. In applying it to a religious subject, the painter created an iconographic type destined to have a long and illustrious posterity in Byzantine art.[67] It was also to serve in representing the emperor and his court, and in the Last Judge-

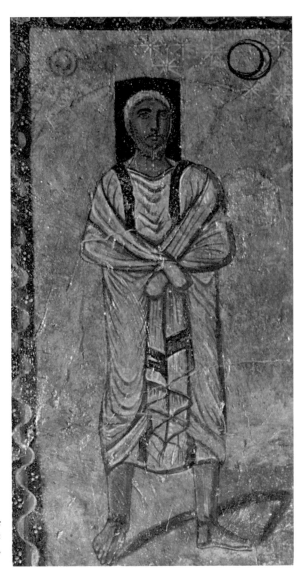

Abraham receives the divine promise (Genesis XV,5) or: Joshua at Gibeon (Joshua X, 12–13). West wall.

ment or the Virgin among the saints. In the context of the synagogue, placed above the sacred symbols of Judaism in the center of the wall oriented towards Jerusalem, this composition perhaps had an eschatological connotation.

The painting evoking the messianic prophecy is framed by four isolated figures symmetrically superimposed, two on either side of the panel. This setting emphasizes the dominance of the composition over the niche. The upper persons can be identified without difficulty. On the right, a bearded man, having removed his boots, stands near a bush. In the left corner of the panel, the hand of God emerges from the clouds. The episode represents the calling of Moses on Mount Horeb when the voice of God was heard from the burning bush (*Exodus* III, 2-6). On the same plane to the left, in an only partially preserved panel, a man dressed in the same manner, also barefoot, is climbing a mountain. It has been accepted that the painting represents Moses climbing Mount Sinai to receive the Tablets of the Law (*Exodus* XIX, 20).

The identity of the two persons on the lower plane is more problematical. To the right, a man in tunic and himation, a square halo round his head, holds a scroll. At his feet there is an object shaped like the ark in another painting in the synagogue and covered by a veil. If the scroll, half-unrolled and inscribed on the reverse, represents the Torah, of which it is said (*Exodus* XXXII, 15) that it is written on both sides, the person may be one of the three great leaders of Israel who renewed the covenant between God and his people: either Moses (*Exodus* XXIV, 7) or Joshua (*Joshua* VIII, 34) or Ezra (*Nehemiah* VIII). Each of these hypotheses has been maintained, but no argument has obtained general consent. The identity of the fourth person is also conjectural. A man, similarly dressed with the same rectangular halo but older than the others as is shown by his white beard, is standing under

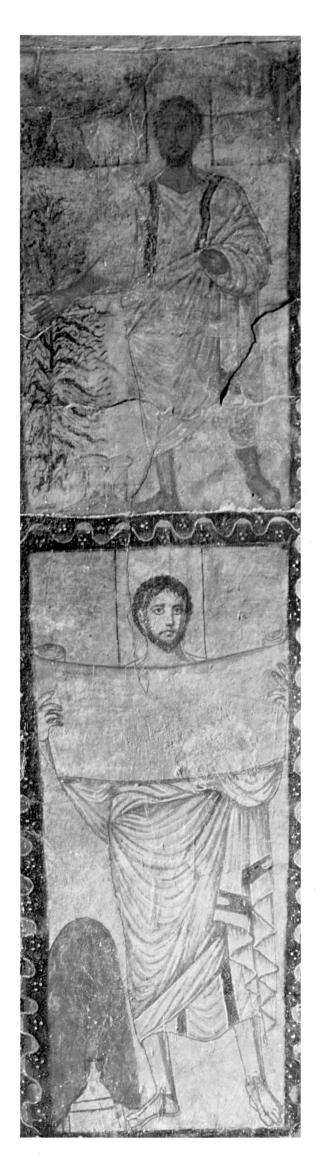

Above: The calling of Moses. The burning bush (Exodus III; 2–6). *Below*: Moses reading the Law (Exodus XXIV, 7); or: Joshua reading the Law (Joshua VIII, 34); or: Ezra reading the Law (Nehemiah VIII). West wall. Portraits framing the central panel.

The Exodus from Egypt. The crossing of the Red Sea (Exodus XIV). West wall. Upper register.

the firmament, indicated by an arch, the sun, moon and stars. The proposed interpretations hesitate between Abraham, counting the stars upon receiving the divine promise (*Genesis* XV, 5) and Joshua making the sun stand still at Gibeon (*Joshua* X, 12-13). Goodenough, who saw in the frescoes the mystical teaching of a sect parallel to rabbinical Judaism, suggests a different explanation for the four personages. Based on texts by Philo of Alexandria whose writings belonged to a current of thought related to that of the sectarians of Dura who are supposed to have commissioned these paintings, Goodenough maintains that the four figures represent Moses the mystagogue at the four stages of his spiritual ascent.[68]

In the pagan temples of Dura-Europos as well as in the Christian chapel, the frescoes follow a similar type of program. The wall facing the entrance is devoted to the principal symbol of the cult; the lateral walls are decorated with processions of worshippers and narrative episodes drawn from the myth of the deity.

This plan seems to have dictated the program of the second decoration of the synagogue. The panel on the outside of the ciborium and the messianic composition above stand for the forbidden representation of the divinity. Narrative paintings illustrating the sacred history are distributed on the three other walls. It seems clear that this plan follows an ideological conception but its precise meaning is even more difficult to establish since the original appearance of the paintings cannot be reconstituted in its entirety. The surviving panels hardly suffice as points of reference as their sequence on the walls are without relation to their narrative content. The infant Moses drawn from the Nile (West Wall) has no apparent link with the anointing of David next to it; similarly, the triumph of Mordechai, on the same wall to the left of the niche, does not in any way refer to the adjoining panel which represents Elijah resurrecting the widow's child. One of the characteristics of the paintings is the absence of chronological or logical order to the scenes. Each panel seems to express an autonomous theme, based on any one of the essential principles of the faith: the superiority of the God of Israel over the pagan divinities, the miraculous aid He extends to his chosen people, the punishment of those who offend his will. These subjects in their turn are orchestrated around a central theme — the promise of national redemption and rebirth, inseparable from future hopes. This fundamental idea, maybe the principal subject of the frescoes, is expressed in the choice

The Exodus from Egypt. Moses leads the Israelites. The Egyptian army drowns (Exodus XIV). West wall. Upper register.

of episodes tracing the history of the chosen people from the patriarchal period to the return to the Holy Land after the Babylonian exile, and culminating in the evocation of messianic prophecies and their accomplishment in the last days.

The person most often represented in the frescoes is Moses, a central figure in Biblical history, who formed the nation. All the important stages of his life are represented. He is seen as an infant rescued from the Nile (*Exodus* I-II); receiving his vocation on Mount Horeb (*Exodus* III, 2-6); leading the departure from Egypt (*Exodus* XIII, 17 – XIV); in the desert camp (*Exodus* XVI); ascending Mount Sinai (*Exodus* XIX); and at the miraculous well at Beer (*Numbers* XXI, 16-18). Another prominent person is the prophet Elijah, in his flight to the brook Kerith (I *Kings* XVII, 3-6), at Zarephath (*ibid.*, 10-16), his miraculous resuscitation of the widow's child (*ibid.*, 17-24) and his contest with the priests of Baal (I *Kings* XVIII, 25-38).

The history of the ark (I *Samuel*, V-VI), the consecration of the Tabernacle (*Exodus* XL), and Solomon's Temple (I *Kings* VI) each form the subject of autonomous panels. David at the outset of his career is anointed by Samuel (I *Samuel* XVI); he figures as the Messiah-King in the central panel, and with Saul in a panel which is thought to depict the scene in the wilderness of Ziph (I *Samuel* XXVI). Jacob's dream (*Genesis* XXVIII, 10-17), the vision of Ezekiel (*Ezekiel* XXXVII), and the triumph of Mordechai (*Esther* VI; IX, 11-14) complete the series of panels whose subjects have been identified. The diagram (p. 64) shows their position on the walls.

The most impressively rendered episode is the Exodus from Egypt. The panel of three scenes, occupies nearly the entire upper section west of the niche. The phases of the action progress from right to left. On the right, a walled city with open gates represents Egypt, recently vacated by the compact armed hosts of the Israelites. The scene is closed by a Moses of heroic dimensions. Before him in the second section naked Egyptians float in the waves; then Moses appears again, turning, as if to make the waters subside and return to their natural bed. The next section is introduced by a third Moses, gigantic in size; behind him is the sea divided into twelve lanes, and on his left, a repetition of the ranks of the Israelites, gliding across a strip of water with fish floating in it. The composition causes a flagrant dislocation in the chronological order of the account, for the drowning

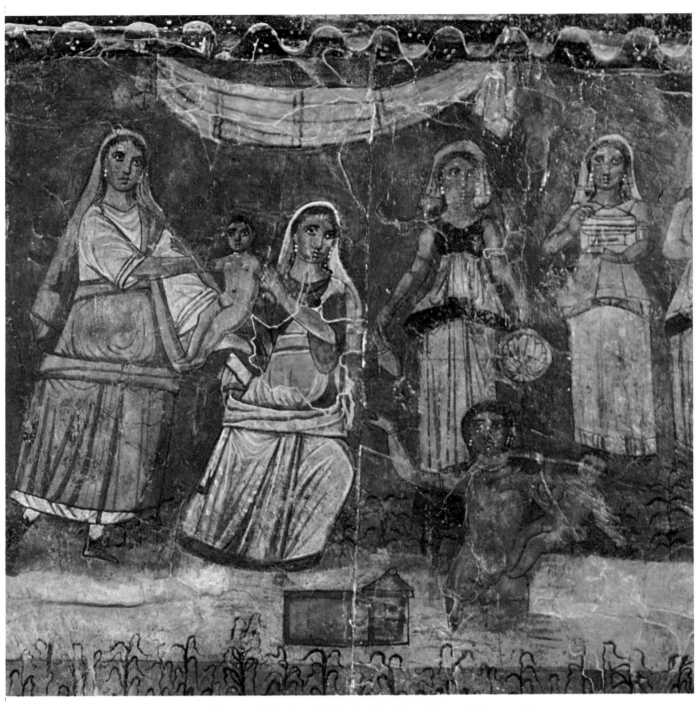

Moses saved from the Nile by Pharaoh's daughter (Exodus I–II) West wall. Lower register.

of the Egyptians is made to precede the crossing of the Red Sea by the Israelites. The reason for this inversion may be pictorial. Since the monumental composition demanded a symmetrical structure, the scene of the drowning where horizontal lines predominate is framed by the two representations of the Israelite army, depicted mainly by vertical lines. Solicitude for textual fidelity may also have been superseded by didactic considerations. The triumph of the Israelites was considered a fitting conclusion to the sequence. Finally, the painter, in adapting his model to a composition on a large scale, seems to have abbreviated the sequence. The first Moses figure should be followed by the separation of the waters, but this episode does not appear at all. The triple representation of Moses provides an indication regarding the underlying model which could have been a sequence of more detailed illustrations. The painter chose the scenes necessary to his composition and omitted the intermediary episodes

that are suggested anyway by the figures as they succeed each other. Such illustrations may have been found in the margins of a written text — codex or roll — before being transposed to monumental painting. Moreover, it is neither certain nor inevitable that the first transposition was made in Dura. The frescoes of the synagogue were perhaps inspired by another composition that has not been preserved.

Almost all the elements of the Exodus panel conform to the Biblical text. Only two details are unmentioned in the source — the division of the sea into twelve lanes according to the number of the tribes and the arming of the Israelites. These details are based on Midrashic texts, [69] an influence that can be perceived in other panels as well. [70] Their presence may indicate that the text of the model was a Biblical paraphrase enriched with elements of legend, like similar texts still known and used today. [71]

The panel devoted to the infancy of Moses also includes elements from the Midrash. The story is related in three scenes, following each other from right to left. On the right, Pharaoh orders the midwives to kill all the male infants born to the Hebrew women (*Exodus* I, 15-16); in the middle, Pharaoh's daughter, having entered the stream naked, takes the child Moses out of the wicker basket (*Exodus* II, 5) and gives him to his mother Jocheved and his sister Miriam who are watching from the bank. The midwives on the right and the two women Jocheved and Miriam wear exactly the same clothes. This detail probably refers to the legend that the two midwives whom Pharaoh commands to kill the children are in fact the mother and sister of Moses. [72] In the center of the composition the painter has placed the principal element of the event, the child saved from the river. Goodenough, who explains the Dura paintings in terms of a mystical belief, considers this scene to be the representation of the miraculous birth or the mystical rebirth of a man-god known in a number of myths, including that of Orpheus. Pharaoh's daughter, providential agent of the action, is accompanied by three other female figures standing slightly to one side, and holding various objects in their hands. According to Goodenough, these are nymphs carrying the celestial graces in the form of gifts. [73] Whatever the real intention of the painter, it seems in fact probable that in adding these three personages he was using an iconographic convention well known at the period and recognized by his clients to be associated with the birth of a great man.

The interpretation of several panels is still uncertain. The immediate problem, the identification of the Biblical episodes that furnished the narrative material, is solved for the most part. Leaving aside the fragmentary or obliterated panels, which allow no more than conjecture, only some minor details still remain obscure. The only exception in this connection is the Ezekiel panel. The two first sections, clearly legible, have been easily identified except for a few details; the interpretation of the last section, quite well preserved in spite of a retouching carried out before the painting was altogether completed, has been more problematic.

The three sections of the panel are distinguished by backgrounds of different colors. The two first divisions represent verses 1 to 11 of chapter XXXVII of *Ezekiel*, which the painter follows almost verse by verse. At each stage of the action the grandiose figure of the prophet appears with the hand of God laid on him or pointing towards him; this formula, also known in western art, indicates that God is commanding the accomplishment of the miracle, or is directly participating in it. The first three figures of Ezekiel, corresponding probably to verses 1, 4 and 7a, [74] appear in the midst of the "dry bones," shown as in paleo-Christian art [75] in the form of *membra disjecta* covered with flesh. The first section is delineated by a cleft mountain, with an overturned house on its slope. This is most probably an allusion to the earthquake which, according to the legend, would cause the coming together of the bones. [76] In the second section a fourth figure of the prophet, in Persian costume like the first three, stands near the reconnected but still inanimate bodies. To the right of the group, a fifth representation

The hand of Jehovah is on me, it transports me...and it puts me in the midst of a valley full of bones (v. 1 a-b).
He tells me: "Make a prophecy over these bones. You will tell them:...Thus spoke Seigneur Jehovah...I will thus make the
spirit enter into you and you shall live (v.4). I will prophesize...then he made a noise...there was fluttering and the bones came together (v. 7).

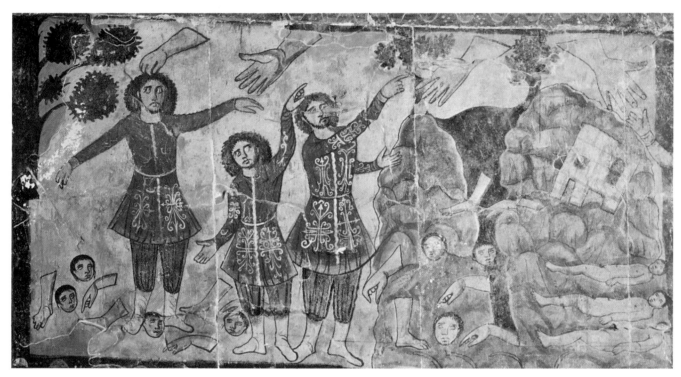

Ezekiel's vision. a) Ezekiel receives the divine command. The mountain is rent (Ezekiel XXXVII). Lower register.

of Ezekiel calls in the proper order to the winds or spirits[77] to breathe life into them. The representation draws on a convention typical of Hellenistic art: the *psychai* communicating breath to the body. The two figures of Ezekiel associated with this phase of the action are dressed in chiton and himation. The scene closes with ten smaller persons, also in Greek costume, raising their arms in a joyful gesture; they personify the "exceedingly great army" of the resurrected (verse 10).

The general significance of these two scenes no longer gives rise to argument, but some details, particularly the repeated apparitions of the prophet and their precise relation to the text, can only be conjecturally interpreted. What significance should be attached to his changes of costume? In the first section and in his apparition next to the mountain during an earthquake, Ezekiel is in Persian clothes. He turns Greek in the resuscitation scene. Considering the importance that the painter assigns to these distinctions of clothing, the variation must have had a precise purpose. Maybe he wished to give the greater weight to the last phase of the miracle where the prophet is at the peak of his mission. According to Goodenough, the artist thus expressed the perfection achieved by the prophet on the mystical way, and his power as psychagogue.[78] The identity of the ten risen persons also raises problems. They are considered by some scholars to be the whole House of Israel, by others, the ten lost tribes who will reappear in the Last Days.[79]

He says to me: "Make a prophecy to the spirit…Say to the spirit: thus spoke Seigneur Jehovah. Come ye four winds,
spirit, breathe over the dead, and make them live." I made the prophecy as he commanded me and
the spirit entered them, they regained life and stood up on their feet: a great, enormous army (v. 9–10).

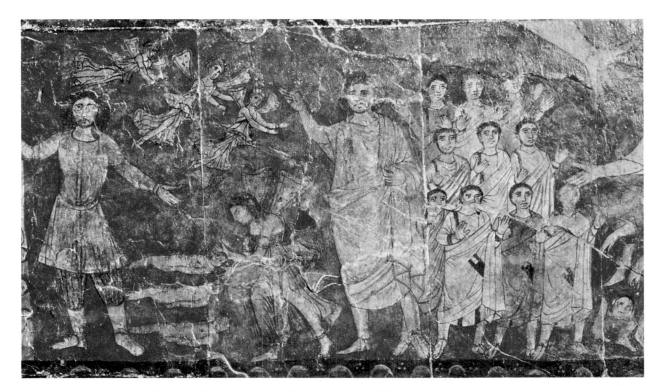

Ezekiel's vision. b) Resurrection of the dead (Ezekiel XXXVII). North wall. Lower register.

In spite of these uncertainties of detail the first two scenes are perfectly integrated into the ensemble of the paintings. The narrative sequence, portrayed with a dense array of detail[80] in the initial section, provides a characteristic example of the painter's method. The context, a parable of the national rebirth, conforms with the ideological program. Besides, in the historical context of the Dura community this subject, of such burning topicality, quite naturally received circumstantial treatment.

An altar topped by a tent containing golden objects and a censer occupies the center of the third scene. On the left, a kneeling person in Persian dress clings to the altar, while a soldier in Roman armor standing behind him grips his shoulders. To the right of the altar the outline reveals two superimposed versions. In the first, a standing figure in Persian dress brandishes a sword and prepares to kill a man standing in front of him, also in Persian costume. In the course of his work the painter changed the expression of this person to make him lean towards the executioner who seizes him by the hair and seems ready to decapitate him. In the still free space the artist placed four soldiers, smaller figures but wearing the same armor as the soldier in the foreground.

This third section has not yet received a generally accepted interpretation. The first difficulty is caused by the rather confused state of the scene due to the change carried out halfway through the execution of the painting. The real problem, however, lies elsewhere. There is no episode in *Ezekiel* that corresponds to the scene of the

*"Ezekiel, his name means 'force of God'...was delivered in captivity in Chaldea, where the Israelites
decided to let him perish, as the prophet accused them of worshipping idols. He was buried
in the Tomb of Arphaxad" (Isidore of Seville, De ortu et obitu patrum, Migne, Patrologia Latina, v. 83, col. 1279).*

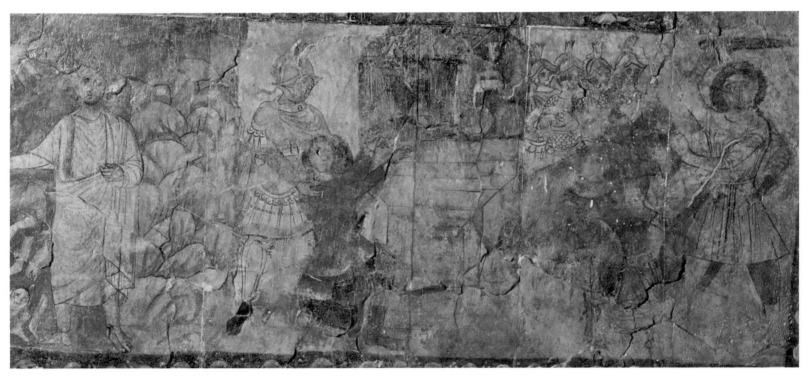

Ezekiel's vision. c) The martyrdom of the prophet. North wall. Lower register.

fresco. Nevertheless, according to a general rule observed throughout the synagogue, the scenes in a single frame form a literary unit, whatever the number of episodes it comprises.

Since the book of *Ezekiel* offers no episode that could serve to explain the scene, numerous suggestions have been made, referring to other parts of the Bible. These range from the execution of Joab by Benaiah (I *Kings* II, 28-34),[81] to the stoning of Zechariah (II *Chronicles* XXIV, 20-22),[82] and the history of Jehoiakim (II *Chronicles* XXXVI, 6-8), supplemented by the Midrash (*Leviticus Rabba* XIX, 6; *Genesis Rabba* XCIV, 6).[83]

The explanation that fits the iconography most closely suggests the first book of the *Maccabees* as a source (II, 25).[84] In 163 B.C.E. envoys sent by Antiochus Epiphanes attempted to make the Jews sacrifice at a pagan altar erected at Modin. When Mattathias refused, another Jew advanced to carry out the order. Outraged, Mattathias slew the apostate and afterwards the officer. Based on the illustration of this episode in medieval manuscripts,[85] Henri Stern recognizes Mattathias killing the sacrilegious Jew in the right-hand portion of the panel, and on the left, one of Mattathias' sons[86] in military attire, preparing to kill the Greek officer who is wearing a Persian tunic and kneeling before the altar.

The agreement with the source might be more precise if the left section of the painting represents the sacrifice carried out under pressure from the Greek officer in military attire by the unfaithful Jew in Persian costume kneeling

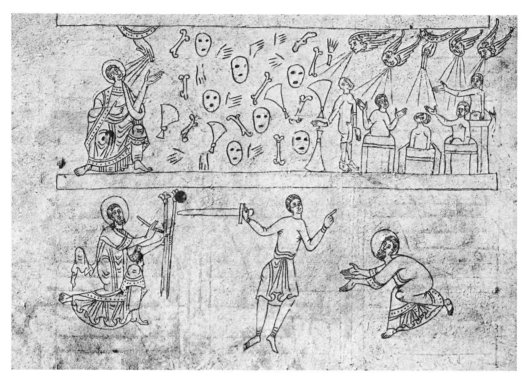

Ezekiel's vision. The martyrdom of the Prophet. Roda Bible, Catalogne, XI century, Paris, Bibliothèque Nationale, ms. Lat. 6, vol. III, fol. 45 v.

near the altar. This substitution would allow the chronological order of the episode to be maintained from left to right across the panel and at the same time would account for the clothes—the officer in military dress, the Jews in Persian tunics to the left and right of the altar respectively—details that the Dura painter always treated with great attention.

But this hypothesis runs up against one problem.[87] The story of the Maccabees has no connection at all with the vision of Ezekiel that is represented in the first two sections of the panel. There is, moreover, no ground for supposing that the painter renounced the principle adhered to in all the other panels by associating disparate scenes within a single frame.

The only interpretation that takes this unity into account is Goodenough's.[88] He suggests that the final section represents the death of Ezekiel himself. The tradition relating to the martyrdom of Ezekiel has not been preserved in Jewish literature. But it is corroborated by early Christian writings. The *Epistle to the Hebrews* already contains allusions interpreted in this sense.[89] The Christian apocrypha, which may be traced to Hebrew originals of the second century, were also aware of it,[90] and it recurs in such medieval authors as Isidore of Seville.[91] The texts of this author inspired the illustrations of an eleventh century Biblical manuscript known as the Bible of Roda,[92] which shows on three successive full-page illustrations the story and martyrdom of Isaiah, Jeremiah and

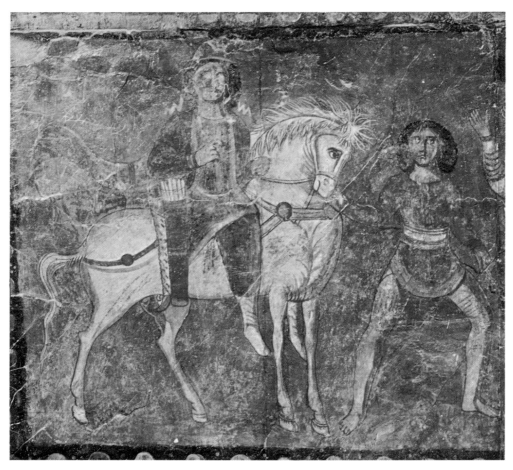

The triumph of Mordechai (Esther VI). West wall. Lower register.

Ezekiel. Isaiah is sawed in half (vol. III, fol. 2v), Jeremiah is stoned (*ibid.*, fol. 19v), and Ezekiel decapitated (*ibid.*, fol. 45v). As Goodenough points out, Isidore of Seville only mentions Ezekiel's death; the manner of it is taken from another earlier source, perhaps Jewish, that may have predated the frescoes and figured in the original iconographical repertoire.

The richness of the Ezekiel cycle is exceptional. Most of the other compositions do not contain more than two scenes, and there are several panels representing only one scene. The dual scene panels include the story of Esther and Mordechai (west wall, lower section to the left of the niche). The episodes move from left to right in the direction of the niche. The first scene shows Mordechai conducted in triumph by Haman (*Esther* VI, 7-11); in the second, Ahasuerus on his throne, surrounded by courtiers, gives a letter to a messenger, probably the decree ordering the hanging of the sons of Haman and the prolongation of the festival of Purim (*Esther* IX, 12-13). The distinction between the two phases of the narrative is shown by the change in the proportion of the personages. The two juxtaposed episodes are constructed according to well known iconographical models in oriental art. On the left, an "imperial triumph;" on the right, a "royal audience." The elements of the composition, faithful to the Biblical text, are enhanced at two points by details from the Midrash. Haman, leading Mordechai's horse, is shown wearing a tunic that barely covers his body. This odd costume refers to the legend that mentions the wearing of beggarly clothing among the humiliations inflicted on Haman.[93] In the second scene the steps of Ahasuerus' throne are adorned with birds and lions. This is the decoration of the throne of Solomon, that according to the Midrash, was taken by Nebuchadnezzar to Babylon where it was later seized by Ahasuerus.[94] Furthermore, Haman, who in popular tradition in some way personified the arch enemy of the Jews, is shown blinded. The emotional reactions here demonstrate how intensely the Dura community felt the ancient history to be a

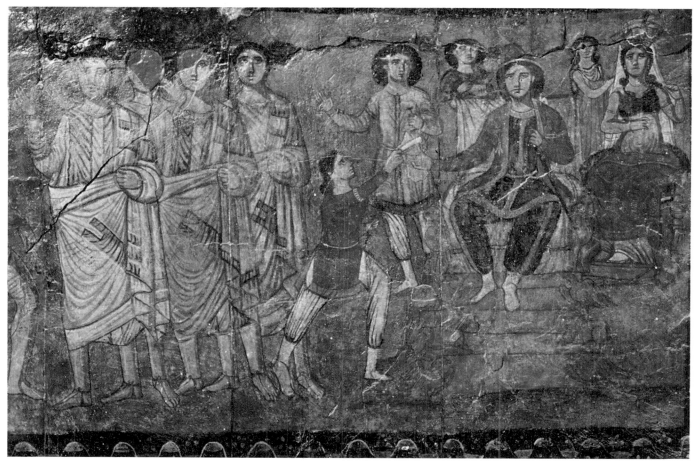

Purim festival (Esther IX, 11–14). West wall. Lower register.

story for all time. Long dead heroes and foes, victories and defeats that demarcate the past, are the images of an eternal story, the covenant between God and his people.

Sudden passionate interventions appear in other panels. The fresco adjoining the Esther and Mordechai scenes represents the episode of the prophet Elijah resuscitating the child of the widow of Zarephath (I *Kings* XVII, 17-24). In the center of the composition the painter has placed the prophet on a sumptuously decorated bed, holding up the living child towards the spectator. The divine hand that appears above the prophet is the sign of the accomplished miracle. The scene is surrounded by inscriptions of a personal nature, such as "the child lives," or invocations calling for help from the prophet. The unique miracle was thus interpreted as the sign of a permanent possibility; perhaps the image was regarded as a symbol of magical potency.

Jacob's dream, Samuel anointing David, and other episodes whose interpretation remains uncertain because of the deteriorated state of the painting are depicted in monoscenic panels. The ensemble of the panels presents an almost complete repertoire of the great figures of the sacred history—the patriarchs Abraham and Jacob with their sons; the most eminent chiefs and kings, Moses, Aaron, Samuel, Saul, David and Solomon; the most popular prophets, Elijah and Ezekiel, and the important persons of the period of the Babylonian exile, Esther, Mordechai and Ezra. They are identifiable by their attributes or by their action.

In the presentation of the paintings the traditions of oriental art predominate. The treatment of the personages is equally removed from the naturalistic conception of Hellenistic art and from the conventions dominating Roman official art. Expressionless faces, their eyes gazing into space, the heroes appear detached from their actions. The movements are stereotyped; the static figures are shown in full face, the weight of the body carried on one foot drawn in profile, the other foot slightly to the fore. A few figures, on the other hand, express an intensity

of movement that the painter attempts to translate by making the different parts of their bodies turn in various directions. The head is painted facing the spectator, the torso in profile, the hips again facing forward, the legs placed apart in imitation of a rapid step. This movement, rendered in a purely analytic manner, neither convincing nor natural, is used to express both the emotion of Mordechai before Ahasuerus and that of the widow of Zarephath showing her dead child to the prophet. Conventional gestures indicate the nature of the act performed. Direct intervention is shown by a hand pointing forward, prayer is shown by crossed hands, covered by the edge of the tunic, and a chant of joy or an acclamation by both hands raised towards the heavens.

To define the social situation of these persons, the artist uses two well known conventions of oriental art, distinction by physical proportions or by clothes. The principal figure of a scene is of gigantic stature; figurants of secondary importance diminish in size according to their standing or number.

Clothes reveal the social position of the figures. The painter distinguishes between four types, two Greek and two Oriental. Sages and prophets are dressed in the Greek manner, in chiton and himation, and wear sandals. The end of the himation is rolled over the left arm, held folded near the body while the right arm performs the gesture suited to the action. This type of personage repeats a Hellenistic formula intended to represent the statesman. The painter has given this costume to the heroes who participate in the most significant episodes in the history of Israel — Abraham receiving the Covenant, Moses at the burning bush and on Mount Sinai, then leading the Exodus; it is also the costume of Samuel anointing David, of Elijah and Ezekiel after the accomplishment of the miracle. It covers the figures of the resuscitated in the Ezekiel panel, but also the priests of Dagon and Baal on Mount Carmel.

Court officials and religious officiants are in Persian dress — short belted tunic, baggy trousers, boots of supple leather. This garb is won by the courtiers surrounding Ahasuerus and Pharaoh; it is also the costume of the angels who appear to the sleeping Jacob, and of Ezekiel before and after the principal phase of his mission.

For the kings a large loose cloak and a Phrygian cap are added to this costume. The Messiah-King, the triumphant Mordechai, Pharaoh and Ahasuerus all appear thus outfitted.

The soldiers wear two kinds of armor. The painter probably reproduced the uniforms he had seen in Dura itself. The Persian type, a tunic reaching the knees with close-fitting trousers and boots, is worn by some of Ebenezer's troops. Roman armor, even if somewhat whimsically interpreted, with cuirass, tall helmet with plumes, and chlamys, narrow trousers and high boots, is worn by the Greek officer in the final episode of the Ezekiel panel and also by the Israelite army during the Exodus. Servants wear a thigh-length tunic. This garment also marks the disgrace of personalities of high rank; it is worn by Haman condemned to serve Mordechai.

To these four types of masculine clothing correspond an equal number of feminine variants. The prophetesses Miriam and Jocheved and the widow of Zarephath wear a simple chiton with sleeves and a himation attached on the left shoulder; the end of the himation is passed over the head like a veil. Esther, the glorious queen, has a tunic without sleeves, a wide skirt and a royal mantle, and a turreted diadem. The female servants wear an oriental version of the Greek *peplos*, with *keplon* attached above. The nymphs accompanying Pharaoh's daughter on the banks of the Nile are also in Greek dress, as are the *psychai* in the Ezekiel panel whose butterfly wings and graceful flight are entirely faithful to Hellenistic prototypes.

The conventions of the settings also continue in oriental traditions. The organization of the panels in horizontal sections recalls Assyrian and Babylonian reliefs. The succession of planes is achieved by the superimposition of figures. The persons in the foreground are placed in the lower part of the panel, those of the background in the

upper part. Sometimes, by way of exception, a colored band designates the scene of the action; elsewhere a landscape element summarily evokes the decor demanded by the text. This analytical method never aspires to the representation of a natural setting or an individual interior.

Traditional formulas of oriental art also provided models for the various types of scenes. In the "royal audience," especially at the courts of Ahasuerus and Pharaoh, the king is seated facing the spectator, the courtiers stand on both sides, while the persons being received in audience advance from the left. For the depiction of an army the model varies according to the phase of the action. The static or marching army, like that of the Israelites leaving Egypt, is shown in compact phalanxes. In the battle of Eben Haezer the fighting is portrayed by hand-to-hand combat.

The influence of Hellenistic art is especially perceptible in the representation of architectural elements. In the Temple of Solomon, Dagon's Temple, the arch is structured with great portals surmounted by triangular pediments. The acroteriums of Solomon's Temple are adorned with graceful victories. The sanctuaries are surrounded by enclosures. The Temple has seven of these divisions, maybe because of a cosmological symbolism, since the sacred edifice was the abode of the divine presence at the center of the universe. The enclosures have three monumental entries like the facades of the hypogeums near Jerusalem, or those of Herod's Temple. Towns are designated by a fragment of wall with heavy masonry, and a gate surmounted by a blind arch. At the gate of Tanis, victories decorate the acroterium, as on the Temple itself.

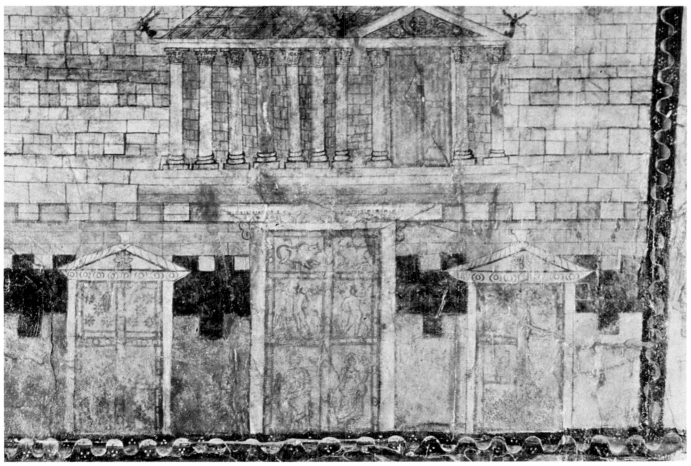

Solomon's Temple (I Kings, VI). West wall. Middle register.

The narrative method is based on the juxtaposition of units of literary accounts, episodes relating to the same story being grouped within panels defined by black-painted borders. Some panels contain only one scene. When the text demands the presentation of successive phases of the action, two or three scenes linked by their common subject are simply placed next to each other. Scenes belonging to two different texts are never found together within the same panel. The episodes depicted in a single scene show the principal person with one or more accessories that are indispensable for situating the action. The simplest in presentation are the four portraits framing the messianic panel. Elsewhere, the narrative effect of the single scene is intensified by the number of participants, although the fundamental procedure is not modified; for instance, Samuel anointing David in the presence of his brothers. A good example of the juxtaposition of two scenes showing two successive phases of the same event is the episode of the ark among the Philistines. The temple of Dagon with the idols broken and scattered on the ground to the right and the departure of the ark on the left, expressively summarize the text (I *Samuel* V and VI).

Elsewhere, the exposition of the theme demanded three episodes and sometimes even more. Their sequence in the panel does not necessarily conform to the chronological order of the narrative. A desire for equilibrium in the composition or a didactic intention might have led the artist to invert the phases of the action, for instance, in the Exodus scene. In order to achieve a more concise presentation, or simply to exploit the available space judiciously, certain panels give an abridged version of the story, omitting one or more intermediary episodes. This abbreviation is particularly felt in the account of Elijah at the house of the widow of Zarephath. On the left, the widow in mourning holds out the dead child towards an invisible person. Elijah taking the place of this person in the center of the panel represents the final phase of the resuscitation; half-recumbent on the bed, the prophet holds the living child in his hands. Elijah receiving the child from the widow's bosom and the action of reanimation, both very precisely described in the text (I *Kings* VII, 19-22), are omitted. To Elijah's right, forming a symmetrical pendant to the first female figure, the widow appears with the child already clothed. The three scenes give the result of the three principal stages of the action. It is quite probable that the painter had a larger repertoire at his disposal, and that he selected the scenes that suited his program. Such a repertoire would also explain his procedure of repeating the same personage at each moment of the action. Moses appears three times in the Exodus panel, Ezekiel no fewer than six in the illustration of his vision, even seven in Goodenough's interpretation.

The incontestable unity of conception and method supports an assumption of a well-defined plan. This assumption gives rise to several questions. Should the execution of the frescoes be attributed to one artist or to a team? If several painters participated what was the division of tasks? Were the people responsible for the actual implementation also the authors of the conception?

It seems logical to suppose that a work of such size could not have been carried out by a single artist. The collaboration of many hands may even be discerned in the frescoes. There are differences in the treatment of the faces, in the drawing of the draperies, in the degree of skill manifested in handling movement. It would perhaps be going too far to attribute each section not only to a distinct artist but to an artist of a different culture, as has been proposed.[95] It is simpler to assume that the execution of the frescoes was the work of a team of painters who worked under the direction of the master of a workshop. It is also likely that the painters responsible for the technical execution were advised by educated men, versed in the Biblical and Midrashic literature; the choice of subjects, their general disposition and the additions based on Midrashic sources, should probably be attributed to their collaboration.[96]

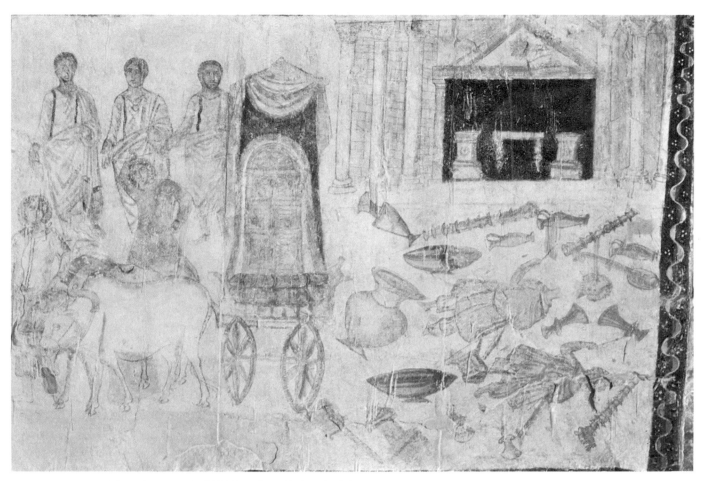

The Ark among the Philistines. Dagon's Temple (I Samuel V and VI). West wall. Middle register.

Indeed, as previously seen, not only does the order of the frescoes not follow the Biblical account, but the Biblical text alone is not enough to support it. A considerable number of details are based on the Midrashic paraphrases and commentaries that were added to the original text. Careful study of the frescoes has even demonstrated that they contain no element that cannot be justified by a literary source. Among the para-biblical texts most frequently used are the Targum of Babylonia and Palestine.[97] The Midrashic elements derive chiefly from the *Midrash Rabba,*[98] and from a text known in an eighth century version as the *Pirkei of Rabbi Eliezer.*

The presence of this Midrashic material in the frescoes is of fundamental importance. In the first place it provides information for the dating of certain texts. In particular, the antiquity of the *Midrash Rabba* and of elements in the *Pirkei of Rabbi Eliezer* receives indisputable confirmation. The free use of these materials shows that in the third century the Biblical narrative and the Midrashic amplification formed an indivisible and living unity. Iconographically considered, a number of these elements appeared in Hebrew medieval manuscripts when narrative art was revived in the illuminated codex after an interruption of several centuries. Examples are the representation of the Exodus, where the sea appears divided by twelve lanes to give passage to the twelve tribes,[99] the miraculous throne of Solomon with its alternating eagles and lions on the steps to assist the king in mounting,[100] Pharaoh's daughter herself descending to the Nile to take the infant Moses out of the stream[101] instead of sending her servant, as in the Bible. These Midrashic materials also figure in the illumination of certain Greek and Latin manuscripts. The most celebrated examples are the Vienna Genesis[102] and the Ashburnham Pentateuch.[103] It cannot be assumed that their Midrashic elements were inspired by the frescoes of the Dura

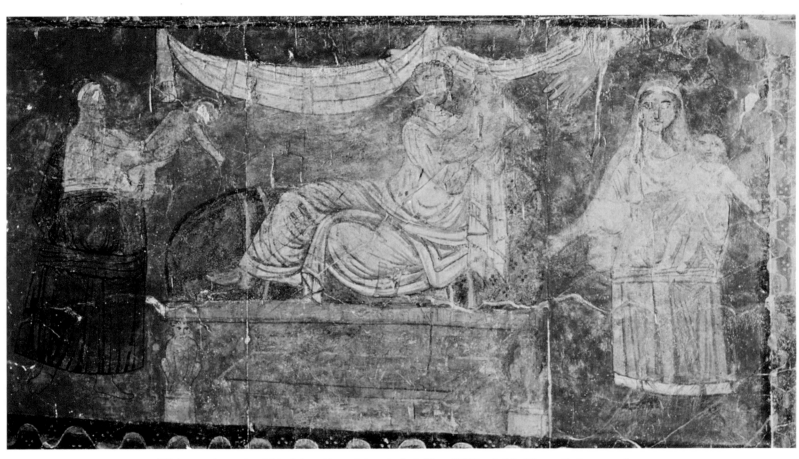

Elijah resuscitates the child of the widow of Zarephath (I Kings XVII, 17–24). West wall. Lower register.

synagogue. But they could have been copied from Jewish manuscripts—in Hebrew, Aramaic or Greek—manuscripts that are today lost, but formed the intermediary links between the frescoes or their models and medieval illumination.

Our final concern is the problem presented by the models. It seems hardly likely that such a complex creation should be, in all its parts, the work of local artists belonging to the Jewish community of a small frontier outpost far removed from the great cultural centers. Local inspiration is no doubt responsible for the organization of the paintings and the general plan of the decoration which is similar to those of other sanctuaries of Dura-Europos. But the narrative material and the iconographical types betray other origins. In mural painting, no example survives to permit comparison. It may of course be presumed that the wealthy communities of northern Mesopotamia, at the meeting point of Hellenistic and Persian influences, Edessa or Nisibis, decorated their synagogues in imitation of pagan sanctuaries, but the existence of such decoration remains hypothetical.[104]

Moreover, the iconography encountered in the Dura synagogue was probably not originally destined for mural painting. Several indications converge to suggest that the episodes in their original form figured as illustrations of manuscripts.[105] The existence of a more extensive repertoire of models is forcefully supported by the selection and subdivision of subjects; some Biblical books, *Genesis*, *Exodus* and the historical books, are abundantly represented; others, like *Leviticus*, *Deuteronomy* and most of the prophetic books, are entirely absent. The cycles of illustrations drawn from *Exodus*, the books of *Samuel*, also the books of *Kings*, begin with the first chapter of the relevant Biblical account. Within the cycles the chronology of the episodes most frequently follows the narrative. Most of the panels represent a single scene or juxtaposed scenes that can be separated into monoscenes. These characteristics perfectly suit a model in the form of a manuscript roll, where the illustrations follow the narrative from episode to episode in the margin or in the text. From such a repertoire the painter of the synagogue could have chosen the scenes he wished to use, and contracted or condensed them according to the requirements of his conception. The transposition from manuscript illustration into mural painting was effectuated earlier and elsewhere, and the frescoes of the synagogue may have reproduced an already existing adaptation.

If a model manuscript indeed existed, it was not the Bible. The copying of the Bible was subject to meticulous regulations, excluding all ornamentation. The manuscripts of the Dead Sea which do not have the slightest decoration are clear evidence of this attitude. On the other hand it is known that in the period between the conquests of Alexander and the Hasmonean monarchy, when Hellenistic influence reached its highest point in the Jewish world, certain authors wished to propagate the Bible in fashionable literary forms. The Biblical stories were transposed into rhymed prose or into hexameters for the Greek or Hellenized public. Fragments of these works, now lost, survive in a quotation given by Eusebius.[106] There is no evidence to counteract the supposition that the copyists, moved by an ambition to make these texts as attractive as those of the pagans, illustrated them in imitation of Greek manuscripts. The transposition from manuscript illustration into mural painting was effected earlier and elsewhere, and the frescoes of the synagogue may have reproduced an already existing adaptation.

The art revealed by the excavations at Dura Europos can hardly be conceived as having been an isolated phenomenon. Even though the paintings of the synagogue, conserved by a miraculous chance, are a unique evidence, they invite one to assume the existence on a wider scale of a Jewish narrative art in Antiquity. This assumption should not seem more improbable today than the existence of a painted synagogue hall was before 1932. Before appearing on frescoes, narrative art based on the Bible may have accompanied manuscript texts, and it was in that form that it was to attain its full flowering in the Middle Ages. But long before that, this narrative trend

transcended the boundaries of the Jewish world and Biblical iconography became the principal source of Christian art until the Renaissance. By establishing the basis of this iconography in Dura or its models, Judaism made one of its most fruitful contributions to European culture.

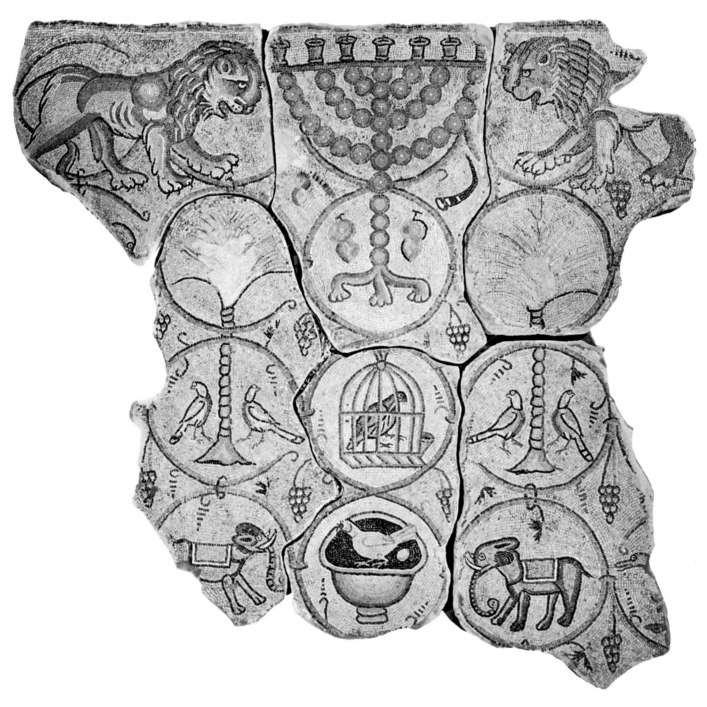

Mosaic pavement of the synagogue. Maon, c. 530. Jerusalem. Israel Museum.

THE IMAGE OF THE WORLD

After the failure of the Bar Kochba revolt (135 C.E.), the Jewish community of the Holy Land underwent a period of persecution and profound upheavals. With the accession of the Severan dynasty in 193, there began a phase of conciliation. Cultural life was full of vitality, adapting itself to new conditions, and the center moved to the Galilee which was the seat of all religious institutions. The transformation in the structure of daily life led to new phenomena in all cultural spheres. In the arts the most significant development was the rapid evolution of synagogue architecture. The dominating concept was revolutionary in that for the first time a sanctuary was conceived of that allowed the participation of the entire congregation in worship. This type of structure was also adopted by the Christian churches and became the basis of all religious edifices in the west. Several elements borrowed from local architecture were incorporated into the construction, but the originality of the Jewish contribution safeguarded the national and religious particularity of the buildings. In the decoration, first of the walls and afterwards of the pavements, Jewish and Hellenistic motifs were used side by side. During the earlier period, a symbolic language still predominated, but its vocabulary was progressively enriched and the representation of animate beings was freely admitted. When this architecture attained its full development between the fourth and fifth centuries, narrative and later allegorical art were associated with the symbols in works of high quality. The decline of synagogue architecture began with the rise of Islam, and it came to an end with the expansion of the Moslem empire, bringing to a close the intellectual hegemony of the eastern communities in the Jewish world.

The origin of the Bet Knesset—"house of assembly"—as an institution is still a subject for conjecture. Attempts to trace its origins back to the epoch of the first Temple, recorded chiefly in the Midrashic literature, have no historical foundation. But it is recognized that "houses of assembly" serving communal purposes, whether a school, a tribunal or hostel, but without any specifically religious function, existed from a very early period. The use of these communal houses for assemblies of a religious nature may go back to the Babylonian exile. In fact, it is in the book of the exiled prophet Ezekiel (11,16f) that one finds the expression "little sanctuary" which the Talmud afterwards applies to the synagogue (*Megillah* 29a). The assumption is that, deprived of the great sanctuary of Jerusalem, the exiles experienced the need to institute communal prayers and public readings of the Scriptures on the Sabbath and festivals, and it is probable that on their return, the communities preserved these services. The Talmud affirms that some of the prayers that are still recited to this day originated at the time of Ezra (*Berakot* 33a).

The need for an edifice for worship was also felt in the colonies established outside the Holy Land. The Elephantine letters, written in Aramaic by a Judaean military colony in Egypt in the service of the Saite Pharaohs, then of the Persians, attest to the existence of a sanctuary, even a sumptuous one, from the end of the seventh or the beginning of the sixth century B.C.E. In Egypt again, at Schedia near Alexandria, the celebrated house of assembly, as stated by Philo[107] and the Talmud,[108] also served for religious services and was erected in the third century. According to numerous testimonies the institution was widely diffused in the Jewish centers of Europe and North Africa in the first century.[109]

During the period of the Second Temple houses of assembly were already numerous in Jerusalem itself, even on the Temple Mount. It is not definitely established that they were all intended to serve religious purposes. At all events, according to the Mishna (*Sota* VII, 7) and the Talmud (*Sukkot* 53a), the priests whose attendance was not required at the Temple during certain festivals, gathered in the synagogues to pray.

In addition to the literary evidence, archeological discoveries confirm that synagogues existed before the destruction of the Temple. The earliest known was found at Ophel, or the "city of David," in Jerusalem.[110] Nothing remains of the building, but the Greek inscription that commemorates the foundation of the synagogue by "Theodotos, son of Ouettenos, priest and synagogue chief, son of a synagogue chief." The epigraphy of this text is similar to that of Herodian monuments. The Greek and Latin nomenclature of the inscriptions suggests that the founders of the synagogue were Jews from the western provinces of the Empire. The synagogue itself was intended to serve pilgrims from the West, since according to the inscription, the edifice included a hostel offering shelter to travelers.

Two other structures, contained in the fortresses built by Herod at Massada[111] and at Herodion, were probably transformed into prayer halls during the Zealot occupations, that is, before 70 C.E. Their plan, with a double colonnade and benches lining the walls on three sides, already foreshadows that of the first Galilean synagogues.

The era of grand structures was not really inaugurated before the end of the second century. During the four centuries that followed, more than sixty such edifices were erected in Galilee alone. The plan, the design of the facade, the methods and the style of the decoration changed from period to period, but the principles of architectural conception were established from the beginning.

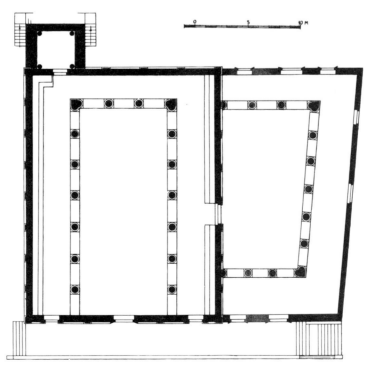

Capharnaum. Plan of the synagogue. Third century.

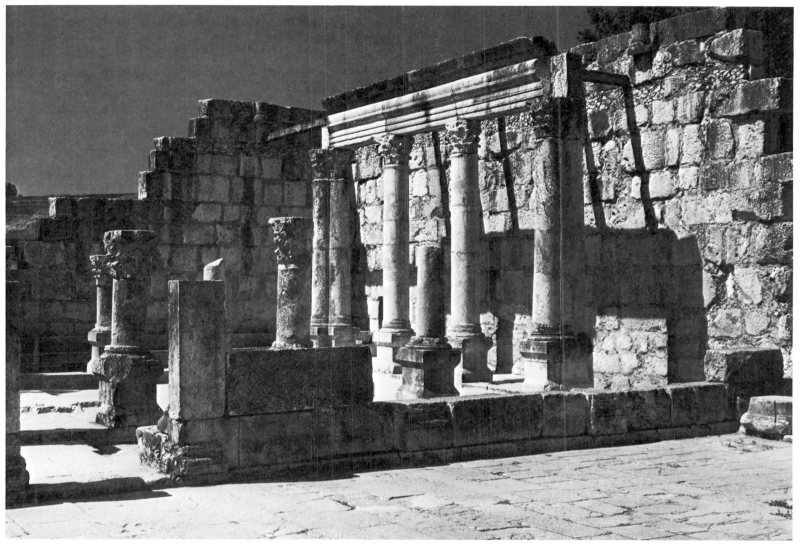

Capharnaum. View of the prayer hall.

The first and most fundamental of these principles was based on a symbolic conception. Jerusalem, as a terrestrial projection of the axis of the universe, symbolized the ideal center of religious life, even after the destruction of the Temple. The new synagogues that were built were not expected to replace the Temple, unique for all time, but to perpetuate its memory in the expectation of its reestablishment in the messianic age. The symbolic idea was expressed in formal terms by the orientation of the edifices, the location of each synagogue being defined in relation to the Temple.[112] Even though the principle was implemented in various ways and was given diametrically opposed interpretations from one period to another, the dominant conception never changed. The Talmud stipulates that the synagogue should be built on the highest point of the town,[113] and this recommendation was quite generally followed in the Holy Land. It seems that it was not implemented in the Diaspora where the political situation usually called for prudence and imposed discretion rather than emphasis on Jewish religious edifices.

Reconstruction of the internal disposition of the buildings are often conjectural. It is supposed, for instance, that men and women were separated in the hall of assembly. This hypothesis is generally admitted by archeologists, but no absolute proof exists. The section reserved for women is supposed to have consisted of a gallery surrounding the hall on two or three sides, a hypothesis that finds some support in a Talmudical allusion to the Herodian Temple.[114]

The number of rooms of the synagogue was determined by the various secondary functions that were not devoted entirely to religious services. The building served as an educational center, as a seat for the religious

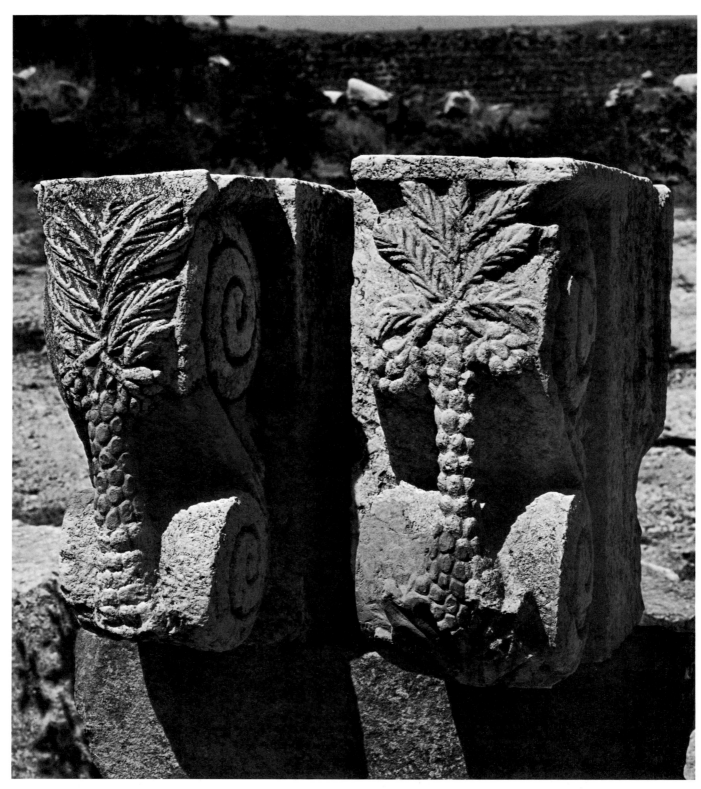

Capharnaum. Capitals with palm leaves.

tribunal, and as lodging for travelers. These multiple uses involved the addition of several annexes, and porticoed courtyards for the reception of guests.

The development of the plan of these buildings and the style of their ornamentation passed through three major phases that coincide to some extent with the chronology of the structures. The synagogues of the first period and those of the last constitute groups that were homogeneous in both construction and decoration. Those of the intermediary stage, a period of transition and experiment, are characterized by the great number of variations.

The synagogues of the first period are distinguished from the later buildings by their orientation — the facade and the entry doors are turned towards Jerusalem. The first consequence of this arrangement was to make the faithful perform a half-turn as soon as they entered the synagogue to face the holy city during the prayer.[115] Another result was the difficulty of fixing a permanent site for the ark, since the space that in theory should have been reserved for it coincided with the entrance. It is thought that in these early synagogues the ark was placed in the hall on a temporary support for the duration of the service only.

This particular interpretation of the principle of orientation was repeated in contemporary churches. Eusebius notes in his chronicles[116] that, in the churches of the region the entrance faced east and the apse west[117]. The first building constructed in this manner was the Cathedral of Tyre, built during the reign of Constantine The inconveniences of this orientation, especially in Christian worship, where the altar had to be placed in the apse, soon led to its abandonment. The orientation was also modified in synagogues during the transitional period.

Capharnaum. Lintel with medallions of acanthus leaves and geometrical figures.

The best known and most imposing of the structures of the first type, the synagogue of Capernaum, may serve as an example of the plan.[118] The ensemble of the buildings, occupying a surface of 360 square meters, is composed of three main parts—the hall of prayer, a narrow vestibule in front of the facade, and a porticoed court adjacent to the east side. The prayer hall, oriented north-south with the entrance to the south facing Jerusalem, presents the typical plan of the first synagogues. Three colonnades divide it into a central nave surrounded by three aisles. The columns demarcating the two long and the one transversal aisle meet at the corners in twin columns. According to Kohl and Watzinger's reconstruction, the colonnades supported the galleries, which were reserved for women. A chamber with a staircase leading up to the galleries was attached to the north-west corner of the hall. An opening in the east wall gave access to a trapezoidal court that was surrounded by porticoes, except on the side of the prayer hall.

The plans of other edifices belonging to the same group show only minor variations that can often be imputed to the demands of the site or simply to greater or lesser financial means of the community. The prayer hall of Chorazin[119] is of more modest dimensions. Its plan is distinguished from that of Capernaum by the substitution of a terrace for the entrance vestibule. Of the synagogue of Meron,[120] a small village near Safed in northern Galilee,[121] only the foundations exist and point to a plan with a considerably elongated shape. The synagogue of Beth Shearim is also based on a plan of this type.[122] European synagogues, which still belong to this type of structural design, display wider variations of the plan. The prayer halls of Ostia[123] and Aegina in Asia Minor[124] do not have columns. Those of Milet[125] have no transverse colonnade. The plans of Ostia and Aegina underwent transformations at a later date that brought them into conformity with structures of the second phase.

The most sumptuous synagogue of the Diaspora, Sardis, discovered only a few years ago, still belongs to this group.[126] The structure is wedged into a great complex of public buildings, all non-Jewish. The hall of prayer

Capharnaum. Capital with candelabrum.

96

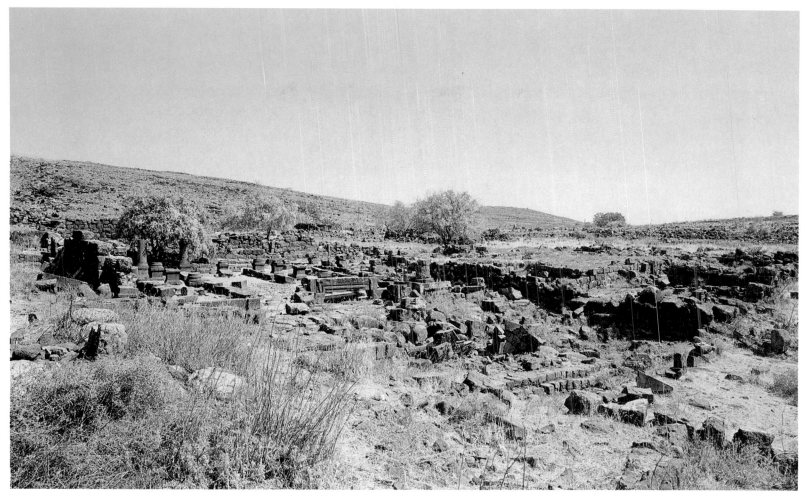

Chorazin. Traces of third century synagogue.

lies on the east-west axis, with the entrance facing towards Jerusalem and the apse at the western end. The walls of the apse were marble and the floor had a mosaic pavement with floral motifs. Some fragments found in front of the apse allow the reconstitution of a marble table supported by eagles and flanked by lions. Near the entrance were two stone structures, one perhaps intended as support for the ark, the other for the candelabrum. These structures are in the eastern part of the hall on the same side as the entrance. This was also the direction towards which the faithful turned during the service. Thus, the apse does not yet coincide with the pole of orientation, as it does in buildings of the final period. It is thought that in these first synagogues the apse contained reserved seats for the elders of the community.

All the theories relating to the facades of these buildings are conjectural. In spite of their minuteness, the reconstructions proposed by Kohl and Watzinger for Capernaum, for instance, rest only on suppositions. Certainly, the surviving vestiges do not contradict these reconstitutions as far as the principal dispositions are concerned, and in fact, they have not been disproved by archeology, but they should still be considered as hypotheses.

According to the reconstitution proposed for Capernaum,[127] three monumental entrances gave access to the hall of prayer. The central entrance was wider than the others and was surmounted by an arcade and screened. Three windows, placed above the lateral doors, the arcade and screen, admitted light into the hall, an arrangement with many similarities to the Nabatean structures during the early centuries of our era.[128] The reconstitution of the facade of the synagogue in Kfar Bir'am is also conjectural.[129] The first photographs, taken at the beginning of the excavation, show only the central entrance, surmounted by a lintel. According to the present reconstitution, the facade had two stories. Its three entrances were preceded by a portico of columns.

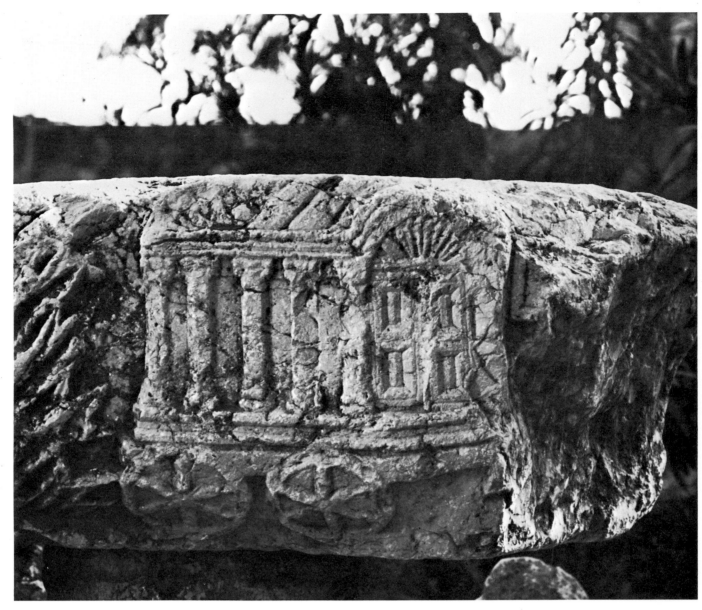

Capharnaum. Lintel decorated with the Ark of the Covenant.

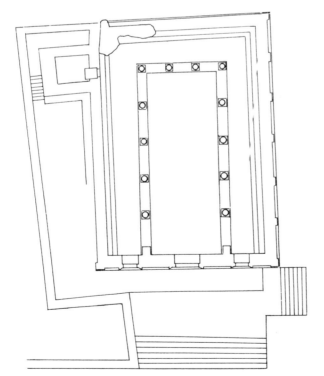

Chorazin. Plan of the synagogue.

Meron. Plan of the synagogue.

The interior disposition of these synagogues seems to have been extremely simple. This austerity was deliberately assumed, it is thought,[130] to avoid distracting the faithful during the service. The furniture consisted only of benches along the walls on three sides, and a seat of honor for the oldest member of the community.[131] This was no doubt the "Moses seat" mentioned in the Gospels (*Matthew* XXIII, 2) and rabbinical writings.[132] A rare example of this seat has been preserved in the Chorazin synagogue.

The columns had Attic bases and the capitals were most frequently Corinthian in a variation rather different from the classical models. The deep relief and sharp edges of the acanthus leaves, emphasizing the contrast between the light and shadowy areas, recall the ornamental technique of the ossuaries. On the rare Ionian capitals that have been found, flat concentric circles replace the classical volutes. The little columns with fluted shafts that flanked the windows had capitals decorated with leaves and garlands in the Syrian style.

Ornamentation was reserved for the facades, door lintels and window pediments. Some fragments of frieze, which were part of the balustrade of the galleries, are the only exceptions to this rule that applies to all the edifices of the first group.

The repertoire of motifs displays an increasing tolerance of figurative representation. The religious symbols, the usage of which became common, occur in compositions together with animal figures, or even openly with pagan mythological themes. This accessibility to figurative art is all the more significant since the monuments which benefited from it were religious edifices erected in the very center of the orthodox faith. It is scarcely conceivable that they could have been executed without the consent of the religious authorities or in opposition to them. The phenomenon seems to be analogous to that already observed in the Roman catacombs. Themes taken over from Greco-Roman mythology were adopted in the form of genre ornaments without regard for their specific religious sense. This tolerance ignited a violent reaction of which little is known in detail. At a period conjecturally placed at about the fifth century, figurations of animate beings underwent a more or less systematic obliteration. Only the reliefs of Chorazin seem to have escaped the general devastation, the synagogue being already unaffected at the time.[133] Elsewhere, the work of purification disfigured the sculptures to the point of rendering reconstitution often difficult, if not impossible.

At this period of synagogue-building the religious symbols, especially the candelabrum and the ark, came to be accepted as the official signs of Judaism. They appeared on door lintels, window pediments and on capitals, in exactly the positions occupied by the busts of deities in Syrian architecture. This way of "signing" edifices was to be adopted in Constantinian churches, perhaps through the intermediary example of the synagogues; their lintels and capitals carry in the same place the cross or the monogram of Christ.[134]

The symbols still often appear isolated. The candelabrum figures on a Capernaum capital as a central motif among the acanthus leaves. It is accompanied by ritual objects, notably on a frieze fragment of the same provenance or by a conch, as on a Chorazin fragment. The ark appears on a Capernaum relief that has become particularly famous. The fragment represents a miniature temple with closed doors, an arcade and conch above; the structure is placed on a wheeled pedestal. The architectural element recalls representations of the Temple facade, or in an even more exact paralell, the ark and its base as they appear on the panel illustrating the capture of the ark by the Philistines at Dura-Europos.

Apart from explicitly religious symbols, the iconographical repertoire always includes abstract or plant motifs, typical of Jewish art. Examples include the rosette and the triple bunch of grapes, alternating with the tendrils

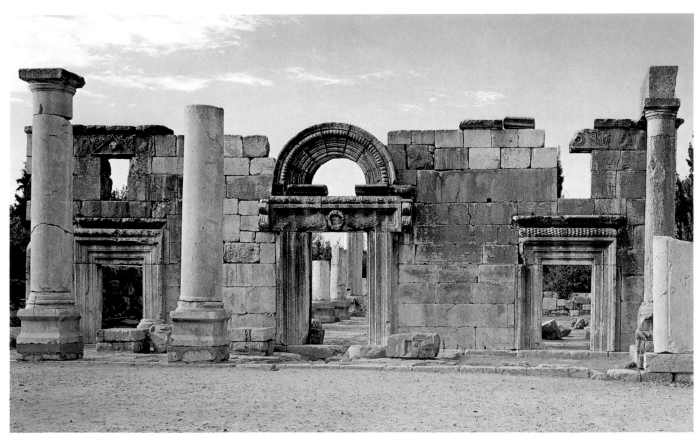

Kfar Baram. Reconstruction of the synagogue facade. Third century.

of a garland of acanthus leaves in a Capernaum-type frieze. Geometrical motifs subject to magical interpretation, such as the pentagram or hexagram,[135] replace the plant motifs on other fragments from the same synagogue.

Animal representations show the surviving influence of ancient Near Eastern traditions. The most common theme is the lion, as it appears in the habitual repertoire of this art: two lions confronting one another, one on each side of an amphora, or lions and griffins in various compositions; in one of the few preserved sculptures from Chorazin the lion probably symbolized the guardian of the sanctuary. The silhouette of an eagle with outspread wings is discernible on a doorpost fragment from Capernaum. Its features were carefully effaced, most probably because of its affinity with the identical emblem on the temples of Bel[136] or because of its importance in Hellenistic symbolism.

Themes from Greco-Roman mythology, already seen in the ornamentation of Capernaum, are present in even greater number in Chorazin. A Capernaum doorsign from the principal entrance is decorated with winged *putti* holding a garland. At Chorazin a head of Medusa and centaurs fighting lions are surrounded by acanthus leaves. Another fragment is decorated with Dionysian scenes; men and women carrying clusters or pressing grapes follow each other in a series of medallions outlined by vine leaves.

The dating of the synagogues of the first phase from a stylistic point of view has been established by analogy with the structures and decoration of contemporary local architecture. The suggested dates stretch from the end of the second to the end of the third century. Archeological evidence, especially from the coins found on the sites, has corroborated this hypothesis. Literary sources also support it. Eusebius, for instance, notes in his chronicles that the Chorazin synagogue was already abandoned at the end of the third century or the beginning of the

fourth.[137] This dating was seriously questioned by the unexpected results of a recent excavation campaign.[138] During several probings at Capernaum, coins from the reigns of Constantine II (337-340) and Theodosius I (379-395), as well as shards from the fifth century, were found sixty or even ninety centimeters below the pavement. Their presence at such a deep level seems difficult to reconcile with the date currently accepted for this monument that has been regarded as the most important for dating early synagogues by analogy with local architecture. However, the arguments in favor of an early date still prevail. The most decisive criterion is the orientation of the facade of Capernaum in the direction of Jerusalem, the typical disposition of constructions of the first period. This orientation was modified in all edifices without exception during the period of transition that in Galilee began in the first half of the fourth century. In some synagogues of the first group the orientation was corrected by later additions or transformations. At Capernaum an adytum placed before the entrance doors transformed the facade into a wall of orientation, the actual entrance being resituated in a side wall. These modifications, justified in the edifices of the first period, were not required in later synagogues, where the orientation followed the new dispositions from the beginning. The problem still remains of reconciling apparently convincing stylistic arguments with undeniable archeological proof. In defense of the early dating of the synagogue, it has been suggested that the coins may have penetrated into the earth during repairs of the pavement.[139]

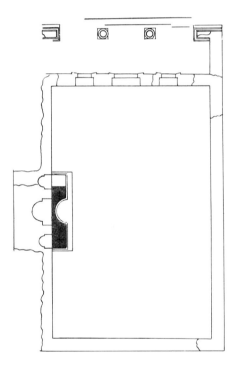

Eshtemo'a synagogue. Plan. IV–V cent.

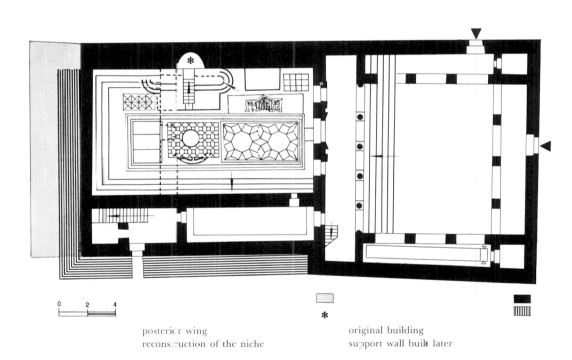

0 2 4

posterior wing
reconstruction of the niche

*

original building
support wall built later

Susiya synagogue. Plan. IV–V cent.

The synagogues of the second phase display differing plans and interior dispositions, but have the common denominator of a new orientation as well as a permanent site for the ark. It is quite probable that the need to establish and reserve a specific location for the ark led to the adjustment of the plan. Since a permanent location for the ark had to be placed somewhere along the wall facing Jerusalem, this wall could no longer be made to coincide with the entrance.

Among the various solutions attempted, the earliest in date is a prayer hall without columns, designed to be used across the width of the room. This type of arrangement first appeared in the Diaspora. Especially at Dura-Europos, one of the long walls oriented towards Jerusalem has a niche flanked by columns in the center. The entrance was on the opposite wall. In Judaea, the broad plan of the prayer hall is somewhat different in conception. At Eshtemoa[140] and Susiya,[141] two edifices southwest of Hebron, a few kilometers from each other, the niche for the ark is also along a long wall, but the entrance is placed on a short side wall facing east. The design of the niche was different at both locations. At Eshtemoa a triple niche was built into the north wall, which has survived at a height of two meters. The widest niche is in the center, most probably intended for the ark;

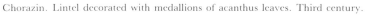

Chorazin. Lintel decorated with medallions of acanthus leaves. Third century.

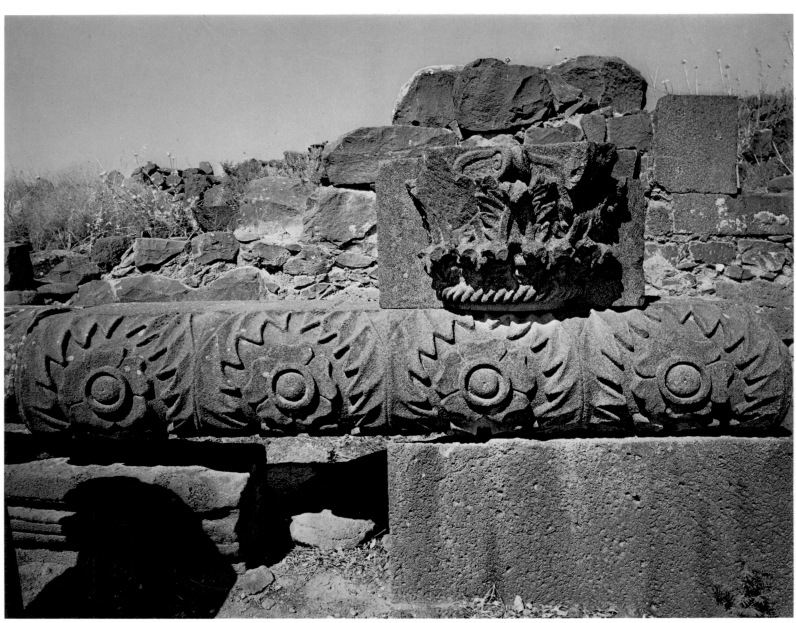

Chorazin. Fragment of a lintel decorated with Medusa's head. Third cent.

the two narrower ones on either side may have contained some candelabra, as they are seen in mosaics. This triple niche was later replaced by an independent structure of one niche placed in front. At Susiya, the niche was approached by a platform that was moved slightly eastward during a rebuilding.

The plan of the synagogue of Yafya[142] shows another variation. Two rows of columns divide the hall into three naves, with the transverse aisle suppressed. No emplacement was provided for the ark. In contrast to all the other synagogues, Yafya is oriented towards the sea.[143] A variant resembling the plan of Yafya is the synagogue of Hammath[144] near Tiberias, incorporated into the main town during the second century. Four levels of structures have been uncovered. The synagogue, famous for its pavement, belongs to the second level. The hall of prayer, without niche or apse, is divided into four naves by three rows of columns. The second level, to the west, is wider than the others and was the most important. It was prolonged on the side of the wall oriented towards Jerusalem, and an annex was opened in this extension, probably to house the ark. Traces of paintings found on the walls indicate that the annex at least was decorated with frescoes.

While new synagogues were being built, older edifices underwent transformations to permit fixed installation of the ark. At the synagogue of Beth Shearim,[145] the entrance was blocked up by a stone arch, as at Capernaum, an access to the hall was moved to the lateral east wall. Similar modifications appear in the plan of the synagogue discovered at En Gedi.[146] The entrance, originally in the wall facing Jerusalem, was closed up by

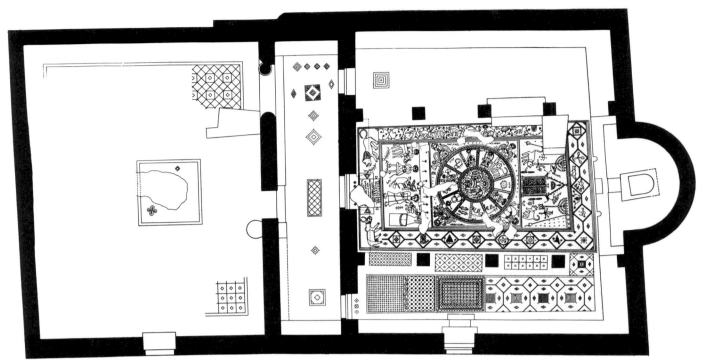

Beth Alpha. Plan of the synagogue. 517–518 C.E.

a structure containing the Torah niche, preceded by a platform. At Ostia, an apse, slightly displaced in relation to the axis of the building, was constructed near the columns separating the hall of prayer from the vestibule. The plan of the synagogue of Aegina, with its semi-circular apse to the east, already foreshadows certain structural characteristics of the following period, that, during the fifth century, led to the definitive solution. Influenced by contemporary church buildings, the designers of synagogues adopted the plan of a basilica with three naves, the apse oriented towards Jerusalem and the entrance in the opposite wall.

Again in the Diaspora, at Stobi,[147] the new plan was put into effect for the first time. The oldest edifice of this type is the synagogue of Djerash [148] which was converted into a church in 530, about one hundred years after it was built. The apse of the former synagogue, facing west — the correct orientation in this region — coincides with the vestibule of the church whose apse is to the east. The best known synagogue of the group is Beth Alpha, discovered, with its astonishing pavement, in 1929.[149] Two other edifices of the same type have been found in the south of the country at Maon,[150] accidentally discovered in 1959 during road building operations, and at Gaza, where only some pavement fragments have been preserved. The contemporary synagogue of El Hammeh[151] displays a composite plan. The hall is surrounded by three aisles, as in plans of the first type, in which the center opens onto an oval apse, as in the last phase. A recent discovery at Beth Shean has revealed an edifice situated outside the walls of the Roman town.[152] Its plan diverges from the model of all the other synagogues thus far discussed. In fact, contrary to what was suggested at the start of the excavations, these vestiges are not those of a synagogue properly speaking, but are the remnant of a square-shaped small private prayer hall with two entrances — at the eastern and western sides. The last in date of the old synagogues of the Holy Land is in Jericho.[153] According to the Arab coins found on the site, its construction could not have been prior

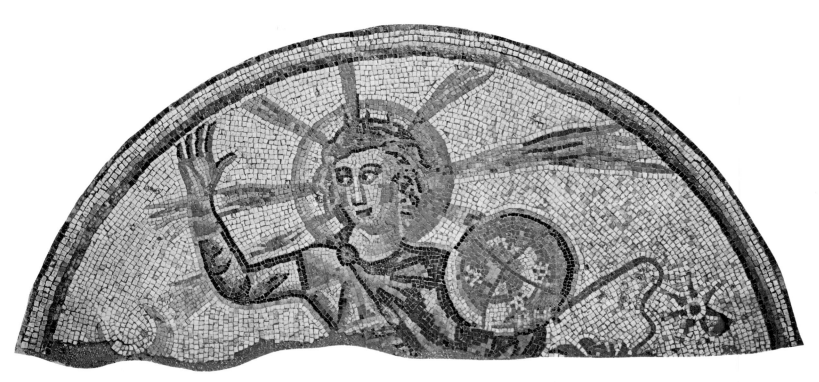

Helios with quadriga. Hammath near Tiberias. Mosaic pavement. IV century.

Summer. Detail of the Seasons. Hammath near Tiberias. Mosaic pavement. IV century.

Details of the Zodiac. Capricorn. Aquarius. Hammath near Tiberias. IV century.

Details of the Zodiac. Virgo. Libra. Hammath near Tiberias. IV century.

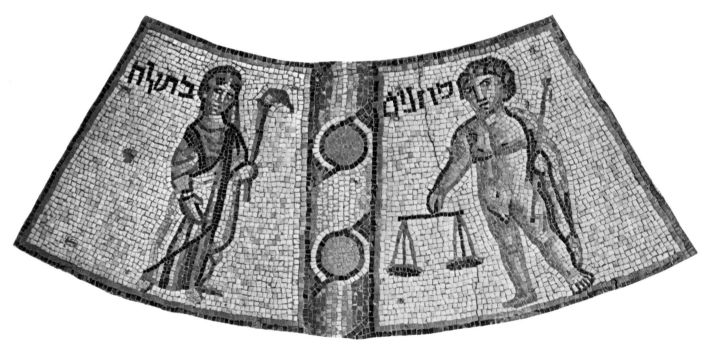

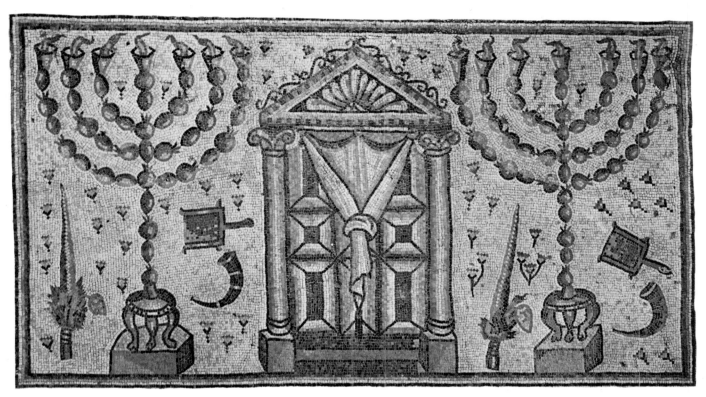

The Ark of the Covenant and sanctuary implements. Hammath near Tiberias IV century.

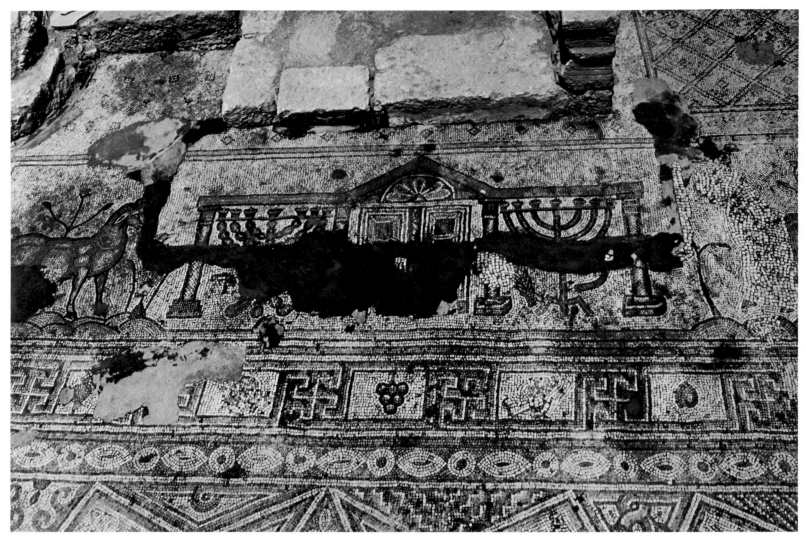

The Ark of the Covenant flanked by candelabra. Susiya. Mosaic pavement. IV–V century.

to the seventh century. Its hall with only one nave and its restricted dimensions are indications of modest ambitions. The era of sumptuous edifices came to an end.

A radical change took place in the decoration of synagogues at the outset of the transitional period. Reliefs and sculptures in the round disappeared from the facades and the ornamentation moved to the interior. The reasons for this reversal are difficult to determine. It is possible that a doctrinal decision was one of the causes. In any event, if there were new restrictions, they were aimed specifically at three-dimensional representations. In the two-dimensional art of the interior, animal and even human figurative themes were widely tolerated.

The most important part of the decoration was the pavement mosaic. The art of mosaic in the synagogues reflects a moment of equilibrium and flowering that has never been surpassed in Jewish art. Some of the iconographic vocabulary was derived from the symbolic art of the second Temple. However, the symbols no longer appear as isolated elements, but are integrated into a complex iconographical program, the visual expression of a symbolic idea. The style reflects the changing influences of the artistic context; the content of the compositions is remarkably consistent.

Using a schematic division, four phases, independent of the type of constructions, can be distinguished in the chronological evolution of these compositions. The various stages of decoration seem to have depended more on ideological factors.[154] During the initial period the repertoire of motifs remained entirely abstract. Geometric figures or stylized floral motifs, rhythmically repeated, transformed the pavement into an ornamental carpet. The most beautiful mosaic of this type to have survived in its entirety is at Aegina in Asia Minor. Fragments exist at Caesarea and in the vestibules and aisles of several other synagogues. This genre of ornamental mosaic continued to decorate the annexes even after the appearance of historiated mosaics, reserved exclusively for the central nave.

The first type of historiated composition appeared towards the middle of the fourth century. With some iconographical variations and considerable differences of style, this composition survived for close to two centuries. Two famous mosaics, the only examples to have been preserved almost intact, mark the chronological limits of the genre: Hammath, near Tiberias, deduced to have been built in the first half of the fourth century, and Beth Alpha which bears an inscription dated 517/518.[155]

The Ark of the Covenant flanked by candelabra. Beth Shean. Mosaic pavement. VI century. Jerusalem, Israel Museum.

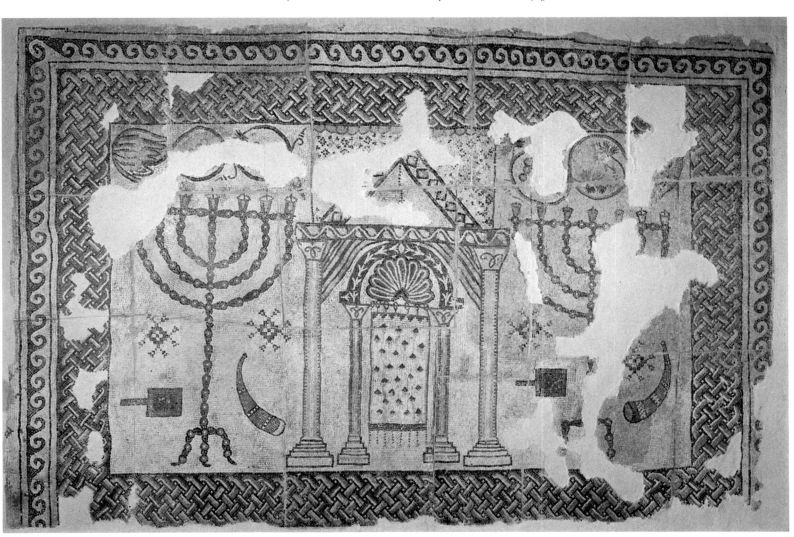

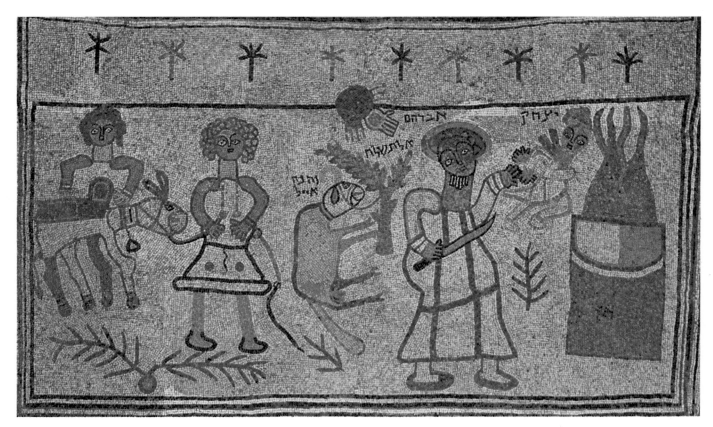

The sacrifice of Isaac. Beth Alpha. Mosaic pavement. 517–518.

The graphic plan of all of these compositions is uniform. The pavement of the nave is divided into three panels — two transversal rectangles near the entrance and in front of the niche or apse and a square central panel with two inner concentric circles. Four corner pieces anchor the larger circle in the square.

This geometric plan formed the framework of a three-part composition that represented the universe with its hierarchically superimposed levels. The panels near the entry correspond to the physical world and represent, either the guardian lions of the sanctuary, as at Hammath, or a Biblical episode evoking the intervention of God on behalf of his chosen people – Daniel in the lions' den at Na'aran and the sacrifice of Isaac at Beth Alpha.

The central square contains the image of the astral world. In the interior circle is the solar body, center of the universe, in the form of Helios on his quadriga. He is surrounded by the twelve signs of the Zodiac lodged in the twelve compartments of the exterior circular band. In the four corner pieces are four feminine figures personifying the seasons whose succession reflects the passage of time in the physical world. At Hammath each figure is accompanied by an attribute that characterizes the season. Autumn holds a bunch of grapes, winter a wine amphora, spring the first fruits, summer a sheaf and sickle. The captions give the name of the month that introduces each season.

Going beyond the image of the cosmos which is subject to the movement of the stars and the rhythm of time, the upper panel has the sphere of the heavenly realm as its theme. This is evoked by its outward sign and embodiment in our world, the sacred symbols of the Temple. In the frescoes of Dura-Europos, the religious symbols were already associated with the niche to signify its function. The upper panels fulfill the same role in the mosaics. They are always placed before the niche, and when this is not in line with the axis of the floor, the loca-

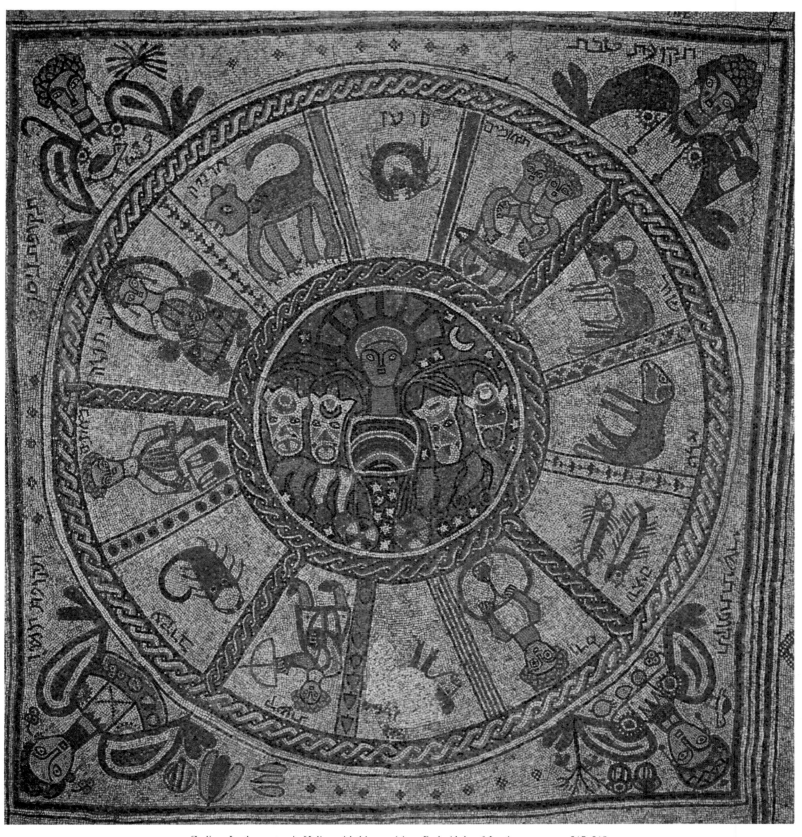

Zodiac. In the center is Helios with his quadriga. Beth Alpha. Mosaic pavement. 517–518.

tion of the panel changes. This happens at Susiya, where a panel with the sacred symbols is placed laterally in order to remain in front of the niche which is to the north of the entrance. The "orientation" of mosaics bearing religious symbols was adopted in the Christian churches of the East,[156] following the synagogue usage.

If the compositions preserve the same structure, their style shows important variations. In the initial phase, especially at Hammath, the Hellenistic influence was dominant. It is reflected in the iconographic types as much as in the treatment of the different elements. The ark is based on the model of a Greek temple—the volumes are clearly expressed, the bases and capitals drawn with precision. Helios appears with all the attributes of *sol invictus*, as he is on Roman coins.[157] Wearing the *pallium*, his head crowned by a diadem and surrounded by a halo of seven rays, he carries the globe in his left hand and salutes with his right.

The astrological symbols are the replica of Greco-Roman prototypes. Virgo, a veiled woman, carrying a torch, reverts to the iconography of Koré-Persephone; Aquarius is depicted as a nude athlete; Libra, also a handsome nude youth, holds a scepter, like Minos or Radamanthos.[158] The nudes are freely treated, the bodies harmonious and realistic. The animal figures are supple and correctly proportioned.

In the Beth Shean mosaic the Hellenistic influence diminishes. The architectural form of the ark still conforms to the Greco-Roman type, but the attempt at a faithful rendering of the three-dimensional aspect of its elements is replaced by an interplay of lines that merges form and volume into ornament. The pediment is no more than a triangle of interlaced designs; the conch is an open flower and the capitals are indicated by twisted fringes. The column shafts are flat surfaces and the bases are replaced by a system of straight lines. The ornamental tendency finally prevails in the mosaic of Beth Alpha, marking an uncompromising return to the ancient Oriental traditions. The iconographic types are still the same, but the lack of depth and the two-dimensional treatment of the bodies radically transform their character. The human figures are static, in rigid frontal poses, while animal movement appears immobile. In fact, the boundary between animated representation and pure decoration is barely perceptible. The symbols of the Zodiac show a few variants in their attributes which probably originated in Byzantine models. Virgo wears the red shoes of the Empress, Helios the elaborate diadem of the Emperor.[159]

The iconographic variations are much less evident than the stylistic. The panels of symbols are constructed according to the same scheme in all the examples. The architectural element—the facade with the ark or the latter alone—occupies the center; two candelabra, surrounded by ritual objects, accompany it, one on either side. The form of the objects and the number of accessories are slightly modified from one synagogue to another. At Susiya the door of the ark is unveiled; at Hammath it is covered by a curtain fastened in the middle. A carpet decorated with flowers replaces the door in front of the ark at Beth Shean; a curtain drawn back on both sides is a substitute for the door of the Temple in the same synagogue, similarly, in the Beth Alpha panel. The proportions of the candelabra vary more than their form. With the exception of Susiya where summarily drawn curved lines indicate the branches, they are always constructed according to the Biblical injunction of flowers and chalices, and seven burners whose flames converge at Hammath and rise vertically at Beth Shean and Beth Alpha.

The number of ritual objects depicted with the candelabra seems to have been left to the discretion of the mosaic artist. At Hammath and Beth Alpha the series is complete, including the *shofar*, the incense shovel, the *lulav* and the *etrog*; at Beth Shean the shovel and *shofar* appear alone without the plants. The traditional repertoire was occasionally enriched. At Susiya the unusual figure of a ram appears on the extreme left of the composition. It probably had a counterpart on the right. The richest and most original of the panels is that of Beth Alpha. The artist has filled all the available space on the two sides of the ark with objects and animal figures scattered

Inscription commemorating the name of the builders and donators to the synagogue. Susiya. Mosaic pavement. IV–V cent.

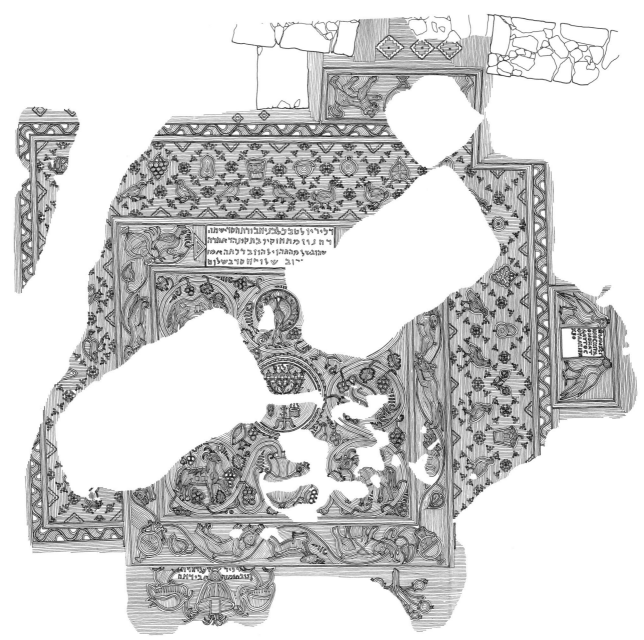

Beth Shean. Plan of the mosaic pavement in a private prayer hall. VI century.

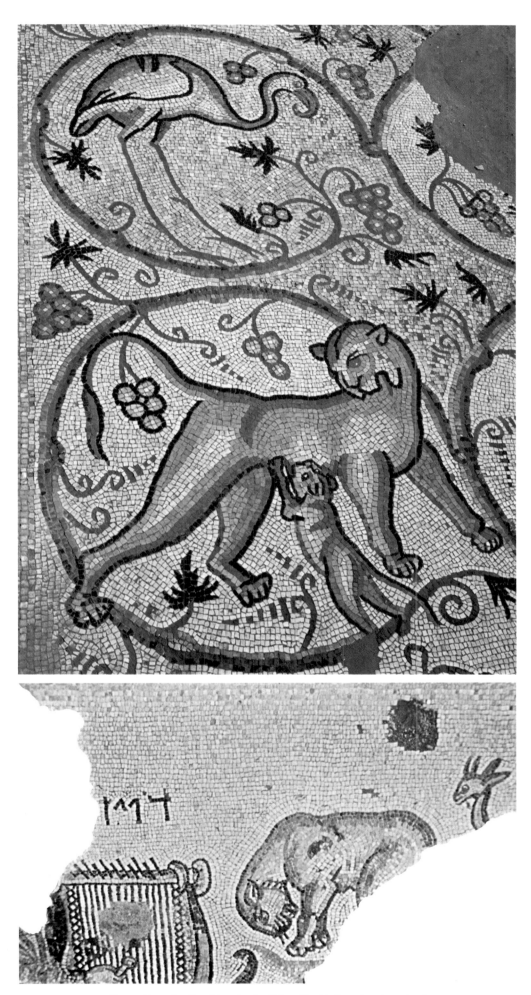

Gaza. *Above:* Scrolls with animals. *Below:* David charming the animals. Mosaic pavements. Israel, Beersheva Museum.

in the manner of carpet ornaments. In the foreground appears the already familiar theme of guardian lions, shown in profile, petrified in a clumsy gesture of open jaws. Surrounding the lions and near the candelabra, the complete series of ritual accessories is set out in purely schematic and analytic form. Behind the lions, shrubs with a bird in their branches may have a symbolical significance. The most remarkable innovation is the presence of two birds leaning against the pediment, one on either side of the ark. Their appearance and flagrant disproportion in size between them and that of the ark recall a magical plaque set with mirrors where two giant birds appear near the ark.[160]

In the two complete examples of the Zodiac that have survived, the iconographic variations are insignificant. On the other hand a fragment of mosaic pavement exists where the same geometric plan carries out a different conception. In the synagogue of Yafya,[161] the twelve compartments of the exterior circle are occupied, not by astrological symbols but by the emblems of the twelve tribes. The pavement has undergone serious damage. The animated figures, both human and animal, were systematically effaced. Only some pieces that accidentally escaped destruction and a partially preserved inscription allow the identification of the Biblical emblem of the tribe of Ephraim and the last consonants of his name. The two iconographic themes are not entirely unconnected. The procession of the signs of the Zodiac refers to the sequence of months, which is linked to the succession of the priestly classes who have been designated to serve at the holy places; in turn, the priestly classes are served by the tribes which appeared in rotation.[162]

The panel of the Biblical episode is preserved intact only at Beth Alpha. Two other fragments demonstrate that such an episode was an integral part of the concept, at least after a certain period. At Djerash a fragment representing a procession of animals and two inscriptions giving the names of Ham and Japhet indicate an illustration from the Noah story. At Na'aran a rampant lion and the caption "Peace to Daniel" are the only surviving elements of a panel which undoubtedly represented Daniel in the lions' den.

At Beth Alpha the mosaicist chose the theme of the Sacrifice of Isaac in two juxtaposed scenes summarizing the beginning and end of the narrative. The servants and the donkey to the left belong to the initial phase of the episode. The right-hand portion of the panel shows Abraham grasping the knife in his right hand and Isaac bound on the altar where the faggots are already burning. Above Abraham, the hand of God emerges from the clouds, indicated by a circle and seven rays. Along the same axis in the foreground appears the tree — substituted for the Biblical bush as at Dura — with the ram hanging vertically from its branches. Incriptions bear the names of Abraham and Isaac and corresponding to their image are the verses: "Lay not thine hand" (*Genesis* XXII, 12) and "behold behind him a ram" (*ibid.*, 13). The narrative method is not essentially different from that of the Dura paintings in which the action is evoked by the principal phases and the intermediary episodes are implied. The iconographic model that inspired the mosaicists must have been more elaborate and closer to the future classic figuration of this scene than the model used by the Dura artists. In effect, the illustration of the sacrifice at Beth Alpha approaches the formula that was current in the Middle Ages in Jewish as well as in Christian art. Did this model originate from a Jewish or Christian source? The question remains unanswered. It may be noted in any case that the people and the movements go from left to right in the direction of Greek script. The style of the scene is archaic. The bodies are transformed into ornament, the inexpressive faces are surrounded by stereotyped coiffures and the movements are analytically rendered, shoulders and torso presented frontally and feet in profile, spread apart to represent walking. The provincial and purely decorative character of this mosaic is more pronounced in the narrative part of the pavement.

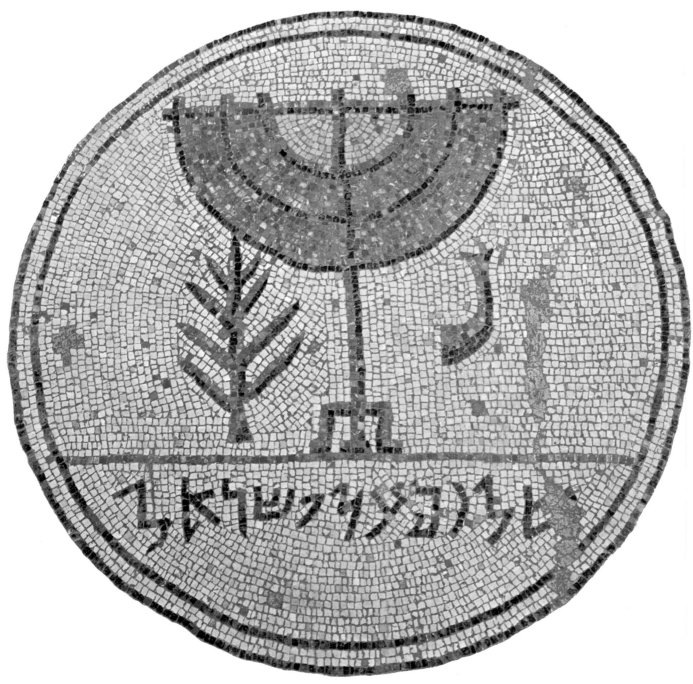

Candelabrum in the center of geometric ornaments. Mosaic pavement. Jericho. VII century.

Towards 520, shortly after the completion of Beth Alpha, this type of composition gave way to a different scheme. Except for one evidence all human representations were excluded. This renaissance of doctrinal scruples is a general phenemenon of the period. It affected churches prior to the synagogues, as a consequence of the edict of Theodosius II.[163]

The most complete example of the new type is the pavement of the synagogue of Maon.[164] The carpet-motif consists of scrolls emerging symetrically from a central amphora. The scrolls are inhabited by various animals - elephants, leopards, hares, birds. On the central axis the scrolls contain allegorical themes: a chicken hatching an egg, a bird in a cage. At the top of the axis, between two guardian lions, a candelabrum reminds of the sacred character of the hall.

A similar mosaic, with more freely designed scrolls was found in the synagogue of Gaza. At Beth Shean, the reduced dimensions of the hall imposed a simplified plan. The scrolls occupy a central square which encloses the candelabrum.

The style of these pavements is dominated by hellenistic influence. Some of the motifs are widely attested in western works of art. The bird in the cage,[165] well known in contemporary Christian mosaics,[166] has its source in the

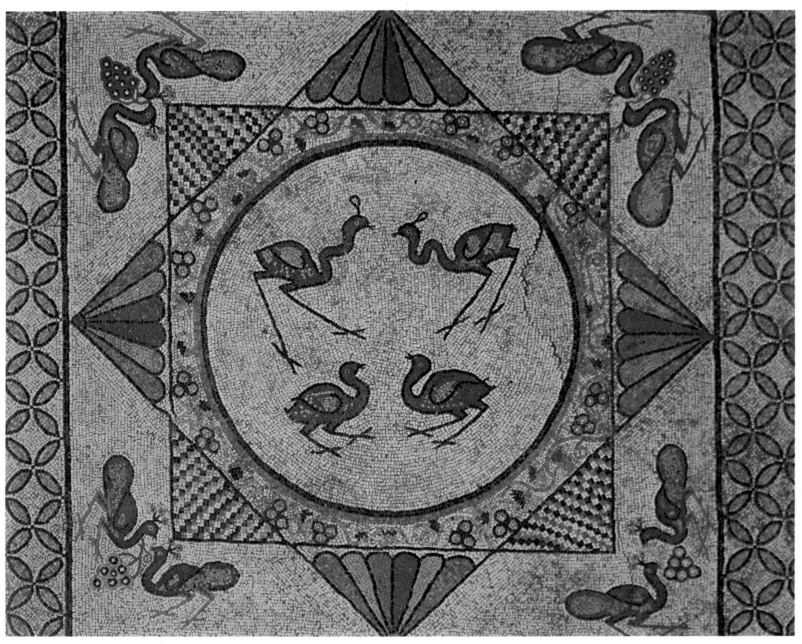

Ein Gedi. Mosaic pavement with birds. IV–V cent.

neo-platonic allegory of the soul as prisoner of the body, a theme mentioned also by the Church Fathers, especially St. Augustine.[167] The Gaza fragments contain the only human figure known in these mosaics. Giraffes, lions, tigers and zebras inhabiting the scrolls, surround a royal figure playing the harp. The caption identifies the figure as David, represented with the attributes of Orpheus. The parallel between Orpheus and David, already established in the Dura frescoes, survived in mediaeval manuscripts.

In the course of the VIth century, doctrinal strictness progressed and the images of all living creatures were eliminated from the repertoire unless being transformed in ornaments. Typical of this stage is the pavement of the synagogue of En-Geddi,[168] where chickens or peacocks are integrated into the geometric ornaments. Finally even these ornament-like animals were excluded and the decoration was reduced to geometric forms only, with a candelabrum as central symbol. A mosaic of this type was found in Jericho, the latest synagogue known in the Holy Land.

The architecture of Late Antique synagogues, with their sculpted ornaments and mosaic pavements, show that when enjoying favourable political and economical conditions, Jewish civilization has produced monuments in which symbolical thought, specific communal needs and techniques shared with ambiant local crafts merged in harmonious creations.

THE WESTERN WORLD

Curtain of Torah ark. Inscription: "This is the Gate of the Lord into which the righteous shall enter."
(Psalms 118, 20). Turkey, XVIII cent. (199 x 148 cm.). Jerusalem, Heichal Shlomo Museum.

STYLES OF THE DIASPORA

The history of the establishment of Jewish communities in Europe begins in the first centuries of the Christian era, but their artistic activity has few traces prior to the Middle Ages. Aside from several excavations, no known monument antedates the eleventh century, and among the extant works of art, those prior to the fifteenth century are relatively rare. The evolution of Jewish art in the Diaspora was entirely dependent on the political and social forces that determined the conditions of Jewish life in Europe. As ethnic minorities living within increasingly centralized societies, the Jews felt the impact of their surrounding cultures. The plastic arts, of course, require the active support of society, and it is altogether apparent that the Jews were no less dependent on this support. However, the Jews did not accept external influences with passivity. The cultivated classes, which were more or less integrated into the larger society, generally contributed to the local culture and accepted its values and stylistic trends. The result is that Jewish art has many diverse styles which must be considered within an historical context since Jewish art at this point in time was clearly very much a part of European culture. Its trends can be differentiated according to the place and the time, but its creations, apart from stylistic variations, reflect the intellectual heritage of the communities that gave rise to them. Several monuments and objects of European art must be regarded as Judaic either because of their functions within the Jewish community, their symbolic value or the iconographic traditions depicted.

It seems that the continuity of the iconographic traditions of Jewish art was never compromised by the disparity of styles, although political factors seriously impeded certain fields of artistic production. Civil architecture, for example, was virtually nonexistent because the Jews always felt insecure. Even the synagogues, which fulfilled the most important needs of the community, were quite modest until modern times. Either because of imposed restrictions or as a measure of prudence, the outside walls of the synagogues were always unornamented. Aesthetic aims were reflected in their interiors alone.[169]

Synagogues were built according to principles handed down from the past. Among the compelling precepts were the orientation towards Jerusalem, the adaptation to the demands of the liturgy, and the secondary functions of the edifice. The positioning of the ark in the center of the eastern wall reinforced the notion of the main prayer hall facing Jerusalem, a tradition firmly established by centuries of tradition.[170] In European synagogues, other meaningful traditions arose, such as the reading of the weekly portion of the Torah on the Sabbath and of the prophets during festivals. A platform (called *bimah* from the Greek $\beta\eta\mu\alpha$) was provided for the officiating reader and was visible from all parts of the hall.

Architects solved the various religious imperatives in different ways, often coming up with solutions that were merely variations of local building plans. The convention of having a separate area for women was not universal. In fact, in the beginning no trace of it exists either in the Spanish synagogues or in those in the Gothic style. In fact, miniatures in Hebrew manuscripts of the thirteenth or fourteenth centuries show men and women sitting together in the synagogue.[171] In both Worms and Prague, the sections reserved for women became later additions. The separation was ensured, at first, by a curtain placed at the rear of the men's section. In Italy and in other northern countries where a baroque architecture dominated, the concept of an upper gallery was adopted.

Like its ancient prototype, the medieval synagogue was a communal and cultural, as well as religious institution. It was a place for lessons, prayers and public meetings. The number of rooms depended on the size of the community and on its financial means. Various conditions affected the architectural conceptions of the synagogues, which in the end, account for the diversity of forms, so that the monuments of each region belong to a very distinct artistic world.

THE MUDYAR STYLE

According to tradition, the establishment of Jewish colonies in the Iberian peninsula—*Sefarad* in Hebrew— preceded the arrival of Christianity. Historical evidence does not contradict this. A single Jewish ossuary, dating from the first century of the Christian era, was discovered in Tarragona. A fourth century trilingual inscription in Hebrew, Greek, and Aramaic, was deciphered in Tortosa. It seems that Jews enjoyed full civic liberties and privileges until limitations were imposed in the fourth century by the Synod of Elvira.

The Ummayad domination inaugurated a Golden Age of Judaism in Spain. The stimulating contact with the conquerors' civilization and the enjoyment of almost universal economic prosperity led to a rich flowering of arts and letters in Jewish centers of culture. Evidence of this comes from literary sources since no visual monument has been preserved. During the first centuries of the Christian reconquest, the situation of the Jews remained quite good. Members of wealthy families were still confidants of the court. Indeed, up until the end of the fourteenth century the hostility of the Church was felt very sporadically.

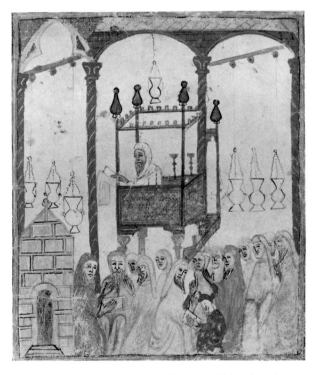

Barcelona Haggadah. Spain, XIV cent. (23.3 x 19 cm.).
London, British Library, Or. ms. 2884, Folio 17 v.

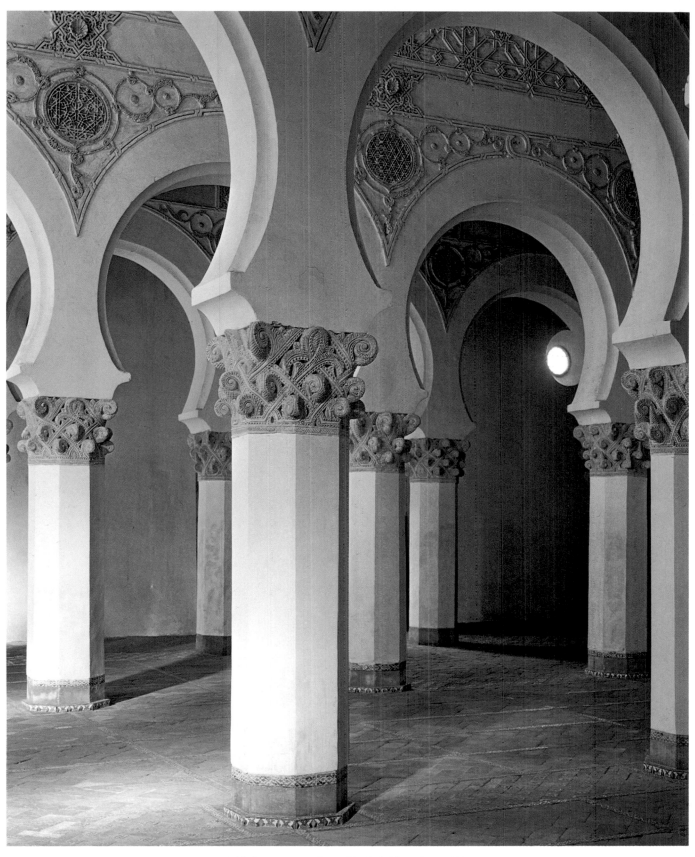

Toledo synagogue (Santa Maria la Blanca), c. 1200.

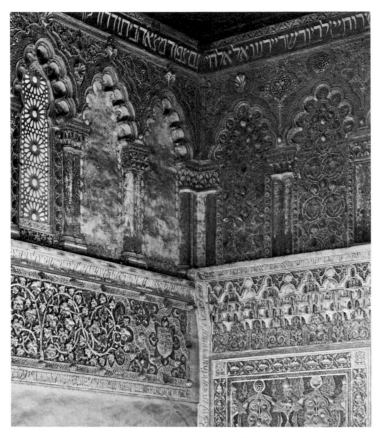

Synagogue of Samuel Halevi Abulafia. Toledo. c. 1360.

From an artistic perspective, the Islamic influence survived Christianity's political victory. Synagogue builders, while adopting the vocabulary of Islam, followed general trends, although Islamic influence affected mainly the ornamental language. The structural plans of the edifices were influenced by the then contemporary Romanesque and Gothic styled churches. Thus, the West contributed the architectural structure while the East provided the ornamentation. The *Mudyar* style evolved from the combination of these two artistic traditions and was appreciated by Jewish patrons. Surviving Spanish synagogues, four out of one hundred and nineteen mentioned in literary sources, were all built in this mode.[172]

In the thirteenth century in Toledo,[173] the earliest synagogue is now known by the name it received when it was transformed into a Christian chapel in the fifteenth century—Santa Maria la Blanca or Santa Maria de las Nieves.[174] A relatively modest trapezoidal structure, the hall is divided into five equal naves by four rows of octagonal pillars. The smooth white walls and white pillars create a striking contrast with the piercing arabesques on the arcades and capitals. The pillars support horseshoe arches, above which are the polylobed arcades. The capitals are decorated with acanthus leaves and fir cones, reminders of Romanesque and Byzantine art, and sinuous arabesque forms that have their origins in Islam.

Even more sumptuous is the ornamentation in another Toledan synagogue that was built about one hundred and fifty years after La Blanca. It is believed to have been the private synagogue of Don Samuel Halevi Abulafia, treasurer of Pedro I of Castille (1356-1369). But the brilliant career of Samuel Abulafia ended in tragedy. A victim of court intrigues, he was executed in 1361, a few years after the completion of the synagogue he had constructed for himself. The building later became the church known as the Ermita del Transito de Nuesta

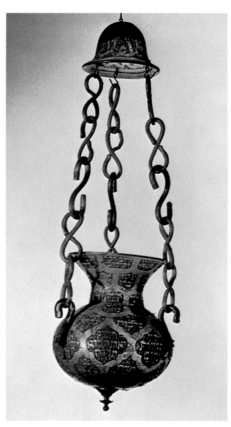

Glass Sabbath lamp. Hebrew inscriptions. Damascus, 1694. Length: 92 cm. London, Jewish Museum.

Synagogue of Ibn Ezra, Fostat. XIII cent. Carved wooden doors (H.: 204 cm.; W.: 90 cm. for each door).
Jerusalem, Israel Museum.

Seder plate. Lustre ware. Spain, c. 1450. (diam.: 45 cm.). Jerusalem, Israel Museum.

Señora.[175] The prayer hall has one nave and is covered with a layer of stucco almost to the entire height of its walls. Stylized floral motifs and arabesques decorate the panels which are also framed by incriptions in large ornamental letters. The calligraphy is used as a decorative motif and belongs to an ancient Jewish artistic tradition. Hebrew script lends itself extremely well to the adornment of walls, panels and manuscripts. However, this type of decoration was not strictly ornamental in function. Following a religious custom, the script evoked the memory of the patron of the work and the scriptural allusions referred to the sacred character of the building. Thus, apart from Abulafia's name, the writing in the prayer hall of the sanctuary consists of quotations referring to Solomon's Temple and lists of the cultural accessories of the Tabernacle.[176] Every part of this edifice, including its furniture, seems to be a reminder of Solomon's Temple.

The interiors of the Spanish synagogues are known only through such indirect sources as miniatures, which permits us to reconstitute the disposition and appearance of the furniture. These miniatures contain significant illustrations of the synagogue service and appear in the Passover *Haggadot*. In a fourteenth century *Haggadah*,

now in the National Museum of Sarajevo,[177] the painter presents the ark with open doors (fol. 34), the Torah scrolls standing erect inside. In Antiquity the scrolls were customarily shown lying horizontally. This image suggests the new form given to the ark—namely, its placement against a high wall without an apse. A scene from another *Haggadah* of the same period shows the reader standing on the *bimah*,[178] which appears here to be an independent construction reached by steps. The ornaments, as well as the lamp providing light for the reading, are typical of the Islamic style.

At the end of the fourteenth century Jewish artistic activity declined because of the increasing hostility of the Church. And, in 1492, the Edict of Expulsion extinguished the flourishing culture of the Jewish communities of the Iberian peninsula. However, until this very day, Jews continue to inhabit various parts of the Moslem empire.

The most propitious period for Jewish artistic expression, according to Islamic sources and the diaries of Jewish travelers, occurred during the Ummayad rule, followed by the reign of the Fatimids which was still favorable in spite of occasional local persecutions. Of the numerous synagogues mentioned in the texts, especially in Egypt, none survive. Among the rare medieval vestiges are the doors of an ark in sculptured wood that have been preserved from the celebrated synagogue of Ibn Ezra at Fostat. This eleventh century synagogue was reconstructed from a Coptic basilica. The inscription that frames the doors of the ark seems to be contemporary with the early existence of the synagogue. The sculptured panels, with motifs characteristic of the Mameluke period in Egypt, may have been fifteenth century additions. The condition of the building deteriorated and was demolished in 1892, after which it was entirely reconstructed according to the original plans. During the demolition, the celebrated *Genizah*—a depository of discarded sacred books—was discovered, with its treasure of manuscripts that included liturgical poetry and archival documents going back to the eighth century.[179]

THE GOTHIC STYLE

The history of Jewish colonies along the Rhine and in Germany itself begins during the Roman empire. Cultural life developed early there and attained a peak during the reign of Charlemagne. For the following three centuries, the Jews enjoyed certain liberties, after which their freedom was sharply curtailed with the First Crusade in 1096. Diverted from their distant aims by immediate targets, the Crusaders unleashed their fervor against the Jewish communities. Nevertheless, the frequent persecutions did not culminate in the general banishment of the Jews; the political disunity of Germany allowed refugees expelled from one town to find shelter in a neighboring one. Thus, despite the martyrdom that marked this epoch of Jewish history, cultural development continued. Germany and the north of France became centers of Hassidism, a mystical current that flourished from the eleventh to the thirteenth century. Its influence, its ascetic tendencies and its distrust of any aesthetic manifestations had a lasting effect on the evolution of Jewish art in private as well as communal life.

Synagogue architecture followed a Gothic style in northern European countries. The constructions were of two types: a hall with one nave that encouraged a compact central arrangement, or a hall with two naves, separated by columns.

The earliest known one-nave edifice was discovered in 1976 in Rouen in the ancient Jewish quarter. From its style, one can assume the date of its construction to have been around 1100 C.E. The pillars around the outside walls rest on bases with a kind of geometrical ornamentation. Those flanking the entrance stand on zoomorphical bases with the ornamentation of a lion on the left, and a dragon on the right, alluding to Psalm 91: 13.[180] Two other synagogues, also with one-nave, have been discovered in Sopron in Hungary near the Austrian border. The earlier one, going back to the thirteenth century, has Gothic windows with stained glass fillings. A tympan hanging over the entrance is decorated with sculpted vine scrolls, referring to the expression, "the vineyard of the Lord" (*Isaiah* V,7), and is usually symbolic of Israel.[181]

The best known two-nave synagogue is in Worms.[182] The eminent master of Troyes, Rashi (Rabbi Salomon ben Isaac) taught there. Worms had been an important center of Talmudic learning since 1034 although the synagogue was not completed until a century later. In an inscription engraved on one of the columns, the date is cryptically indicated in verses from *Kings I,* VII, 40-49. The total numerical value of the letters gives the Hebrew calendar year of 4935 which corresponds to 1175 C.E. The inscription also has symbolic significance because of the quotations referring to Solomon's Temple.

The Worms edifice has two equal-sized columns. Its capitals are decorated with acanthus leaves, and in accordance with the austerity of the times, were the only ornamentation of the hall. Several annexes were added centuries later, including a women's gallery in 1213, and a room for teaching, called "Rashi's hall" after the revered master. A watercolor of 1840 gives us an idea of the interior of the synagogue, but only after its reconstruction in 1616. The painter, Heinrich Hofmann, places the *bimah* in the center between two columns and surrounds it by rather flamboyant balustrades. This central disposition of the *bimah* remained characteristic of most northern Gothic synagogues. In 1936 the Worms Synagogue was destroyed by fire. The one now standing in its place has been reconstructed according to the original plans.

The Ratisbon synagogue was similarly constructed. However, it is known only through an engraving by Albrecht Altdorfer. Another synagogue with two naves is the Altneuschul of Prague which still functions as a synagogue. As in Worms, the naves are of equal size and are separated by two massive pillars supporting five-grained vaults. The *bimah* is surrounded by a fifteenth century balustrade of forged iron and stands between the pillars. Eventually this central area was enlarged to contain a vestibule to the south of the hall and a woman's gallery that was added 1732. The floor of the main hall is below ground level. Through the centuries, the disparity was accentuated, sometimes deliberately. For example, while respecting the restrictions limiting the exterior height of the edifice, the builder could use the different levels to change the interior height of the walls. The interior of the Altneuschul contains some sculptured stone ornaments, especially on the tympan which hangs over the entrance and is filled with vine scrolls similar to those of the Sopron synagogue.

After the fourteenth century the one-nave plan became more common.[183] The central disposition of the *bimah* is to be found in the synagogues of Bamberg and Miltenberg. It also occurs in the Pinkas Schul in Prague, originally a prayer hall in a private house, and given its present form after two successive alterations in the sixteenth and seventeenth centuries.[184] Our knowledge of the interiors of these Gothic synagogues, except for the tympan of the Alteneuschul, comes from literary sources. It seems that sculptured reliefs and stained glass windows in the Gothic style were commonly used, a supposition that has been confirmed by medieval Hebrew manuscripts.

Marriage contract. Krems, Austria. 1392. Parchment. Vienna, Nationalbibliothek, Cod. Hebr. 218.

Marble plaque with ornamental inscription. Padua, before 1682. Jerusalem, Italian synagogue.

ITALIAN BAROQUE

The first Jewish colonies in Italy were established under the Roman empire. They continued to grow during the Middle Ages because of the influx of refugees from France, Germany and Spain who made the Italian cities the first stage or the final destination of their migration. These refugees came from different places and were never entirely comfortable in the new communities. In fact, they preserved the writing characteristics of their native lands, the liturgical traditions of the synagogue and their dialects. However, the visual arts escaped this fragmentation. The Renaissance and Baroque styles were adopted by all artists so that for monuments and art objects created in Italy there seemed to be a unified formal language. Most of the larger cities of northern Italy flourished with Jewish culture.[185] The most important centers of Hebrew printing were in Italy.[186] Also, literature and science developed there. The illumination of Hebrew manuscripts acquired a refined technique that was worthy of the best Renaissance workshops.[187] Italy underwent a cultural burgeoning that was supported by considerable economic ease. Wealthy families everywhere were in the service of the aristocracy. Every prince—even the Popes— had Jewish doctors and Jewish bankers. Celebrated humanists such as Marcello Ficino and Pico de la Mirandola, ecclesiastics of high rank, such as Cardinal Egidio of Viterbo, sought instruction in the Hebrew language and literature from rabbis or converts in their service.[188] But these influential connections did not mitigate the hostility of the Church and in 1516, the first institutionalized ghetto was created in Venice. It was followed by the Roman ghetto in 1555 that came about after the Papal Bull *Cum nimis absurdum* of Paul IV.

With the arrival of ghettos, nearly all synagogue construction as independent edifices ceased. Prayer halls were installed on the upper floors of ordinary houses so that there was no indication of their real function. The interiors, however, were given special attention. Italian Jews shared the tastes of their contemporaries and often decorated synagogue furniture magnificently with gold and sculpted ornamentation.[189]

As if it were a privilege, each community jealously maintained a private hall of prayer. The interiors were always the same. A bold solution was found to solve the problem of the double cultual center. The ark and the

bimah were constructed face to face at the two extreme ends of the hall. On the eastern side, the ark was slightly embedded in the wall or simply set against it. On the western side, the platform was raised on several steps and dominated the entrance. Benches for the faithful lined the walls, leaving the central area entirely free. A new arrangement for the women's section consisted of galleries on either side of the hall. In Italian synagogues there were two seats of honor on either side of the ark for the elders of the community.

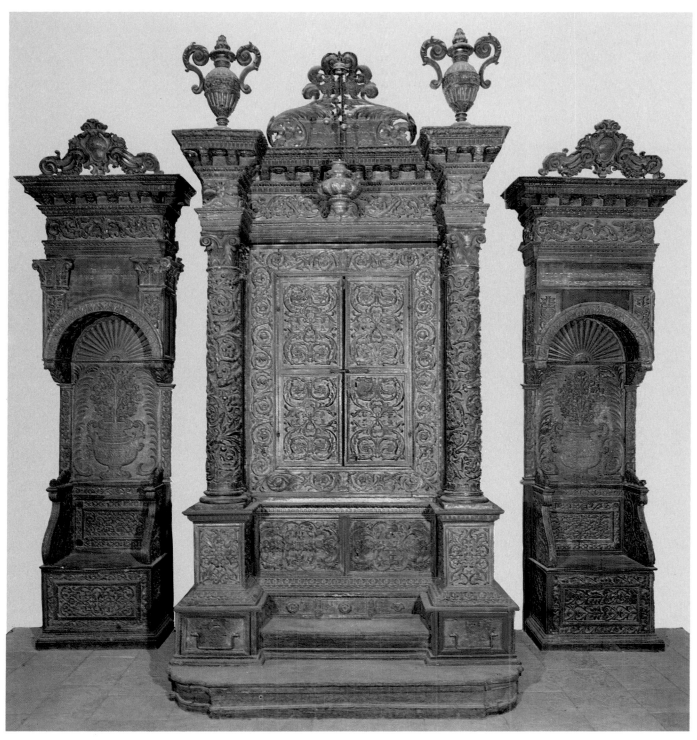

Ark with two seats of honor. Mantua, 1543. Jerusalem, Italian synagogue.

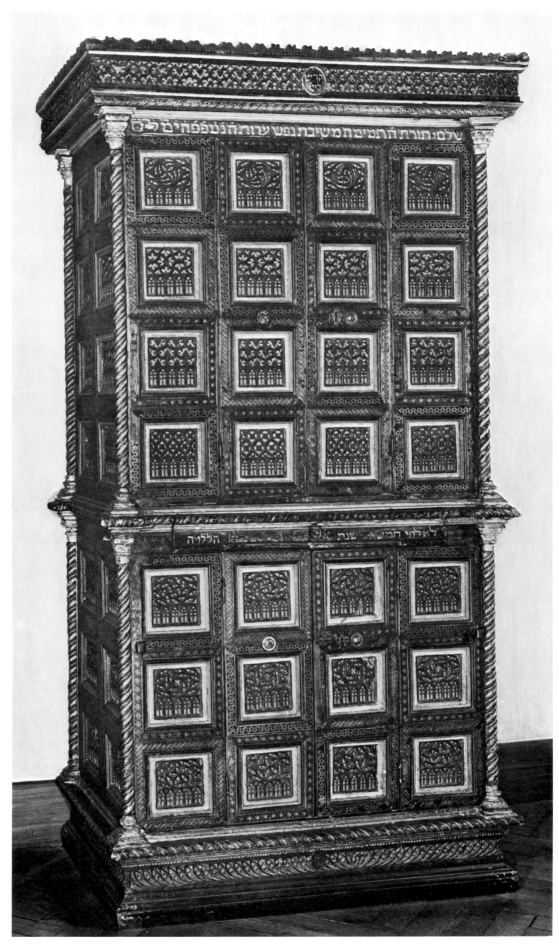

Ark. Modena, 1472. Paris, Musée de Cluny. Coll. Strauss-Rothschild.

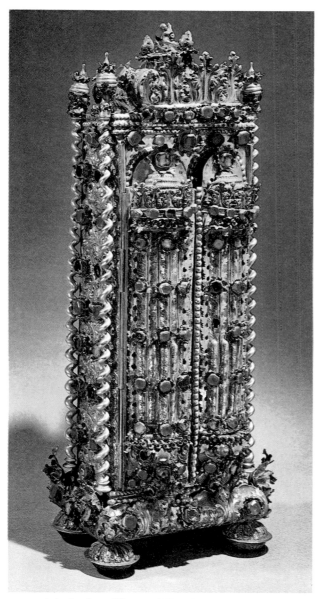

Ark. In silver. Vienna, 1707. (57.5 x 21.7 x 15cm.).
Paris, Musée de Cluny.
Coll. Strauss-Rothschild.

The ornamentation followed local artistic trends — albeit with a slight chronological lag. Pieces of furniture in the Renaissance style are rare. The ornamental motifs of an ark from Modena, dated 1472, is now in the Musée de Cluny, Paris, and is in the flamboyant style. A Mantuan ark of 1543, now in the Italian synagogue in Jerusalem[190], has been preserved together with the two seats of honor on either side. The ark has a sculptured floral decor and is covered with a bronze patina, although it was formerly enhanced with a gold covering. The door of the ark is flanked by little columns set on bases that conceal small cupboards for safeguarding the ritual objects. The two amphorae that presently stand on these columns are later additions. Within the leaves of the doors are the precepts of the Ten Commandments inscribed in gold letters. Another relic in the Renaissance style is a stone plaque, originally inserted in a wall in a Padua synagogue, and bearing an inscription in a floral frame that is richly decorated. Since the Padua synagogue was constructed in 1682, it is likely that the stone was reused at that time. Baroque furnishings are more frequently found. A particularly well-preserved ensemble, the interior of the synagogue of Vittorio Veneto has been reconstructed in the Israel Museum of Jerusalem. The convoluted lines and heavy, gilded floral ornamentation give us a good example of the tastes of that period.

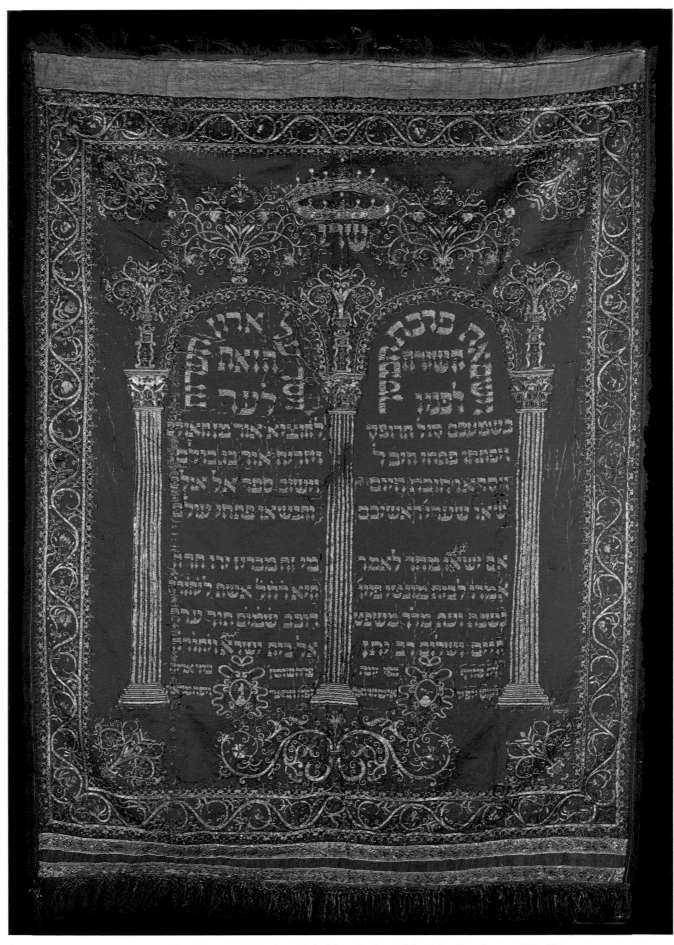

Curtain of Torah ark, with armorial bearings of the Montefiori and Olivetti families. Pesaro, 1620. Velvet embroidered in gold and silver thread. Jerusalem, Italian synagogue.

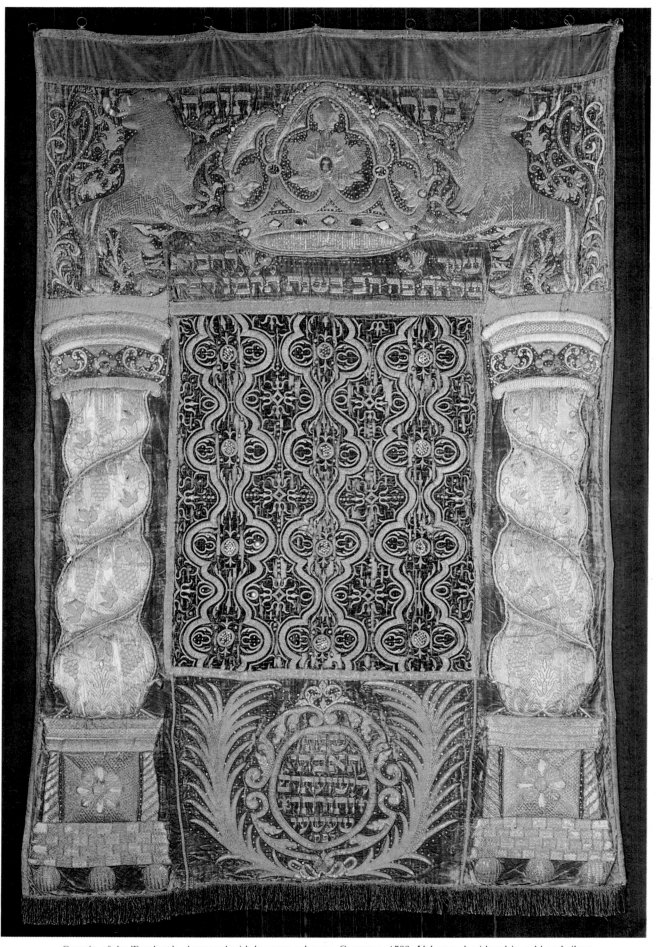

Curtain of the Torah ark, decorated with baroque columns. Germany, 1783 Velvet embroidered in gold and silver thread. Jerusalem, Heichal Shlomo Museum.

THE NORTHERN NEO-CLASSICAL STYLE

In 1579, with the revolt of the Protestant entities in the Low Countries against the domination of Catholic Spain, the Netherlands became one of the principal centers of refuge for the Jews, especially those Marranos fleeing from Spain. The Jews formed sizeable communities and had considerable influence in the economic and social life of Amsterdam. Indeed, their prosperity impacted on the construction of their synagogues which seemed to have undergone a period of frenzied activity. Each congregation—Amsterdam had five—built a synagogue for its own use; in size and appearance these edifices represented the social conditions of their respective patrons.

The era of ambitious synagogue construction coincided with the rearrangement of the plans of Protestant churches.[191] In fact, these plans served as future models for the neo-classical style of the synagogues in the northern countries, after which there were minor modifications. Fundamental to these structures are the basilica with three naves, overhead galleries on the side naves and an entirely free central area dominated by the *bimah*

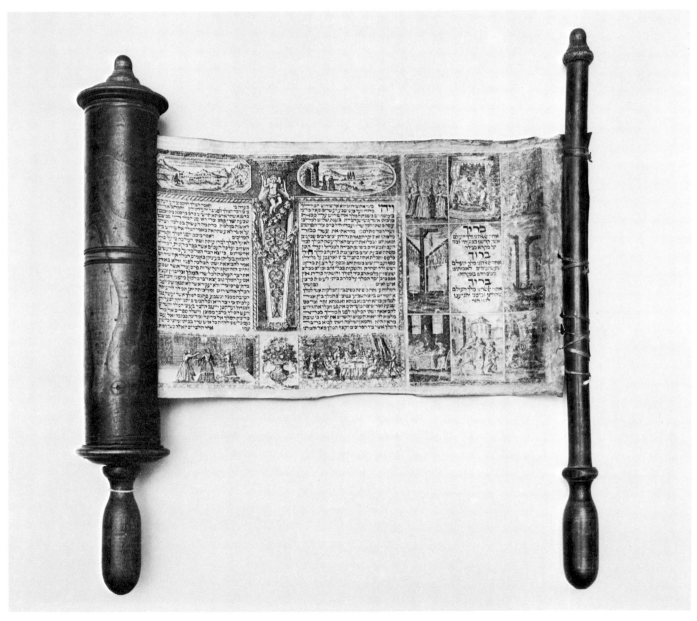

Esther scroll. Italy, XVII century. Parchment (H.: 19 cm.; W.: 165 cm.). Jerusalem, Israel Museum.

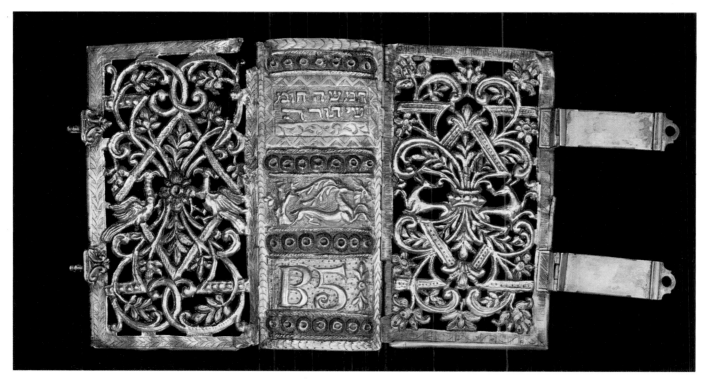

Binding, partly guilded silver. Pentateuch inscribed on the back. Poland, XVIII cent. (14 x 22 cm.).
Coll. Victor Klagsbald, Paris.

in the middle and the ark at the eastern end. One of the first structures of this kind was the synagogue of the United Portuguese congregations, completed in 1639.[192] The prayer hall, whose roof had a double cylindrical vault, can be compared with the churches of the Remonstrants that was built about twelve years earlier. The synagogue of the Ashkenazi community was designed by the architect of the city of Amsterdam, Daniel Stalpert. This edifice is distinguished by its massive masonry walls and its facade in which neo-classical elements are used together with rows of windows that differ in design at each level — in the Renaissance manner. A triangular pediment supported on Tuscan columns forms part of the monumental entrance giving access to the vestibule which is located in a lower wing, distinctly apart from the principal structure. The interior, cold and imposing, is dominated by enormous Tuscan columns. The ark, rather sober and solemn in appearance, is situated at the end of the hall.

The most celebrated of the neo-classical synagogues of the north is the new synagogue of the Portuguese community. Constructed in 1675, it has never fallen into disuse.[193] According to certain traditions, it is the work of the master mason Elias Bowman whose models were later adopted by a number of great synagogues. The general plan of the interior is characterized by harmony and balance, and does not really introduce fundamental changes from other structures. The Tuscan columns are reinforced by two rows of slender columns in the background which support the galleries. Thus, the interior space is somewhat enlarged and the proportions of the hall seem more graceful. The shrine of the ark which occupies the entire length of the east wall is contained in a splendid structure with three portals, defined by half-columns and surmounted by triangular pediments. The central portion of the shrine, the ark itself, is crowned by the two Tablets of the Law bearing the first words of the Decalogue. This symbolical decor is not of Jewish origin but rather appears for the first time in 1623 in the Huguenot church of Charenton, France. The synagogues frequently repeat this theme, although it is not known where and when this decoration first appeared in a Jewish house of prayer.

The Bevis Marks synagogue in London belongs to the same group of constructions. Its inauguration in 1701 marks the official return of the Jews to England after four centuries of banishment. The interior design of the hall is slightly different from that of the Amsterdam synagogues. The platform is installed in the western part of the hall which is entirely occupied by benches for the congregation. Elsewhere, the Portuguese synagogue remained the favorite model of builders in northern Europe.

THE SOUTHERN NEO-CLASSICAL STYLE

No Jewish monument survives in central France. Although Jewish settlements are known to have existed since the fourth century, and literature and religious thought enjoyed a certain flowering period, the development of the arts, especially architecture, was brusquely interrupted by the expulsion of the Jews in 1306 — an act that affected all Jews who were living in territories governed by the French king. In the fourteenth century the southern

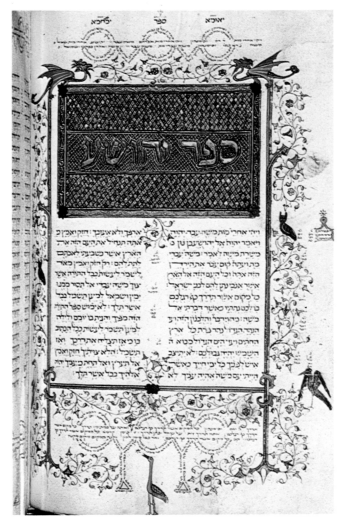

Bible. Carcassonne, 1422. Parchment (28.5 x 20.2 cm.).
New York, Pierpont Morgan Library, ms. G 48, Folio
167.

regions that were under papal domination served as areas of protection and refuge for the exiled Jews.[194] The autonomy granted by the Pope permitted the Jews to continue to use their native dialects, their liturgical traditions, and to a certain extent, to continue with their artistic production.

However, the synagogues of these regions as they exist today, provide us only with information about the final stages of their construction. In fact, in the eighteenth century, adaptations were made of the original fourteenth century edifices. The first of the southern synagogues was that of Carpentras, erected in 1367. Antoine

138

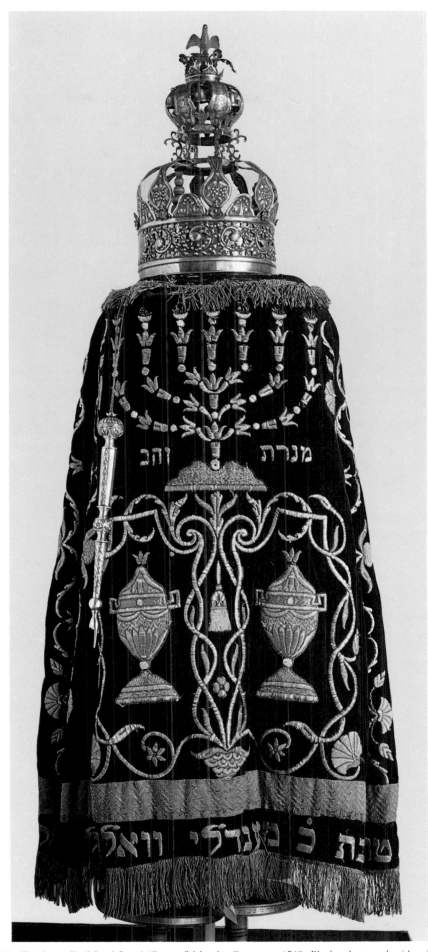

Ornaments of the Torah scroll: "Mantle" and "Crown." Mantle: Germany, 1748. Black velvet, embroidered in gold and silver with the names of the donors. (67 x 45 cm.). Crown: Poland, XVIII cent. Silver (H.: 27.9 cm.; diam.: 40 cm.). Jerusalem, Heichal Shlomo Museum.

of Germany, the architect, completed the adaptation of this edifice in 1741.[195] The original prayer hall was modest in size but had certain innovations that were afterwards adopted by all of the synagogues of Comtadin. For example, the ark was placed at the eastern end at ground level with the *bimah* facing it, and dominating the entrance. A second novel feature was in the women's gallery. As it presently stands this gallery was a recent addition. According to records of the eighteenth century,[196] the women were situated in an open hall below the level of the principal area. A grill or grating allowed them to view the officiants of the service as well as the Torah scrolls. Also in the Comtadin synagogues was a piece of furniture called "Elijah's chair." Placed to the right of the ark, this seat was named in honor of the prophet who was the patron and protector of the newborn, and became a popular tradition. Congregants celebrating the circumcisions of their children made use of it.

FROM FORTRESSES TO WOODEN SYNAGOGUES

Historical circumstances as well as local artistic styles influenced synagogue architecture in Poland and in the Ukraine. In Poland in the sixteenth century and even later, civil and religious edifices were provided with defensive elements so that the communities could protect their buildings against the frequent incursions of the

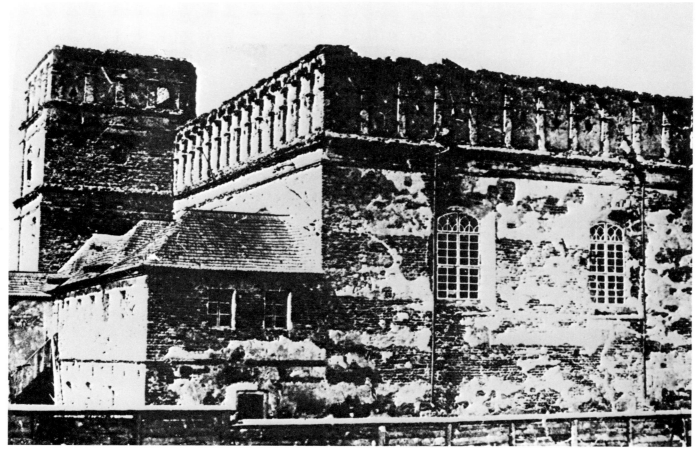

Lutzk. View of the synagogue. XVII cent. Old photograph.

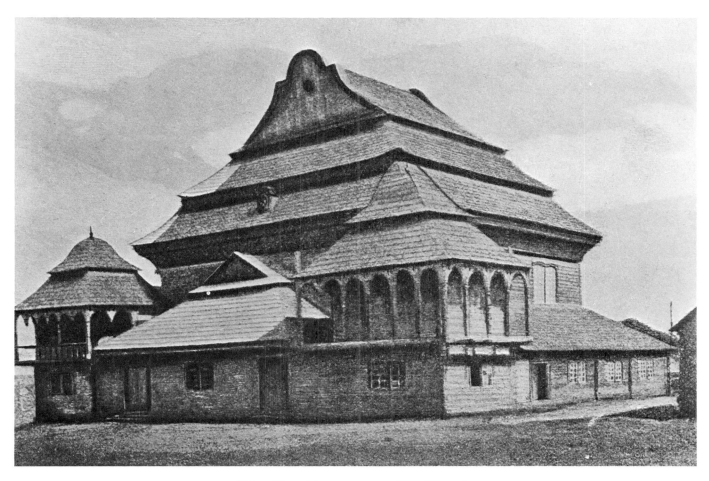

Wolpa. View of the synagogue, c. 1700. Watercolor.

Luboml. View of the synagogue, XVIII cent. Drawing.

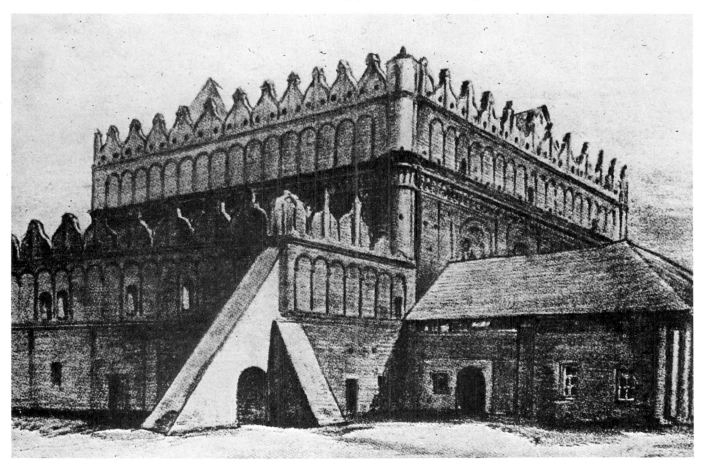

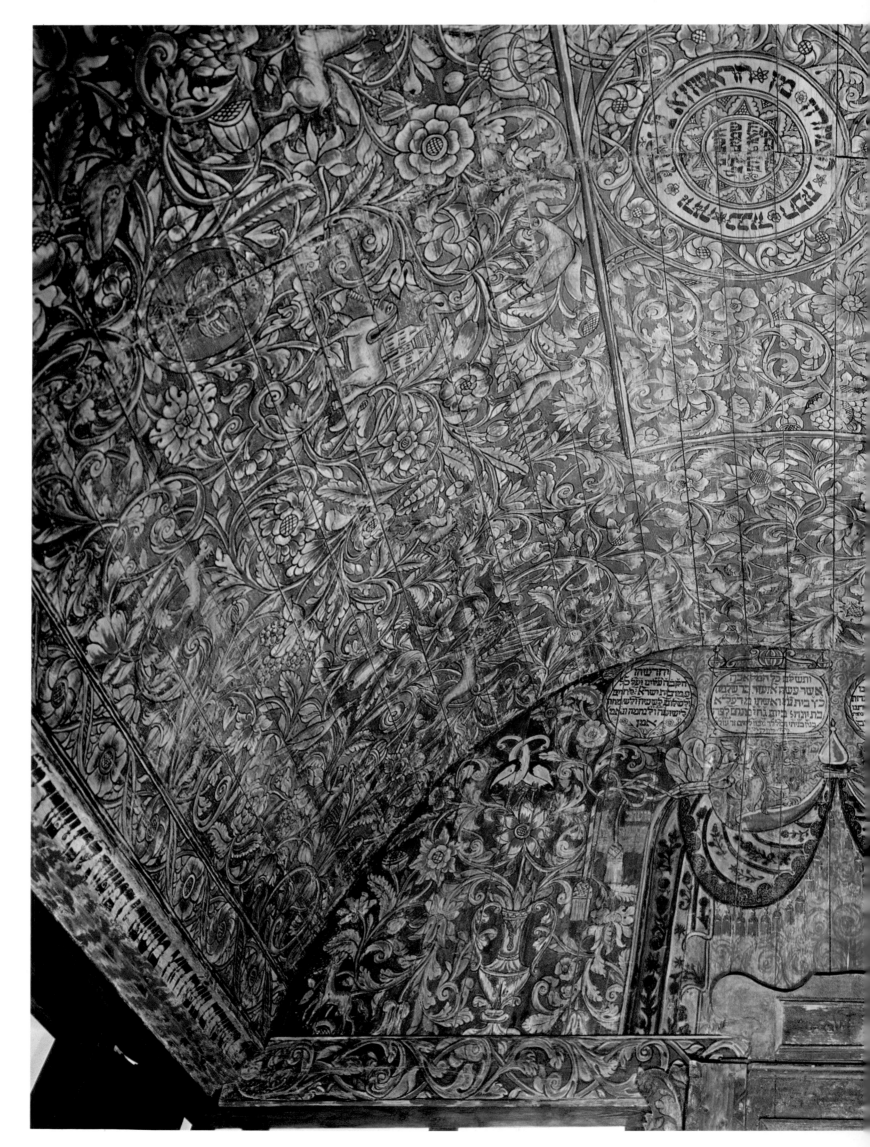

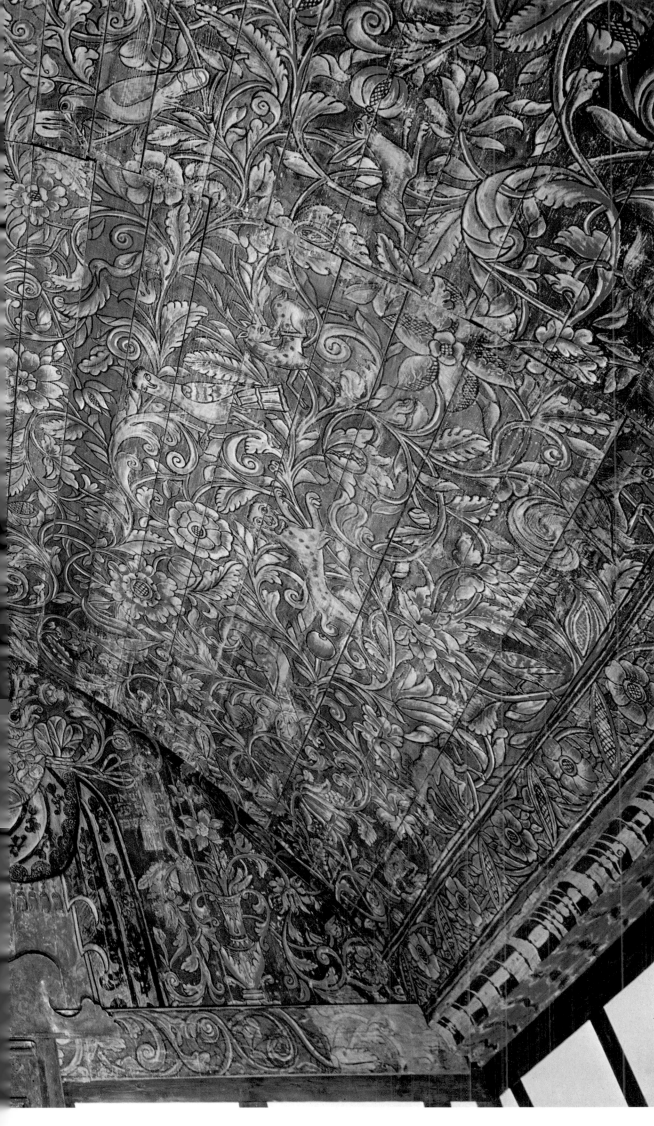

Horb-am-Main synagogue.
Painted ceiling, 1735.
Jerusalem, Israel Museum.

Cossacks. High masonry walls, surmounted by arcades or crenellated parapets — as at Zolkiev — gave the synagogues the appearance of being medieval fortresses. At Lutz, an inner staircase leading to a watchtower was added.

In the interior of these synagogue-fortresses the platform was placed in the center of the hall, surmounted by a domed baldaquin that rested on four pillars which at times also extended to support the cylindrical vaults of the ceiling. The platform, surrounded by a balustrade and slightly raised above ground level, was fully illuminated by direct lighting from the windows high up on the wall; the light seemed to fall in an almost theatrical manner on the domed canopy. This arrangement, particularly in the Przemysl Synagogue built in 1595, was repeated with variations in other places. At Lvov (1632) and Vilno (1633), the pillars of the dome, placed at equal distances, divide the hall into two concentric squares which correspond to the nine ceiling vaults, equal in size. This plan was carried to the east by Polish immigrants. Two famous examples are the Ashkenazi synagogues named after Isaac Luria, popularly called the "Ari", and the Sephardi synagogue consecrated to the memory of Isaac Aboab, both in Safed in the Galilee.

Wolpa. Prayer hall. Cross-section based on Wischnitzer's *The Architecture of the European Synagogue.*

144

From the seventeenth century on, a certain vernacular architecture, together with masonry construction, spread into Poland and adjacent countries.[197] The use of wood, which was a readily available resource in these regions, inspired new designs in local churches and manor houses. The edifices consisted of juxtaposed cells that were covered separately. The interior plan presented a series of halls that were square or almost square, and varied in number and arrangement depending on local conditions. The roofs were graded in height, according to hierarchy. The roof of the prayer dominated the others, while that of the vestibule was the lowest. Structural variations correspond to a topographical rather than chronological differentiation. The complex interiors of Galician synagogues reflect the influence of local artisans. The synagogue of Gvozdziec, for example, apart from the prayer hall, has a lower adjoining room reserved for the women and an annex constructed of stone that was used during the very cold months of the year. The timber roof of the main hall has a dome with three superimposed levels. The alternately concave and convex segments create a crown-like covering. In the Wolpa synagogue in Lithuania, the central aedicule with its four pillars is combined with the dome ceiling. The octagonal dome is fitted to the square hall by pendentives whose articulations follow the successive levels of the dome. Four slender pillars support the cupola crowning the dome. The decorative balustrades that extend inside the dome on three successive levels also have a functional purpose: the two lower tiers serve as the balustrades of the galleries placed within the dome area.

The walls of these wood synagogues are often entirely covered with paintings. Traditional motifs from Jewish iconography are intimately mixed with elements of local folklore. The inscriptions in ornamental frames, following customary usage, refer to Biblical verses describing the construction of Solomon's Temple. The images of the ceremonial objects emphasize their symbolical character. Also, familiar legendary figures are introduced which present a new repertoire of Jewish folklore. The speed of the gazelle serves a symbolical motif for the accomplishment of God's will. The elephant carrying a tower becomes an example of endurance in accepting the yoke of the commandments, while the bear searching for honey represents the sweetness of the divine word. Finally, the stork, in Hebrew called *hassidah,* recalls the homophonic name of the devout. This popular but essentially didactic repertoire is often completed by a view of Jerusalem, whose high cupolas resembling local constructions seem to be pledges of the eternal hope of return.[198]

As a result of the persecutions in Poland after 1648, Jews moved westward and brought with them the concepts of wood synagogue architecture and painted decoration. Wood synagogues appeared in Moravia, Bohemia, southern Germany and as far west as Lorraine. Several such structures still survive on their original site, while others have been reconstructed in museums. Among the latter, the most celebrated are those signed by the artist Eliezer Sussman of Brod, and includes the synagogue of Horb which is now in the Israel Museum in Jerusalem.[199]

After the emancipation and the removal of the last restrictions, synagogue architecture followed the successive movements of European construction. Variations affected the style, but the basic plan remained unaltered. Until very recently, the design of the neo-classical synagogue was untouched.

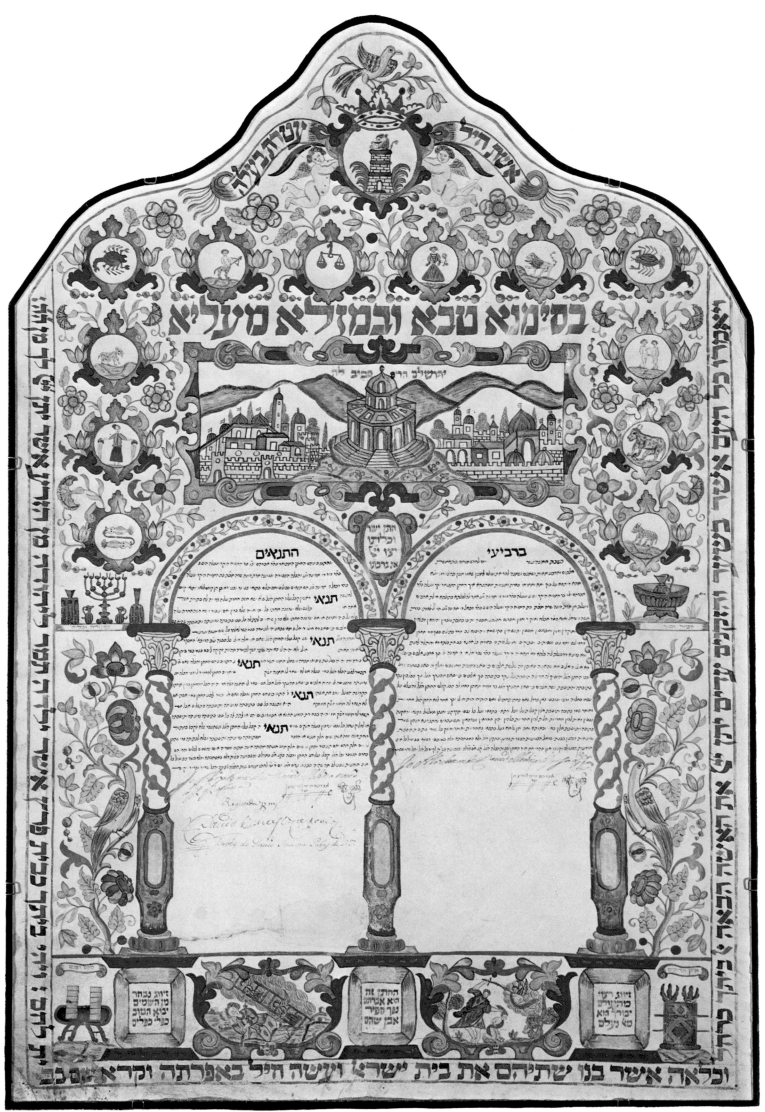

Marriage contract. *Ketuba.* Livorno, 1728. Jerusalem, Italian synagogue.

CEREMONIAL ART

Ceremonial art has great significance in Jewish religious life. Embellishing the festivals with beautiful objects is a way of showing concern for the proper fulfillment of the precepts. In fact, in displaying adorned objects, it is as if one is embellishing the precepts themselves (*hiddur mitzvah*).

The beginnings of Jewish ritual art are not very well known; several allusions in literary sources from the Talmudic period on indicate that certain precious objects were reserved for solemn occasions. Except for some clay lamps, there are no surviving objects that go back earlier than the tenth century; furthermore, there are very few existant pieces produced prior to the fifteenth century. Despite this, it seems that the truly creative period preceeded this time, since a number of ritual objects that have been preserved show characteristic Gothic ornaments and forms. In later periods, out of respect for tradition, these objects were reproduced almost without any modifications.[200]

Occupational limitations compelled the Jews to use Christian artisans for executing their ritual requirements. In most European countries Jews were excluded from the guilds so that they had no choice but to entrust non-Jews with the production of their ritual objects. The situation was quite different for the Jews living in Islamic lands. There, Jews had a monopoly for working with precious metals and nearly all work requiring silver or gold was in the hands of Jewish artisans.

In Spain, and especially in Sicily, where Moslem influence outlived the Christian reconquest, the Jews benefitted from the fairly liberal governments. They incorporated themselves into autonomous groups in which they were free to fabricate the furniture for their synagogues and other accessories. A certain traveler, Obadia di Bertinoro, who visited Palermo around 1487–1488, expresses his admiration in his description of the riches of the synagogue of that city. In Western Europe, however, the Middle Ages were a time of stringent restrictions. It was not until the eighteenth century with the decline of the guilds' power that Jews were once again able to become artisans. A few exceptions still required special authorizations. In eastern Europe, the real involvement of the Jews in the production of ritual objects is difficult to ascertain since very rigid laws prevented the Jews from signing their names to their works. Finally, in the eighteenth century the guilds of major European cities began to open their door to Jewish artisans. After the French Revolution, the remaining restrictions were abolished everywhere, and the guilds were forced to revise their rigid structures, and open their doors to everyone. The crafts were liberated.[201]

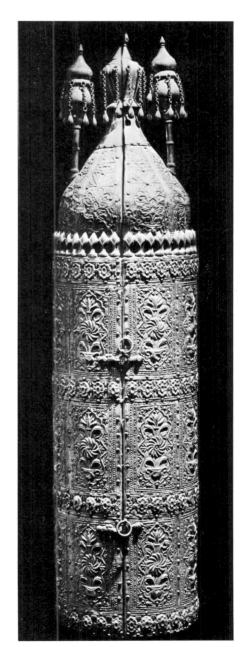

Sheath of Torah scroll (Tiq). India, XIX cent. Silver inlaid with precious stones. (H.: 116 cm.; diam.: 29 cm.). Jerusalem, Israel Museum.

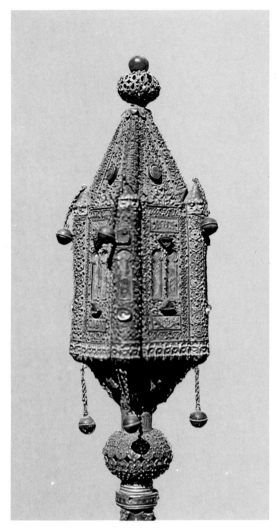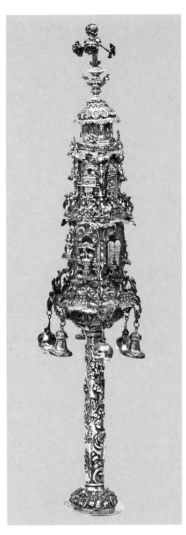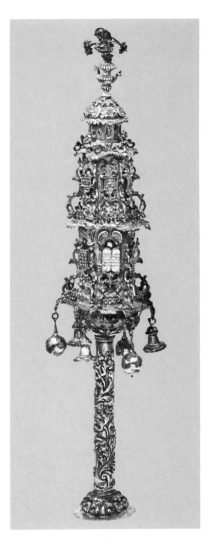

"Pomegranates." (*rimmonim*). Ornaments of the Toral scroll. a). Sicily, XV cent. Silver inlaid with precious stones. Palma de Majorca, Cathedral Treasury; b,c) Italy, XVI cent. Silver inlaid (H.: 33 cm.). Jerusalem, Israel Museum.

The center of Jewish ritual life revolved around the Torah scrolls, the instrument of the revealed Word. Extremely precise prescriptions govern the copying of a Torah scroll. These rules must be scrupulously observed before a scroll can be accepted for use in the synagogue. Because of these hieratic rules, however, the calligraphy of the manuscripts remained almost entirely exempt from the morphological variations that affected laic writing during the centuries. Ornamentation of the text in any form is strictly forbidden. The embellishment of the scrolls is limited to the support of the surrounding protective objects.[202]

The two rods around which the parchment is rolled — symbols of the Tree of Life — are topped by "pomegranates" (*rimonim*), or in the oriental variations, by "apples" (*tapuzim*). Originally, these ornaments were made of wood and were carved in one piece with the rod. In the Middle Ages they became detachable and were replaced by gold or silver work. The oldest known European examples are preserved in the Treasury of the Palma Cathedral in Majorca. They originated in Sicily and probably date from the fifteenth century. Shaped like little square towers, they are decorated with double horseshoe arches in the Mozarabic style. "Pomegranates" in an architectural form are characteristic of the entire Baroque period in Europe. In Italy in the eighteenth century, quadrangular storeyed turrets, carrying little bells and invested with a floral decor, presented a symbolical theme on each of their four facets. To the symbols inherited from Antiquity — a candelabrum or Tablets of the Law

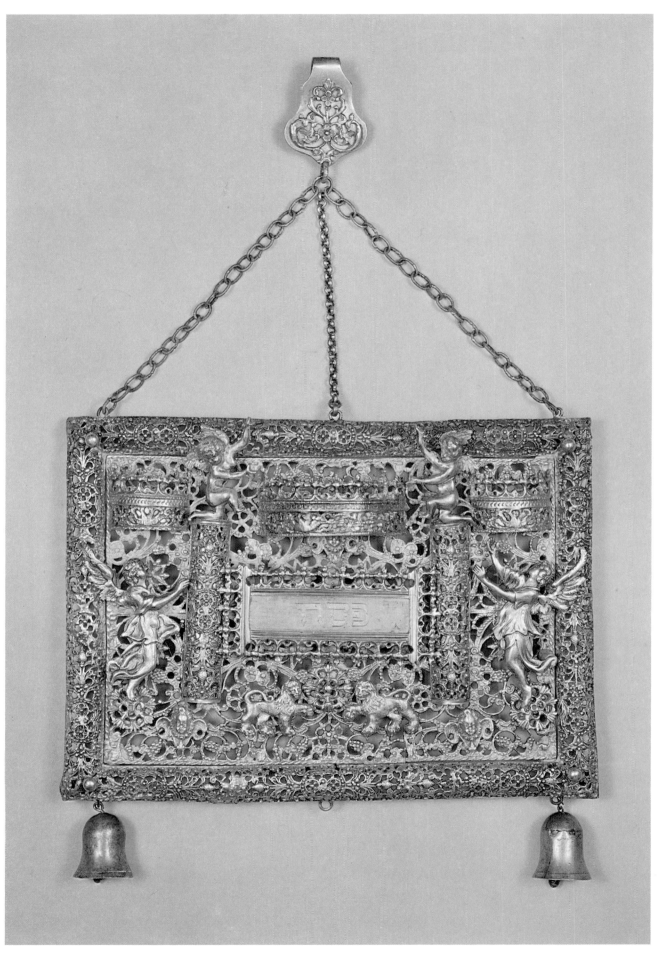

Ornamental plaque (*tass*). Frankfort-am-Main, XVIII cent. Silver, partly guilded. (24.8 x 18 cm.). Paris, Musée de Cluny, Coll. Strauss-Rothschild.

Pointers for reading; a) Russia, 1862. Silver inlaid with enamel (25 cm.); b) Stamp: Amsterdam, XVII cent. Silver (17 cm.); c-d) Central Europe, XVIII cent. Silver (22 x 23 cm.). Coll. Victor Klagsbald, Paris.

— were added such representations as priestly raiment or two hands in a gesture of benediction, the fingers spread in pairs.

In the north in the seventeenth and eighteenth centuries, the ornamentation of the pomegranates became more and more complicated. Multiple-storeyed towers were combined with crowns, especially in Holland and England, and elaborate floral compositions tended to replace the architectural forms of the preceding century.

The custom of placing a crown over the Torah scrolls is evidenced from archival documents as early as the twelfth century. Such crowns are mentioned in an inventory of 1186–1187, and were among the textual fragments that were discovered in the Fostat Genizah. In 1439, a contract was drawn up commissioning the Avignon goldsmith Robin Tissard to fashion a crown for fifty florins for "le rouleau des Juifs." In the western centers the usual type of crown resembled the imperial insignia. In central Europe, an elaborate decor, sometimes of considerable weight, departed from the prototype. In Poland, crowns of two levels, supported by rampant lions, combined the traditional Jewish components with figures from local art. In North Africa, the crowns appeared to be rectangular plaques that could be joined or opened out like a necklace. In Italy, pomegranates and crowns were sometimes used simultaneously but in Ashkenazi centers, the convention of the crown prevailed.

The protection of the Torah scrolls is recommended in the Talmud (*Shabbat* 133b). In the oriental communities, the scroll is placed in a sheath (*tik*), and is held there even during the reading. Some silver sheaths of the seventeenth and eighteenth centuries are still preserved. In the west, sheaths were used only for portable scrolls, those used by travelers. Overall tradition requires the scrolls to be enveloped in a precious richly embroidered cloth, the patterns differing in Sephardi and Ashkenazi centers. These protective mantles, as they were popularly called, are adorned with a plaque of precious metal that has interchangeable tablets. Each tablet is engraved with the name of a festival and serves, in turn, during its corresponding ceremony. As a reference to the High Priest's

Crown. Ornament of Torah scroll. Morocco. XIX cent. Silver, partly guilded. (15,5 × 86 cm.).
Jerusalem, Hekhal Shlomo Museum.

robe (*Exodus* XXVIII, 33-35), the edges of the plaques are sometimes furnished with little bells whose joyous sound adds to the brilliance of the service.

The pointer completes the list of ornaments surrounding the scrolls. It permits the reader to follow the text without touching the letters with his fingers. These pointers are usually of gold or silver and consist of a hand — hence their name *yad* — mounted on a long shaft, decoratively treated or bearing an inscription.

When not required for the service, the Torah, clad in all its ornaments, lies in the ark. This is concealed by a curtain and executed with great care since it is the central piece of synagogue decoration. A distant replica of the curtain of the Tabernacle (*Exodus* XXVI, 31-37), this characteristic decoration of Jewish halls of prayer figures in most of the mosaics as well as in many of the illuminated medieval manuscripts. The surviving specimens are of a late period. In the west, the velvet or brocade cloth carries the traditional symbols: the columns of the Temple, the guardian lions of the sanctuaries, the Tablets of the Law. In the east, the motifs of the Jewish repertoire yield to the characteristic decor of Moslem prayer rugs: a niche and a lamp. Although it belongs to an oriental type of decor, the lamp evokes the "eternal flame" burning before the veil of the Tabernacle (*Leviticus* XXIV, 2-4), its shape indicating an adaptation of the candelabrum.[203]

The liturgical year is punctuated by the weekly recurrence of the Sabbath; each phase of the holiday is marked by a ritual act and a specific object corresponds to each ritual.[204] The arrival of the Sabbath every Friday evening is announced by a candle lighting ceremony at sunset. During the Middle Ages and until the eighteenth century, the Sabbath lamps were in the form of a star: their burners, in bronze or silver, were kept alight with oil. It was not until the eighteenth century, particularly in Europe, that candelabra replaced these lamps. As the lamp is lit on the Sabbath, a blessing is said over a cup of wine, a tradition that was known in the literature since the first century of the common era. The cup had to be flawless, and made of some precious metal, silver or

gold-plated silver, and decorated with Biblical scenes chosen from the Bible: the sacrifice of Isaac, Jacob's dream, or the theophany on Mount Sinai. One light initiates the beginning of the festival, another marks its end. The latter has the function of "separating" (*havdalah*) the Sabbath from the other days of the week. The lamp used for the *havdalah* ceremony is in the form of a turret on a small raised base. The spice box called *hadas,* from the myrtle leaves contained in it, appears in the fifteenth and sixteenth centuries. It was in the shape of a Gothic tower with flags, a clock and guards. The shape came about as a result of the influence of European Christian

Spice box. Nuremberg, XVIII cent.
(28 x 8.2 cm.). Paris,
Musée de Cluny. Coll. Strauss-Rothschild.

Candle holder for the closing
ceremony of the Sabbath
(*Havdalah*). 33 cm.
Frankfort-am-Main, 1741.
Jerusalem, Israel Museum.

Sabbath lamp. Italy, XVIII
cent. Silver. 80 cm.
Jerusalem, Israel Museum.

monstrances or reliquaries that the Jews were aware of, either directly from Jewish artisans or indirectly from pawned Church utensils. However, there is no spice box that antedates the sixteenth century.[205]

The first feast of the Jewish year is Passover. A joyful festival commemorating the departure from Egypt, Passover is essentially a family holiday.[206] It is inaugurated on the eve of the first day by a meal called the *seder,* the word means ordering. The traditional foods, of which each has a symbolical significance, are laid out on plates especially designed for this occasion. The borders of these plates are frequently illustrated with ritual scenes relating to the festival, and the center is inscribed with excerpts from the ritual book, the *haggadah,* which is read aloud during the meal and dominates the entire Passover ceremony.

Cup for the Passover meal (*seder*). Moses and Aaron before Pharaoh; Joseph and Potiphar's wife; Joseph, viceroy. Germany, XVIII cent. Ivory. 93 cm. Jerusalem, Heichal Shlomo Museum.

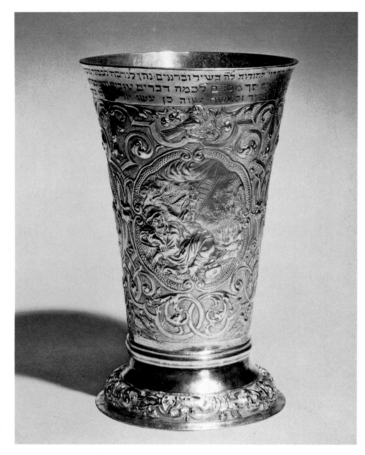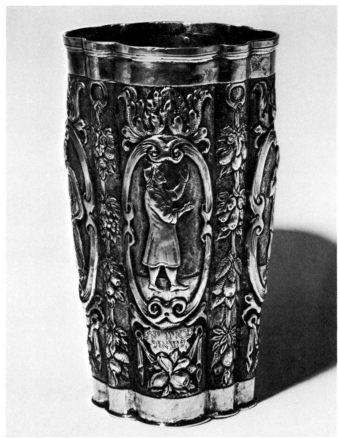

Ritual cup: a) for the Sabbath benediction. Nuremberg, 1765. 15.2 x 9.5 cm.;
b) for the Passover meal. Germany, XVII cent. 16.5 x 9.5 cm. Jerusalem, Israel Museum.

The text of the *haggadah* was definitively established in the thirteenth century and since that period has been copied and presented as an independent book of ritual. Didactic in nature and intended for family usage, the *haggadah* offers an ideal field for illumination. Small genre scenes evoking the various preparations for the festival and the moment of the paschal ceremony frequently decorate the margins, as do topics intended for the edification of the children that are extracted from familiar passages of the text. A particularly popular theme is the story of the four sons who personify in metaphorical language the different ways in which children learn Biblical precepts. The figures of the "wise," the "wicked," the indifferent, and the "simple," — the one "who does not know how to ask questions" — are people always found in the *haggadah* decorations. These figures also appear on the objects used in the Passover ceremony, on such objects as the gold or silver cup for Elijah that is placed on each table during the meal. The popular prophetic figure, who according to tradition still lives among his people and may one day be encountered by the pious, is expected to make a stop at every Jewish home during the Passover ceremony. His cup is full to the top, and the front door is left ajar for him to enter. The decoration reproduced here displays the images of the four sons on four medallions in gold-plated silver. Ivory cups, with relief ornamentation, are more unusual; one of the rare examples is preserved in Jerusalem in the Heichal Shlomo Museum.

The festival of *Rosh Hashanah* or the Jewish New Year is a more solemn occasion, announced in the synagogue by the sound of the trumpet or *shofar*. *Rosh Hashanah* marks the beginning of the ten days of penitence during which, according to tradition, the destiny of every person is fixed for the coming year. The last of the ten days, *Yom Kippur* or the Day of Atonement is one of fasting. Devout Jews wear white, with appropriate belts and head coverings, signs of contemplation, withdrawal and repentance.

The Feast of *Sukkot* or Booths, once a great festival celebrated in the Temple, announced the harvest. Fruits were brought to the Temple. *Sukkot* also has a symbolic significance, namely the dwelling in tents by the Israelites when they wandered in the wilderness. The observance is marked by the erection of a leafy booth or *sukka,* and is left standing for seven days. Meals are eaten in the *sukka.* Finally, *Sukkot* has an eschatological meaning that goes back to the banquet of the righteous that will be held after the coming of the Messiah. The booth is generally adorned with an image of Jerusalem, the ultimate goal of every pilgrimage. The memory of the agricultural festival lingers in the ritual sheaf that is used during the synagogue service. It is made up of the fruits of the Holy Land, and includes the palm tree and citrus fruit, familiar in the ancient mosaics.

Of all of the ceremonial objects, the best known, even in non-Jewish circles, is the lamp used during the Festival of Dedication, the Festival of Lights, or *Hanukah.*[207] The holiday was instituted in commemoration of the purification of the Temple after the victory of Judah Maccabee over the Syrian army of Antiochus Epiphanes in 163 B.C.E. According to the legend, after the Temple was purified, the oil burned for eight days — a miracle — instead of only one day. In memory of this event, one additional candle is lit every evening until all eight are burning on the last day of the holiday. As these flames are not supposed to illuminate, one additional flame

Esther scroll. Engravings by Shalom Italia. Amsterdam, 1640. 30 x 6 cm. Jerusalem, Israel Museum.

Marble Hanukah lamp. Inscription on the base: "The commandment is a lamp, and the Torah is light" (Proverbs 6, 23). Avignon, XII cent. (21.2 x 12.3 x 8 cm.). Coll. Victor Klagsbald, Paris.

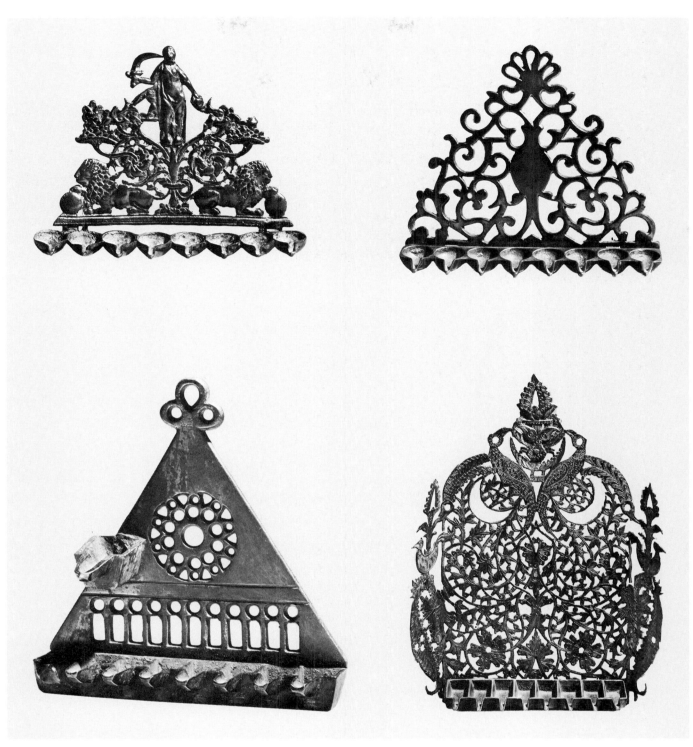

Bronze Hanukah lamps; a) Germany. XVII cent. (38 × 27 cm.); b) Bologna, XVI cent. (18 × 22 cm.);
c) France, XIV cent. (15.3 × 18.5 cm.), Morocco, XIX cent. (44 × 32 cm.).

is added, the "servant" or ninth light, the one which makes the use of the others permissible. Lamps specifically designed for this festival are therefore composed of nine burners; eight are symbolical in function, and the ninth, distinguished by its position, is utilitarian. At first, the eight burners were aligned horizontally. The earliest lamps of this type were of clay, like the ancient oil lamps, and without ornaments. A particularly rare piece in marble, originating in Avignon in the twelfth century, has burners in the form of arcades carved in a tall rectangular socle whose base is surrounded by a Biblical verse referring to the symbolism of light (*Proverbs* VI, 23). The form of the lamps was modified in the twelfth or thirteenth century when metal was used and the custom spread of

suspending the lights, preferably outside of the house. This change incurred the addition of a back wall so that the lamp was fixed to it. However, even after the custom of suspending lamps was abandoned, the wall was retained and became an important element of decoration.

Lamps made in France in the fourteenth century — only a few are known — had a triangular back wall shaped rather like a tympan of a cathedral with a Gothic rosette in the center. In Italy, in the seventeenth and eighteenth centuries, the twining contours of the backs were influenced by Baroque ornamentation. Lamps originating in Poland are decorated with animal figures whose graceful design constitutes the pierced metalwork frame of the back. In central Europe, the scene of Judith's victory over Holofernes was sometimes represented on the upper part of the lamp. The victory of Judith had become confused with that of Judah Maccabee. Towards the

Engagement ring. Italy, XVI cent.
.19 cm. Paris, Musée de Cluny.
Coll. Strauss-Rothschild.

end of the Middle Ages, a Hanukah lamp of a different type became widespread. It was made in the image of a candelabrum, but was distinguished from it by its additional burner, since the exact replica of the candelabrum was forbidden. (*Rosh Hashana* 24a).

The liturgical festival ends with the most joyful of festivals, *Purim,* in the Book of *Esther.* The festival itself includes all of the manifestations generally associated with popular celebrations — a carnival, banquet and gifts. The rites and ceremonies accompanying *Purim* have brought about a flourishing popular art, namely the decoration of the *Esther* scroll. The service for the festival consists mainly of reading the Book of *Esther.* In preparation for the ceremony, the Book of *Esther* is usually copied as a separate scroll; later it was also used on occasions other than *Purim.* Since the text was widely diffused and contained no mention of the Divine name, the *Esther* scrolls lent themselves to painted and engraved decoration. The margins of the text are animated with scenes illustrating episodes of the story, or the festivities that commemorate it. The columns of writing, twelve in number according to the traditional layout, are enclosed in floral or architectural frames. In the eighteenth century, allegorical figures were added at the head or base of the columns. Some celebrated examples, notably the engravings of Shalom Italia, were frequently copied.[208] The sheath protecting the scroll is also an object of art, and is usually made of ivory or silver, and adorned with motifs that in eastern lands are encrusted in gold, and with filigree work in regions of central Europe.

Apart from the festivals, each stage of Jewish life is marked by ceremonies that are both religious and domestic. Objects and accessories enhance the solemnity of the occasion with their richness, while the decor explains its symbolical significance. For example, the accessories of the circumcision ceremony are usually decorated with the scene of Abraham about to sacrifice his son Isaac, a scene which will remain for all time the model of absolute obedience to the divine will.

Marriage, from several points of view, is a juridical act. The conditions of the contract are precisely defined in a document called the *ketuba,* written in Aramaic on parchment, and executed by hand. The ornamentation of *ketubot,* together with that of the *Esther* scrolls, retained the privilege of painted decoration long after it disap-

Binding. Venice. XVIII cent. Silver filigree, enamelled plaques. 9 x 14 cm. Jerusalem, Israel Museum.

peared from books.[209] The paintings accompanying the *ketubot* range from simple ornaments to allegorical themes appropriate to the occasion, and in the neo-classical period, to mythological themes. Rich clothes and jewels enhance the splendor of the nuptial ceremony. The wedding ring, the main symbol of the occasion, sometimes represented such great monetary value that it remained the property of the community that lent it to the bride for the first week of her marriage. A special type of Jewish wedding ring has as an ornament a small aedicula set with precious stones and engraved with a wish for the happiness of the wearer.

Following a custom that was common in the east, one practiced by the Egyptians and by certain Moslems today, pious Jews marked their houses with a symbol, the *mezzuzah,* perhaps once considered as apotropaic. The *mezzuzah* is a small piece of parchment that on one side has the Biblical verses (*Deuteronomy* VI, 4−9 and XI,

Key casket. Ferrara, c. 1460–1480. 12 cm. x 8.5 cm. x 7 cm. Jerusalem, Israel Museum.

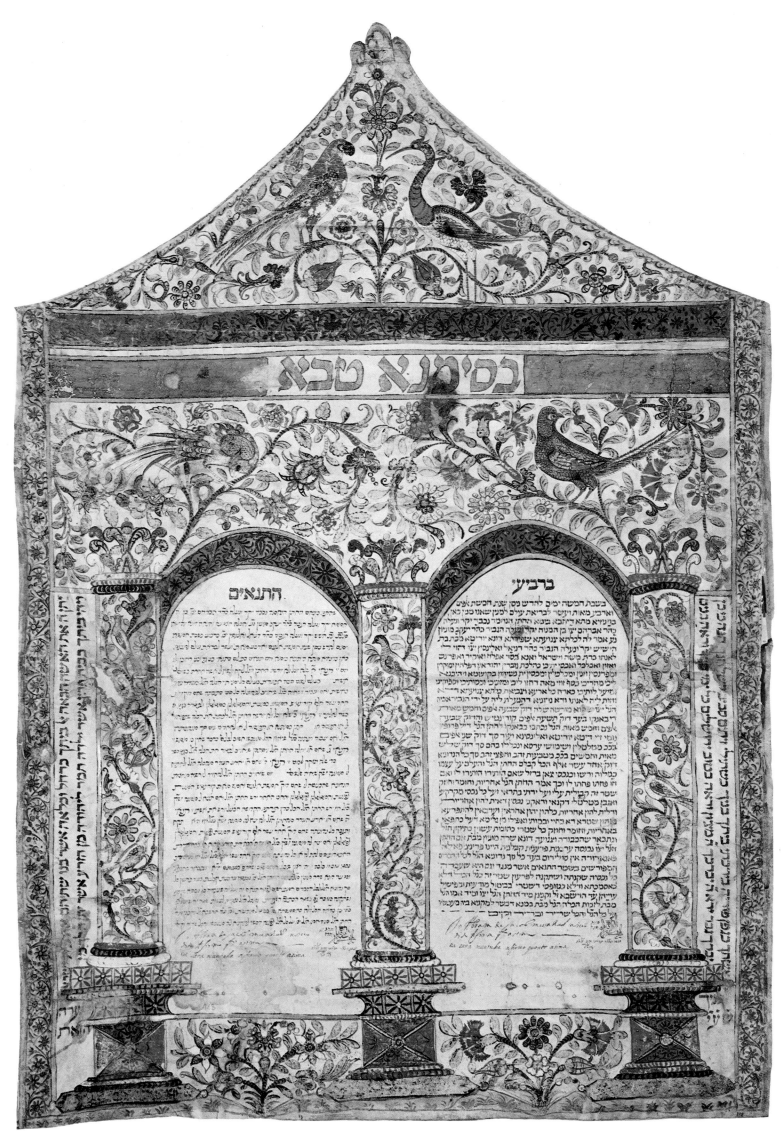

Marriage contract (*Ketuba*). Venice, 1650. Parchment. 82 x 52 cm. Jerusalem, Israel Museum.

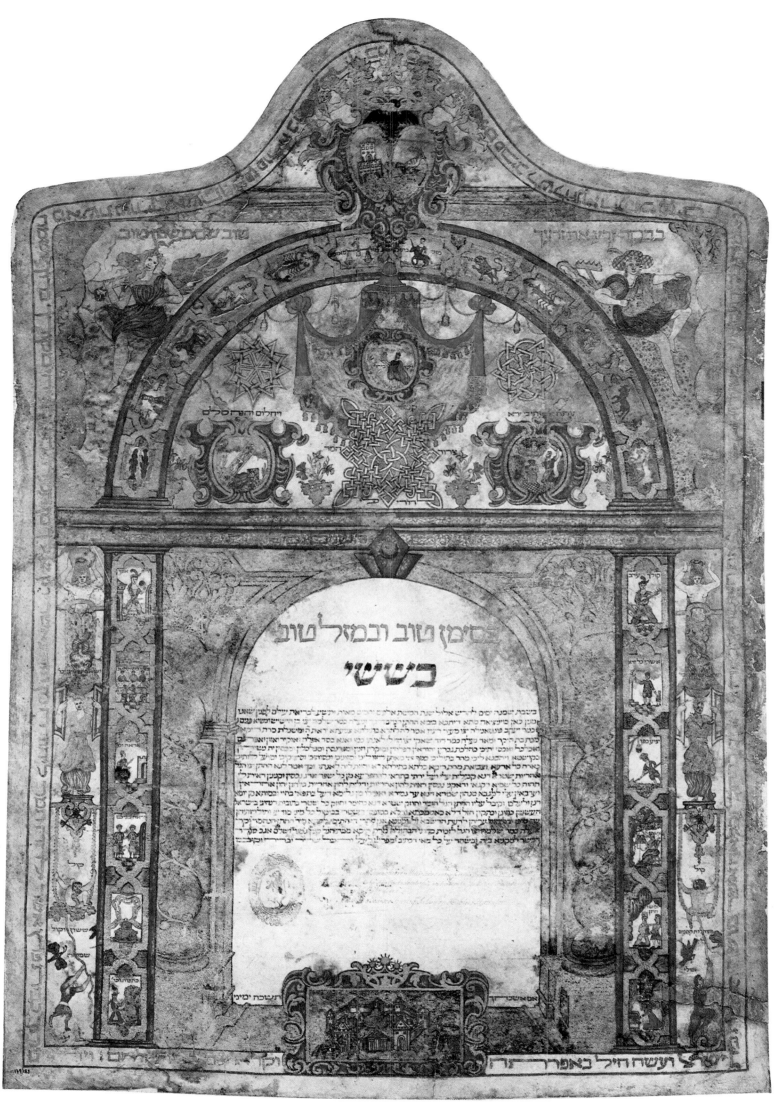

Marriage contract. Venice, 1749. Parchment. 89.5 x 39 cm. Jerusalem Israel Museum.

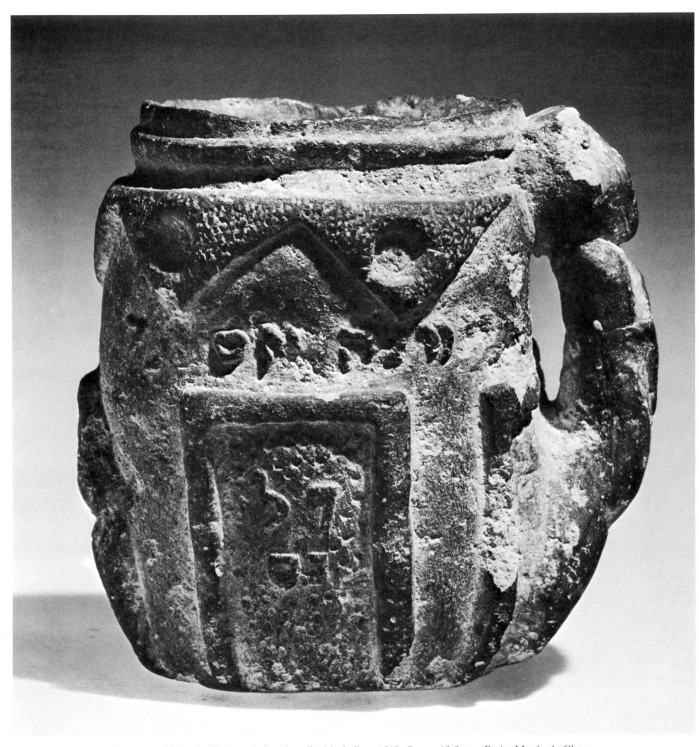

Alms box. Valencia. Date and place inscribed in ladino, 1319. Stone. 13.2 cm. Paris, Musée de Cluny.
Coll. Strauss-Rothschild.

13-21) and on the other side has the Divine name *Shaddai,* the most frequently used in the magical formulas of every period. The sheath protecting this miniature scroll that is to be fixed on the doorpost is often an object of delicately ornamented metalwork.[210]

Some examples of popular art are associated with charitable societies undertaking the care of the old and the sick, and those performing funeral rites. The most familiar objects of this type are goblets of glass or enamelled terra cotta on which the members of the respective society are shown engaged in their habitual activities.

Among objects of domestic use, special care was devoted to book bindings. Silver bindings in niello work, decorated with gems, with family devices or symbolical themes — for example, two hands in a gesture of priestly benediction — often bore the signature of renowned silversmiths, some of whom were Jews. In the absence of a signature, Hebrew inscriptions may identify the craftsman, as in the binding reproduced which has the names of the three parts of the Bible in Hebrew characters on the spine.

The same kind of indication allows the identification of the Italian fifteenth century artisan who fashioned a niello casket. This small *chef d'oeuvre* of craftsmanship has no ritual purpose. It probably contained the keys of the linen cupboards of the lady of the house. The face of the casket displays a niello plaque, engraved with three feminine figures personifying the womanly virtues as they are defined in the *Talmud* (*Shabbat* 31b). The cover is decorated with three rows of fleurets, encircled by Hebrew letters whose numerical values codified the combination for opening the lock of the casket. Other engraved inscriptions give the names of various pieces of linen in Italian, transcribed in Hebrew characters. The signature of the artisan, Jeshurun Towar, has been tentatively recognized in one of these words. The casket may come from Ferrara and is dated 1460–1480.[211]

The minor art of the Diaspora is integrated into the local art of each cultural region. European in Europe, it borrows the oriental language when in the east. Whether assimilation was necessary or necessitated by circumstances, or was the active and voluntary participation of a minority in a civilization, the habits and artistic tastes of the majority, the phenomenon was general and consistent. Nevertheless, Jewish art of this period is not entirely devoid of originality. Symbolical ideas, certain Biblical themes and traditional forms inspired by the rituals are proper to this art and individualize it, whatever the style of the ornaments. Evidently, there is sometimes a lack of balance between the elements that belong to Judaism and the borrowed material: the almost general constriction on the exercise of artisanship is responsible. In the field of illumination the picture is quite different. Without ceasing to remain open to the aesthetic currents of his milieu, the Jewish painter remained in control of his art.

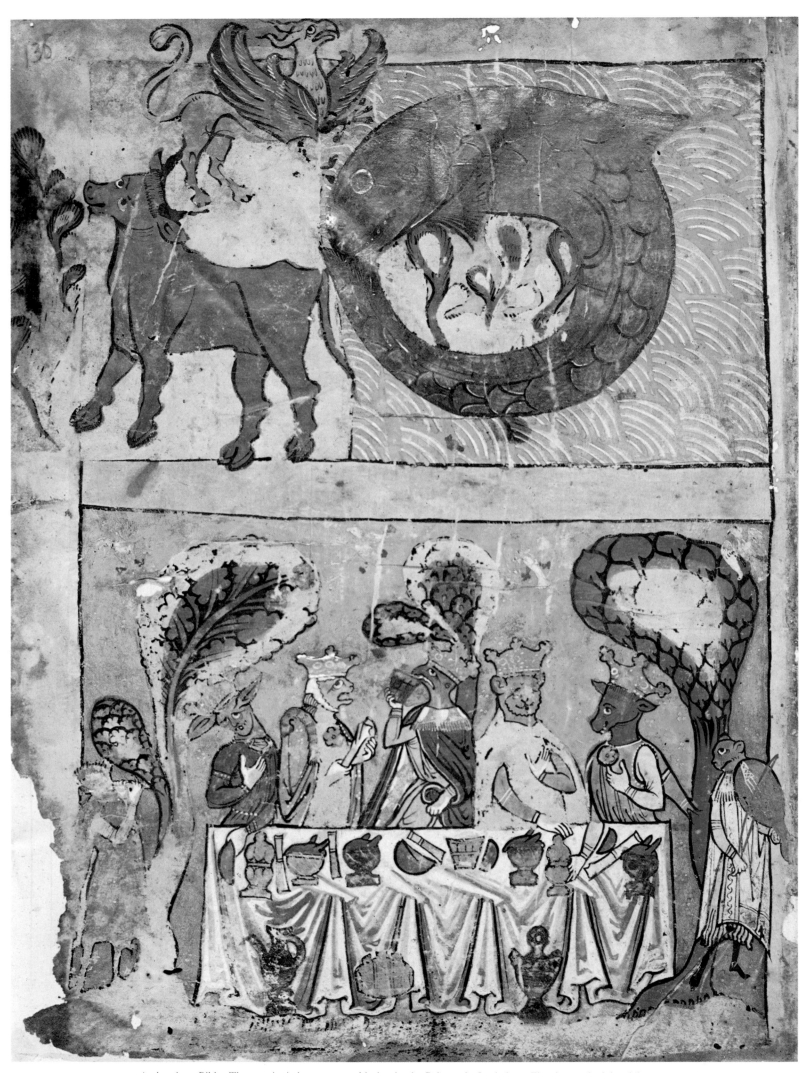

Ambrosiana Bible. The messianic banquet: mythical animals, Behemoth, Leviathan, Ziz; the meal of the righteous.
Germany. Ulm? 1236–1238. Parchment. 45.3 x 34.3 cm. Milan, Milan, Biblioteca Ambrosiana, sm. B 32 INF. Folio 136.

THE RENAISSANCE OF NARRATIVE ART:
ILLUMINATED MANUSCRIPTS

Book painting was a privileged field of Jewish art in the Middle Ages. Refuge of the spiritual and literary heritage, daily companion of every Jew attached to his traditions, the book was least affected by the historical and economic tribulations that so gravely impeded the evolution of the other arts. The origins of Jewish book painting go back to the Hellenistic period. Between that era and the first known illuminations in the tenth century, continuity is only attested by sparsely scattered records preserved by the Christian and by theoretical reconstructions that will perhaps always remain in the realm of hypothesis.

The art of illumination reemerged in the oriental school that flowered during the ninth and tenth centuries in the Arab-speaking countries. Strongly marked by the environment of its origins, the influence of this school endured particularly in Spain, the succeeding center of importance. In Europe, Jewish schools of illumination participated in the great artistic movements of the West. They adopted the techniques and shared the styles, but the themes and more expressly, the perspective in which these were projected, were their own. Hebrew manuscript illumination made its appearance in Europe in the last decades of the thirteenth century, in Spain, Italy, France and Germany simultaneously. Its diversity, striking from the start, reflected the various intellectual trends that arose within the European communities even more than the stylistic variations caused by the influences of local art. In contrast to the mystic world of southern Germany, where the movement of Ashkenazi *hassidism* molded thought and feeling, stands the serene lucidity of the French school, and the style of the Spanish, in which the ornamental vein inherited from Islamic art was allied to a certain realism and a Mediterranean joy of color and form. After a flourishing but ephemeral period in France, more prolonged in Germany and Spain, most of these schools suffered premature extinction, succumbing to the pressures of history. At the end of the fifteenth century, only Italy still represented a refuge for Jewish illumination, and there it achieved perfection before it yielded to engraving.

This too lightly sketched account barely traces the outline of an evolution that cannot be described in detail, even in the pages that follow. Rather than a historical summary, an attempt will be made through a careful selection of images to evoke the multiple aspects of Hebrew manuscript illumination in the course of its all too brief history.[212]

THE ANTECEDENTS

The earliest extant Hebrew illuminated manuscripts of oriental origin are of the ninth century, and only towards the mid-thirteenth century did they appear in Europe. It is rather improbable that these dates correspond to a real beginning. Frequent migrations, successive waves of prohibition of figurative representation, whether

imposed from within or without, as in Islamic or Byzantine environments and the deliberate destruction of manuscripts certainly hastened the disappearance of many examples. The gap of ten centuries separating medieval illuminations from the frescoes of Dura-Europos — the earliest known records of Jewish narrative art, themselves perhaps far removed from the origin — is only sporadically punctuated by the indirect but inescapable evidence afforded by Christian works of art. In 1901, in a discussion of the Ashburnham Pentateuch, Strzygowski[213] drew attention to this manuscript which follows the text of the Vulgate, while the illustrations are provided with captions conforming to the Vetus Latina, and contain elements that trace their literary sources to the Midrash.[214] The divergence between text and captions, the components of Jewish origin in the illustrations, and certain stylistic peculiarities, led Strzygowski to propound the hypothesis that the Ashburnham Pentateuch had, as its model, an illustrated Jewish manuscript, in Greek, Hebrew or Aramaic. According to stylistic criteria, the model of the seventh century Ashburnham Pentateuch could have been executed in a Syro-Palestinian milieu in the course of the third century.

The discovery of the frescoes of Dura-Europos offered unexpected confirmation of this hypothesis. The Midrashic material, and the narrative method, including the juxtaposition of "monoscenes"[215] and the repetition of the protagonist at each stage of the story, suggest that one consider the frescoes as the transposition in monumental art of a much longer sequence of illustrations, probably accompanying the text of a manuscript. The date of the synagogue — 244-245 C.E. — placed that of its model in the Hellenistic era. Between that period and the Middle Ages, Midrashic elements occasionally, if sparsely, recur in Christian monuments and manuscripts of diverse date and provenance. The mosaics of Santa Maggiore, the product of a Roman center, the Vienna Genesis, of Syro-Palestinian origin, the Ashburnham Pentateuch, made perhaps in North Africa, the Vatican Octateuch (Greek 747), from a Constantinople workshop, the illustrations of the Catalonian Roda Bible, some leaves of a psalter from the north of France illuminated in the twelfth century, are some of the best-known evidences.[216] Between these works, so different in style and origin, the only common factor is the presence of illustrations of Midrashic episodes, whose iconographical representation is not even consistent. Nevertheless, these works are the only surviving links between the Jewish manuscripts of Antiquity[217] which, according to Weitzmann, may have been contemporary with the translation of the Septuagint (third century B.C.E.),[218] and medieval Hebrew manuscripts, whose illuminations contain extensive Midrashic material. It is unlikely that these Christian monuments and manuscripts could have served as models for Jewish painters. The Jewish artists of the Middle Ages, in search of specifically Jewish iconographical material, would hardly have reconstituted them with the aid of Christian documents, a supposition that would be against all psychological and historical probability. Besides, the legendary elements are much more numerous in the Jewish manuscripts, and the iconographical formulae are more varied. The assumption that Jewish communities preserved certain iconographical traditions up to the Middle Ages, and hence that a Jewish art of illumination existed the evidence of which has vanished, seems unavoidable.[219] The illustration of Bibles and prayerbooks — we will return to this question — preserves some elements of this art. The continuity of certain iconographical traditions may be, if not proved, at least illustrated by the permanence of sacred symbols, attested from Antiquity to the end of the Middle Ages.

THE CONTINUITY OF THE SYMBOLS

In the Bibles of the oriental and later the Spanish schools, two facing pages preceding the text represent the implements of the Sanctuary. The panels representing these implements in synagogue mosaics indicated the sacred character of the niche that housed the Torah. In the manuscripts of the Bible this composition played an analogous role. It expressed both the sacred character of the book and the intimate bond that united this new sanctuary — one of the Hebrew names for the Bible is *miqdash-yah,* "sanctuary of Yah" — with the sanctuary which was the vehicle of God's presence among his people.

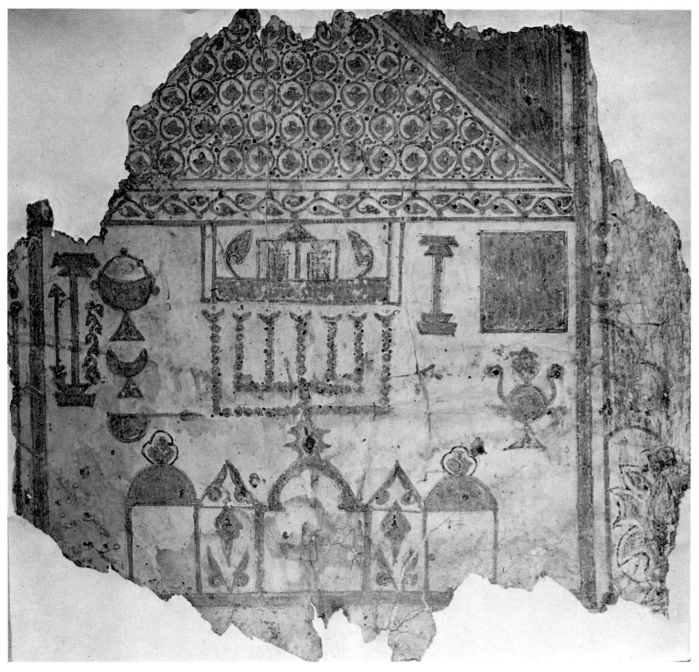

Leningrad Bible. Tabernacle in the desert. Egypt?, 929. Parchment. 35.5 x 30 cm. Leningrad. Public Library, ms. II/17.

Bible. Sanctuary implements. Perpignan, 1299. Parchment. 32.4 x 23.5 cm. Paris, Bibliothèque nationale, ms. Hebr. 7.
Folio 12 v-13.

The oldest known example is in a Bible copied in 929 by Salomon Halevi ben Bouya, probably in Egypt.[220] A surviving fragment represents in outline and in elevation the desert tent with its implements. Under a triangular pediment with a floral decoration, the religious objects are arranged in a square that represents the enclosure. Three entrances are indicated in the lower part. The objects are delineated in gold on the unpainted parchment ground. A monumental candelabrum with bent branches stands in the center; on the second plane is the ark with the Tablets of the Law between two stylized leaves that replace the usual cherubim. To the right of the central group is the jar where the manna was stored, and the square incense altar (*Exodus* XVI, 34); to the left, recipients used in the sacrifice, and a column with the flowering rod of Aaron on one side, and the barren stick of the Elders on the other (*Numbers* XVII, 16–25).

The composition, strictly two-dimensional, remains within the norms of symbolical art. The objects, schematic in design and juxtaposed in flat projection, evoke the image of the sanctuary. The floral ornaments, the almost exclusive use of gold on the plain background, even the architectural forms, show the influence of the pictorial style of the Korans of the period. This full-page painting is not the only one,[221] nor, most probably, the first of the kind. It is quite probable that continuity was never broken between these symbolical compositions and the mosaic panels of the sacred symbols from which they seem to be derived.[222] If this continuity is no more than a hypothesis for the early period, it is a certainty during the centuries that followed. From the third quarter of the thirteenth century, the double page composition becomes a steady tradition in the Spanish Bibles. These pages were often executed separately and joined to the manuscripts copied in the workshops of Toledo, Provence, and

then Catalonia. The concept and the structure of the paintings underwent various transformations.[223] The two pages of a manuscript copied and illuminated at Perpignan in 1299, (Paris, Bibl. Nat., ms Hebr. 7), represent the first stage. The intention to evoke an image following the text of the *Exodus* leads to an almost abstract composition. The objects, in burnished gold on a plain parchment ground, and traced with a firm contour, are distributed in geometrical frames with no attempt at suggesting any spatial disposition. The form of the objects betrays influences of contemporary Biblical and Talmudical commentaries.[224] Following these texts, the repertoire is enriched by objects that the Bible does not mention, like the stairway near the candelabrum, and the shovels. Other elements, such as the cherubim, now resembling angels, denote the influence of Christian iconography. Besides these changes affecting the iconography, variations in style appear during the course of the fourteenth century. The plain parchment is replaced by a painted ground, chequered in red and blue; the distribution of the objects, always in burnished gold, followed an arrangement in which geometrical rigidity is abandoned in a search for symmetry and harmony of composition. In addition to these pictorial innovations, the fourteenth century also brought about changes in the interpretation of the symbols. Under the influence of Maimonides' *Mishneh Torah*, which projects the meditation on the sanctuary into the messianic future, the composition prefacing the Bible was also understood as a hint to the sanctuary of the future, to be reconstructed with the coming of the Messiah. The iconographical element that bears witness to this transformation is the image of the olive

Bible. Sanctuary implements. Spain, XIV cent. Parchment. 33.5 x 29.3 cm. London, British Library, Add. ms 15250. Folio 3 v-4.

Kennicott Bible. Sanctuary implements and ritual vessels. Spain. La Coruña, 1476. Parchment.
29.5 x 23 cm. Oxford, Bodleian Library, ms. Kennicott 1. Folio 121.

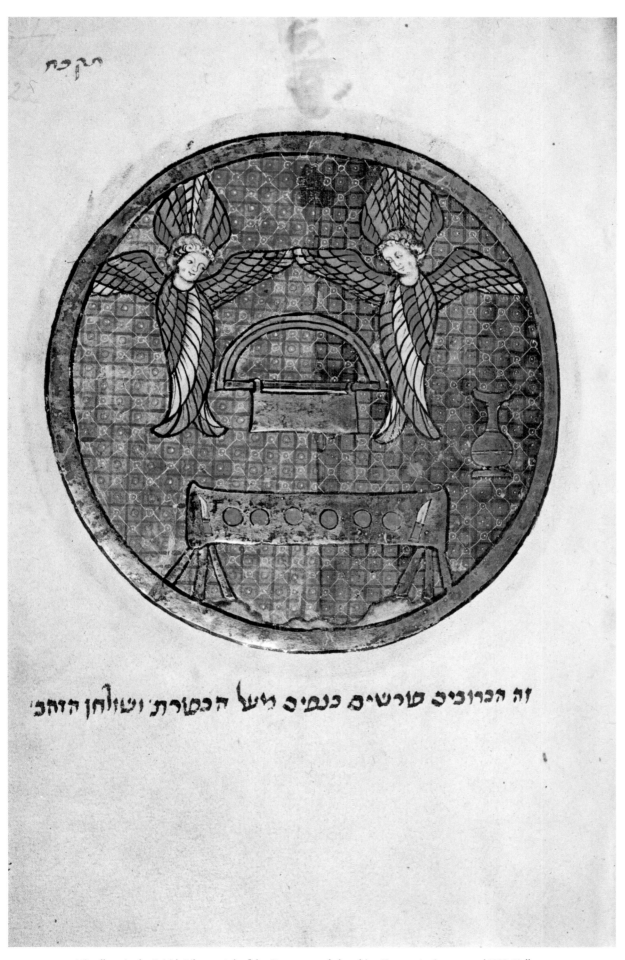

זה הכרובים פורשים כנפים ועל הכפרת ושולחן הזהב

Miscellany in the British Library. Ark of the Covenant and cherubim. France, Amiens around 1280. Vellum.
15.7 × 12 cm. London, British Library, Add ms. 11539. Folio 522.

tree, intimately linked in the book of *Zachariah* (IV, 11–14) with the eschatological vision. In the early period, this element, in the form of a hill bearing two or three olive trees, figures in a corner of the page, its scale, reduced in proportion to the implements, clearly indicates that it is an addition to the original repertoire. Exceptionally, in a Bible from Saragossa, dated 1404 (Paris, Bibliothèque Nationale, ms Hebr. 31), the Mount of Olives, in a full page illumination, forms the third wing of the composition. Elsewhere, only the last part is depicted by the representation of a candelabrum between two olive trees.[225] In one of the latest examples, the Kennicott Bible, illuminated in La Coruña in 1476 (Oxford, Bodleian Library, ms Kennicott 1), the composition is marked by a strange recrudescence of the ornamental trend, which transforms the symbolical composition into an abstract carpet page.[226]

Schematic outlines of the plan of the Temple, drawn for pedagogical purposes with no symbolic intention, occur at the beginning of two Bibles copied at an interval of only a few years, one at Toledo in 1300 (British Library, Or. 2201) and the other at Soria in 1306 (Oxford, Bodleian Library, ms Kennicott 2). In a second, parallel tradition, single objects, detached from the full-page composition, appear in the margins, illustrating the

Marseille Bible. Carpet page with palmettes. Spain, Toledo? around 1250. Parchment. 28 x 23.4 cm. Marseille, Bibliothèque municipale, ms. 1626/II. Folio 232 v.

Kennicott Bible. Carpet page with geometrical interlacings. Spain, La Coruña, 1476. Parchment. 29.5 x 23 cm.
Oxford, Bodleian Library. ms. Kennicott 1. Folio 352 v.

texts describing them. In a manuscript illuminated at Tudela in 1300 (Paris, Bibliothèque Nationale, ms Hebr. 20) the painter Joshua ben Abraham Ibn Gaon used the repertoire of the Temple implements for his first attempts at Bible illustration — a timid, but significant enterprise that inaugurated the insertion of narrative elements within the text. The illustrations of Joshua Ibn Gaon are not limited to the cultural symbols. Always in the margins, frequently in micrography, other objects make their appearance, including even animals connected with such episodes as Noah's ark, the sacrifice of Isaac, the exploits of David or the prophecy of Isaiah.[227] These figures stand on the frontiers of symbolical and narrative art. Their presentation in isolation derives from one, and the other is heralded by their intention to illustrate.

The long survival of symbolical art was one of the principal characteristics of the Spanish school. In northern European works, the pages with the Temple implements appear rarely. In Germany, the abstract character of the symbols found hardly any propitious terrain. In the French school, the Temple implements appear once, on a page of a manuscript that will be discussed in detail below (British Museum, Add. ms 11639). The ark, the shewbread table, the jar of manna here take on an aspect near to reality, and the faces of the angels are clearly expressed. The Gothic artist has lent human dimensions to the abstract symbols.

Pentateuch. Carpet pages with geometrical ornamentation, gold on parchment, outlines traced in micrography.
Egypt, c. 1010.

REMINISCENCES OF THE ORIENT

Multiple bonds existed with the East. As the iconographic traditions and the ornamental repertoire, the decorative methods of Arab painting penetrated also into the West. As in oriental books and Korans, in Hebrew manuscripts of the Bible, the ornaments were placed at the beginning and end of major sections, heads of chapters and of pericopes. The book as a whole opened on one or several carpet pages. They had no illustrative purpose; their function was that of a binding. The style of Koran ornamentation left a perceptible imprint on the carpet pages of the oriental school. Pages with a geometrical structure traced by lines of micrographic writing covering the entire surface, or decorated with a rosette painted in gold on the parchment ground, in a calligraphic frame, open a Pentateuch probably written at Fostat in the early eleventh century.[228] The abundance of gold, the stylized floral motifs and the tight compositions reflect the influence of local art. The new element, belonging to Jewish art, is the ornamental application of calligraphy, which the Arab Orient used only on monuments.

In Spain the ornamental carpet pages were at times joined to already executed manuscripts to embellish the opening or separate the sections. The texts of Bibles copied in different centers are decorated with identical carpet pages, probably produced by the same workshop, or according to the same model book. The page of a Toledo manuscript now preserved in Marseille (Bibliothèque Municipale, ms 1626/III) is adorned with a carpet pattern exactly like that of another Bible copied in the same period, in 1260, at Burgos (Jerusalem, Jewish National and University Library, Ms Hebr. 4°, 790).[229] These illuminations of the Spanish school have only their inner binding or separator function in common with those of eastern manuscripts. Their style, the use of varied colors, red, green, violet, for the backgrounds as well as for the ornaments, the floral motifs come from other sources. The double palm leaves, a heritage of Sassanide art, was elaborated and transformed in Islamic architectural decoration, and imported, via the Arab conquest from Palestine, through North Africa to the Iberian peninsula.[230] Another ornamental trend, characterized by elaborate interlacings, which shows affinities with 12th century Korans executed in Spain,[231] appears in the Kennicott Bible painted in La Coruña in 1476. The strange archaic style of this manuscript is probably due to the fact that the decoration was based on much earlier models, as it is proved by its colophon, which reproduces faithfully that of a Bible from 1300.[232]

Carpet pages with rosettes, outlined in micrography on a filigree ground, enclosed in floral borders, are characteristic elements of manuscripts produced in the last active peninsular workshop in Lisbon[233] (British Library, Or. ms. 2626-28). The four varieties of floral borders appearing in the Lisbon Bibles show the influences of Italian and Flemish painting, widely spread in fifteenth century Spain and Portugal. Another ornamental trend is attested in some Yemenite manuscripts, as a Bible from Sana dated 1475, in which Chinese motifs, carried by the Mongol invasion of the thirteenth century, were integrated into the repertoire.[234]

CALLIGRAPHY

A new type of carpet page was created by the ornamental use of script, a motif particular to Jewish art. Very decorative in itself, the Hebrew script was adapted in various ways to serve as an ornament. During the fourteenth and fifteenth centuries, still in Spain, entire pages inscribed with geometrical interlacings outlined by

Later Prophets. Carpet page with floral ornamentation. Yemen, San'a, 1475. Paper. 39.5 x 28 cm. London, British Library, Or. ms. 2211. Folio 1 v.

micrographic script replaced the floral carpet pages at the opening of the Bibles. Even the frame was composed of letters of varying sizes or, in some refined examples, by a filigree border traced in violet ink. The text of these carpet pages contained literary additions, textural apparatus, and sometimes, as on a page of a fifteenth century Bible, the entire text of the Psalms (Paris, Bibliothèque Nationale, ms. Hebr. 29).

Bible of Josuah Ibn Gaon. Calendar of festivals. Spain, Soria? c. 1310.
Parchment. 28.4 × 22.6 cm. Paris, B.N., ms. Hebr. 21. Folio 4 v.

The special organization of the carpet pages served as a model for the elegant layout of the calendars joined to the manuscripts. In two of his Bibles (Paris, Bibliothèque Nationale, ms. Hebr. 20 and 21) the painter Joshua Ibn Gaon inscribed the calendars of the festivals on rotating circles attached to the center of the page, and inserted in a rectangular framework. The spandrels are decorated with floral and animal motifs and human masks.

Initially the micrographic script allowed the scribes to place the sometimes profuse textual annotations in the margins. These annotations were often arranged in ornamental forms, ranging from simple geometrical forms to figures of living beings, and at times even constituting veritable illustrations. The Bible of Joshua Ibn Gaon has numerous examples of the kind in its margins.[235] The artist inscribed his signature and even the entire

בּרך תורה ה אלהים ולך העולם ולב חורה וחורה חוטן
עושה שלום ובורא אורكال אור עולם ונכר חיים
חודם מאוק{...} אמר ויהי

מדינה

Stuttgart Mahzor. Initial composed of the letters *aleph* and *lamed* (*El*). Reserved decor of zoomorphic silhouettes forms part of the letters. Germany, XIII cent. Parchment. 41.5 x 31 cm. Stuttgart, Württenbergische Landesbibliothek, Cod. Or. Fol. 42. Folio 15.

colophon in the marginal grotesques traced in micrography. The marginal micrographic illustrations also spread to the north. In the Pentateuch of the Duke of Sussex, executed by a German school of the 1300s (British Library, Add. ms. 15282),[236] the account of the sacrifice of Isaac is accompanied in the margin by the figure of the ram entangled in the bush, traced in micrography.

The ornamental letter as such is known in the south as well as the north. Silhouettes of hybrides and zoomorphic grotesques, spared on the ink ground of the characters, decorate the large letters of titles and initial words in most German manuscripts. Since Hebrew writing does not use capitals, the ornamentation of the single initial is exceptional. However under western influence, the ornamented initial appears sporadically in Spain, and more frequently, especially in the fifteenth century, in German and Italian manuscripts. The illuminator Joel ben Shimon[237] in his *Haggadah* in the British Museum (Add. ms. 14762) uses it quite frequently. The *Haggadah* in the Darmstadt Landesbibliothek (Cod. Or. 8)[238] has some initials enclosing not only ornaments, but even human figures.

In another kind of ornamental writing, the stems of the letters, transformed into grotesques or hybrids, or mask-like faces, form the actual body of the characters. Animal and man-shaped letters of this kind appear in some thirteenth century manuscripts from southern France, and a more elaborate type, in the colophon of Joseph Ha Sarfati (Joseph "The French Man") who decorated a Bible in Cervera in 1300 (Lisbon, Biblioteca Nacional, ms. 72), and which was copied 275 years later by Joseph ben Hayim in the Kennicott Bible.[239]

To embellish their copy, the scribes also had recourse to shaped script and ornamental lay-out of the script columns or of the marginal commentaries, in order to distribute in an aesthetic way the end of the text, or simply to end the uniform succession of the columns. Pages decorated with animal and grotesque figures occur even in treatises of religious thought or jurisdiction.[240]

Darmstadt Haggadah. Germany, XV cent. Parchment. 35.5 x 24.5 cm.
Hessische Landes- und Hochschulbibliothek, Cod. Or. 8. Folio 4.

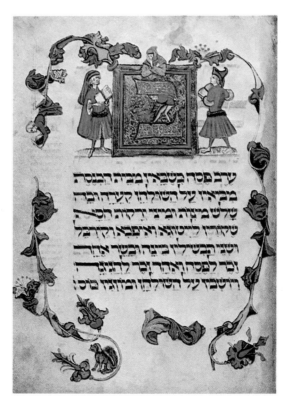

THE MYTHICAL UNIVERSE: SOUTHERN GERMANY

Narrative illumination appears approximately at the same time in southern and northern Europe. From the second half of the thirteenth century copies of the Bible, prayerbooks (*mahzorim*), juridical and scientific works were enriched by frontispieces, full or half-page illuminations and marginal scenes illustrating the text. The workshops of southern Germany and the Rhineland were among the most active centers to produce illuminated manuscripts. Characteristic productions of these centers are great folio Bibles and ritual manuscripts, as well as *Haggadot*, smaller in size, for family use. Although their style is diversified according to the geographical areas, the increasing number of historiated illustrations with human protagonists and the use of vivid contrasting colors surrounded by heavy black strokes are features common to most of them.

The subjects are drawn by preference from the *Midrash*, but Jewish legend is not the exclusive source. Themes borrowed from oriental mythology, and from Christian literary and iconographic sources are also integrated into the illustration of the Bibles and prayerbooks. The fantastic nature of the images is accentuated by that of people with bird or animal heads. These, it seems, owe their creation to doctrinal scruples, being the solution adopted in the face of the Ashkenazi Hassidim's opposition to the representation of human faces.[241] Their generalized use is one of the striking characteristics of Ashkenazi manuscripts of the thirteenth century.

The final illumination of one of the earliest Bibles of this school — the colophon indicates that it was written in 1236 for a commissioner of Ulm (Milan, Biblioteca Ambrosiana, ms. B. 30–32 INF.) — gives the iconographical transposition of the eschatological legend of the banquet of the righteous.[242] The literary theme is the final victory of the righteous over the cosmic forces, represented in the upper register by mythological animals: the ox, *behemot* or *shor ha-bar*, incarnating the forces of purity, the enormous fish Leviathan, curled in on himself, and a griffin, metamorphosis of the sun bird, *ziz*, Jewish adaptation of the phoenix. Although they were not regarded as demonic forces, these creatures were to be "consumed" by the righteous during the celestial repast, according to the legend.[243] In the lower register are the righteous, wearing the crowns of their virtues on their lion, ox and bird-like heads, assembled under the cool shadow of trees, about a table laden with golden dishes and various foods, while musicians with lion-cub heads enliven the feast. The vivid tones of red and blue, the drawing with its thick and firm lines, the lively attitudes, the expressive glances lend an appearance full of gaiety to the strange gathering. The theme of gigantic animals representing the cosmic forces has parallels in Persian cosmological tales: *kar*, the coiled fish, *sarsoak*, the pure beast, and *kark*, the griffin of triple nature.[244] Z. Ameisenowa even detects the influence of these legends in the Ulm Bible illumination in which the griffin replaces the bird mentioned in the Midrash.

The illustration of ritual manuscript (*mahzorim*) gave rise to an entirely new repertoire, now adopted in most of the *mahzorim*, with hardly any changes, however varying may be their style.[245] The liturgical hymns (*piyyutim*) and the Biblical pericopes were headed by narrative scenes created for this purpose. Some of these illustrations give the visual transposition of the contents, or of a characteristic element of it: others transpose the first word of the text. In some cases, these visual transpositions give a literal interpretation of the first word, disregarding the general context. Examples of these literal illustrations are the great romanesque gate surrounding the prayer "Blessed be Thou who opens for us the gates of mercy," found in most of the *mahzorim*, as well as the blooming roses painted at the heading of the *piyyut* "The roses of the valley."[246] In some cases a commentary attached to

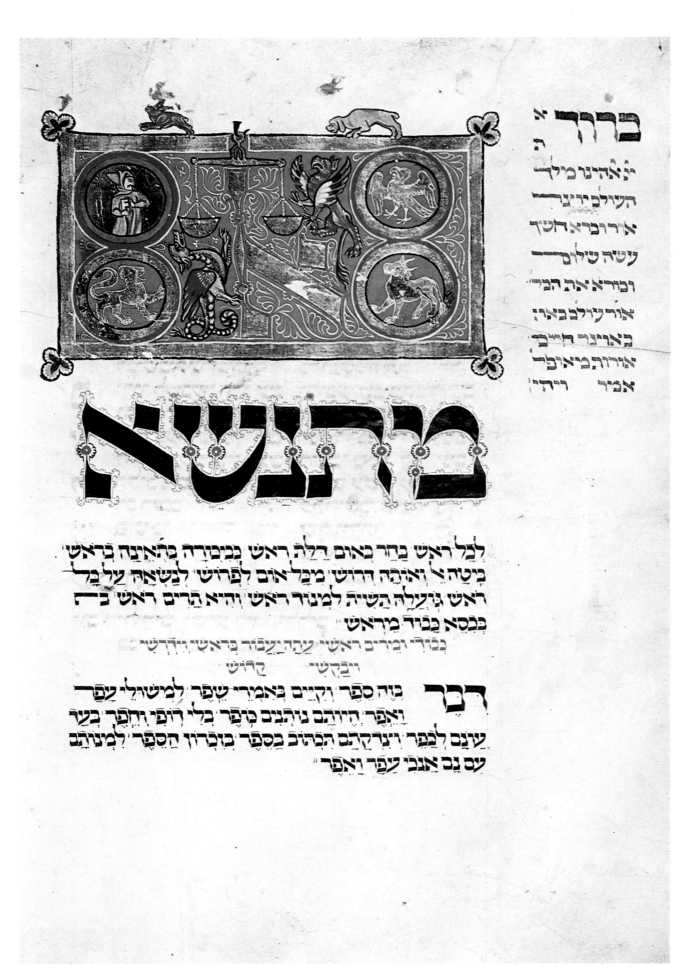

Leipzig Mahzor. Vision of Ezekiel. Southern Germany, around 1300. Parchment. 49.1 x 36.5 cm. Leipzig, Universitätsbibliothek, ms. V. 1102. Folio 31 v.

a *piyyut* influenced the artist and the addition of an iconographical element endowed the illustration with a new signification. In the Wroclaw *mahzor* the painter added to the romanesque gate five medallions, four of which enclose the four "living creatures" (*hayyot*), represented by an eagle, a man, a lion and an ox. The fifth medallion displays an empty throne. These five elements allude to the vision of Ezekiel (ch. I) describing the *merkavah*, the divine throne, empty because the one who is supposed to be sitting on the throne is beyond the realm of what

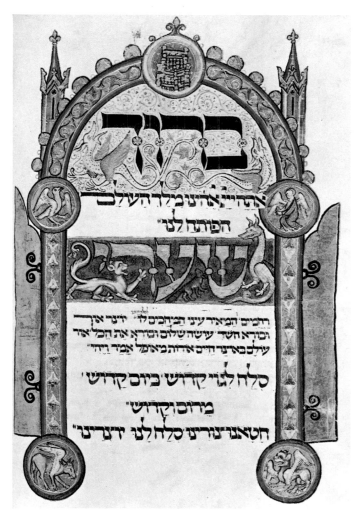

Wroclaw Mahzor. Vision of Ezekiel. Germany, around 1320. 54 x 38 cm. Wroclaw, Bibl. univ., ms. Or. I/1. Folio 89 v.

the human eye can perceive. Although the iconographical transposition of the *hayyot* was taken over from Christian art, the addition of the empty throne transformed the illustration into a genuine Jewish subject appropriated to the commentary based on Hassidic *merkavah* texts.[247] Another illustration in which the commentary has inflected the significance of the iconography is the money-changer in the first volume of the Worms *mahzor*. In a romanesque portal, a man weighing with a scale the *shekalim* owed to the Temple, illustrates the pericope of the week. By adding a devil who tries to draw on his side the scale, and also the captions "Israel" and "shekel" to the scales, the painter transformed the simple act of weighing the coins into a weighing of the souls.[248] The allusion to the Judgment of the Last Day is perceivable in the illustration joined to the same text also in the Leipzig *mahzor*.[249] In an ornamental frame, the group of letters *alef* and *lamed* — which forms the divine name *El*, first

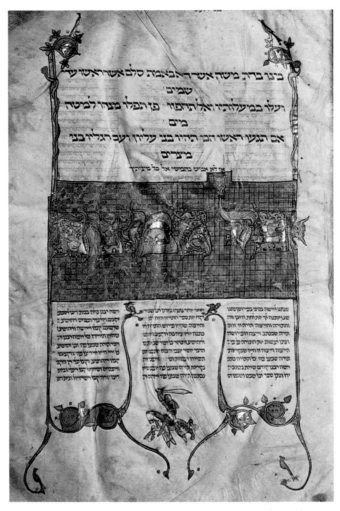

Judah Maccabee. France, 1296. Parchment. 50 × 35 cm. Budapest,
Tudományos Akadémia. Coll. Kaufmann, ms. A 77/1. Folio 2.

word of the text — occupies the center of the composition. A scale hangs suspended from the upper border of the frame. A dragon and a griffin stand erect on either side of the scales. Four corner medallions enclosing the emblems of the *hayyot* — man, eagle, lion and ox — indicate that the weighing takes place in the eschatological realm.

Texts of the main festivals were mostly accompanied by the illustration of the Biblical event which gave rise to the feast: the Israelites leaving Egypt for Passover, Moses receiving or delivering the Torah for *Shavuot*, the sacrifice of Isaac for the New Year. Some of these iconographical topics could have been created for the illustration of Bibles, as the tree with Aman and his sons hanging on it, which appears first in the Wroclaw Bible (Wroclaw, University Library, ms M 1106) written in 1236, before becoming a typical element of *mahzor* illustrations.

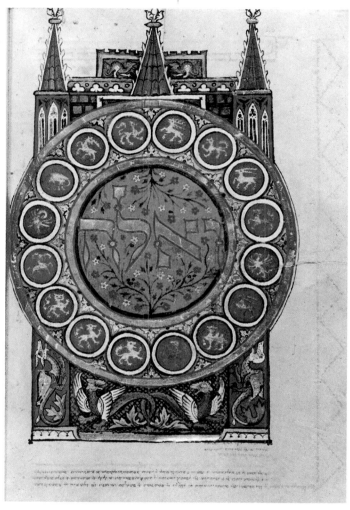

Pentateuch of the Duke of Sussex. Southern Germany, around 1300. Parchment. 22.8 x 16.2 cm.
London, British Library, Add. ms. 15282. Folio 75 v.

Narrative illustration attained its peak in the second quarter of the thirteenth century. Among the ritual manuscripts a new trend is represented by the three dispersed volumes of the tripartite *mahzor* produced around 1320 in a workshop located in the area of the Upper-Rhine.[250] The manuscript originally formed two volumes, and was divided in three at an unknown date, for a former owner, the volume now in the British Library having been constituted from two parts detached from those kept in Budapest and in Oxford.[251] The *mahzor* is decorated in the usual manner by initial word panels, some of which include narrative elements alluding to the text. Three of the paintings, at the beginning of the *Song of Songs*, the *Book of Ruth* and the prayer for *Shavuot*, display more elaborate compositions. King Solomon, the presumed author of the *Song of Songs*, is shown with the sword of justice

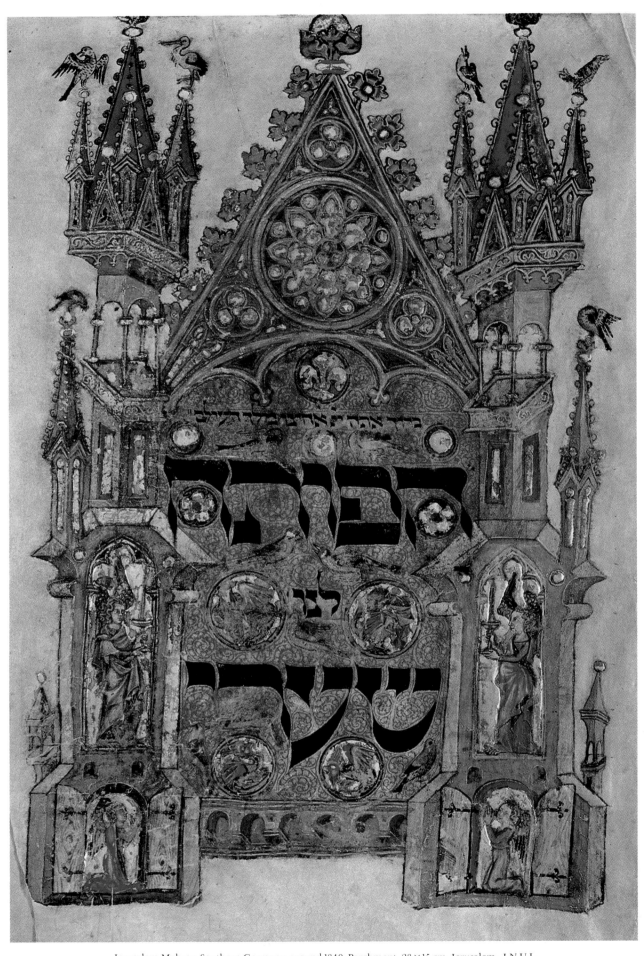

Jerusalem Mahzor. Southern Germany, around 1340. Parchment. 23 × 15 cm. Jerusalem, J.N.U.L.
ms. Hebr. 8, 5214. Folio 83.

186

in his hand, seated on his legendary throne whose steps are supported by lions and eagles. Near to him, in a gothic turret, are a scroll of the Torah and the eternal flame. At his left zoocephalic female figures in two super-imposed compartments allude perhaps to the visit of the Queen of Sheba (I *Kings* X, 1–13) and to the prostitutes of his celebrated Judgment (I *Kings* III, 16–27). On top of the *Book of Ruth* is the summarized iconographical transposition of the account, with Ruth following the harvesters and Boaz handing over the six measures of barley put in her mantle (*Ruth* III, 15 f). The painting at the opening of *Shavuot* shows Moses, followed by Aaron and the Israelites, receiving the Law.[252]

In these manuscripts the use of animal heads is no more systematic. The main artist's style, with the supple folds of the draperies bordered with white strokes, the smooth movements of the elongated bodies, the warm tones of olive green, yellow and ocre red, is related to Latin and German manuscripts of the Upper-Rhine.[253]

The latest of the group of large ritual manuscript, a *mahzor* now in the library of Darmstadt (cod. Or. 13) contains most of the subjects illustrating the ritual manuscripts but in a less refined technique. Its date, 1348, coincides with the spread of the Black Death which seems to have provoked an interruption in book illumination. Manuscripts produced in the middle of the fourteenth century display entirely different features. The large folio volumes are superseded by rituals of smaller size, the narrative scenes are abandoned for a highly refined ornamental art with almost no figural representations. Some reminiscences of the former iconographical subjects still survive, as the lacy portal illustrating the "gate of mercy" in a *mahzor* now divided between Vienna and Jerusalem, dating from c. 1360.[254] Parallel to this technical, aristocratic trend, a crude but lively popular art developed in the illustrations of the *Haggadot*, which contain a treasure of direct information about the daily life of fifteenth century Jewish communities in South Germany.[255]

THE MYTH IS HUMANIZED: FRANCE

The serene clarity of the Gothic paintings of the French schools stands in strong contrast to the imaginative world of the Ashkenazi illuminations. But their history is that of a beginning full of promise, an ephemeral episode, barely sketched out in the last quarter of the thirteenth century and brusquely interrupted in 1306 by the edict of expulsion. The rare surviving manuscripts of the northern French workshops bear witness to an artistic culture of high quality. A remarkable example of Jewish illumination, a Miscellany today in the British Library (Add. ms. 11639),[256] may be attributed to one of these workshops. The manuscript includes various texts, Biblical, liturgical and scientific, whatever a pious Jew might require to accompany his prayers or furnish material for his meditation. The scribe, Benjamin, signed his work in several places, without indicating the date or the place where he worked. The date can be established from textual criteria. The manuscript contains several calendars, the first referring to the year 1267; it also contains one of the earliest copies of Isaac of Corbeil's *Sefer Mitzvot Katan*, composed in 1278, and mentions, with the usual eulogies for the living, the name of R. Yehiel of Paris, who died in 1286. The manuscript was hence copied between these two dates, probably closer to the eighties. As for the place of origin, codicological and paleographic criteria confirm univocally that the manuscript was executed in northern France. The style of the paintings pinpoints the place of origin as Amiens.[257]

Destruction of Sodom. France, Amiens, around 1280. Vellum. 15.7 × 12 cm.
London, British Library, Add. ms. 11639. Folio 740 v.

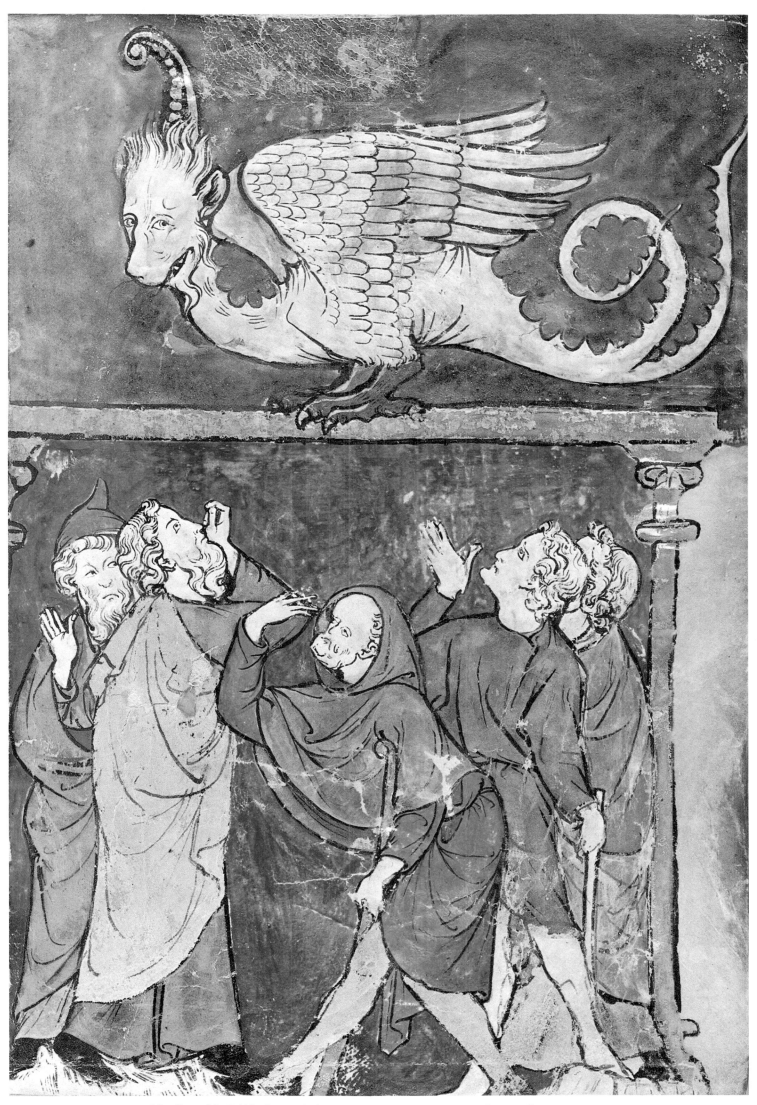

Miscellany of the British Library. The brazen serpent. France, Amiens around 1280. Vellum. 15.7 ×12 cm.
London, British Library, Add. ms. 1639. Folio 742 v.

The manuscript is profusely decorated with painted ornaments and animal figures, but it really owes its fame to forty-one full page paintings scattered through the codex in six sequences. These sequences are the contribution of four workshops, with two or three artists working in each. Three of the workshops were active when the manuscript was copied, as the scribe and the painters seem to have worked in close collaboration. The most representative painting of the first workshop is the image of Aaron lighting the Menorah (fol. 114v).[258] The elongated proportions of the slightly bent body, the smooth drapery falling in light folds, the pathetic face surrounded by curly hair colored yellow, show strong affinities with Latin manuscripts from the region of Amiens,[259] an area open to influences coming from England via Flanders, to France.

The paintings of the second workshop, most of them with Biblical subjects inserted within the text columns, have not only common stylistic features, but also a common ideological background. The chosen themes present in a concentrated set the events of Jewish history that are the tokens of God's providence, active through the mediation of the elected Biblical figures. Episodes from the life of Abraham, Lot, Judith, Esther and Daniel, as well as the deliverance from the slavery in Egypt, are evoked not only as events of the past but also as guarantees for the future. Stylistically these paintings are linked to another northern French school whose activity is again localized in the region of Amiens, either by historical data, or by calendars containing the names of local saints.[260]

The most celebrated paintings are those of the third workshop, composed by Midrashic and Biblical subjects, almost all of which are represented in *tondi*. These Biblical subjects — e.g. Solomon's Judgment, the temptation of Adam and Eve, Samson rending the lion, Noah's ark, the sacrifice of Isaac, David confronting Goliath — do not reflect a theological idea but point to the high deeds of the most popular Biblical heroes who have become assimilated to the heroes of romances and legendary accounts, the most flourishing and characteristic literary genre of this period. The gracious figures, sensitive faces framed by equally colorless hair, the sense of balance and harmony of the compositions, show affinities with a group of manuscripts executed by the Parisian artist Maître Honoré, or by his students. Even though the period of Maître Honoré's full maturity is linked to Paris by archive documents, he is known to have been born in Amiens. His earlier activity could well have taken place in his native city, a circumstance which could give account of the affinity between his works and the Hebrew Miscellany. Amiens, which appears as having been an important center of illumination in the third quarter of the thirteenth century, had also an active Jewish community.[261] The stylistical affinity between the paintings of the Hebrew codex and the Latin manuscripts of the area bears witness to the cultural exchange between the Christian and Jewish craftsmen. The Miscellany appears thus not only as an outstanding work of Jewish art but also as an important evidence of medieval history.

Before the end of the thirteenth century, another workshop situated in northeastern France in Lorraine produced the earliest known illuminated copy of Moses Maimonides' *Mishneh Torah*. The sumptuous four volumes codex, copied by Nathan b. Simeon Halevi in 1296, once in the collection of David Kaufmann, is now at the Hungarian Academy of Sciences in Budapest.[262] The fourteen books of the Code and the Introduction open on a full page frontispiece, decorated by painted initial words written in bold ornamental letters on colored ground, and stylized floral stalks running vertically next to the text columns to the upper and lower margins, where they frame the marginal scenes composed by grotesques, illustrations of animal fables and Biblical narratives. The Biblical scenes, representing Judah the Maccabee, Samson rending the lion, David and Goliath, the sacrifice of Isaac, Moses proposing the Law to the Israelites, Adam and Eve tempted by the serpent, are not illustrating Maimonides' text. They come from thirteenth century Latin Psalter illustrations that the painter of the codex

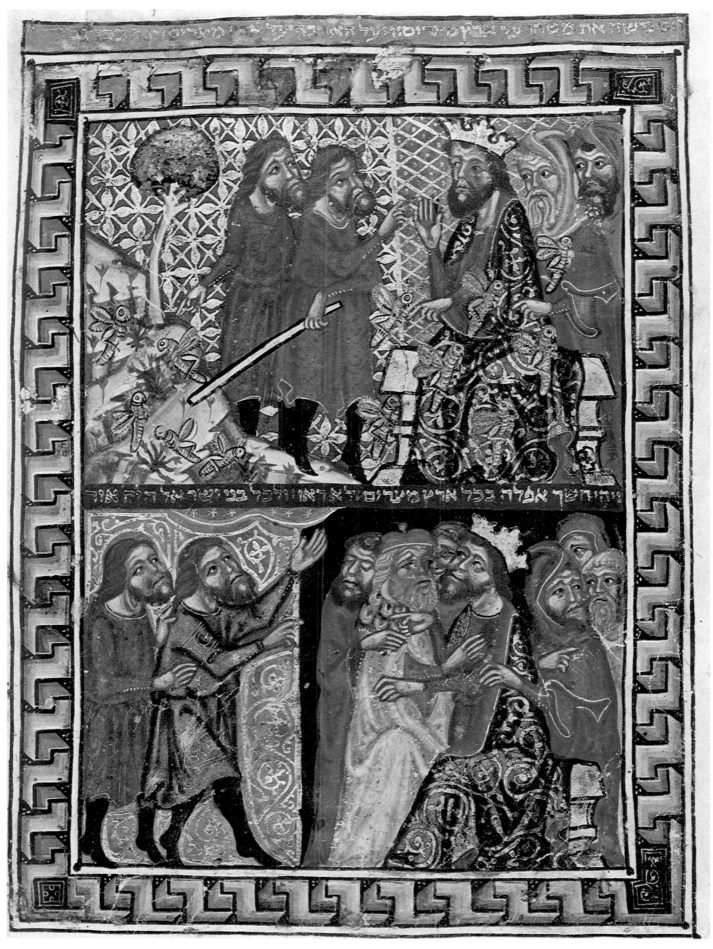

Haggadah. The plague of the locusts, darkness. Spain, XIV cent. Parchment. 27.5 × 23 cm. London, British Library, Or. ms. 1404. Folio 5 v.

Sarajevo Haggadah. The Creation. Spain, XIV cent. Parchment. 22 x 16 cm. Sarajevo, National Museum. Folio 1 v-2.

adapted by inserting them on a page where a word of the Code, or its commentary, offered the possibility of creating a link between the illustration and the text.[263] The ingenious adaptation of an iconography created for a different context could only have been the work of a Jewish artist with a first-hand knowledge of the *halachic* and exegetic background of the *Mishneh Torah* as well as of the iconographical topics to which he may have had access through a copy book taken from a Christian workshop. The Kaufmann *Mishneh Torah* is one of the last witnesses of Jewish book painting in northern France. It is, as the London Miscellany, evidence of the high quality of these workshops, and also of the free cultural exchange between Jewish and Christian artists in spite of the religious and political antagonism that led to the Expulsion of 1306, and hence to the end of all cultural activity. However, shortly before the extinction of this school, an unidentified workshop produced a quire with eight full-page paintings that were joined to the London Miscellany. Placed in *tondi*, these paintings repeat some of the subjects already found in the manuscript, as the destruction of Sodom or the Israelites with the brazen serpent. But the style, with the individualized passionate faces, the vivid polychromy, is that of the romance manuscripts of the first decades of the fourteenth century.

THE GOTHIC PERIOD IN SPAIN

The second quarter of the thirteenth century, when influences from France and Italy penetrated to Spain, also saw the flourishing of narrative illustration in Hebrew manuscripts. However, Bibles produced in the Peninsula, still under the remote influence of restrictions inherited from the east, have almost no narrative paintings. The ornamental carpet pages, joined to the beginning and the end of the volumes, were systematically placed outside the text. Within the text itself, only a few timid and sparsely scattered attempts may be observed to juxtapose an isolated marginal figure to some important passage. The Bible of Burgos[264] and the Bible of Cervera[265] contain a small number of these; the manuscript illuminated by Joshua Ibn Gaon at Tudela includes several.[266] These figures mark the transition from symbolical to narrative art: with the methods of the first, an approach is attempted towards the second. However, a new type of manuscript, appearing during the same period, gives a stimulating impulsion to narrative art. It is the *haggadah*, the Passover ritual, that constituted an autonomous volume offering a most convenient context for historiated illumination. Not subject to the restrictions surrounding the texts of the Bible, composed with didactic intentions especially for the education of children, present in each family for the Passover ceremony, the *haggadah* presented an open field to illustrators. The text, which differed only by minor variants in the Ashkenazi, Sephardi and Italian rites, was illustrated according to different methods in each. In the Ashkenazi and Italian *haggadot*, all the illustrations accompanying the text were placed in the margins. In Sephardic *haggadot*, the margins contained only the scenes relating to the rituals of the festival or those that explained the didactic allusions in the text. The Biblical event commemorated, the Exodus from Egypt, is illustrated in a series of full page paintings grouped outside the text, at the beginning, or, less frequently, at both the beginning and the end of the volume.[267]

Sometimes the Biblical cycles added to the *haggadot* are limited to the Exodus. Others also contain episodes from Genesis; the most comprehensive of these sequences, that of the *haggadah* of Sarajevo[268] covers the entire account of the Pentateuch, from the creation to the blessing pronounced by Moses before his death. The iconographic representations are similarly diverse; several scenes, in manuscripts of different provenance, make use of the same iconography; other manuscripts, stylistically close and perhaps produced in the same workshop, only partially agree in their versions. It is thought that the painters had at their disposal models containing detailed cycles, and that they selected the scenes according to their personal choice. No *haggadah* now known contains all of the possible scenes, so that it can be considered as identical with this presumed model. Besides, apart from the immediate model of the Spanish workshops, the veritable prototype of the *Haggadah* probably preceded the diversification of the systems of illustration, as the iconography of most of the ritual scenes is identical in the manuscripts of all three groups.[269]

The iconography of the Biblical cycles has many links with that of the psalters and historiated Latin Bibles of France and Spain. The originality and the specifically Jewish character of the *haggadah* iconography derives from the large number of Midrashic episodes interpolated into the Biblical narrative. Some of these elements, as we have seen, had already been used by the painters of the synagogue of Dura-Europos; their presentation in the frescoes and in the *haggadot* is similar. The Midrashic material of the latter is, nevertheless, incomparably richer. Although some of these legendary episodes coincide with representations that appeared during the course of the centuries in various Christian works of art, their great variety in subject and iconographic type indicates

a different source. The hypothesis of a richer model, embracing the whole Pentateuch, to which Jewish artists had direct access until a period close to the formulation of the *haggadot* in the thirteenth century, seems to be the only theory that offers a satisfactory explanation. No surviving evidence gives rise to a definition of the nature or the character of the manuscripts that may have been models for the illustrations of the *haggadah*. But the appreciable number of elements apparently arising from a common source makes it necessary to assume their existence.

During the first half of the fourteenth century, when most of the illuminated *haggadot* were produced, Jewish paintings in Spain combined the Mauresque heritage with influences from France and Italy. These three currents, discernible in varying proportions, also determined the style of the *haggadot*.

Moorish reminiscences are particularly perceptible in two manuscripts illuminated in the same workshop. The first — in the John Rylands Library in Manchester (ms. Hebr. 6)[270] — is the work of a technically trained artist who was an excellent draftsman. The painter of the second — now in the British Library (Or. 1404) — is superior in decorative talent. His tightly packed compositions, the lack of depth, the alternation of entirely flat vivid color patches and surfaces loaded with lavishly gilded ornamentation, recall Mauresque ornamental carpet pages. Only the figures, especially in the facial modeling, reveal the influence of Italian art.

This influence is more strongly felt in a *haggadah* of some decades later, now in the National Museum of Sarajevo.[271] Its fame is chiefly due to its comprehensive cycle of Biblical illustrations, embracing the entire Pentateuch from the creation — rarely represented in Hebrew manuscripts — to the death of Moses. The chequered backgrounds of the scenes, the unindividualized surroundings, still belong to the Gothic tradition. But the treatment of the figures, the warm tones applied in thin layers, and some architectural elements represent the Italian influence. In the drawing of people, the painter's resources seem to have been limited; the faces, only slightly modeled in grisaille, are all uniformly in three-quarter profile and owe a certain vivacity to their expression alone. The clothes do not reveal shape or movement; the drapery, barely indicated by touches of tonal gradation, remains schematic. The first two pages of the cycle, devoted to the creation, are distinguished from the others by their sustained coloring and their firmer drawing. The successive phases of the creation are illustrated in eight compartments, four to the page: the Divine Spirit, in the form of luminous rays, hovering over the darkness; the separation of light and dark; the successive appearance of the firmament, the terrestrial globe with plants, luminaries, animals and man. In each of the first seven compartments concentric arcs indicate the cosmic space in which the action takes place. The eighth compartment, which corresponds to the seventh day, shows a man in meditation: this is the faithful observing the Sabbath repose. This iconography, without parallel in Jewish art, is also far removed from the formulas of Christian art. It is especially distinguished from the latter by the absence of the Creator, whose representation was inconceivable to a Jewish artist, while He appears often in the Octateuchs and in most Latin manuscripts. Among the latter, only one group presents affinities with the iconography of this *haggadah*. The Bibles of Pampeluna[272] contain a cycle of the creation in which the successive appearance of created beings is represented on globes, as in the *haggadah*, without the image of the Creator. We cannot know whether the painter of the *haggadah* used one of these manuscripts, or if the Christian artist had seen a Jewish model similar to the prototype of the Sarajevo *haggadah*. The second hypothesis cannot be rejected, for these Bibles, considerably earlier than the Sarajevo manuscript, contain several illustrations of Midrashic episodes.[273]

One of the finest of Jewish illuminated manuscripts, the *Golden haggadah* (British Museum Add. ms. 27210), given this name because of the sparkling backgrounds of its paintings, attests by its style the spread of the French influence.[274] The manuscript is from a Catalonian workshop, probably in Barcelona, where the French style

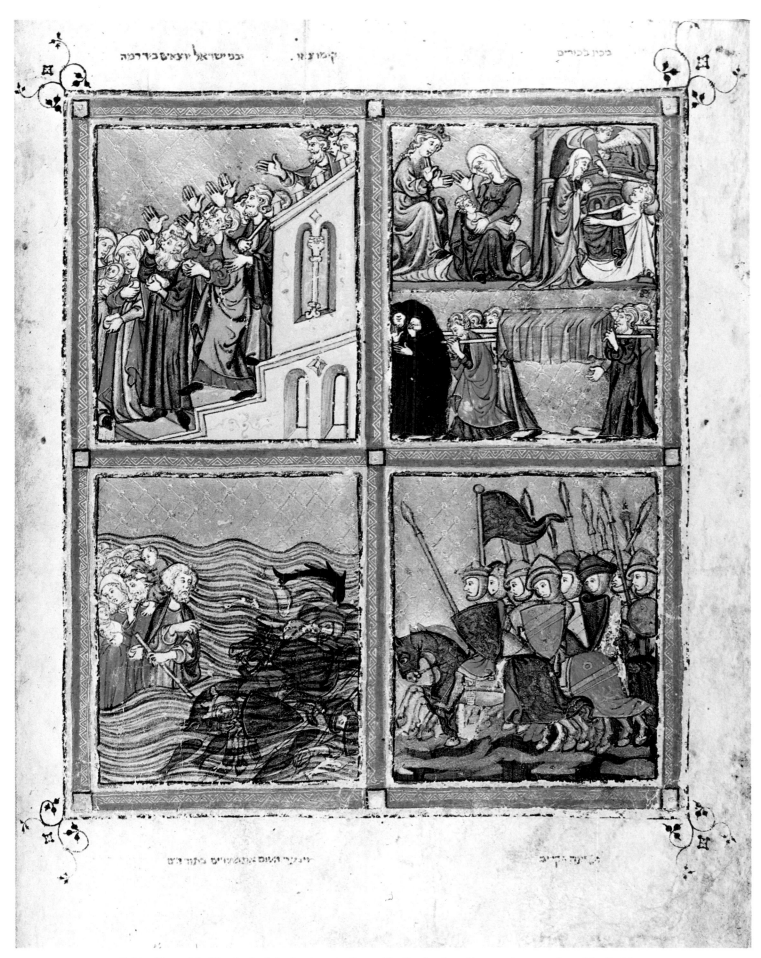

Golden Haggadah. The death of the first-born in Egypt. The Exodus from Egypt and the crossing of the Red Sea. Spain, Barcelona?, around 1320. Parchment. 24.7 x 13.5 cm. London, British Library, Add. ms. 27210. Folio 14 v.

Miscellany from Hamburg. Betrothal. Italy, Padua, 1477. Parchment. 15.2 x 11.5 cm. Hamburg, Staats- und Universitätsbibliothek, Cod. Heb. 337 (SCRIN 132). Folio 75 v.

predominated in the first quarter of the fourteenth century. The two first quires of the manuscript contain illustrations of Biblical episodes, from Adam naming the animals to the dancing Miriam. The Biblical cycle of this *haggadah* is particularly rich in Midrashic material. The iconography of the paintings has numerous affinities with the historiated French Bibles, with contemporary French psalters, and in certain scenes, especially the first, with the eleventh century Octateuch in the Vatican (ms. Gr. 747). The similarities between the iconography of the *haggadah* and of the Octateuch are the most difficult to explain. The two manuscripts are widely separated in time, and no possible intermediate manuscript has been identified.[275]

The two quires are illuminated by two different hands, each painter having illustrated one quire. The two artists worked in the same style and probably belonged to the same workshop, but it is especially the second whose style follows closely that of the Parisian school. He was perhaps Parisian in origin, since Barcelona at that period was the favorite refuge for fugitives leaving France after the expulsion of 1306. His figures appear with natural expressions, faces lightly modeled in grisaille, and their eyes sheltered under prominent eyebrows surrounded by abundant curled hair like an ornament. Their gestures, rendered vivid and expressive by hands that are at times somewhat emphasized, add animation to the scenes. The landscape elements that situate the episodes without recreating its realistic setting, help to unify the compositions. The architecture, with the sometimes unsuccessful attempts at corrrect perspective, indicates that the Italian influence was already present in the Iberian peninsula.

ITALY

The illumination of Hebrew manuscripts reached its culminating point at the end of the fifteenth century in the workshops of northern Italy. This was also to be its end before engraving evicted it from the printed books.

From the great masters of the Renaissance Jewish painters learned perspective and the faithful representation of nature; genre scenes with individualized interiors took the place of flat surfaces and an atmosphere filled with a luminous haze created an illusion of depth in the landscape scenes. Curiosity grew. The profane sciences, animals, the humble events of everyday life became as worthy of interest as the heroic episodes of a remote past, and even these, to be understood and appreciated had to match in luxury the surroundings of wealthy contemporaries.

Hebrew manuscript workshops flourished in all the major cities of northern Italy. Very few specifically Jewish features distinguish their production from contemporary local illumination. Only the sometimes intimate link between the image and the text, or the evident familiarity with the rituals and customs, indicates that the painter knew the material at first hand. These criteria in their turn are sometimes rendered ambiguous by the secularization of Jewish life itself. In a Miscellany compilation of halachic treatises, copied at Padua in 1477, now in Hamburg (Cod. Hebr. 337) one of the illuminations represents a betrothal scene. The event takes place in the open air, under a deep blue sky before a bare rock. The luxuriously dressed couple exchange rings, with a dog as sole witness. The painting, added later to the manuscript, originated in a Venetian workshop whose activity is attested in some other contemporary Hebrew manuscripts.[276]

Sometimes a secondary detail, a reminiscence of an iconographic theme typical of Jewish art, helps to identify the painter. This is the case in a manuscript of Avicenna's *Canon*, of the University Library of Bologna (ms. 2197),[277] illustrated with paintings in the style of the Ferrarese school. Half page illuminations on the opening

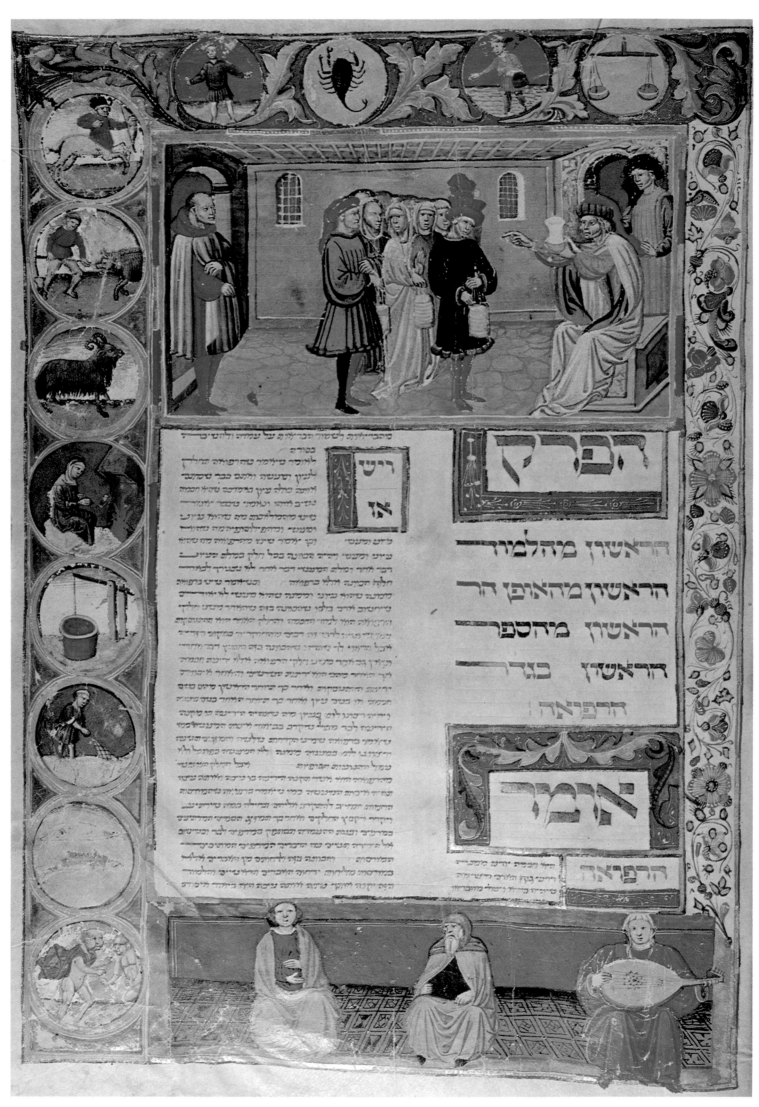

Canon of Ibn Sina. The teaching of medicine. Framed in the signs of the Zodiac and the Liberal Arts.
Italy, Ferrara?, XV cent. Parchment. 43 x 29 cm. Bologna, Biblioteca Universitaria, ms. 2197. Folio 23 v.

Judith and Holophernes. Judah Maccabee. Ferrara?, around 1470. Vellum. 21 x 16 cm. Jerusalem, Israel Museum, ms. 180/51. Folio 217.

pages of the four books of the *Canon* adorn the manuscript. That of the first book represents a master of medicine, alembic in hand, lecturing to his attentive disciples. The natural attitudes, the expressive faces, the supple draperies and the perspective of the frame are the work of an artist of quality. He is also responsible for the border, which has three figures personifying the liberal arts in the lower part. In the medallions on the top and sides the signs of the Zodiac complete the allusions to the arts and sciences. The signs of the Zodiac belong to the familiar repertoire of Hebrew manuscripts, especially the prayerbooks, where they often figure in the margins of liturgical poems that enumerate them. Of these signs, only the Water carrier departs from the common type of symbol. In all the Hebrew manuscripts, the Water carrier is represented by a well to which a pail is attached, because of the Hebrew name of the constellation, *deli*, which means pail. This is the version used by the Ferrarese painter. This secondary detail is like the signature of the Jewish painter, whose hand can be recognized in all the paintings of the manuscript.

The greater number of the manuscripts, even during the fifteenth century, are copies of the Bible. Certain books of the Scriptures also form separate volumes, written for the use of private owners, who often entrusted them to painters for enrichment. These Biblical images of the Renaissance have nothing in common with the heroic world of Romanesque and Gothic painting. It is daily life, elegant certainly, but eminently human, that animates them. A manuscript of small format, the work of a Florentine workshop, recently acquired by the Israel Museum, Jerusalem (ms. 180/55), contains three books only, *Psalms*, *Job* and *Proverbs*. Each book begins with

The battle against Sihon and Og. Ferrara?, around 1470. Vellum. 21 x 16 cm. Jerusalem,
Israel Museum, ms. 180/51. Folio 164.

a full page illumination, surrounded by a rich floral border. They represent the "author" of each book in a characteristic episode of his life. David triumphs over Goliath, Job, covered with ulcers, is seated in the ashes before his friends, and Solomon delivers his famous judgment. The legendary element — the miraculous throne — is lacking; absent also is the desire to arouse solemn feelings. The elegance of the drawing, and the harmony of the colors and forms absorb the painter's entire attention.

Mantua Haggadah. 1568. Woodcuts. Paper. 30 x 22 cm. Jerusalem, Israel Museum.

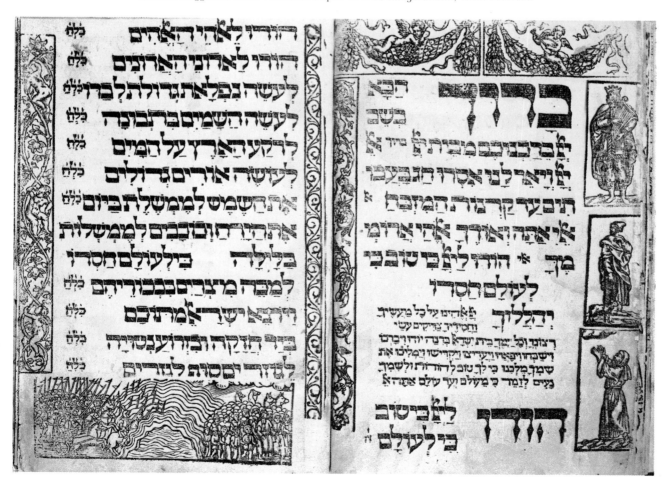

To the Ferrara workshop also should be attributed one of the most precious illuminated Hebrew manuscripts. The great number of illuminations with ritual subjects, and the sure knowledge of Jewish customs make probable that the painters — there were at least three — were Jews. The manuscript, bequeathed by the Rothschild family to the Israel Museum (ms. 180/51)[278] contains an anthology of Biblical, ritual and literary texts, on more than 470 leaves, almost all illuminated. Biblical and secular subjects, or animal fables, are illustrated in the form of miniature pictures, placed in the text or in the margins. Each is an outstanding work, highly sophisticated in technique, reflecting the high quality of book painting in the fifteenth century. The graceful figure of Judith before the sumptuous tent of Holofernes, in a setting of flowing draperies and gay colors, hardly evokes a premonition of the approaching tragedy. The battle against the kings Og and Sihon (*Numbers* XXI, 21–35), who are mounted on white chargers, takes place in the sunny landscape of the Emilian hills.

At the end of the fifteenth century the art of illumination began its slow decline. For a time it survived in the printed book. Bibliophiles readily confided their incunabulae to be decorated by hand, while painters prepared the models for the first engravings.[279] The *Esther* scrolls and the marriage contracts, obligatorily executed by hand, perpetuated illumination in a form perhaps less refined but not stultified. An eighteenth century revival in Holland and Germany gave rise to the fashion of *haggadot* whose margins were enlivened with small genre scenes, almost unvarying copies of the celebrated engraved *haggadot* published in Mantua, Venice, Amsterdam and Prague, which borrowed part of their iconography from the illustrations of contemporary Christian Bibles.[280] Autonomous painting, which in the West inherited the artistic experience accumulated during the centuries by the illuminators, did not suscitate vocations among Jewish artists until after the Emancipation. This intellectual current, so fertile in certain domains, was to provoke a profound change of direction in art, especially in painting. The search for a new aesthetic led progressively to the abandonment of the traditional norms, while the symbols and iconography inherited from the past were eliminated from the repertoire.

EPILOGUE

The history of Jewish art, from its beginnings in the first decades of our era, until the eighteenth century — the chronological landmarks fixed for this survey — is that of the two forms of visual expression that fashioned it: symbolic language and narrative iconography. These two factors, in differing weights but in permanent association, are present at every step of its evolution. Both issue from the same historical event: the confrontation of the Jewish people with the Greco-Roman world. The formulation of symbols responded to the necessity of reinforcing the spiritual cohesion endangered by geographical dispersion, and the need to affirm national unity lost on the stage of history.

The iconographic narrative arose out of more intellectual impulses. In a specifically Jewish form, it was designed to offer the cultivated classes the equivalent of one of the most attractive aspects of Hellenistic culture. At the same time it opened up a road for the diffusion of Jewish culture in the surrounding world. In assuming the form of a commentary on Biblical history, narrative art did not become less of a privileged instrument in sustaining the hope for national rebirth.

Identity, religious as much as national, and the hope of restoration sum up the ideological foundations of Jewish art. The repertoire of sacred symbols and Biblical iconography, the latter enriched by Midrashic elements, constitutes the language that transmits them. With a constancy impervious to change of environment, through filiations whose missing links can only be conjectured, Jewish art remained faithful to its vocabulary throughout its history.

The tenacious continuity of the themes is in striking contrast with the heterogeneity of style that was manifested in each successive period. This wide diversity led nineteenth century historians to the conclusion, perhaps too hastily formulated, that Jewish art lacked recognizable identity. This way of looking at the question suffered, it would seem, from a distortion caused by a perspective that tend to isolate the products of Jewish civilization from their historical contexts.

From the Roman conquest to the recent creation of a national state, the Jewish people has been composed of spiritual families restricted in number and geographically scattered, whose material civilization has been that of the countries in which they settle. During late Antiquity, the Jewish civilization of the Orient belonged to the Hellenistic world, as did the cultural patterns of its neighbors. It was the same in Europe, where the culture and art of the Jewish communities living in the West formed an integral part of European culture and art. The connections were multiple, and were manifested in all spheres. In art, the most evident marks of this symbiosis were carried by the styles and techniques. Even the iconography is not always exempt from the influence of the surrounding art. But the derivation was not always one-sided. If Jewish art was most often the receiver, it did not always remain restricted to this role. The elaboration of Biblical iconography, a fundamental element in the formation of Christian art, is the most eloquent witness to this fact. There can be no doubt that this is one of the most fruitful contributions of Judaism to the artistic civilization of the West. It does not stand alone. Certain methods of ornamentation, certain motifs, the organization of the decor in the art of the illuminated book in certain regions, notably in Spain or in the East, also testify to their Jewish sources. Certainly, in the architectural techniques or in work in precious metals, the part played by Jewish artists, especially in Europe, is negligible. But how were the Jews to perfect an art whose practice is forbidden? In these two domains, only the principles

inherited from Antiquity, and the forms consecrated by centuries of use belong properly to Jewish art. This alienation of techniques did not, however, affect the survival of the symbols, which remained immutable. The Jewish art of the Middle Ages is the faithful mirror of a people who, while sharing the material civilization of the countries where fate had placed them, never ceased to cultivate the acute conscience of an intransigent intellectual particularity.

The social trammels and material restrictions that existed throughout the Middle Ages certainly contributed to the preservation of the essentially intellectual character of Jewish art. In practice, they obliged it to adhere to its first vocation: teaching. It remained a hieratic art that delivered its message in symbols, taught the great principles of the faith through narrative cycles, and preserved its didactic character even under the appearance of popular art.

This intellectual exclusivity carried within itself the germs of decadence. Paradoxically, this tendency was first manifested during the epoch of the great social revolutions of the eighteenth century — chiefly the French revolution — to which the related movement of the Emancipation corresponded. While these revolutionary movements favored the suppression of social barriers, the Emancipation provided the stimulating impulse that drew the Jewish artist out of his isolation. Attracted by new horizons, these artists abandoned the enclosed terrain of tradition and wholeheartedly adopted contemporary aesthetic expressions. Jewish art renounced its exclusive role, that of the transposition of the Word, and the search for formal harmonies gradually led to the suppression of the hierarchy between the contents and the medium. In this system of new values, traditional art had no mission to fulfill. It survives in synagogue architecture and in ceremonial art to serve the imperative needs of religious life, and in the works of isolated artists striving to resume ancient traditions and reconcile them with the new aesthetic norms.

GLOSSARY

Agadah, Hebrew "sayings;" this appellation groups the legends, homilectic elaborations, maxims of the sages and anecdotes recorded in the Rabbinical literature, but does not include the religious laws (for these, see *halakha).*

Amora (Pl. *amoraim).* Title carried by the rabbis of Palestine and Babylon from the third to the sixth centuries. Their teachings, the *gemara* explicates the *Mishnah,* and, together with it, constitutes the Talmud.

Aravah. See *Etrog.*

Ashkenazi. A Biblical term. Used since the Middle Ages to designate a region of Jewish culture comprising France to the north of the Loire, the Rhineland, the present Germany (East and West), and eastern Europe.

Baraita. Aramaic for "exterior"; collection of the teachings of the rabbis of the first two centuries of our era, not included in the *Mishnah.*

Behemot. Also called *shor habar.* Legendary beast that at the end of days will engage in mortal struggle with the Leviathan; its flesh will be consumed by the Righteous at the eschatological banquet.

Bima. Transliteration of the Greek βῆμα. Used since the Talmudic period to designate the reader's platform in the prayer hall.

Etrog. Hebrew for citrus fruit. One of the four species (with the *lulav,* palm branch, *hadas,* myrtle, and *aravah,* willow) that constitute the ritual sheaf used in the Feast of the Tabernacles services (see *Sukkot.)* It is often represented alone or with the *lulav,* or else in a symbolical composition evoking the implements of the Sanctuary.

Gemara. Aramaic for "completion." Designates the collection of the analyses and discussions of the *amoraim* on the *Mishnah.* It is the indispensable complement of the *Mishnah* and together with it forms the Talmud.

Geniza. Depôt of sacred books no longer in use. The celebrated *geniza* discovered in a medieval synagogue in Fostat at the end of the nineteenth century contained a large number of ancient manuscripts.

Hadas. See *Etrog.*

Haggadah. Passover eve ritual intended for family use. It contains an account of the Exodus from Egypt, together with the prayers and liturgical poems appropriate to the ceremony. Since the thirteenth century the *haggadot* have been independent books, liberally decorated and illustrated.

Halakha. Ritual laws and laws of social and personal conduct contained in the Talmud.

Hanukah. Feast of the Dedication, commemorating the restoration of the cult in the purified Temple after the victory of Judah Maccabee over the armies of Antiochos Epiphanes in 163 B.C.E. During the eight days of the festival, an additional candle is lit every evening, reaching eight on the last day. One of the names of the festival is the "Feast of Lights."

Haroset. Dish made with nuts, apples and wine, served at the seder. It symbolizes the mortar the Israelites used in building cities for their Egyptian masters.

Hassidim. Mishnaic term, lit. "devout." Applied in the Middle Ages to the adherents of an ascetic trend current in Germany from the eleventh to the thirteenth centuries. It should be distinguished from the messianic movement of the eighteenth century, popularly known as "Hassidism."

Hazzan. The officiant who leads the liturgical singing and the communal prayers in the synagogue.

Hiddur Mitzvah. Embellishment of the *mitzvot.*

Ketubah. Hebrew for "written document." Marriage contract given to the bride, specifying the obligations of the husband in case of divorce, and the material compensations assured to the wife in case of widowhood.

Leviathan. Gigantic fish which, according to the legend, will emerge from the sea in the messianic age and will be vanquished in combat with *Behemot.* Its flesh will be served to the Righteous at the messianic banquet.

Lulav. See *Etrog.*

Mahzor. Hebrew for "cycle." In the Hellenistic period used to designate the cycle of prayers. Since the Middle Ages used as the name of the prayerbook containing the prayers and the liturgical poems belonging to the festivals of the entire year.

Maror. Bitter herb. Dish served at the *seder* to symbolize the bitterness of the Israelites' slavery in Egypt.

Marranos. Jews of Spain and Portugal, forcibly converted to Christianity, who secretly continued to observe the religious practices of Judaism. The appellation was extended to include their descendants who settled principally in the Netherlands.

Massorah. Hebrew for "tradition." List of variants relating to the oral regulations for the correct transmission of the orthography, vocalization and notation of the biblical text. Biblical manuscripts often include the *massorah magna*, the principal variants, written in the form of lists at the beginning and end of the manuscripts, as well as on the upper and lower margins of the pages, and the *massorah parva*, brief notes recorded in the side margins.

Massoretes. Authors of the *massorah*.

Matzah. Unleavened bread, the only kind authorized during the eight days of the Passover festival.

Megillah. Hebrew for "scroll." Can be applied to every ritual manuscript, including the Bible, written in the form of a scroll. The term is used more particularly for the Book of *Esther* when it is copied on a scroll for ritual reading on the occasion of the *Purim* festival. The following hagiographic books are called the "five scrolls:" the *Song of Songs*, read at Passover, the Book of *Ruth*, read at the Festival of Weeks (see *Shavuot*), the Lamentations of Jeremiah, read on the Ninth of Av, anniversary of the destruction of the Temple in 70 C.E., *Ecclesiastes*, read as part of the service during the Feast of the Tabernacles (see *Sukkot*), and the Book of *Esther*, read during the *Purim* service.

Mezuzah. Hebrew for "doorpost." Sheath containing a small scroll of parchment with the Biblical verses *Deuteronomy* VI, 4-9 and XI, 13-21. It is attached to the doorpost of every room of habitation in a Jewish house. The same verses are enclosed in the *Tefillin*.

Menorah. Hebrew for "lamp." The specific name of the seven-branched candelabrum whose prototype was fashioned for the Tabernacle of the desert. Its image became the central symbol of Judaism.

Midrash. Hebrew meaning "calling-for." Homilectic exegesis of the Scriptures. The great Midrashic compilations contain for the most part comparative Biblical material explicating the books of the Bible verse by verse. The compilations were made over a long period, from the third century B.C.E. to the twelfth C.E., chiefly in the fifth and sixth centuries.

Mishnah. Code of ritual laws and precepts conceived and edited by the rabbinical doctors at the end of the second century. The principal redactor of the Mishnah was Rabbi Judah Hanasi, president of the Sanhedrin.

Mitzvah. Hebrew for "precept or commandment." Judaic religious law prescribes 613 precepts, a number that corresponds to the parts of the body.

Nakdan. Hebrew for "punctuator." Scribe charged with the vocalization and notation of the Biblical text and the copying out of the *massorah*.

Parasha. (Pl. *parashiyot*). Hebrew "pericope." Name of the section for the weekly Sabbath readings, according to the annual division of the Pentateuch.

Pesah. The Passover festival. The term is used in token of the sparing of the Israelites when the angel of death slew the firstborn of the Egyptians.

Piyyut. From the Greek *poietes*. Liturgical poems inserted into the festival services from the third or fourth century onwards.

Purim. Festival fixed on the 14 or 15 of the month Adar of the Hebrew calendar, commemorating the deliverance of the Jews of Persia from the intrigues of Haman, thanks to the intervention of Queen Esther and her uncle Mordechai. The history of this deliverance is told in the book of *Esther*.

Seder. Hebrew "order." *Pesah* (q.v.) eve ceremony, celebrated in the Jewish home in memory of the departure from Egypt. The ceremony includes a ritual meal and the reading of the *haggadah* (q.v.).

Shavuot. Feast of Weeks. Held seven weeks after *Pesah*, to commemorate the revelation of the Torah to Moses on Mount Sinai. It was also the festival of the presentation of the first fruits at the Temple.

Shema. Hebrew "listen." *Deuteronomy* 6:4; the first words of the confession of faith, proclaiming the unity of God; it is uttered in the morning and evening prayer, and is included in the *tefillin* (q.v.) and *mezuzah* (q.v.) scrolls.

Shofar. Ritual trumpet prepared from a ram's horn according to precise prescriptions, and sounded on New Year's Day.

Siddur. Hebrew "arrangement." Book of daily prayer.

Sidra. Aramaic "order"; name of the pericopes for the weekly Sabbath readings according to the triennal division of the Pentateuch.

Sukkot. Festival of the Tabernacles. It commemorates the sojourn of the Israelites in the desert. It was also an agricultural festival in the biblical period, celebrated at the end of the harvest. The pious spend the eight days of this festival in a leafy booth.

Talit. Shawl with fringes, worn during the prayer.

Talmud. Body of traditional teaching based on the explication of the Mishnah. The Talmud of Jerusalem, compiled between 350-400 C.E. contains the teachings of the rabbis of Palestine. The Talmud of Babylon, whose redaction was completed by the end of the fifth century, contains the

teaching of the rabbis of the oriental schools. During the Middle Ages the Babylonian Talmud became the most important source of rabbinical teaching.

Tanna. (Pl. *tannaim*). Aramaic "teacher." Title given to the rabbis of the first and second centuries whose teaching is recorded in the *Mishnah* (q.v.).

Targum. Hebrew "translation." Aramaic paraphrase of the Bible, which includes, as well as the translation proper, also exegetical and midrashic material. The best-known versions are the Targum Onkelos, the Targum of Jerusalem, called "Fragmentary" and the Targum of Jonathan.

Tefillin. Phylacteries worn during the morning prayer, bound to the forehead and left arm.

Torah. Hebrew "teaching." The Five books of Moses, or Pentateuch.

Tosefta. Aramaic "addition." Teachings of the *tannaim* (q.v.), referring to the Mishnah, whose sequence they follow.

Ziz. Legendary bird of great size whose feet rest on the earth and whose head touches the heavens. Like *Leviathan* and *Behemot*, it will be consumed by the righteous at the eschatological banquet.

NOTES

ABBREVIATIONS

BASOR *Bulletin of the American Schools of Oriental Research*

BIES *Bulletin of the Israel Exploration Society*

BJPES *Bulletin of the Jewish Palestine Exploration Society*

BJRL *Bulletin of the John Rylands Library*

EI *Eretz Israel*

HUCA *Hebrew Union College Annual*

IEJ *Israel Exploration Journal*

JAOS *Journal of the American Oriental Society*

JJA *Journal of Jewish Art*

JJPES *Journal of the Jewish Palestine Exploration Society*

JPOS *Journal of the Palestine Oriental Society*

JQR *Jewish Quarterly Review*

JWCI *Journal of the Warburg and Courtaued Institutes*

MGWJ *Monatsschrift für Geschichte und Wissenschaft des Judentums*

PEF Q.ST. *Palestine Exploration Fund, Quarterly Statement*

PEQ *Palestine Exploration Quarterly*

PJES *Palestine Jewish Exploration Society*

PL *Patrologia Latina, ed. Migne*

PSBA *Palestine Society*

QDAP *Bulletin of Archeologie Quarterly of the Department of Antiquities in Palestine*

RA *Revue d'Archéologie*

RAC *Rivista di Archeologia Christiana*

RB *Revue Biblique*

REJ *Revue des Études Juives*

RHR *Revue de l'Histoire des Religions*

ZDPV *Zeitschrift der deutschen Palästina Vereins*

INTRODUCTION

[1] II *Maccabees*, chapter 7.

[2] See Babylonian Talmud, *Avodah Zarah,* 44 b.

[3] Jerusalem Talmud, *Avodah Zarah,* 3, 1.

[4] *Ibid.,* 3, 3.

[5] *Ibid.,* 3, 2. According to a manuscript version; cf. I.N. EPSTEIN, *Tarbiz,* 3, 1932 p. 20 (in Hebrew). See also E.E. URBACH, "The Rabbinical Laws on Idolatry in the Second and Third Centuries in the Light of Archeological and Historical Facts," IEJ, 9, 1959, p. 149–165, 228–245.

[6] See the *responsa* of Rabbi MEIR OF ROTHENBURG on *Tosefot Yoma* 44 b.

[7] For instance in a tripartite *mahzor*-prayerbook for the whole year; see B. NARKISS, *Hebrew Illuminated Manuscripts,* Jerusalem, 1969, pp. 106–109, pl. 33, 34.

[8] M. NARKISS, "The origin of the spice box known as 'Hadass', " EI, 6; 1960, p. 189–198 (Hebrew); *idem.,* "Origins of the spice box," JJA, 8, 1981, p. 28–41.

[9] H. STERN, "Orpheus in the Synagogue of Dura-Europos," JWCI, 21, 1958, p. 1–7.

[10] Z. AMEISENOWA, "Animal-headed gods, evangelists, saints, righteous men," JWCI, 12, 1949, p. 21–45; B. NARKISS, "On the Zoocephalic Phenomenon in Medieval Ashkenazi Manuscripts," *Essays in Honor of Moshe Barash.* Jerusalem, 1983, p.49–62.

[11] L.H. VINCENT, *Jérusalem de l'Ancien Testament,* Paris, 1956. vol. 2, p. 373–423.

[12] *Ibid.,* p. 432–470.

[13] *Ibid.,* 471–495.

[14] FLAVIUS JOSEPHUS, *The Jewish War,* V, 5, 184–226; in VINCENT, *op. cit.,* 1, p. 433–434.

[15] FLAVIUS JOSEPHUS, *Jewish Antiquities,* XV, 11, 380–402; 410–425; in VINCENT, *op. cit.,* 1, p. 434–435.

[16] VINCENT, *op. cit.,* 1. p. 331–342.

[17] Y. YADIN, *Massada,* London-New York, 1966.

ORIENT

THE GENESIS OF SYMBOLS

18 M. Avi-Yonah, *Oriental Art in Roman Palestine*, Rome, 1961 (hereafter: Avi-Yonah, *Oriental art*), p. 13.

19 M. Narkiss, *Coins of Eretz Israel*, Jerusalem, 1936 (in Hebrew); A. Kindler, *Coins of Eretz Israel*, Jerusalem, 1971 (in Hebrew).

20 Herod reckoned his reign from the year corresponding to 40 B.C.E., when Octavius promised him the government of Palestine. He assumed it effectively three years later. The coins struck in 37 on the inauguration of his reign are dated as of the third year.

21 W. Wirgin, "On King Herod's Messianism," IEJ, 11, 1961, p. 153-154.

22 Cf. Flavius Josephus, *Jewish War*, I, XXXIII, 648-655; *Jewish Antiquities*, XVII, VI, 149-167.

23 A. Reifenberg, "Portrait Coins of the Herodian Kings," *Numismatic circular*, 1935, p. 3-11.

24 B. Narkiss, "Symbolical Representations of the Temple," *Ha Universita*, 13, 1968, p. 11-20 (in Hebrew).

25 Avi-Yonah, *Oriental Art*, p. 15-21.

26 S. Krauss, "La double inhumation chez les juifs," REJ, 97, 1934, p. 1-34; M. Meyers, *Jewish ossuaries: reburial and rebirth; secondary burials in their Ancient Near Eastern setting*, Rome, 1971. Our thanks to Professor A. Caquot for this reference.

27 H.L. Vincent, "Sur la date des ossuaires juifs," RB, 43, 1934, p. 564-567.

28 M. Avi-Yonah, "Oriental Elements in the Art of Palestine in the Roman and Byzantine Periods," II, QDAP, 13, 1948, p. 128-165, especially p. 151-158.

29 Avi-Yonah, *Oriental Art*, p. 21-27.

30 R. Dussaud, *Les monuments palestiniens et judaïques au Musée du Louvre*, Paris, 1912.

31 Flavius Josephus, *Jewish Antiquities*, XX, 93-95.

32 This sarcophagus is now in the Israel Museum, Jerusalem.

33 B. Maisler, "The excavations at Sheikh Ibreiq (Beth Shearim), 1936–1937," JPOS, 18, 1938, p. 41-49; M. Avigad, "Beth Shearim," IEJ, 4, 1954, p. 88-107; 5, 1955, p. 205-239; 8, 1958, p. 276-277; 9, 1959, p. 205-220; B. Mazar, "Beth Shearim," IEJ, 6, 1956, p. 261-262; 10, 1960, p. 264. Final report by B. Mazar, M. Sowa, B. Lifschitz, M. Avigad, *Beth Shearim*, vols. 1-3, Jerusalem, 1957-1972; Goodenough, *Jewish symbols in the Greco-Roman period* (cited below as Goodenough, *Jewish symbols*), 1, New York, 1953, p. 89-110.

34 Flavius Josephus, *Autobiography*, 118.

35 The title of *nasi*, given to the president of the Sanhedrin, was used for the first time by Judah, son of Simeon b. Gamaliel, principal redactor of the *Mishnah*.

36 B. Lifschitz, "La vie de l'au-delà dans les conceptions juives. Inscriptions grecques à Beth Shearim," RB, 68, 1961, p. 401-411; M. Schwabe, "La vie de l'au-delà à Beth Shearim," in *Studies in memory of A. Gulak and S. Klein*, Jerusalem, 1942, p. 187-200.

37 Cf. Philo, *Vita Mosis*, 2, 102; Flavius Josephus, *The Jewish War*, V, 5, 217; VII, 5, 149.

38 W. Wirgin, "The Menorah as Symbol of Judaism," IEJ, 12, 1962, p. 140-142.

39 Avi-Yonah, "Oriental Elements," 1, QDAP, 10, 1944, p. 105-151.

40 M. Avigad, Sarcophagi at Beth Shearim," *Archeology*, 10, 1957, p. 266-269.

41 M. Avi-Yonah, "The Leda Coffin from Beth Shearim," EI, 8, 1967, p. 1967, p. 143-148 (in Hebrew); *idem*, "The Leda Sarcophagus from Beth Shearim," *Scripta Hierosolymitana*, 24, 1972, p. 9-21.

42 Avi-Yonah, *Oriental Art*, p. 40.

43 O. Marucchi, *Le catacombe romane*, Rome, 1932, p. 227-247; Müller, *Die jüdische Katakombe am Monteverde zu Rom*. Leipzig, 1912; Goodenough, *Jewish symbols*, 2, p. 4-14.

44 T. Reinach, "Une nouvelle nécropole judéo-romaine," REJ, 72, 1921, p. 24-28; R. Wischnitzer, "La catacombe de la Villa Torlonia," REJ, 91, 1931, p. 102-107; K.H. Regenstorf, "Zu den Fresken der jüdischen Katakombe der Villa Torlonia in Rom," ZAW, 31, 1932, p. 33-60; Goodenough, *Jewish symbols*, 2, p. 35-44.

45 R. Garrucci, *Cimitero degli antichi Ebrei scoperto recentemente in Vigna Randanini*, Rome, 1862; *idem. Storia dell'arte cristiana nei primi otto secoli*, Prato, 1872-1880, VI, p. 156-157; Goodenough, *Jewish symbols*, 2, p. 14-35.

46 R. Garrucci, *Dissertazioni archeologiche di vario argomento*. Rome, 1866, II, p. 155; *idem.*, *Storia dell'arte cristiana*, VI, pl. 491, no. 19; F. Cumont, "Un fragment de sarcophage judéo-païen," RA, Series 5, vol. 4, 1916, p. 1-16; *idem.*, *Recherches sur le symbolisme funéraire des Romains*, Paris, 1942, p. 484-498.

47 R. Garrucci, *Vetri ornati di figure in oro trovati nei cimeteri dei Cristiani primitivi di Roma*. Rome, 1958; *idem, Storia dell'arte christiana*, VI, p. 157; Goodenough, *Jewish symbols*, 2, p. 108-120.

48 A. Jellinek, *Beit Hamidrash*. Jerusalem, 1967, 6, p. 150-151 (in Hebrew).

49 A. Reifenberg, "Vergleichende Beschreibung einiger Jüdisch-Palästinensischen Lampen,"JPOS, 11, 1931, p. 63-67; *idem.*, "Jüdische Lampen," JPOS, 16, 1936, p. 166-179.

50 Avi-Yonah, *Oriental Elements, I, QDAP*, 10, 1942, p. 144-147.

51 P.V.C. Baur, "David and Goliath on an Early Christian Lamp," *Yale Classical Studies*, 1, 1928, p. 41-51.

52 F. Neuburg, *Glass in antiquity*, London, 1949.

53 D. Barag, "Glass pilgrim vessels from Jerusalem," *Journal of*

Glass Studies, 12, 1970, p. 35-63, with exhaustive bibliography on p. 63.

[54] L.Y. RAHMANI, "Mirror-plaques from a Fifth-Century A.D. Tomb," IEJ, 14, 1964, p. 50-60.

[55] L.A. MAYER and A. REIFENBERG, "Three Ancient Jewish Reliefs," PEF. Q. ST., 1937, p. 136-139.

NARRATIVE SYMBOLS

[56] Their names are Clark Hopkins, le Comte du Mesnil du Buisson, Margaret Crosby, Frank E. Brown, Van W. Knox; Cf. GOODENOUGH, *Jewish Symbols,* IX, p. 3.

[57] Cf. C.H. KRAELING, *The Excavations at Dura-Europos. Final Report.* VIII: *The Synagogue,* New Haven, 1956, p. 326. (hereafter: KRAELING, *The Synagogue).*

[58] *Ibid.,* p. 4-6.

[59] Cf. *Ibid.,* L. TORREY on the inscriptions, p. 267-268.

[60] The principal hypotheses are the following: R. MESNIL DU BUISSON distinguishes a different subject in each of the three registers, respectively, historical, liturgical, and didactical or moralizing; Cf. *Les peintures de la synagogue de Doura-Europos, 245-256 après J.C.,* Rome, 1939 (hereafter: DU MESNIL, *Les peintures),* p. 14-17. A. GRABAR discerns an analogy between the program of the frescoes and the programs of official Roman art; Cf. "Le thème religieux des fresques de la synagogue de Doura (245-256 après J.C.)." RHR, 123, 1941, p. 143-192 and 124, 1941, p. 5-35 (hereafter: *Le thème).* R. WISCHNITZER interprets the frescoes in terms of the messianic idea; Cf. *The Messianic Theme in the Paintings of the Dura Synagogue.* Chicago, 1948 (hereafter: WISCHNITZER, *The Messianic Theme),* E.H. GOODENOUGH (*Jewish Symbols,* 9, 10), believes them to stem from a mystical trend parallel to rabbinic Judaism. On the occasion of a symposium organized to commemorate the 40th anniversary of the discovery of Dura, J. GUTMANN proposed the hypothesis that the program of the synagogue presented the celebra-

tion and the scriptural justification of the new liturgy founded on prayer and the reading of the Bible, substitutes for the sacrifices which were abolished with the destruction of the Temple. This would make it to some extent analogous with the program of the apse of Santa Maria Maggiore, fourth century, or of San Vitale in Ravenna, fifth century. Cf. J. GUTMANN, ED., *The Dura-Europos Synagogue: A Reevaluation (1932-1972),* with contributions by C. HOPKINS, R. BRILLIANT, M.L. THOMPSON, B. GOLDMAN, A. SAEGER, M. AVI-YONAH, J. GUTMANN, Missoula Montana, 1973.

[61] Cf. *Genesis Rabba* 40, *Song of Songs Rabba,* IV, 4.

[62] Suggested by KRAELING, who always prefers interpretations that remain close to the text; Cf. KRAELING, *The Synagogue,* p. 58.

[63] *Ilana,* instead of *sebakh* in the Hebrew text.

[64] Cf. L. GINZBERG, *The Legends of the Jews,* Philadelphia, 1968, IV, p. 115; A. JELLINEK, *Beit Hamidrash,* Jerusalem, 1967, "The Garden of Eden," 5. p. 47. Is this a tree or a vine? The question remains unanswered. But either would have the same significance; cf. KRAELING, *The Synagogue,* p. 63 and GOODENOUGH, *Jewish Symbols,* 9, p. 79.

[65] Cf. H. STERN, "The Orpheus in the Synagogue of Dura-Europos," JWCI, 21, 1958, p. 1-7.

[66] Cf. below, p. 115.

[67] Cf. GRABAR, "Le thème," RHR, 124, p. 32-35.

[68] Cf. GOODENOUGH, *Jewish Symbols,* IX, p. 110-123.

[69] Collections of homilectic and legendary elaborations on the various parts of the Bible.

[70] On these elements and their disposition in the frescoes, cf. the table in KRAELING, *The Synagogue,* p. 352-353.

[71] Especially the Targum Onkelos, the official Aramaic version of the babylonian schools; the Targum called "Pseudo-Jonathan," or first Targum of Jerusalem.

[72] *Exodus Rabba,* on *Exodus* 1:15 and 16.

[73] Cf. GOODENOUGH, *Jewish Symbols,* IX, p. 199-224; also *idem.,* "The Paintings of the Dura-Europos Synagogue. Method and an Application," IEJ, 8, 1958, p. 69-79.

[74] The exact correspondance of the repeated representations of Ezekiel with the relevant verses of the text is variously interpreted; cf. especially, KRAELING, *The Synagogue,* p. 190, n. 742, who gives a list of these interpretations. We here follow KRAELING's version.

[75] GOODENOUGH, *Jewish Symbols,* 10, p. 181-182, and 11, fig. 301 and 302.

[76] Explanation provided by the *Pirke de Rabbi Eliezer,* chap. XXXIII; cf. GRABAR, "Le thème," p. 150.

[77] The Hebrew word *ruah* in the text may have both meanings.

[78] GOODENOUGH, *Jewish Symbols,* 10, p. 194.

[79] The first hypothesis is that of KRAELING, in *The Synagogue,* p. 193; the second is proposed by GRABAR, in "Le thème," RHR, 123, 1941, p. 150-152 and by WISCHNITZER, in *The Messianic Theme,* p. 44.

[80] On the method of "cyclic" illustration, cf. K. WEITZMANN, *Illustration in roll and codex. A study of the origin and method of text illustration,* Princeton, 1947, p. 17-34, and *idem,* "Narration in early Christendom," AJA 61, 1957, p. 83-91.

[81] DU MESNIL, *Les peintures* p. 100-103; GRABAR, "Le thème," RHR, 124. p. 12 ff.; WISCHNITZER, *The Messianic Theme,* p. 36-38.

[82] E.L. SUKENIK, "The Ezekiel panel in the wall decoration of the Synagogue of Dura-Europos," JPOS, 18, 1938, p. 57-62.

[83] KRAELING, *The Synagogue,* p. 200-201.

[84] H. STERN, "Quelques problèmes d'iconographie paléochrétienne et juive," *Cahiers archéologiques,* 12, 1962, p. 99-113, especially p. 104-108.

211

85 Cf. the list of these manuscripts in the article cited, p. 106, n. 5.

86 The Bible does not mention the act of the sons of Mattathias; but it is related by FLAVIUS JOSEPHUS, *Jewish Antiquities*, XII, VI, 265-271.

87 This difficulty is mentioned by H. STERN himself, *op. cit.*, p. 108.

88 Cf. GOODENOUGH, *Jewish Symbols*, 10, p. 185-191.

89 Chapter XI, 37. [The prophets] were stoned, sawn in two, they perished by the sword..."

90 Especially *The Lives of the Prophets*, first mentioned by Epiphanius in the fourth century; cf. *Jewish Symbols*, 10, p. 188 and n. 112.

91 ISIDOR OF SEVILLE, *De ortu et obitu Patrum*, XXXIX; Migne, PL, 83, 143.

92 Paris, Bibliothèque Nationale, ms. lat.6.

93 Midrash Rabba on *Esther* 6:10.

94 Targum I and II of the *Book of Esther*. According to Targum I the throne is a copy of the original; according to Targum II it is the original itself.

95 The opinion is held by DU MESNIL DU BUISSON, in *Les peintures*, p. 150-154.

96 GOODENOUGH, in *Jewish Symbols*, 9, p. 21-23 calls the supposed author of the program " the philosopher," to emphasize the intellectual character of his task.

97 Cf. above, n. 71.

98 A homilectic and Midrashic expansion which follows the five books of the Pentateuch verse by verse.

99 Cf. C.O. NORDSTRÖM, *The Duke of Alba's Castilian Bible*, Uppsala, 1967, p. 88-96.

100 E.g. in a manuscript illuminated in Germany in about 1320. Budapest, Hungarian Academy of Sciences, ms. Kaufmann 384, fol. 183v.

101 E.g. in the "Golden Haggada," British Museum, Add. ms. 27210,

fol. 9; facsimile edition, B. NARKISS, *The Golden Haggadah*. London 1970.

102 Vienna, Nationalbibliothek, Cod. Theol. Grec 31. Facsimile edition, H. GERSTINGER, *Die Wiener Genesis*, Vienna, 1931. See also O. PÄCHT, "Ephraïmillustration, Haggadah und Wiener Genesis," in *Festschrift Karl Svoboda*, Wiesbaden, 1959. O. MAZAL, *Kommentar zur Wiener Genesis* (introduction to a new facsimile edition). Frankfort a/Main, 1980.

103 Paris, Bibliothèque Nationale, Nouv. Acq. lat. 2334. On the Midrashic elements in this manuscript cf. J. GUTMANN, "The Jewish origin of the Ashburnham Pentateuch miniatures," JQR N.S. 44, 1953-1954, p. 55-72.

104 Cf. KRAELING, *The Synagogue*, p. 390-392.

105 K. WEITZMANN, "Die Illustration der Septuaginta," *Münchener Jahrbuch der bildenden Kunst*, 1952, p. 96-120; *idem.*, "Zur Frage des Einflusses jüdischer Bilderquellen auf die Illustration des Alten Testaments," in *Mullus; Festschrift Theodor Klauser*, Münster, 1964 (*Jahrbuch für Antike und Christentum*), Ergänzungsbd. (1), p. 401-215; J. GUTMANN, "The illustrated Jewish manuscript in Antiquity. The present state of the question," *Gesta*, 5, 1966, p. 39-41.

106 Cf. KRAELING, *The Synagogue*, p. 396-397 and n. 288.

IMAGE OF THE WORLD

107 *De legatione ad Cajum*, ed. A. Pelletier, Paris, 1972, 134, p. 161 and n. 4.
108 Mishna *Sukkah* IV; V, 1; Babylonian Talmud, *Sukkah* 51 b, etc.

109 Cf. *Acts of the Apostles*, 9:20; 13:5; 14:1; 15:21; 17:1; etc.

110 R. WEILL, "La cité de David. Compte rendu des fouilles exécutées à Jérusalem, sur le site de la ville primitive. Campagne 1913-14," REJ, 69, 1919, p. 1-85; 70, 1920, p. 1-36; 71, 1920, p. 1-45; C. CLERMONT-GANNEAU, "Une synagogue de l'époque hérodienne à Jérusalem,"

CAIBL, 1920, p. 187; T. REINACH, "L'inscription de Theodotos," REJ, 71, 1920, p. 46-56; L.H. VINCENT, "Découverte de la synagogue des affranchis à Jérusalem, RB, 30, 1921, p. 247-277; S.A. COOK, "The Synagogue of Theodotos at Jerusalem," PEF, Q.ST. 1921, p. 247; E.L. SUKENIK, *Ancient Synagogues in Palestine and Greece*, London, 1934, (cited below as SUKENIK, *Ancient Synagogues*), p. 69; GOODENOUGH, *Jewish Symbols*, I, p. 179.

111 Y. YADIN, *Massada*, London, 1966. *idem.*, in *Ancient Synagogues Revealed*. Jerusalem, 1981, p. 19-23; G. FOERSTER, *ibid.*, p. 24-29.

112 The principle is defined in *Tosefta Berakot* III, 15-16; cf. S. LIEBERMANN, *The Tosefta*, New York, 1955, 1, p. 15-16.

113 *Shabbat* 11a; *Tosefta Megillah* IV, 23; LIEBERMAN, *op. cit.*, II, p. 360.

114 S. KRAUSS, *Synagogale Altertümer* (Berlin, 1922), Hildesheim, 1966, p. 356, remarks that according to the Mishnah, *Middot* II, 5, *from the floor reserved for them in the Temple "the women looked down at the men who stood below."*.

115 The injunction of facing Jerusalem during the prayer is based on Solomon's prayer (*I Kings* 8:44 and *II Chronicles* 6:38): "If thy people go out to battle against their enemy, whithersoever thou shalt send them, and shall pray unto the Lord toward the city which thou hast chosen, and toward the house that I have built for thy name..." and the custom is confirmed in *Daniel* 6:10: "...and his window being open in his chamber toward Jerusalem, he kneeled upon his knees three times a day, and prayed and gave thanks before his God..."

116 EUSEBIUS, *Historia Ecclesiastica*, XXXVII.

117 None of the synagogues predate the Constantinian churches.

118 H. KOHL and C. WATZINGER, *Antike Synagogen in Galilaea*, Leipzig, 1916 (cited below as *Antike Synagogen*); G. ORFALI, *Capharnaüm et ses ruines*, Paris, 1922; *idem*, "La dernière période de l'histoire de Capharnaüm," JPOS, 2, 1922, p. 87-93; SUKENIK, *Ancient Synagogue*, p. 7-21;

212

GOODENOUGH, *Jewish Symbols*, I, p. 181–192. *Ancient Synagogues Revealed*: G. FOERSTER (p. 45,57), M. AVI-YONAH (p. 60).

119 C. WATZINGER, *Denkmäler Palästinas. Eine Einführung in die Archäologie des Heiligen Landes*, Leipzig, 1935; KOHL-WATZINGER, *Antike Synagogen*, p. 41–58; SUKENIK, *Ancient Synagogues*, p. 21–24; GOODENOUGH, *Jewish Symbols,*, I, p. 193–199.

120 KOHL-WATZINGER, *Antike Synagoguen*, p. 80–88; GOODENOUGH, *Jewish Symbols*, I, p. 200–201.

121 The site is perhaps that spoken of by FLAVIUS JOSEPHUS in *The Jewish War*, II, XX, 573 and III, III, 40.

122 B. MAZAR, *Beth Shearim*, I, Jerusalem, 1957; *Jewish Symbols*, I, p. 208.

123 G. FOERSTER, "A Survey of Ancient Diaspora Synagogues," in *Ancient Synagogues Revealed*, p. 164. M.F. SQUARCIAPINO, "La sinagoga di Ostia," *Bollettino d'Arte*, 46, 1961, p. 326–337; R. WISCHNITZER, *The architecture of the European Synagogue*, Philadelphia, 1964, p. 5–7.

124 SUKENIK, *Ancient Synagogues*, p. 44; GOODENOUGH, *Jewish Symbols*, II, p. 75.

125 SUKENIK, *Ancient Synagogues*, p. 40–42; GOODENOUGH, *Jewish Symbols*, II, p. 78.

126 D. GORDON MITTEN, *The Ancient Synagogue of Sardis. A Progress Report*. Cambridge, Mass, 1969. A. SEAGER in *Ancient Synagogues Revealed*, p. 178.

127 G. ORFALI, *op. cit.*, pl. IV and IX.

128 G. FOERSTER, *Galilean Synagogues and their Relation to Hellenistic and Roman Art and Architecture*, Jerusalem, 1972 (Ph.D. thesis, typescript in Hebrew). *Idem*, in *Ancient Synagogues Revealed*, p. 45.

129 KOHL-WATZINGER, *Antike Synagogen*, p. 89–100; SUKENIK, *Ancient Synagogues*, p. 24–26; GOODENOUGH, *Jewish Symbols, I, p.* 201–203.

130 Cf. AVI-YONAH, "Synagogue Architecture in the Late Classical Period," in C. Roth, *Jewish Art*. London, 1971, p. 65–82, especially p. 70.

131 Cf. SUKENIK, *Ancient Synagogues*, p. 59.

132 *Pesikta de Rab Kahana*, 7b, ed. B. Mandelbaum, New York, 1962, p. 12.

133 Information given by Eusebius, *Onomastikon*, ed. E. Klostermann, (Leipzig, 1902), Hildesheim, 1966, p. 174, line 24.

134 On the relations between synagogues and churches, cf. above, p. 95.

135 At this period the hexagram had not yet acquired the significance that turned it into a national emblem. Cf. G. SCHOLEM, "Das Davidschield," in *Judaica*. Frankfurt a/Main, 1960, p. 75–118.

136 Cf. KOHL-WATZINGER, *Antike Synagogen*, p. 196 and fig. 302, and photographs of the temples at Kadesh and Palmyra in *Annales Archéologiques de Syrie*, 7, 1957, p. 2–3.

137 Cf. above, n. 133.

138 V. CORBO, S. LOFFREDA, A. SPIJKERMANN, *La sinagoga di Cafarnao dopo gli scavi del 1969*. Piblicazioni dello Studium Biblicum Franscicanum, Collectio minor no. 9. Jerusalem, 1970.

139 G. FOERSTER, "Ancient Synagogues in Israel," *Kadmoniyot*, 5, 1972, p. 38–42 (in Hebrew).

140 First mentioned by W.F. ALBRIGHT and N. GLUECK in AJA, 41, 1937, p. 150. Excavation report by L.A. MAYER and A. REIFENBERG, "The Synagogue of Eshtemoa. Preliminary report," JPOS, 19, 1941, p. 314–326; GOODENOUGH, *Jewish Symbols*, I, p. 232–236; Z. Yeivin, "The Synagogue of Esthemoa," in *Ancient Synagogues Revealed*, p. 120.

141 Preliminary excavation report by S. GUTMANN, Z. YEIVIN, E. NETZER, in *Kadmoniyot*, 5, 1972, p. 47–52 (in Hebrew). *idem.*, in *Ancient Synagogues Revealed*, p. 123.

142 L.H. VINCENT, "Vestiges d'une synagogue antique à Yafa de Galilée," RB, 30, 1921, p. 434–438; E.L. SUKENIK, "The Ancient Synagogue at Yafa near Nazareth," *Bulletin Rabinowitz*, 2, 1951, p. 6–24;

GOODENOUGH, *Jewish Symbols*, 1, p. 216–218.

143 FLAVIUS JOSEPHUS, *Jewish Antiquities*, 14. Section 258 mentions the custom of orienting the synagogues towards the sea.

144 M. DOTHAN, "The Synagogue at Hammath-Tiberias," in *Ancient Synagogues Revealed*, p. 63; *idem.*, "The Aramaic Inscription from the Synagogue of Severus at Hammath-Tiberias," EI. 8, 1967, p. 183–185 (in Hebrew).

145 Cf. above, n. 122.

146 D. BARAG, in *Kadmoniyot*, 3, 1970, p. 97–100 and 5, 1972, p. 52–54 (in Hebrew). D. BARAG, Y. PORAT and E. NETZER in *Ancient Synagogues Revealed*, p. 116.

147 A. MARMORSTEIN, "The Synagogue of Claudius Tiberius Polycharmus in Stobi," JQR, N.S. 27, 1936–1937, p. 373–384. G. FOERSTER, "A Survey of Ancient Diaspora Synogogues," in *Ancient Synagogues Revealed*, p. 164.

148 C.H. KRAELING, ed., *Gerasa, City of the Decapolis*. New Haven, 1938, p. 234–241 and 318–324; GOODENOUGH, *Jewish Symbols*, 1, p. 259–260.

149 E.L. SUKENIK, *The Ancient Synagogue of Beth Alpha*. Jerusalem-London, 1932; GOODENOUGH, *Jewish Symbols*, I, p. 241–253.

150 S. LEVY, L. Y. RAHMANI, A.S. HIRAM, I. DUNAYEVSKY, M. AVI-YONAH, Z. YEIVIN, "The Ancient Synagogue of Maon (Nirim)," *Bulletin Rabinowitz*, 3, 1960, p. 6–40.

151 SUKENIK, *Ancient Synagogues*, p. 81–82; *idem.*, *The Ancient Synagogue of El-Hammeh (Hammath by Gadara)*. Jerusalem, 1935; GOODENOUGH, *Jewish Symbols*, 1, p. 239–241.

152 To be distinguished from the sixth century synagogue situated within the walls. Cf. D. BAHAT, "The Synagogue at Beth Shean," *Kadmoniyot*, 5, 1972, p. 55–58 (in Hebrew).

153 D. BARAMKI, "An early Byzantine Synagogue near Tell es-Sultan, Jericho" (with an appendix by M. AVI-YONAH), QDAP, 6, 1938, p.

73-77; Goodenough, *Jewish Symbols,* 1, p. 259-262.

154 M. Avi-Yonah, "La mosaïque juive dans ses relations avec la mosaïque classique," in *Art in Ancient Palestine,* Jerusalem, 1981, p. 383-388; *ibid.,* "A survey of mosaic pavements in Palestine", p. 283-382.

155 On the inscription giving the date, cf. below, p. 113

156 A. Grabar, "Recherches sur les sources juives de l'art paléochrétien," 1, *Cahiers Archéologiques,* 11, 1960, p. 41-71.

157 M. Dothan, "The Representation of Helios in the Mosaic of Hammath-Tiberias," in *Atti del Convegno internazionale sul tema Tardo Antico e Alto Medievo.* Rome, Accademia Nazionale dei Lincei, 1968, p. 99-104.

158 Cf. Avi-Yonah, *op. cit.,* (above, n. 154), p. 385-386.

159 *Ibid.,* p. 387.

160 Reproduced in Goodenough, *Jewish Symbols,* III, fig. 442.

161 E.L. Sukenik, "The Ancient Synagogue of Yafa near Nazareth," *Bulletin Rabinowitz,* 2, 1951, p. 17-23.

162 M. Avi-Yonah, "A List of Priestly Courses from Caesarea," IEJ, 12, 1962, p. 137-139; *idem.,* "The Caesarean Inscription of the 24 Priestly Courses," EI, 7, 1964, p. 24-28 (in Hebrew); *idem.,* "The Caesarea Inscription of the Twenty Four Priestly Courses," in *Studies in memory of Henry Trantham.* Texas, 1964, p. 46-57.

163 Cod. Justinianus, Dig. I, VII, 1, which in 427 proscribed the representation of religious symbols in churches.

164 M. Avi-Yonah, "The Ancient Synagogue of Maon (Nirim). The Mosaic Pavement," *Bulletin Rabinowitz,* 3, 1960, p. 25-35.

165 A. Grabar, "Recherches sur les sources juives de l'art paléochrétien," 2, *Cahiers Archéologiques,* 12, 1962, p. 124, n. 5, p. 125 and fig. 8.

166 A. Grabar, "Un thème de l'iconographie chrétienne: l'oiseau dans la cage," *Cahiers Archéologiques,* 16, 1966, p. 9-16. O. Hjort, "L'oiseau dans la cage: exemples médiévaux à Rome," *Cahiers Archéologiques,* 18, 1968, p. 21-31.

167 *Soliloquia* 1, 14, 24.

168 Cf. above, n. 146.

THE WEST STYLES OF THE DIASPORA

169 R. Krautheimer, *Mittelalterliche Synagogen,* Berlin 1927; G. Lukomski, *Jewish Art in European Synagogues from the Middle Ages to the 18th Century.* London, 1947; F. Landsberger, "The house of the people," HUCA, 22, 1949, p. 149-155; R. Wischnitzer, *The Architecture of the European Synagogue.* Philadelphia, 1964 (cited below as Wischnitzer, *European Synagogue*). These works contain information on synagogues thoughout Europe. Some specific bibliographical references are added in the notes that follow.

170 F. Landsberger, "The Sacred Direction in Synagogue and Church," HUCA, 28, 1957, p. 181-203.

171 In a fourteenth century *Haggadah* from Barcelona (London, British Library Or. 2884, fol. 17v), the reader standing on the *bimah* is surrounded by the faithful, both men and women. The Sarajevo *haggadah* (fol. 34) also shows men and women together, before the ark.

172 F. Cantera Burgos, *Sinagogas españolas.* Madrid, 1955, p. 151-366.

173 E. Lamberg, *Tolède,* Paris, 1925; *idem,* "Les synagogues de Tolede," REJ, 84, 1927, p. 15-33.

174 It has not been possible to identify this synagogue with any of the medieval synagogues mentioned by name in the literary sources.

175 Cantera Burgos, *op. cit.,* p. 45-47.

176 C. Roth, "Las inscriciones historicas de la Sinagoga del Tránsito de Toledo," *Sefarad,* 8, 1948, p. 1-22.

177 C. Roth, *The Sarajevo Haggadah.* London, 1963.

178 Cf. above, n. 171.

179 R. Gottheil, "An Eleventh Century Document Concerning a Cairo Synagogue," JQR, 19, 1907, p. 467-539; *idem.,* A Document of the Fifteenth Century Concerning the Two Synagogues of the Jews in Old Cairo," JQR, n.s. 18, 1927-1928, p. 131-152; J. Mosseri, "The Synagogues of Egypt: Past and Present," *The Jewish Review,* 5, 1914.

180 *Art et Archéologie des Juifs en France médiévale,* ed. B. Blumenkranz, Toulouse, 1980. Cf. the contributions of B. Blumenkranz, M. Baylé.

181 A. Scheiber, "La découverte d'une synagogue médiévale à Sopron," REJ, CXVIIII, 1959, p. 79-93. F. David, *A soproni ô zsinagoga.* Budapest, 1978.

182 O. Böcher, *Die alte Synagoge zu Worms,* ed. E. Roth, Frankfort a/ Main, 1961, p. 11-154.

183 A. Grotte, *Deutsche, Böhmische und Polnische Synagogentypen.* Mitteilungen der Gesellschaft zur Erforschung jüdischer Kunstdenkmäler, 7/8, Berlin, 1915; Q. Schürer, *Prag. Kultur Kunst, Geschichte,* Vienna–Leipzig, 1930; Z. Münzerova, *Staranova synagoga v Praze,* Prague, 1932.

184 H. Volavkova, *The Pinkas Synagogue. A Memorial of the Past and of Our Days.* Prague, 1955.

185 C. Roth, *The History of the Jews in Italy.* Philadelphia, 1946; A. Milano, *Storia degli Ebrei in Italia.* Turin, 1963.

186 A. Marx, *Studies in Jewish History and Booklore.* New York, 1944, p. 277-295.

187 B. Narkiss, *Hebrew Illuminated manuscripts* Jerusalem, 1969, p. 36 f.

188 F. Secret, *Les Kabbalistes chrétiens de la Renaissance.* Paris, 1963; E.G. Weil, *Elie Lévita, humaniste et massorète,* Paris, 1963.

189 J. Pinkerfeld, *Italian synagogues from the Renaissance to the present day.* Jerusalem, 1954 (in

Hebrew); U. NAHON, "Synagogues from Italy in Israel," in *Scritti in memoria di Sally Mayer.* Jerusalem, 1956, p. 259-277 (in Hebrew).

190 V. KLAGSBALD, *Catalogue raisonné de la collection juive du musée de Cluny.* Paris, 1981, no. 123.

191 H. ROSENAU, "The Synagogue and Protestant Church in Architecture," JWCI, 4, 1940, p. 80-84.

192 J. MEIJER, in D.H. De Castro, ed., *De Synagoge der Portugees-Israelitische Gemeente te Amsterdam.* Amsterdam, 1950.

193 J.S. DA SILVA ROSA, *Geschiedenis der Portugeesche Joden in Amsterdam, 1593-1925.* Amsterdam, 1925.

194 I. LOEB, "Les juifs de Carpentras sous le gouvernement pontifical," REJ, 12, 1886, p. 34-64; 161-235.

195 A. LUNEL, "Les synagogues comtadines," *L'Oeil,* 4, 1955, p. 14.

196 Cf. WISCHNITZER, *European Synagogue,* p. 71.

197 A. BREIER, M. EISLER, M. GRUNWALD, *Holzsynagogen in Polen.* Baden, 1934; M. AND K. PIECHOTKA, *Wooden Synagogues.* Warsaw 1959.

198 R. WISCHNITZER, *Symbole und Gestalten der jüdischen kunst.* Berlin, 1935.

199 D. DAVIDOWICZ, *Wandmalereien in alten Synagogen.* Hannover, 1969.

CEREMONIAL ART

200 K. SCHWARZ, *Jewish Ceremonial Objects.* Berlin, 1933. F. LANDSBERGER, *A History of Jewish Art.* Cincinnati, 1946. S.S. KAYSER, G. SCHOENBERGER, *Jewish Ceremonial Art.* Philadelphia, 1959. J. GUTMANN, *Jewish Ceremonial Art.* New York, 1964. C. ROTH, "Ritual Art." in *Jewish Art. An illustrated History.* Jerusalem, 1971, p. 118-131. A. KANOF, *Jewish Ceremonial Art and Religious Observance.* New York, 1969.

201 M. WISCHNITZER, *A History of Jewish Crafts and Guilds.* New York, 1965.

202 F. LANDSBERGER, "The Origin of European Torah Decoration," HUCA, 24, (1952-1953), p. 133-150.

203 F. LANDSBERGER, "Old-time Torah Curtains," HUCA, 19, (1946), p. 353-387.

204 F. LANDSBERGER, "The Origin of the Ritual Implements for the Sabbath," HUCA, 27, (1956), p. 387-415.

205 M. NARKISS, "The Origin of the Spice Box known as 'Hadass'," EI, 6, (1960), p. 189-198 (in Hebrew).

206 R. WISCHNITZER, "Passover in Art, " in *Passover Anthlogy,* ed. Ph. Goodmann, Philadelphia, 1961.

207 R. WISCHNITZER, "L'origine de la lampe de Hanuka, " REJ, 89, (1930), p. 135-146. M. NARKISS, *The Hanukkah Lamp,* Jerusalem 1939 (in Hebrew with English summary). F. LANDSBERGER, "Old Hanukka Lamps, " HUCA, XXV (1954), p. 347-367.

208 NARKISS, M., "The Oeuvre of the Jewish Engraver Shalom Italia," TARBIZ, 25, (1955-56), p. 441-451; 26, (1956), p. 87-101 (in Hebrew).

209 F. LANDSBERGER, "Illuminated Marriage Contracts," HUCA, 26, (1965), p. 503-542. J. GUTMANN, "Wedding Customs and Ceremonies in Art," in *Jewish Marriage Anthology,* ed. Ph. and H. Goodmann, New York, 1965, p. 175-183. D. DAVIDOVIC, *The Ketuba. Jewish Marriage Contracts Through the Ages.* Tel-Aviv, 1968.

210 F. LANDSBERGER, "The Origin of the Decorated Mezuzah," HUCA, 31, (1960), p. 315-330.

211 M. NARKISS, "An Italian Nielo Casket of the Fifteenth Century," JWCI, XXI (1958), p. 288-295. *idem.,* in *Memorial S. Meyer.* Milano, 1956.

THE RENAISSANCE OF NARRATIVE ART

212 The notes to this chapter do not give an exhaustive bibliography for each manuscript mentioned.

Catalogues and older works superceded by more recent research have been omitted. Preference is given to books and articles dealing with the specific questions here discussed. B. NARKISS, *Hebrew illuminated manuscripts.* Jerusalem, 1969, contains a history of Jewish illumination (Introduction, p. 13-39), full descriptions, and a complete bibliography (p. 170-172) of most of the manuscripts we mention. (Hereafter NARKISS, *Hebr. ill. mss.,* with the corresponding page number). Cf. also J. LEVEEN, *The Hebrew Bible in Art.* London, 1944. J. GUTMANN, *Hebrew Manuscript Painting.* New York, 1978.

213 J. STRZYGOWSKI, *Orient oder Rom. Beiträge zur Geschichte der spätantiken und früchristlichen Kunst.* Leipzig, 1901, p. 32-39.

214 On the Midrashic Elements of the Pentateuch, cf. J. GUTMANN, "The Jewish Origins of the Ashburnham Pentateuch Miniatures," JQR, n.s. 44, 1953-1954, p. 55-72.

215 Cf. WEITZMANN, *Illustration in Roll and Codex.* Princeton, 1947, p. 17-34.

216 O. PÄCHT, "Ephraimillustration, Haggadah und Wiener Genesis," in *Festschrift Karl Swoboda.* Wiesbaden, 1939, p. 213-221; K. WEITZMANN, "Die Illustration der Septuaginta," *Münchener Jahrbuch der bildenden Kunst,* 3-4, 1952-1953 (hereafter, "Septuaginta"), p. 96-120; *idem,* "Zur Frage des Einflusses jüdischer Bilderquellen auf die Illustration des Alten Testamentes," in *Mullus; Festschrift Theodor Klauser.* Münster, 1964, Jahrbuch für Antike und Christentum. Ergänzungsbd. (1), p. 401-416; J. GUTMANN, "The illustrated Jewish Manuscript in Antiquity. The Present State of the Question," *Gesta,* 5, 1966, p. 39-41; C.O. NORDSTRÖM, "Rabbinic Features in Byzantine and Catalan Art," *Cahiers archéologiques,* 15, 1965, p. 179-205

217 Since the various works give different versions of the same midrashic text, it would seem that they had different Jewish manuscripts as models.

218 WEITZMANN, *Septuaginta,* p. 120.

219 B. NARKISS, *The Golden Haggadah. A fourteenth century illuminated Hebrew manuscript in the British Museum.* London, 1970 (hereafter NARKISS, *The Golden Haggadah*), the Introduction, especially p. 62–69.

220 M. METZGER, "Quelques caractères iconographiques et ornementaux de deux manuscrits hébraïques du Xe siècle," *Cahiers de civilisation médiévale,* 1, 1958, p. 205–215; NARKISS, *Hebr. ill. mss.,* p. 42.

221 Another example, differently conceived, but of the same school, is reproduced in NARKISS, *Hebr. ill. mss.,* p. 44.

222 C. ROTH, "Jewish Antecedents of Christian Art," JWCI, 16, 1953, p. 24-44.

223 C.O. NORDSTRÖM, "Some Miniatures in Hebrew Bibles," in *Synthronon.* Paris, 1968, p. 89–105; T. METZGER, "Les objects du culte, le sanctuaire du désert et le Temple de Jérusalem dans les Bibles hébraïques médiévales, enluminées en Orient et en Espagne," BJRL, 52, 1970, p. 397–437; 53, 1971, p. 167–209.

224 Chiefly those of R. Solomon ben Isaac (Rashi) and Moses Maimonides.

225 Lisbon, Biblioteca nacional, ms. 72, fol. 316v; NARKISS, *Hebr. ill. mss.,* p. 52 and pl. 6.

226 *The Kennicott Bible,* Facsimile ed. Introduction B. NARKISS, A. COHEN-MUSHLIN, London 1985.

227 B. NARKISS and G. SED-RAJNA, "La première Bible de Josué ben Abraham Ibn Gaon," *Manuscrits hébreux enluminés conservés dans les bibliothèques de France* (Specimen). Paris, 1972; REJ, 130, 1971, p. 255–269.

228 The Pentateuch was copied by Samuel b. Jacob, scribe of the second Leningrad Bible (ms. B. 19a; cf. NARKISS, *Hebr. ill. mss.,* p. 44); cf. R. GOTTHEIL, "Some Hebrew Manuscripts in Cairo," JQR, 17, 1904-1905, p. 609-655, n. 14. On the oriental school, see R.H. PINDER WILSON and R. ETTINGHAUSEN, "The Illuminations in the Cairo Moshe b. Asher codex of the Prophets completed in Tiberias in 895 A.D.," in P. Kahle, *Der hebräische Biebeltext seit Franz Delitsch.* Stuttgart, 1961, p. 95–98.

229 NARKISS, *Hebr. ill. mss.,* p. 50 and pl. 5.

230 G. SED-RAJNA, "Toledo or Burgos," *Journal of Jewish Art 2,* 1975, 6–21.

231 R. ETTINGHAUSEN, *La peinture arabe.* Geneva, 1962, reproduction on p. 172.

232 Cf. C. ROTH, "An additional note to the Kennicott Bible," in *Gleanings. Essays in Jewish history, letters and art.* New York, 1967, p. 316–319.

233 G. SED-RAJNA, *Manuscrits hébreux de Lisbonne. Un atelier de copistes et d'enlumineurs au XVème siècle.* Paris, 1970, pl. 14 and 15. NARKISS, *Hebr. Ill. mss.,* p. 78–80 and pl. 20.

234 R. ETTINGHAUSEN, "Yemenite ms of the 15th century," EI, 7, 1964, p. 32-39.

235 Cf. above, n. 227.

236 NARKISS, *Hebr. ill. mss.,* p. 104.

237 F. LANDSBERGER, "The Washington Haggadah and its Illuminator," HUCA, 21, 1948, p. 73–103; A. and W. Cahn, "An Illuminated Haggadah of the Fifteenth Century," *Yale University Library Gazette,* 41, 1967, p. 166–176; J. GUTMANN, "Thirteen Manuscripts in Search of an Author: Joel ben Simeon, 15th Century Scribe-Artist," *Studies in Bibliography and Booklore,* 9, 1970, p. 76–95; NARKISS, *Hebr. ill. mss.,* p. 171, n. 42. M. Beit-Arie, "Joel Ben Simeon's Manuscripts: a Codicologer's View," JJA, 3-4, 1977, pp. 25–39.

238 *Die Darmstädter Pessach-Haggadah. Codex orientalis 8 der Landesbibliothek zu Darmstadt aus dem vierzehnten Jahrhundert;* facsimile edition, with commentaries by B. ITALIENER, A. FREIMANN, A.L. MAYER, A. SCHMIDT. Leipzig, 1928; also new facsimile edition with introduction by J. GUTMANN, H. KNAUSS, P. PIEPER, E. ZIMMERMANN: *Die Darmstädter Haggadah. Codex orientalis 8 der Hessischen und Hochschulbibliothek Darmstadt.* Berlin, 1972.

239 Cf. NARKISS, *Hebr. ill. mss.,* p. 52, and above, n. 226.

240 E.g. a copy of the *halachic* compendium of Isaac Alfasi. Paris, Bibliothèque nationale, ms. Hebr. 311.

241 B. NARKISS, "On the Zoocephalic Phenomenon in Medieval Ashkenazi Manuscripts," *Essays in Honor of Moshe Barash.* Jerusalem, 1983, p. 49-62.

242 Z. AMEISENOWA, "Das messianische Gastmahl der Gerechten in einer hebräischen Biebel aus dem 13 Jahrhundert. Ein Beitrag zur eschatologischen Ikonographie der Juden," MGWJ, 79, 1935, p. 404–422; J. GUTMANN, "When the Kingdom comes," *Art Journal,* 27, 1967–1968, p. 168–175.

243 Cf. L. GINZBERG, *The Legends of the Jews.* Philadelphia, 1925, 5, p. 41–49. The Leviathan-Behemot theme occurs frequently in the early Midrash. The banquet theme only appears in the later texts (A. JELLINEK, *Beit Hamidrash,* reprinted Jerusalem, 1967, 6, p. 45–46), and, in an allegorical interpretation, in medieval rabbinic literature (GINZBERG, *loc. cit.,* p. 43, n. 127).

244 *Bundahis,* in *The Sacred Books of the East,* V: M. MULLER, ed., *Pahlavi texts.* Oxford, 1880, chap. 14–24.

245 G. SED-RAJNA, *Le mahzor enluminé. Les voies de formation d'un programme iconographique.* Leiden, 1983. (Hereafter: G. SED-RAJNA, *Le mahzor*).

246 *Ibid.,* pp. 20–21.

247 *Ibid.,* pp. 31–32.

248 B. NARKISS, *Hebr. ill. mss.,* p. 26. R. WISCHNITZER, "The moneychanger with the Balance. A topic of Jewish iconography," *Eretz Israel,* 6, p. 23–25.

249 B. NARKISS, *Machsor Lipsiae.* Leipzig, 1964, p. 94. G. SED-RAJNA, *Le mahzor,* p. 32.

250 Budapest, Tudományos Akadémia, col. Kaufmann, ms. A. 384;

London, British Museum, Add. ms. 22413; Oxford, Bodleian Library, ms. Mich. 619; cf. B. Narkiss; "A Tripartite Illuminated Mahzor from a South German School of Hebrew Illuminated Manuscripts around 1300," in *Proceedings of the Fourth World Congress of Jewish Studies.* Jerusalem, 1968, 2, p.129-133; G. Sed-Rajna, *Le mahzor*, p. 16, 71-75.

251 Cf. G. Sed-Rajna, *Le mahzor*, p. 71.

252 *Ibid.,* figs. 49 and 50.

253 Cf. G. Sed-Rajna, *Le mahzor*, p. 47-48.

254 Vienna, ÖNB Codex Hebr. 163; Jerusalem, Jewish nat. and univ. Libr., ms Heb. 8° 5214.

255 The most famous examples are the second Nürnberg Haggadah, Jerusalem, Schocken Library, ms 24087; The *Yahuda Haggadah.* Jerusalem, Israel Museum, ms 180/50 in B. Narkiss, G. Sed-Rajna, *Iconographical Index of Hebrew Illuminated Manuscripts,* vol. 2, Munich, 1982.

256 M. Metzger, "Les illustrations bibliques d'un manuscrit hébreu du Nord de la France," *in Mélanges René Crozet.* Poitiers, 1966, p. 1237-1253; Narkiss, *Hebr. ill. mss.,* p. 86; Z. Ameisenowa, "Die hebräische Sammelhandschrift Add. 11639 des British Museum," *Wiener Jahrbuch der Kunstgeschichte,* 24, 1971, p. 10-49.

257 G. Sed-Rajna, "The paintings of the London Miscellany," *Journal of Jewish Art,* 9, 1982, pp. 18-30 (hereafter Sed-Rajna, *London Miscellany*).

258 Reproduced in Sed-Rajna, *London Miscellany,* p. 20, fig. 1.

259 E.g. a "Hagiographic compilation, Paris, Bibl. nat. nouv. acq. fr. 16251; Sed-Rajna, *London Miscellany,* fig. 2.

260 *Ibid.,* p. 19.

261 L. Lazard, "Les revenues tirés des Juifs de France dans le domaine royal," *Revue des Etudes Juives,* 15, 1887, pp. 233-261.

262 Facsimile edition, *Codex Maimuni.* Budapest 1980, with an Introduction by A. Scheiber (text), G. Sed-Rajna (paintings); G. Sed-Rajna, "The illustrations of the Kaufmann *Mishneh-Torah," Journal of Jewish Art,* 6, 1976, pp. 64-77. (Hereafter: Sed-Rajna, *The Kaufmann Mishneh Torah).*

263 Sed-Rajna, *The Kaufmann Mishneh Torah,* pp. 66-69.

264 B. Narkiss, *Hebr. ill. mss.,* p. 50; G. Sed-Rajna, "Toledo or Burgos," *Journal of Jewish Art,* 2, 1972, pp. 2-21.

265 Narkiss, *Hebr. ill. mss.,* p. 52.

266 Cf. above, note 227.

267 On the different recensions of the Haggadah illustrations see B. Narkiss, *The Golden Haggadah.* London, 1969, Introduction, pp. 43-61. (Hereafter: Narkiss, *Golden Haggadah).*

268 D.H. Muller and J. von Schlosser, *Die Haggadah von Sarajevo. Eine Spanisch-jüdische Bilderhandschrift des Mittelalters.* Vienna, 1898. *La Haggadah de Sarajevo,* facsimile edition with introduction by C. Roth. Grenoble, 1963; Narkiss, *Hebr. ill. mss.,* p. 60.

269 Cf. Narkiss, *Golden Haggadah,* pp. 62-73.

270 H. Rosenau, "Notes on the illuminations of a Spanish Haggadah in the John Rylands Library," BJRL, 36, 1953-1954, p. 475-478; C. Roth, "The John Rylands Haggadah," BJRL, 43, 1960, p. 136-156.

271 Cf. above, n. 268.

272 F. Bucher, *The Pampeluna Bibles.* New Haven, 1970, pl 3, 4, 6.

273 J. Gutmann, "The Haggadic Motif in Jewish Iconography," EJ, 6, 1960, p. 15-22.

274 Narkiss, *Golden Haggadah;* idem., *Hebr. ill. mss.,* p. 56.

275 Narkiss, *The Golden Haggadah,* p. 62-68.

276 Narkiss, *Hebr. ill. mss.,* p. 158.

277 F. Rodrigez, *Di alcuni codici miniati della Biblioteca universitaria di Bologna.* 1957; Narkiss, *Hebr. ill. mss.,* p. 148.

278 Narkiss, *Hebr. ill. mss.,* p. 152; B. Narkiss; G. Sed-Rajna, *Iconographical Index of Hebrew Illuminated Manuscripts,* vol. 3, Jerusalem, 1983.

279 E. Naményi, "La miniature juive au XVIIème siècle," REJ, 116, 1957, p. 27-41; *idem.,* "The Illumination of Hebrew Manuscripts after the Invention of Printing," in C. Roth, ed., *Jewish Art.* Jerusalem, 1971, p. 423-454.

280 R. Wischnitzer, "Von der Holbeinbibel zur Amsterdamer Haggadah," MGWJ, 75, 1931, p. 269-286; *idem.,* "Zur Amsterdamer Haggadah," MGWJ, 76, 1932, p. 239-241.

BIBLIOGRAPHY

AVIGAD, N., "Architectural Observations on Some Rock—Cut Tombs," PEQ, 79, 1947, p. 112-115.

AVIGAD, N., "The Rock Carved Façades of the Jerusalem Necropolis," IEJ, 1, 1950-1951, p. 98-106.

MAZIÉ, A., "The Tomb of Josaphat in Relation to Hebrew Art," JJPES, 1, 1925, parts 2-4, p. 69.

MINOS, P.S.O., "The Tombs of the Kings in Jerusalem," PSBA, 33, 1911, p. 19-25.

NARKISS, B., "On the Zoocephalic Phenomenon in Medieval Ashkenazi Manuscripts," Essays in Honor of Moshe Barash, Jerusalem, 1983, pp. 49-62.

NARKISS, M., "The Origin of the Spice Box Known as 'Hadass'," EI, 6, 1960, p. 189-198 (in Hebrew).

NARKISS, M., "Origins of the Spice Box," JJA, 8, 1981, pp. 28-41.

SLOUSCHZ, N., "The Excavations around the Monument of Absalom," PJES, 1, 1927, 2-4, p. 17.

URBACH, E. E., "The Rabbinical Law of Idolatry in the Second and Third Centuries in the Light of Historical and Archaeological Facts," IEJ, 9, 1957, p. 149-165, and p. 228-245.

VINCENT, L. H., Jérusalem de l'Ancien Testament, (1-2), Paris, 1956.

VINCENT, L. H., "Un Hypogée Juif," RB, 7, 1899, p. 297-304.

YADIN, Y., Massada. London-New York, 1966.

THE EASTERN WORLD

GENESIS OF SYMBOLS

AVI-YONAH, M., Oriental Art in Roman Palestine. Rome, 1961.

AVI-YONAH, M., Art in Ancient Palestine. Jerusalem, 1981.

GOODENOUGH, E. R., Jewish Symbols in the Greco-Roman Period, 1-3, New York, 1953.

COINS

KADMAN, N., The Coins of the Jewish War of 66-73 C.E. Tel Aviv-Jerusalem, 1960.

KINDLER, A., "The Coinage of the Hasmonean Dynasty," Numismatic Studies and Researches, 3, Jerusalem, 1958.

KINDLER, A., Coins of Eretz Israel. Jerusalem, 1971 (in Hebrew).

NARKISS, B., "Symbolical Representations of the Temple," Ha Universita, 13, 1968, p. 11-20 (in Hebrew).

NARKISS, M., Coins of Eretz Israel. Jerusalem, 1936 (in Hebrew).

REIFENBERG, A., "Portrait Coins of the Herodian Kings," Numismatic Circular, 1935, p. 3-11.

REIFENBERG, A., "Unpublished and Unusual Jewish Coins," IEJ, 1, 1950-1951, p. 175-178.

WIRGIN, W. "On King Herod's Messianism," IEJ, 11, 1961, p. 153-154.

OSSUARIES, SARCOPHAGI

AVI-YONAH, M., "Oriental Elements in the Art of Palestine in the Roman and Byzantine Periods," QDAP, 10, 1942, p. 105-151; 13, 1948, p. 128-165; 14, 1950, p. 49-80.

DUSSAUD, R., Les monuments palestiniens et judaïques au Musée du Louvre. Paris, 1912.

GRAETZ, H., "Die Jüdischen Steinsarkophage in Palestina," MGWJ, 30, 1881, p. 529-539.

KRAUSS, S., "La Double inhumation chez les Juifs," REJ, 97, 1934, p. 1-34.

MEYERS, M., Jewish Ossuaries: Reburial and Rebirth. Secondary Burials in their Ancient Near Eastern Setting. Rome, 1971.

SAULCY, J. F. DE, "Fragments d'art judaïque," Gazette archéologique, 5, 1879, p. 261-263.

SUKENIK, E. L. "A Jewish Tomb in the Kidron Valley," PEF.Q.ST, 1937, p. 126-135.

VINCENT, L. H., "Sur la date des ossuaires juifs," RB, 43, 1934, p. 564-567.

BETH SHEARIM

1. Archeology

AVIGAD, N., "Beth Shearim," IEJ, 4, 1954, p. 88-107; 5, 1955, p. 205-239; 8, 1958, p. 276-277; 9, 1959, p. 205-220.

MAISLER (MAZAR), B., "The Excavations at Sheikh Ibreq (Beth Shearim), 1936-1937," JPOS, 18, 1938, p. 41-49.

MAZAR, B., "Beth Shearim," IEJ, 6, 1955, p. 261-262; 10, 1960, p. 264.

MAZAR, B., SCHWABE, M., LIFSCHITZ, B., AVIGAD, N., Beth Shearim. Final Report, vol. 1-3, Jerusalem, 1957-1972.

2. Sarcophagi

AVIGAD, N., "Sarcophagi at Beth Shearim," Archaeology, 10, 1957, p. 266-269.

AVI-YONAH, M., "The Leda Coffin from Beth Shearim," EI, 8, 1967, p. 143-148 (in Hebrew).

AVI-YONAH, M., "The Leda Sarcophagus of Beth Shearim," Scripta Hierosolymitana, 24, 1972, p. 9-21.

3. Inscriptions

LIFSCHITZ, B., "La vie de l'au-delà dans les conceptions juives. Inscriptions grecques à Beth Shearim," RB, 68, 1961, p. 401-411.

SCHWABE, M., "La vie de l'au-delà à Beth Shearim," Studies in Memory of Asher Gulak and Samuel Klein. Jerusalem, 1942, p. 187-200 (in Hebrew).

SCHWABE, M., "Greek Inscriptions Found at Beth Shearim in the Fourth Excavation Season 1953," IEJ, 4, 1954, p. 249-261.

ROMAN CATACOMBS

1. General Works

CUMONT, F., Recherches sur le symbolisme funéraire des Romains. Paris, 1942.

GARRUCCI, R., Storia dell' arte cristiana nei primi otto secoli. Prato, 1872-1880.

GARRUCCI, R., Dissertazioni archeologiche di vario argomento. Rome, 1866.

MARUCCHI, O., Le Catacombe romane. Rome, 1932.

PARROT, A., Le Refrigerium dans l'au-delà. Paris, 1937.

2. Monteverde

MÜLLER, N., Die Jüdische Katakombe am Monteverde zu Rom. Leipzig, 1912.

3. Villa Torlonia

BEYER, H. W., LIETZMANN, H., *Jüdische Denkmäler, I. Die Jüdische Katakombe der Villa Torlonia in Rom,* Berlin–Leipzig, 1930.

LEON, H., "An Unpublished Jewish Inscription at Villa Torlonia in Rome," JQR, 42, 1952, p. 413–418.

REGENSTORF, K. H., "Zu den Fresken der Jüdischen Katakombe der Villa Torlonia in Rom," ZAW, 31, 1932, p. 33–60.

REINACH, T., Une nouvelle nécropole judéo-romaine," REJ, 72, 1921, p. 24–28.

WISCHNITZER, R., "La catacombe de la Villa Torlonia," REJ, 91, 1931, p. 102–107.

4. Vigna Randanini

CUMONT, F., "Un fragment de sarcophage judéo-païen," *Revue archéologique,* Series V, vol., 4, 1916, p. 1–16.

GARRUCCI, R., *Cimitero degli antichi Ebrei scoperto recentemente in Vigna Randanini,* Rome, 1862.

MINOR WORKS OF ART

1. Ornamented Glass Grounds

GARRUCCI, R., *Vetri ornati di figure in oro trovati nei cimiteri dei Cristiani primitivi di Roma,* Rome, 1858.

SCHWABE, M., REIFENBERG, A., "Ein unbekanntes jüdisches Goldglas," *Rivista di Archeologia cristiana,* 15, 1938, p. 319–329.

2. Lamps

BAUR, P. V. C., "David and Goliath on an Early Christian Lamp," *Yale Classical Studies,* 1, 1928, p. 41–51.

REIFENBERG, A., "Vergleichende Beschreibung einiger Jüdisch-Palästinensischer Lampen," JPOS, 11, 1931, p. 63–67.

REIFENBERG, A., "Jüdische Lampen," JPOS, 16, 1936, p. 166–179.

3. Pilgrims' Bottles

BARAG, D., "Glass Pilgrim Vessels from Jerusalem," *Journal of Glass Studies,* 12, 1970, p. 35–63.

NEUBURG, F., *Glass in Antiquity.* London, 1949.

4. Mirror Plaques

MAYER, L. A., REIFENBERG, A., "Three Ancient Jewish Reliefs," PEF.Q.ST. 1937, p. 136–139.

RAHMANI, L. Y., "Mirror Plaques from a Fifth Century A. D. Tomb," IEJ, 1964, p. 50–60.

NARRATIVE SYMBOLS

PAINTINGS OF THE SYNAGOGUE OF DURA-EUROPOS

AUBERT, M., "Les fouilles de Doura-Europos. Notes sur les origines de l'iconographie chrétienne," *Bulletin Monumental,* 93, 1934, p. 397–407.

AUBERT, M., "Le peintre de la Synagogue de Doura," *Gazette des Beaux-Arts,* 6e période, 20, 1938, p. 1–24.

DU MESNIL DU BUISSON, Comte, "Une peinture de la synagogue de Doura-Europos," RB, 43, 1934, p. 105–119.

DU MESNIL DU BUISSON, Comte, "Une peinture de la synagogue de Doura-Europos," *Gazette des Beaux-Arts,* 6e période, 14, 1935, p. 193–203.

DU MESNIL DU BUISSON, Comte, "Les deux synagogues successives à Doura-Europos," RB, 45, 1936, p. 72–90.

DU MESNIL DU BUISSON, Comte, *Les peintures de la synagogue de Doura-Europos,* 245–256 après J.-C., Rome, 1939.

GOODENOUGH, E. R., "The Paintings of the Dura-Europos Synagogue. Method and an Application," IEJ, 8, 1958, p. 69–79.

GOODENOUGH, E. R., "The Orpheus in the Synagogue of Dura-Europos," JWCI, 22, 1959, p. 372.

GOODENOUGH, E. R., "Judaism at Dura-Europos," IEJ, 11, 1961, p. 161–170.

GOODENOUGH, E. R., *Jewish Symbols in the Greco-Roman Period,* Vol. 9–11: *Symbolism in the Dura Synagogue.* New York, 1964.

GRABAR, A., "Le thème des fresques de la synagogue de Doura (245–256 après J.-C.)", RHR, 123, 1941, p. 143–192; 124, 1941, p. 5–35.

GUTMANN, J., ed., *The Dura-Europos Synagogue: A Re-Evaluation (1932–1972),* with contributions of HOPKINS, C., BRILLIANT, R., THOMPSON, M. L., GOLDMANN, B., SEAGER, A., AVI-YONAH, M., Missoula, Montana, 1973.

KRAELING, E. G., "The Meaning of the Ezekiel Panel in the Synagogue at Dura," BASOR, 78, 1940, p. 12–18.

KRAELING, C. H., *The Excavations at Dura-Europos. Final Report* VIII. *The Synagogue.* New Haven, 1956.

PERKINS, A., *The Art of Dura-Europos.* Oxford, 1973.

ROSTOVTZEFF, M. I., "Die Synagogue von Dura," *Römische Quartalschrift,* 42, 1934, p. 203–218.

SCHNEID, N., *The Paintings of the Dura-Europos Synagogue,* Tel Aviv, 1946 (in Hebrew).

SONNE, I., "The Paintings of the Dura Synagogue," HUCA, 20, (1947), p. 255–362.

STERN, H., "The Orpheus in the Synagogue of Dura-Europos," JWCI, 21, 1958, p. 1–7.

STERN, H., 'Quelques problèmes d'iconographie paléochrétienne et juive," *Cahiers Archéologiques,* 12, 1962, p. 99–113.

STERN, H., "Un nouvel Orphée — David dans une mosaïque du VIe siècle," *Comptes rendus de l'Académie des Inscriptions et Belles Lettres,* 1970, January–March, p. 63–79.

STERN, H., "Orphée dans l'art paléochrétien," *Cahiers Archéologiques,* 23, 1974, p. 1–16.

SUKENIK, E. L., "The Ezekiel Panel in the Wall Decoration of the Synagogue of Dura-Europos," JPOS, 18, 1938, p. 57–62.

SUKENIK, E. L., *The Synagogue of Dura-Europos and its Paintings.* Jerusalem, 1947 (in Hebrew).

WISCHNITZER, R., *The Messianic Theme in the Paintings of the Dura Synagogue.* Chicago, 1948.

THE IMAGE OF THE WORLD

ARCHEOLOGY

1. GENERAL WORKS

AVI-YONAH, M., "Synagogue Architecture in the Late Classical Period," in *Jewish Art,* ed. Roth C., London, 1971, p. 65–82.

FOERSTER, G., *Galilean Synagogues and their Relation to Hellenistic and Roman Art and Architecture,* Ph. D. thesis, Jerusalem, 1972 (in Hebrew).

FOERSTER, G., "The Synagogues at Massada and Herodion," JJA, 3–4, 1977, p. 6–11.

FOERSTER, G., "Architectural Models of the Greco-Roman Period and the Galilean Synagogue," *Ancient Synagogues Revealed,* Jerusalem, 1981, p. 45–48.

GOODENOUGH, E. R., *Jewish Symbols in the Greco-Roman Period*, I. *The Archaeological evidence from Palestine*. II. *The Archaeological evidence from the Diaspora*. New York, 1953.

GORDON, H. L., "The Basilica and the Stoa in Early Rabbinical Literature," *The Art Bulletin*, 13/3, 1931, p. 3-25.

GRABAR, A., "Recherches sur les sources juives de l'art paléochrétien," *Cahiers Archéologiques*, 11, 1960, p. 41-71; 12, 1962, p. 115-152.

KANAEL, B., *Die Kunst der antiken Synagogen*. Munich-Frankfurt, 1961.

KOHL, H., WATZINGER, C., *Antike Synagogen in Galilaea*. Leipzig, 1916.

KRAUSS, S., *Synagogale Altertümer*. Berlin-Vienna, 1922. Photo Edition, Hildesheim, 1966.

MAY, H. G., "Synagogues in Palestine," *Biblical Archaeologist*, 7, 1944, p. 1-20.

REIFENBERG, A., *Denkmäler der Jüdischen Antike*. Berlin, 1937.

SUKENIK, E. L., *Ancient Synagogues in Palestine and Greece*. London, 1934.

SUKENIK, E. L., "The Present State of Ancient Synagogue Studies," *Rabinowitz Fund for the Exploration of Ancient Synagogues*, Bulletin I, 1949, Jerusalem, p. 8-23.

WATZINGER, C., *Denkmäler Palästinas, eine Einführung in die Archäologie des Heiligen Landes*. Leipzig, 1935.

2. Beth Alpha

BARROIS, A., "Découverte d'une synagogue à Beit Alpha," RB, 39, 1930, p. 265-272.

FREY, J.-B., "Une ancienne synagogue de Galilée récemment découverte," RAC, 10, 1933, p. 287-305.

KRAUSS, S., "Nouvelles découvertes archéologiques de synagogues en Palestine," REJ, 89, 1930, p. 405-408.

MARMORSTEIN, A., "Some Notes on Recent Works on Palestine Epigraphy," PEF.Q.ST. 1930, p. 154-157.

SUKENIK, E. L., "The Ancient Synagogue of Beth Alpha," *Tarbiz*, 1, 1930, p. 122-124 (in Hebrew).

SUKENIK, E. L., *The Ancient Synagogue of Beth Alpha*. Jerusalem-London, 1932.

3. Beth Shean

BAHAT, D., "The Synagogue at Beth-Shean," *Kadmoniyot*, 5, 1972, p. 55-58 (in Hebrew).

4. Beth Shearim

AVIGAD, N., "Excavations at Beth Shearim. Preliminary Report," 1953: IEJ, 4, 1954, p. 88-107. 1954: IEJ, 5, 1955, p. 205-239. 1955: IEJ, 7, 1957, p. 73-92. 1958: IEJ, 9, 1959, p. 205-220.

AVIGAD, N., "The Necropolis of Beth Shearim," *Archeology*, 8, 1955, p. 236-244.

MAISLER (MAZAR), B., "The Excavations at Sheikh Ibreiq (Beth Shearim)," JPOS, 18, 1938, p. 41-49; BJPES, 4, 1937, p. 79-82, (1st campaign); BJPES, 5, 1937-38, p. 49-76 (2nd campaign); BJPES, 6, 1938-39, p. 101-103 (3rd campaign); BJPES, 9, 1941-42, p. 5-20 (4th campaign); BIES, 1956-57, 21, (8th campaign). (Articles in BJPES, later BIES, are in Hebrew with English summary).

MAZAR, B., SOWA, M., LIFSCHITZ, B., AVIGAD, N., *Beth Shearim. Final Report*. Vol. 1-3, Jerusalem, 1957-1972 (in Hebrew).

INSCRIPTIONS

LIFSCHITZ, B., "Beiträge zur Palästinischen Epigraphik," ZDPV, 78, 1962, p. 64-88.

SCHWABE, M., "Greek Inscriptions found at Beth Shearim in the Fifth Excavations Season, 1953," IEJ, 4, 1954, p. 249-261.

SCHWABE, M., LIFSCHITZ, B., "A Graeco-Jewish Epigram from Beth Shearim," IEJ, 6, 1956, p. 78-88.

1. Capharnaum

CORBO, V., *The House of St. Peter at Capharnaum*. Jerusalem, 1969.

CORBO, V., LOFFREDA, S., SPIJKERMANN, A., *La Sinagoga di Cafarnao dopo gli scavi del 1969*, Publicazioni dello studium Biblicum Franciscanum, Collectio minor n. 9, Jerusalem, 1970.

MIDDLETON, R. D., "The Synagogue at Tell-Hum," PEF.Q.ST., 1926, p. 104

ORFALI, G., *Capharnaüm et ses ruines*. Paris, 1922.

ORFALI, G., "La dernière période de l'histoire de Capharnaüm," JPOS, 2, 1922, p. 87-93.

VINCENT, L. H., "L'année archéologique 1921 en Palestine. 4. Recherches à Capharnaüm," RB, 31, 1922, p. 122-124.

2. Chorazin. Moses' Seat

BACHER, W., "Le Siège de Moïse," REJ, 1897, p. 299-301.

KRAUSS, S., "Nouvelles découvertes archéologiques des synagogues en Palestine," REJ, 89, 1930, p. 388-395.

MARMORSTEIN, A., "Some notes on Recent Works on Palestine Epigraphy (The Cathedra of Moses in The Ancient Synagogues)," PEF.Q.ST., 1930, p. 154-157.

ORY, J., "An Inscription Newly Found in the Synagogue of Kerazeh," PEF.Q.ST., 1927, p. 51-59.

RENOV, I., "The Seat of Moses," IEJ, 5, 1955, p. 262-267.

ROTH, C., "The 'Chair of Moses' and its Survivals," PEQ, 1949, p. 100-111.

SUKENIK, E. L., "The 'Chair of Moses' in Ancient Synagogues," *Tarbiz*, 1, 1929, p. 145-151 (in Hebrew).

3. Jerash (Gerasa)

BARROIS, A., "Découverte d'une synagogue à Djerash," RB, 39, 1930, p. 257-265.

CROWFOOT, J. W., HAMILTON, R. W., "The Discovery of a Synagogue at Jerash," PEF.Q.ST., 1929, p. 211-219.

KRAELING, C. H., *Gerasa. City of the Decapolis*. New Haven, 1938, p. 234-241; p. 318-324.

4. Dura-Europos

GOODENOUGH, E. R., *Jewish Symbols in the Greco-Roman Period*, 9-11. New York, 1964.

KRAELING, C. H., *Excavations at Dura-Europos. Final Report VIII. The Synagogue*. New Haven, 1956. (cf. BIBLIOGRAPHY, ch. 3).

5. Eshtemoa

ABEL, F. M., BARROIS, A., "Sculptures du sud de la Judée," RB, 38, 1929, p. 585-589.

GOODENOUGH, E. R., *Jewish Symbols*, 1, p. 232-236.

MAYER, L. A., "Es-Samu," QDAP, 6, 1938, p. 221.

MAYER, L. A., REIFENBERG, A., "The Synagogue of Eshtemoa. Preliminary report," JPOS, 19, 1941, p. 314-326.

SUKENIK, E. L., "The Ancient Synagogue of Esthemoa," *Kedem, Studies in Jewish Archaeology*, 1, 1942, p. 64-69 (in Hebrew).

YEIVIN, Z., "The Synagogue at Eshtemoa," *Kadmoniyot*, 5, 1972, p. 43-45 (in Hebrew).

6. En Gedi

BARAG, D. PORAT, J., "A Synagogue at En Geddi," *Kadmoniyot*, 3, 1970, p. 97-100 (in Hebrew).

BARAG, D., PORAT, J., "The Second Season of Excavations in the Synagogue of En Geddi," *Kadmoniyot*, 5, 1972, p. 52-54 (in Hebrew).

7. El-Hammeh

SUKENIK, E. L., "The Ancient Synagogue of Hammat by Gadara," JJPES, 3, 1934-1935, p. 41-61 (in Hebrew).

SUKENIK, E. L., *The Ancient Synagogue of El-Hammeh (Hammath by Gadara).* Jerusalem, 1935.

8. Hammat near Tiberias

DOTHAN, M., "The Aramaic Inscription from the Synagogue of Severus at Hamat Tiberias," EI, 8, 1967, p. 183-185 (in Hebrew).

VINCENT, L. H., "Les fouilles juives d'el-Hammam à Tibériade," RB, 30, 1921, p. 438-442; 31, 1922, p. 115-122.

9. Jericho

BARAMKI, D. C., "An Early Byzantine Synagogue near Tell es-Sultan Jericho," QDAP, 6, 1938, p. 73-77.

10. Jerusalem. Synagogue of Freed Men

CLERMONT-GANNEAU, C., "Une Synagogue de l'époque hérodienne à Jérusalem," *Comptes rendus de l'Académie des Inscriptions et Belles-Lettres,* 1920, p. 187.

CLERMONT-GENNEAU, C., "Découverte d'une synagogue de l'époque hérodienne," *Syria,* 1, 1920, p. 190-197.

COOK, S. A., "The Synagogue of Theodotos at Jerusalem," PEF.Q.ST., 1921, p. 247.

REINACH, T., 'L'inscription de Theodotos," REJ, 71, 1920, p. 46-56.

VINCENT, L. H., "Découverte de la Synagogue des affranchis à Jérusalem," RB, 30, 1921, p. 247-277.

WEILL, R., "La Cité de David. Compte rendu des fouilles exécutées à Jérusalem sur le site de la ville primitive. Campagne 1913-1914," REJ, 69, 1919, p. 1-85; 70, 1920, p. 1-36; 71, 1920, p. 1-45.

11. Kfar Baram — Inscriptions

AMIRAN, R., "A Fragment of an Ornamental Relief from Kfar-Baram," IEJ, 5, 1956, p. 239-245.

YEIVIN, Z., "The Zodiac Tablet in the Kfar Baram Synagogue," BJPES, 3, 1945-1946, p. 119-121 (in Hebrew).

12. Maon (Nirim)

LEVY, S., "The Ancient Synagogue at Maon (Nirim)," EI, 6, 1960, p. 77-80 (in Hebrew).

LEVY, S., RAHMANI, L. Y., HIRAM, A. S., DUNAYEVSKI, J., AVI-YONAH, M., YEIVIN, Z., "The Ancient Synagogue of Ma'on (Nirim)," *Bulletin Rabinowitz,* 3, 1960, p. 6-40 (in Hebrew).

RAHMANI, L.Y., "The Synagogue of Ma'on (Nirim). Small finds and coins," EI, 6, 1960, p. 82-85.

13. Naaran

VINCENT, L. H., "Le sanctuaire juif d'Ain Douq," RB, N.S. 16, 1919, p. 532-563.

VINCENT, L.H., CARRIÈRE, B., "La Synagogue de Naarah," RB, 30, 1921, p. 579-601.

VINCENT, L. H., "Un Sanctuaire dans la région de Jéricho. La Synagogue de Naarah," RB, 68, 1961, p. 161-177.

14. Ostia

SQUARCIAPINO, M. F., "La Sinagoga di Ostia," *Bolletino de'Arte,* 46, 1961, p. 326-337.

WISCHNITZER, R., *The Architecture of the European Synagogue.* Philadelphia, 1964, p. 5-7.

15. Sardis

GORDON MITTEN, D., [The Fifth Campaign at Sardis]. "The Synagogue," BASOR, 170, 1963, p. 38-48.

GORDON MITTEN, D., (The Sixth Campaign at Sardis]. "The Synagogue," BASOR, 174, 1964, p. 30-44.

GORDON MITTEN, D., "The Ancient Synagogue of Sardis. A Progress Report." Cambridge, Mass. 1969.

SAEGER, A., "The Architecture of the Dura and Sardis Synagogues," *The Dura-Europos Synagogue: A Re-Evaluation (1932-1972).* ed. Gutmann, J., Missoula, Montana, 1973, p. 79-116.

16. Stobi

MARMORSTEIN, A., "The Synagogue of Claudius Tiberius Polycharmus in Stobi," JQR, N.S., 27, 1936-1937, p. 373-384.

17. Susiya

GUTMANN, S., YEIVIN, Z., NASOR, A., "Excavation of the Synagogue at Susiya," *Kadmoniyot*, 5, 1972, p. 47-52 (in Hebrew).

18. Yafya

SUKENIK, E. L., "The Ancient Synagogue at Yafa near Nazareth," *Bulletin Rabinowitz,* 2, 1951, p. 6-24.

VINCENT, L. H., "Vestiges d'une synagogue antique à Yafa de Galilée," RB, 30, 1921, p. 434-438.

MOSAICS

1. GENERAL WORKS

AVI-YONAH, M., "Mosaic Pavements in Palestine," QDAP, 2, 1932, p. 136-162; p. 163-181; 3, 1933, p. 26-47; p. 49-73; 4, 1935, p. 187-193.

AVI-YONAH, M., "Mosaic Floors of Synagogues and Churches in Israël," BJPES, 1, 1933-1934, p. 9-17 (in Hebrew).

AVI-YONAH, M., *Mosaic Pavements in Palestine.* Oxford, 1935.

AVI-YONAH, M., *Israel. Ancient Mosaics.* New York-London, 1960 (Unesco World Art Series).

AVI-YONAH, M., "La mosaïque juive dans ses relations avec la mosaïque classique," *Colloques internationaux du Centre National de la Recherche Scientifique,* Paris, 1965, p. 325-329.

2. Beth Alpha

AVIGAD, N., "The Mosaic Pavement of the Beth Alpha Synagogue and its Place in the History of Jewish Art," *The Beth Shean Valley. 17th Archaeological Convention,* Jerusalem, 1962, p. 63-70.

GOLDMAN, B., *The Sacred Portal. A Primary Symbol in Ancient Judaic Art.* Detroit, 1966.

YEIVIN, Z., "The Sacrifice of Isaac in the Beth Alpha Mosaic," BJPES, 12, 1945-1946, p. 20-24 (in Hebrew).

3. Hammath, near Tiberias

DOTHAN, M., "The Representation of Helios in the Mosaic of Hammath Tiberias," *Atti del Convegno internazionale sul tema Tardo Antico e Alto Medievo,* Roma, Accademia Nazionale dei Lincei, 1968, p. 99-104.

4. Maon (Nirim)

AVI-YONAH, M., "The Mosaic Pavement of the Maon (Nirim)

Synagogue," EI, 6, 1960, p. 86–93.

Avi-Yonah, M., "The Ancient Synagogue of Ma'on. E. The Mosaic Pavement," *Bulletin Rabinowitz*, 3, 1960, p. 25–35.

Grabar, A., "Un thème de l'iconographie chrétienne: l'oiseau dans la cage," *Cahiers Archéologiques*, 16, 1966, p. 9–16.

5. Naaran

Clermont Ganneau, C., "La mosaïque de la Synagogue de Ain Douq (Naaran)," *Syria*, 2, 1921, p. 172–174.

Sukenik, E. L., "Some Problems of the Ornamentation of the Mosaic Floor in the Synagogue of Naaran," *Magnes Anniversary Book*, Jerusalem, 1938, p. 178–180 (in Hebrew).

Vincent, L. H., "Mosaïques avec Zodiaque et Daniel dans la fosse aux lions," RB, 68, 1961, p. 168–169.

THE WESTERN WORLD

STYLES OF THE DIASPORA

Medieval Synagogues

1. General Works

Krautheimer, R., *Mittelalterliche Synagogen*. Berlin, 1927.

Landsberger, F., *A History of Jewish Art*. Cincinnati, 1946.

Landsberger, F., "The House of People," HUCA, 22, 1949, p. 149–155.

Landsberger, F., "The Sacred Direction in Synagogue and Church," HUCA, 28, 1957, p. 181–203.

Lukomski, G., *Jewish Art in European Synagogues from the Middle Ages to the 18th. Century*. London, 1947.

Lukomski, G., "Les Synagogues. L'ancienne architecture religieuse juive en Europe du XI^e au XVIII^e siècle," *Revue de l'Art ancien et moderne*, 70, 1936, p. 211–226.

Rosenau, H., *A Short History of Jewish Art*. London, 1948.

Roth, C., "The European Age in Jewish History" in *The Jews, their History, Culture and Religion*, ed. Finkelstein, Philadelphia, 1960.

Wischnitzer, R., *The Architecture of the European Synagogue*, Philadelphia, 1964.

2. Spain

Cantera Burgos, F., "Inscripciones hebraicas de Toledo," *Sefarad*, 4, 1944, p. 45–72.

Cantera Burgos, F., *Sinagogas Españolas*. Madrid, 1955.

Cantera Burgos, F., "Identificación de nuevas sinagogas en España," *Sefarad*, 22, 1962, p. 3–16.

Lambert, E., *Tolède*. Paris, 1925.

Lambert, E., "Les synagogues de Tolède, REJ, 84, 1927, p. 15–33

Roth, C., "Las inscripciones historicas de la Sinagoga del Transito de Toledo," *Sefarad*, 8, 1948, p. 1–22.

3. Germany–Bohemia

Böcher, O. *Die Alte Synagoge zu Worms*, ed. Roth E., Frankfurt a/Main, 1961, p. 11–54.

Epstein, A., "Jüdische Altertümer in Worms und Speier," MGWJ, 40, 1896, p. 509–515; 554–559; 41, 1897, p. 25–43.

Epstein, A., "Die nach Rashi benannten Gebäude in Worms," MGWJ, 45, 1901, pp. 45–75.

Münzercva, Z., *Staranová synagoga V Praze*. Praha, 1932.

Vilimkova, M., "Seven Hundred Years of the Old-New Synagogue," *Judaica Bohemiae*, 5, 1969, p. 72–83.

Volavkova, H., *The Pinkas Synagogue. A Memorial of the Past and of Our Days*. Praha, 1955.

4. France

Hautecoeur, L., *Histoire de l'architecture classique en France* Paris, 1950, v. 1, p. 712–714.

Loeb, I., "Les Juifs de Carpentras sous le gouvernement pontifical," REJ, 12, 1886, p. 34–64; 161–235.

Art et archéologie des Juifs en France médiévale. Ed. B. Blumenkranz. Toulouse 1980.

5. Italy

Finkerfeld, J., *Italian Synagogues from the Renaissance to the Present Day*. Jerusalem, 1954 (in Hebrew).

Milano, A., *Storia degli Ebrei in Italia*. Torino, 1963.

Nahon, U., "Synagogues from Italy in Israel," (in Hebrew), in *Scritti in Memoria di Sally Mayer*, Jerusalem, 1956, p. 259–277.

Nahon, U., *Arks and Ceremonial Objects from Italy in Israel*. (In Hebrew), Tel-Aviv, 1970.

Roth, C., *Venice*. Philadelphia,

1930.

Roth, C., *The History of the Jews in Italy*. Philadelphia, 1946.

6. Netherlands

Da Silva Rosa, J. S., *Geschiedenis der Portugeesche Joden in Amsterdam 1593–1925*. Amsterdam, 1925.

Meijer, J., in De Castro, D. H., ed., *De Synagoge des Portugees Israelitische Gemeente te Amsterdam*. Amsterdam, 1950.

Rosenau, H., "The Synagogue and Protestant Church in Architecture," JWCI, 4, 1940, p. 80–84.

7. Poland

Breier, A., Eisler, M., Grunwald, M., *Holzsynagogen in Polen*. Baden, 1934.

Davidovicz, D., *Wandmalereien in alten Synagogen*. Hanover, 1969.

Grotte, A., *Deutsche, Böhmische und Polnische Synagogentypen. Mitteilungen der Gesellschaft zur Erforschung Jüdischer Kunstdenkmäler*. 7–8, Berlin, 1915.

Lauterbach, *Die Renaissance in Krakau*. Munich, 1911.

Lorentz, S., "The Renaissance in Poland, *Stolica*, Warsaw, 1955.

Lukomski, G., "Jewish Architecture in Poland," *Journal of the Royal Institute of British Architects*, 3rd. s. 41, 1934, p. 748–753.

Lukomski, G., "The Wooden Synagogues of Eastern Europe," *Burlington Magazine*, 66, 1935, p. 14–21.

Piechotka, M. and K., *Wooden Synagogues*. Warsaw, 1959.

Schneid, O. N., "The Art of the Jews in Poland," *Sinai*, 5, 1942, p. 248–260 (in Hebrew).

CEREMONIAL ART

GENERAL WORKS

Gutmann, J., *Jewish Ceremonial Art*. New York, 1964.

Kanof, A., *Jewish Ceremonial Art and Religious Observance*. New York, 1969.

Kayser, S. S., Schoenberger, G., *Jewish Ceremonial Art*. Philadelphia, 1959.

Landsberger, F., *A History of Jewish Art*. Cincinnati, 1946.

Roth, C., "Ritual Art," in *Jewish Art, An Illustrated History*, Jerusalem, 1971, p. 118–131.

SCHWARZ, K., *Jewish Ceremonial Objects.* Berlin, 1933.

WISCHNITZER, M., *A History of Jewish Crafts and Guilds.* New York, 1965.

TORAH ORNAMENTS

LANDSBERGER, F., "Old-Time Torah Curtains," HUCA, 19, 1946, p. 353–387.

LANDSBERGER, F., "The Origin of European Torah Decoration," HUCA, 24, 1952–1953, p. 133–150.

CEREMONIAL OBJECTS FOR HOLIDAYS

1. Sabbath

LANDSBERGER, F., "The Origin of the Ritual Implements for the Sabbath," HUCA, 27, 1956, p. 387–415.

NARKISS, M., "The Origin of the Spice Box Known as 'Hadass'," EI, 6, 1960, p. 189–198 (in Hebrew).

2. Passover

WISCHNITZER, R., "Passover in Art," in *Passover Anthology,* ed. Goodmann, Ph., Philadelphia, 1961.

3. Hanukah

LANDSBERGER, F., "Old Hanukkah Lamps," HUCA, 25, 1954, p. 347–367.

NARKISS, M., *The Hanukkah Lamp.* Jerusalem, 1939 (in Hebrew).

WISCHNITZER, R., "L'origine de la lampe de Hanuka," REJ, 1930, p. 135–146.

4. Esther Scrolls

METZGER, M., "The John Rylands Megillah and Some Other Illustrated Megilloth of the xvth. to the xviiith Centuries," BJRL, 45, 1962, p. 148–184.

METZGER, M., "A Study of Some Unknown Handpainted Megilloth of the Seventeenth and Eighteenth Centuries," BJRL, 46, 1963, p. 84–126.

NARKISS, M., "The Oeuvre of the Jewish Engraver Shalom Italia," *Tarbiz,* 25, 1955–1956, p. 441–451; 26, 1956–1957, p. 87–101.

5. Family Celebrations

DAVIDOVICZ, D., *The Ketuba. Jewish Marriage Contracts Through the Ages,* Tel Aviv, 1968.

GUTMANN, J., "Wedding Customs and Ceremonies in Art," in *Jewish Marriage Anthology,* ed., Goodmann, Ph. and H., New York, 1965, p. 175–183.

LANDSBERGER, F., "Illuminated Marriage Contracts," HUCA, 26, 1955, p. 503–542.

LANDSBERGER, F., "The Origin of the Decorated Mezuzah," HUCA, 31, 1960, p. 315–330.

NARKISS, M., "An Italian Niello Casket of the Fifteenth Century," JWCI, 21, 1958, p. 288–295. ID., in *Memorial S. Meyer,* Milano, 1956.

THE RENAISSANCE OF NARRATIVE ART

AMEISENOWA, Z., "Das messianische Gastmahl der Gerechten in einer hebräischen Bibel aus dem xiii Jahrhundert. Ein Beitrag zur eschatologischen Ikonographie der Juden," MGWJ, 79, 1935, p. 404–422.

AMEISENOWA, Z., "Animal-Headed Gods, Evangelists, Saints and Righteous Men," JWCI, 12, 1949, p. 21–45.

AMEISENOWA, Z., "Some Neglected Representations of the Harmony of the Universe," *Essays in Honour of Hans Tietze.* Paris, 1958.

AMEISENOWA, Z., "Die hebräische Sammelhandschrift Add. 11639 des British Museum," *Wiener Jahrbuch für Kunstgeschichte,* 24, 1971, p. 10–49.

The Bird's Head Haggadah of the Bezalel National Art Museum in Jerusalem, ed. facsimile by SPITZER, M.; introduction by GOLDSCHMIDT, E. D., JAFFE, H. L. C., NARKISS, B., SHAPIRO, M., Jerusalem, 1967.

BUCHER, F., *The Pampeluna Bibles.* New Haven, 1970.

Codex Maimuni. Facsimile ed. of the Kaufmann Mishneh Torah. Introduction A. SCHEIBER, G. SED-RAJNA, Budapest, 1984.

Die Darmstädter Pessach Haggadah. Codex Orientalis 8 der Hessischen Hochschulbibliothek Darmstadt, ed. facsimile; introduction by GUTMANN, J., KNAUS, H., PIEPER, P., ZIMMERMAN, E., Berlin, 1972.

ETTINGHAUSEN, R., *La peinture arabe.* Geneva, 1962.

ETTINGHAUSEN, R., "Yemenite Manuscripts of the xvth Century," EI, 7, 1964, p. 32–39.

FOONER, M., "Joel Ben-Simeon, Illuminator of Hebrew Mss in the xvth Century," JQR, N.S., 27, 1937, p. 217–232.

GOTTHEIL, R., "Some Hebrew Manuscripts in Cairo," JQR, 17, 1904–1905, p. 609–655.

GUTMANN, J., "The Jewish Origin of the Ashburnham Pentateuch Miniatures," JQR, N.S., 44, 1953–1954, p. 55–72.

GUTMANN, J., "The Haggadic Motif in Jewish Iconography," EI, 6, 1960, p. 16–22.

GUTMANN, J., "The Illustrated Jewish Manuscript in Antiquity. The Present State of Question," *Gesta,* 5, 1966, p. 39–41.

GUTMANN, J., "When the Kingdom Comes," *Art Journal,* 27, 1967–1968, p. 168–175.

GUTMANN, J., "Thirteen Manuscripts in Search of an Author: Joel ben Simeon 15th Century Scribe-Artist," *Studies in Bibliography and Booklore,* 9, 1970, p. 79–95.

GUTMANN, J., "Joseph Legends in the Vienna Genesis," in *Proceedings of the Fifth World Congress of Jewish Studies,* Jerusalem, 1973, v. 4, p. 181–184.

La Haggadah de Sarajevo, facsimile ed., introduction by C. ROTH, Grenoble, 1963.

Index of Jewish Art. Iconographical Index of Hebrew Illuminated Manuscripts. B. NARKISS – G. SED-RAJNA. 1, 1976; 2, 1982; 3, 1983.

KAUFMANN, D., "Un manuscrit du Mishne-Tora," REJ, 35, 1898, p. 65–74.

KAUFMANN, D., "Die Bilderzyklen im deutschen Typus der alten Haggada Illustration," *Gesammelte Schriften* iii, p. 229–261; REJ, 38, 1899, p. 74–102.

KAUFMANN, D., "Zur Geschichte der jüdischen Handschrift Illustration," Appendix to MÜLLER, D. H., SCHLOSSER, J., *Die Haggadah von Sarajevo,* 1898.

The Kennicott Bible. Facsimile ed. Introduction B. NARKISS, A. COHEN-MUSHLIN. London, 1985.

LEVEEN, J., *The Hebrew Bible in Art.* London, 1944.

Machsor Lipsiae, ed. facsimile KATZ, E.; introduction NARKISS, B., Leipzig, 1964.

MARGOLIOUTH, G., "Hebrew Illuminated Mss.", JQR, xx, 1908, p. 118-144.

METZGER, M., "Quelques caractères iconographiques et ornementaux de deux manuscrits hébraïques du xᵉ siècle," *Cahiers de Civilisation médiévale,* 1, 1958, p. 205-215.

METZGER, M., "Les illustrations bibliques d'un manuscrit hébreu du Nord de la France," in *Mélanges René Crozet,* Poitiers, 1966, p. 1237-1253.

METZGER, M., *La Haggada enluminée* I. *Étude iconographique et stylistique des manuscrits enluminés et décorés de la Haggada du XIIIᵉ au XVIᵉ siècle,* Leiden, 1973.

METZGER, I., "Les objets du culte, le sanctuaire du Désert et le Temple de Jérusalem dans les bibles hébraïques médiévales enluminées en Orient et en Espagne," BJRL, 52, 1970, p. 397-437; 53, 1971, p. 167-209.

MÜLLER, D. H., SCHLOSSER, J. VON, *Die Haggadah von Sarajevo. Eine spanisch-jüdische Bilderhandschrift des Mittelalters.* Vienna, 1898.

NAMÉNYI, E., "The Illumination of Hebrew Manuscripts after the Invention of Printing," in *Jewish Art,* ed. C. Roth, Jerusalem, 1971, p. 423-454.

NARKISS, B., "Medieval illuminated Haggadot," *Ariel,* 14, 1966, p. 35-40.

NARKISS, B., "A Tripartite Illuminated Mahzor from a South German School of Hebrew Illuminated Manuscripts," *Proceedings of the Fourth World Congress of Jewish Studies,* Jerusalem, 1968, v. 2., p. 129-133.

NARKISS, B., *Hebrew Illuminated Manuscripts.* Jerusalem, 1969.

NARKISS, B., *The Golden Haggadah. A Fourteenth Century Illuminated Hebrew Manuscript in the British Museum,* ed., facsimile with introduction, London, 1970.

NARKISS, B., "La lettre ornementale hébraïque au Moyen Age," *Ariel,* 28, 1973, p. 161-176.

NARKISS, B., SED-RAJNA, G., "La première Bible de Josué ben Abraham Ibn Gaon," *Manuscrits hébreux enluminés conservés dans les Bibliothèques de France,* REJ, 130, 1971, p. 255-269.

NORDSTRÖM, C. O., "The Water Miracles of Moses in Jewish Legend and Byzantine Art, *Orientalia Suecana,* 7, 1958, p. 78-109.

NORDSTRÖM C. O., "Rabbinische Einflüsse auf einige Miniatüren des Serbischen Psalters in München," *Akten des XI Internationalen Byzantinistenkongresses,* Munich, 1960, p. 416-419.

NORDSTRÖM, C. O., "Rabbinica in Frühchristlchen und Byzantinischen Illustrationen zum 4 Buch Moses," *Idea and Form, Studies in History of Art Figura,* N.S. i, 1959, p. 24-47.

NORDSTRÖM, C. O., "The Temple Miniatures in the Peter Comestor Manuscript at Madrid," *Horae Soederblomiance,* VI, 1964, p. 54-81.

NORDSTRÖM, C. O., "Rabbinic Features in Byzantine and Catalan Art," *Cahiers Archéologiques,* 15, 1965, p. 179-205.

NORDSTRÖM, C. O., *The Duke of Alba's Castilian Bible.* Uppsala, 1967.

NORDSTRÖM, C. O., "Some Miniatures in Hebrew Bibles," in *Synthronon,* Paris, 1968, p. 89-105.

PÄCHT, O., "Ephraimillustration, Haggadah und Wiener Genesis," in *Festschrift Karl Swoboda,* Weisbaden, 1939, p. 213-221.

PINDER-WILSON, R. H., ETTINGHAUSEN, R., "The Illuminations in the Cairo Moshe ben Asher Codex of the Prophets Completed in Tiberias in 895 A.D.," in KAHLE, P., *Der Hebräische Bibeltext Seit Franz Delitzsch,* Stuttgart, 1961, p. 95-98.

PORCHER, J., *L'Enluminure française.* Paris, 1959.

PORCHER, J., *Manuscrits à peintures offerts à la Bibliothèque nationale par le Comte Guy de Boisrouvray.* Paris, 1961.

RODRIGUEZ, F., *Di alcuni Codici Miniati della Biblioteca Universitaria di Bologna.* Bologna, 1957.

ROSENAU, H. "Notes on the Illuminations of a Spanish Haggada in the John Rylands Library." BJRL, 36, 1954, p. 475-478.

ROSENAU, H., "Contributions to the Study of Jewish Iconography," BJRL, 38, 1956, p. 466-482.

ROTH, C. "Jewish Antecedents of Christian Art," JWCI, 16, 1953, p. 24-44.

ROTH, C., "A Masterpiece of Spanish Jewish Art: The Kennicott Bible," *Sefarad,* 12, 1952, p. 365-368.

ROTH, C., *The Kennicott Bible.* Oxford, 1957.

ROTH, C., "The John Rylands Haggada," BJRL, 43, 1960, p. 136-156.

ROTH, C., "An Additional Note to the Kennicott Bible," *Gleanings, Essays in Jewish History, Letters and Art,* New York, 1967, p. 316-319.

SCHEIBER, A., *The Kaufmann Haggadah. Facsimile edition of Ms. 422 of the Kaufmann Collection in the Oriental Library of the Hungarian Academy of Sciences,* Budapest, 1957.

SED-RAJNA, G., *Manuscrits hébreux de Lisbonne. Un atelier de copistes et d'enlumineurs au XVᵉ siècle,* Paris, 1970.

SED-RAJNA, G., "Toledo or Burgos?", *Journal of Jewish Art.,* 2, 1975, p. 5-17.

SED-RAJNA, G., *Le Mahzor enluminé. Les voies de formation d'un programme iconographique.* Leiden, 1983.

STRZYGOWSKY, J., *Orient oder Rom, Beiträge zur Geschichte der spätantiken und frühchristlichen Kunst,* Leipzig, 1901.

WEITZMANN, K., "Die Illustration der Septuaginta," *Münchener Jahrbuch der Bildenden Kunst,* 3-4, 1952-1953, p. 96-120.

WEITZMANN, K., "The Octateuch of the Seraglio and the History of its Pictures," *Actes du Xᵉ congrès international d'Etudes Byzantines,* Istanbul, 1957.

WEITZMANN, K., "Zur Frage des Einflusses Jüdischer Bilderquellen auf die Illustration des Alten Testamentes," *Mullus, Festschrift Theodor Klauser, Jahrbuch für Antike und Christentum,* 1964, p. 401-415.

WISCHNITZER, R., *Symbole und Gestalten der Jüdischen Kunst.* Berlin, 1935.

WISCHNITZER, R., "Les manuscrits à miniatures de Maïmonide," *Gazette des Beaux-Arts,* 1935/2, p. 47-52.

WISCHNITZER, R., "Von der Holbeinbiebel zur Amsterdamer Haggadah," MGWJ, 75, 1931, p. 269-286.

WISCHNITZER, R., "Zur Amsterdamer Haggadah," MGWJ, 76, 1932, p. 239-241.

WISCHNITZER, R., "Autour du mystère de la Haggadah de Venise," REJ, 94, 1933, p. 184-192.

WISCHNITZER, R., "The Moneychanger with the Balance: A Topic of Jewish Iconography," EI, 6, 1960, p. 23-25.

INDEX OF ILLUSTRATIONS

INDEX OF NAMES AND SUBJECTS

EZRA, reading the Law, at Dura 70, 81.

FABLES, of animal 202.
FAÇADE of the Temple, iconographic theme 19, 28; on coins 37; on pilgrims bottles 58; on reliefs at Capharnaum 99.
FERRARA, 165, school of painting 197, 202.
FICIN MARCEL, Florentine humanist (1433–1499) 13.
FISH, gigantic, see Leviathan.
FLAME, perpetual, in iconography 151, 187.
FLAVIUS JOSEPHUS, historian (37–95), 16, 17, 21, 24, 27, 42.
FOLKLORE, Jewish 145.
FOSTAT, medieval synagogues 127, school of painting 176.
FOUR SONS, iconographic theme 154.
FRANCE, Jewish communities 138.
— school of painting 187–192;
— Hanukkah lamps 158;
— medieval synagogues 138, 142.
FURNITURE of the Sanctuary, in iconography 169.

GAMALIEL, Rabbi, II C.E. 46.
GAZA, synagogue VI C.E. 104; mosaic pavement 117, 118.
GAZELLE, folklore motif 145.
GENESIS of Vienna (Vienna, National-bibl. Cod. Vindob. Gr. theol. 31), VI C.E. 87, 166.
GENIZA of Fostat 127, 150.
GERMANY, southern, school of painting 167.
GHETTO, institution of 132.
GLASS grounds, ornamented 53.
GOODENOUGH, E.R. 72, 76, 80.
GRAPES, triple, iconographic motif 99.
GWOZDZIEC, synagogue of, XVIII C.E. 145.

HAGGADAH, Passover ritual 12, 154.
— illustrations 193–197.
— of Barcelona (London, Brit. Libr. Or. ms. 2884) 126.
— of Darmstadt (Darmstadt, Hessische Hochschul-und Landes-bibl. Cod. Or. 8) 180.
— of Joel B. Shimon (London, Brit. Libr. Add. ms. 14762) 180.

— of London (Brit. Libr. Or. ms. 1404) 194.
— of John Rylands Library (Manchester, Hebr. ms. 6) 194.
— Golden (London, Brit. Libr. Add. ms. 27210) 194, 197.
— of Sarajevo (Sarajevo, National Museum) 129, 193, 194.
HAGGADOT, engraved 202
HAMAN, at Dura, 80, 82; hanging his sons 184.
HAMMATH near Tiberias, synagogue IV C.E. 103; mosaic pavement 110–112.
HAND, divine, iconographic theme 70, 75, 116.
HANINA, Rabbi, II C.E. 46.
HANUKKAH, festival of Dedication 155; see also Hanukkah lamps.
HASMONEANS, priestly family, II B.C.E. 10, 33; See also Maccabees.
HASSIDIM 11, 181.
HASSIDISM, ashkenazi, spiritual movement in Germany, XI–XIII C.E. 127, 165.
HAVDALAH, ceremony 152. See also Havdalah lamp.
HAYYOT, see living creatures.
HAZOR, Canaanite sanctuary 14.
HEADS of animals, iconographic motif 11, 12, 181.
HEBRON, Tomb of the Patriarchs 17.
HELENA OF ADIABENE 19, 42.
HELICS, in mosaics at Hammath 110; at Beth Alpha 112.
HEROD THE GREAT (37–4 B.C.E.), his constructions 16, 21, 27; coins of 33.
HEROD ANTIPAS (4 B.C.E.–39 C.E.), coins of 35.
HEROD ARCHELAUS (4 B.C.E.–6 C.E.), coins of 35.
HEROD PHILIP II (4 B.C.E.–34 C.E.), coins of 35.
HERODION, fortress of Herod the Great, 20; synagogue 27.
HEXAGRAM, ornamental motif 100.
HIDDUR MITZVAH 11, 147.
HOFMANN HEINRICH, painter XVII C.E. 128.
HOLIDAY of Sukkot 35. See also Lulav, etrog.
HOLY objects of the Temple, iconographic theme, in mosaics 110–116; in illuminations 167–172.
HONORÉ, Maître, patron of illuminated manuscripts in Paris, end XIII 190.
HORB, timber synagogue (1735) 145.
HOUSE of assembly, origins 91; at Jerusalem 91.

IBERIAN penninsula, Jewish communities 122.

IBN EZRA, synagogue, at Fostat, XI–XIII C.E. 127.
IBN SINA (AVICENNA), manuscript of the Canon (Bologna, Bibl. univ. ms. 2197) 197.
ICONOGRAPHY, Biblical, the origins 88; of Haggadot 195–196. See also Dura–Europos.
INCUNABLES 202.
INHUMATION, second, burial practice 40.
ISAAC, sacrifice of, at Dura 66; at Beth Alpha 110, 116; on ritual objects 152, 158; in illuminations 173, 190.
ISAAC ABOAB, synagogue, at Safed, XVIII C.E. 144.
ISAAC LURIA, synagogue, at Safed, XVIII C.E. 144.
ISAIAH, martyr, 80; prophet, in illustrated manuscripts 173.
ISIDORE OF SEVILLE, Bishop (560–636) 80.
ISRAELITES, leaving Egypt, at Dura 75; in illumination 193.
ITALY, Jewish communities 130, synagogues 131; ritual objects 158; schools of painting 197–202.

JACOB, blessing his sons, at Dura 69.
— blessing Ephraim and Manasseh, at Dura 69.
— the dream of, at Dura 73, 81, 82; on ritual objects 152.
JAKIN and BOAZ, the two columns of the Temple 53.
JAR of manna, in illuminations 168.
JEHOIAKIM, history of, at Dura 78.
JEREMY, martyr, 80.
JERICHO, synagogue, VII C.E. 104; mosaic pavement 118.
JESHURUN TOWAR, goldsmith, Ferrara, XV century 163.
JEWISH WAR, coins of, 35.
JOAB, execution of, at Dura 78.
JOCHEVED, mother of Moses, at Dura 75, 82.
JOEL BEN SHIMON, scribe and painter 180.
JOHN HYRCANUS I (135–104 B.C.E.) coins 33.
JOHN HYRCANUS II (63–40 B.C.E.) coins 33.
JOSEPH IBN HAYIM, scribe 180.
JOSEPH «THE FRENCH MAN» scribe and painter 180.
JOSHUA AT GIBEON, Dura 70.
JOSHUA BEN ABRAHAM IBN GAON, scribe and painter 173, 178, 194.

INDEX OF MANUSCRIPTS

TABLE OF CONTENTS

«Ancient Jewish Art» was printed by Imprimerie Paul Attinger, Neuchâtel,
in August 1985